THE EMERGENCE OF JEWISH ARTISTS

In Nineteenth-Century Europe

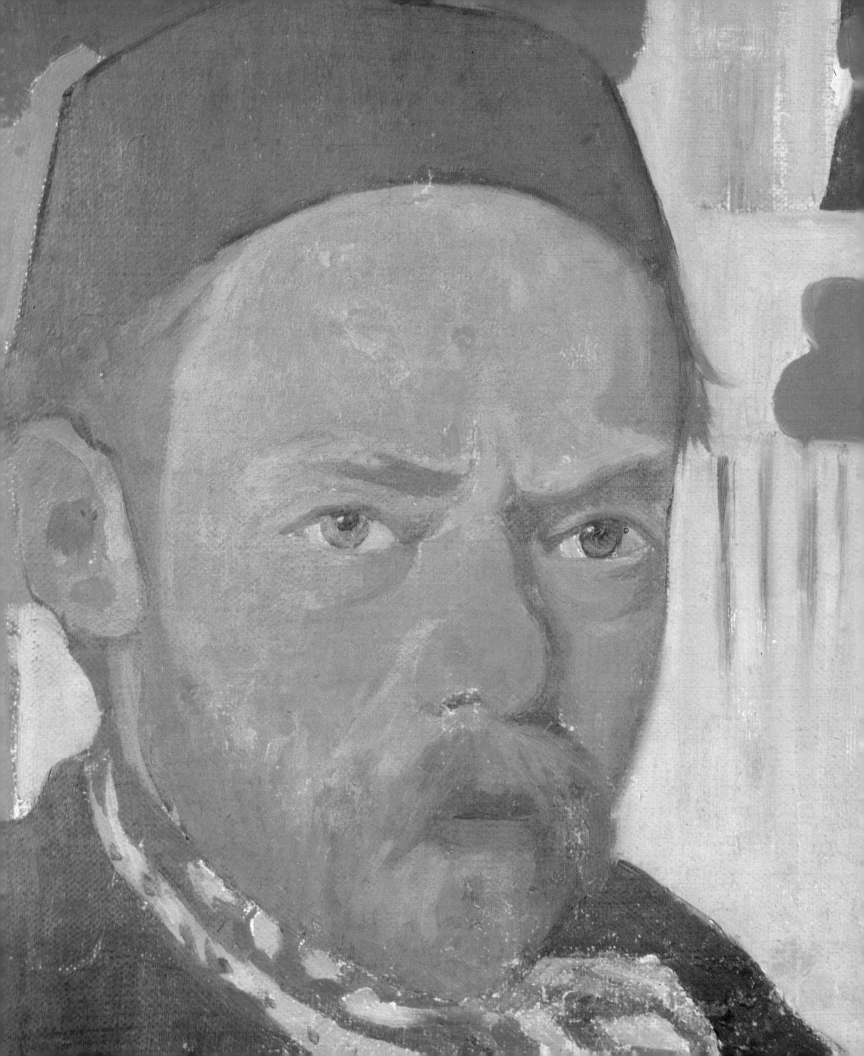

Edited by
Susan Tumarkin Goodman

With essays by
Richard I. Cohen
Susan Tumarkin Goodman
Paula E. Hyman
Nicholas Mirzoeff
Larry Silver
Gabriel P. Weisberg

The Emergence of Jewish Artists
IN NINETEENTH-CENTURY EUROPE

MERRELL

in association with

THE JEWISH MUSEUM, NEW YORK
under the auspices of
The Jewish Theological Seminary of America

This book has been produced to accompany the exhibition
The Emergence of Jewish Artists in Nineteenth-Century Europe
at
The JEWISH MUSEUM
1109 Fifth Avenue
New York
New York 10128
www.thejewishmuseum.org
November 18, 2001 – March 17, 2002

First published 2001 by
MERRELL PUBLISHERS LIMITED

Distributed in the USA and Canada by Rizzoli International Publications, Inc.
through St. Martin's Press, 175 Fifth Avenue, New York, New York 10010

Library of Congress Control Number:
2001093535

British Library Cataloguing-in-Publication Data:
The emergence of Jewish artists in nineteenth-century Europe
Jewish artists
1.Jewish artists – Europe – History – 19th century 2.Painting, Modern – 19th century – Europe 3.Art, Jewish – Europe – History – 19th century
I.Goodman, Susan T. II.Jewish Museum (New York, N.Y.)
704.03924.04

ISBN 1 85894 153 9 (hardback)
ISBN 1 85894 154 7 (paperback)

Produced by
MERRELL PUBLISHERS LIMITED
42 Southwark Street
London SE1 1UN
England
www.merrellpublishers.com

Edited by Ellen R. Feldman and William Zeisel

Designed and typeset in Walbaum by
studioGOSSETT | LONDON

Printed and bound in Italy

Front jacket/cover: Simeon Solomon. *Carrying the Scrolls of the Law* (detail), 1867. See pl. 41.
Back jacket/cover: Camille Pissarro. *Avenue de l'Opéra, Place du Théâtre Français: Misty Weather,* 1898. See pl. 65.
Frontispiece: Jacob Meyer de Haan. *Self-Portrait* (detail), 1889–91. See pl. 60.

Exhibition Curator:
Susan Tumarkin Goodman
Consulting Curator:
Richard I. Cohen
Manager of Curatorial Publications:
Michael Sittenfeld
Exhibition Design:
Lana Hum

Contents

6

Lenders to the Exhibition

Akademie der Künste, Berlin

The Ashmolean Museum, Oxford

The Ben Uri Gallery, The London Jewish
 Museum of Art

Berlinische Galerie, Berlin

Civica Galleria d'Arte Moderna, Milan

Delaware Art Museum, Wilmington

The Forbes Magazine Collection, New York

The Israel Museum, Jerusalem

Istituto Matteucci, Viareggio, Italy

The Jewish Museum, New York

Joods Historisch Museum, Amsterdam

Judah L. Magnes Museum, Berkeley

Kröller-Müller Museum, Otterlo, Holland

Kunsthandel Sabine Helms, Munich

Kunsthandel Wolfgang Werner,
 Bremen/Berlin

Metropolitan Museum of Art, New York

Musée d'art et d'histoire du Judaïsme, Paris

Museo Civico Giovanni Fattori, Livorno, Italy

Muzeum Narodowe w Warszawie, Warsaw

Nationalgalerie, Staatliche Museen, Berlin

National Gallery of Canada, Ottawa

The National Railway Museum, York, UK

Philadelphia Museum of Art

Rijksmuseum, Amsterdam

Städtische Galerie im Städelschen
 Kunstinstitut, Frankfurt

Stedelijk Museum, Amsterdam

Stiftung Jüdisches Museum, Berlin

Stiftung Stadtmuseum Berlin

The Tate Gallery, London

Tel Aviv Museum of Art

Vienna City Museum, Vienna

Weizmann Institute of Science, Rehovot,
 Israel

The Whitworth Art Gallery, The University
 of Manchester

Edmund J. and Suzanne McCormick
 Collection, New Haven, Connecticut

Collection Carmel Friedländer Agranat,
 Jerusalem

Collection Mr. and Mrs. Arthur G. Altschul,
 New York

Collection Reuven and Naomi Dessler,
 Cleveland

Collection Vera Eisenberger KG, Vienna

Collection Mr. and Mrs. Herbert Klapper,
 New York

Collection Sara and Moshe Mayer, Tel Aviv

Studio Paul Nicholls, Milan

Collection Friede Springer, Berlin

Private collections

Donors to the Exhibition

The Emergence of Jewish Artists in Nineteenth-Century Europe is made possible through the leadership support of

Daniel R. and April S. Goldberg
Brenda Gruss and Daniel O. Hirsch
Andrew E. and Marina W. Lewin
Clement and Susan Lewin
Tamar and Stephen Olitsky
Anonymous

in memory of their grandparents Oscar and Regina Gruss.

Major gifts have been provided by the National Endowment for the Arts, the New York Council for the Humanities and the National Endowment for the Humanities, the Milton and Miriam Handler Foundation, and other generous donors. The catalogue has been published with the aid of a publications fund established by the Dorot Foundation.

Foreword

The Emergence of Jewish Artists in Nineteenth-Century Europe, the first museum survey of Jewish artists in Europe between the 1820s and 1910s, brings into view for the general public and the scholarly community a group of virtually unknown artists who have by and large been omitted from standard art-history texts. Many European city and state museums, as well as Jewish museums, have included one or more of these artists in permanent or temporary installations, and there have been notable monographic exhibitions, in particular in Germany and Israel. However, until this exhibition at The Jewish Museum in New York, no institution has mounted as inclusive a presentation. *Emergence* focuses on the nexus of art and Jewish culture as it relates to art history and Jewish social history, exploring the ways in which the paintings reflect, interpret, and refract the experiences of Jewish artists in Europe during a century of great social and political change.

An essential reality underlying *Emergence* is that prior to the mid-1800s there were legal limitations on where Jews could live, work, and study. Political emancipation and social acculturation brought about a new integration into the larger society, and for artists this included access to the artists' guilds and art academies. These first generations of Jewish professional artists are highlighted in the current exhibition and catalogue.

There is a tremendous range of style within the exhibition, with the Jewish content ranging from the apparent to a deliberate absence of specific imagery. The excitement of these works comes from the fact that painting is essentially a newfound means of communication for Jews, and a highly personal and powerful meaning resonates within all of the works on view and represented in the catalogue.

The authors of this catalogue, in their penetrating essays, examine the lives of the individual artists, their relationships with the larger art world, and the complex array of issues that informed their aesthetic choices. Each makes a persuasive case for the importance of the artists, and I greatly appreciate the scholarship and writing of our essayists: Richard I. Cohen, at the Hebrew University in Jerusalem; Susan Tumarkin Goodman, Senior Curator-at-Large at The Jewish Museum; Paula E. Hyman, at Yale University; Nicholas Mirzoeff, at the State University of New York at Stony Brook; Larry Silver, at the University of Pennsylvania; and Gabriel P. Weisberg, at the University of Minnesota.

Emergence represents a milestone at The Jewish Museum in terms of its involvement with nineteenth-century painting by Jewish artists in bringing together both our exhibition and collection interests. The museum's engagement with

this period began with important acquisitions for the collection, and in this context we benefited greatly from the inspiration of an important collector and patron—the late Regina Gruss, who, with her husband, Oscar, created an environment in their home that beautifully combined art and ceremonial objects, narrative visual works with post-emancipation Expressionist painters, and works that depicted both the secular and religious lives of Jews in the modernist period. Polish by birth, Regina and Oscar Gruss emigrated to America in the middle of the twentieth century. Mrs. Gruss later became involved with The Jewish Museum after her husband's death. She made possible the museum's initial important acquisitions of nineteenth-century Jewish painters, and she continued to inspire our expanded interest in the subject. No one at the museum can look at the works in this exhibition without remembering her home and the way these paintings reflected her values and her life. The dedication of this exhibition to the memory of Regina Gruss attests to our continued admiration and appreciation for what she provided us, spiritually and materially.

Our donors have recognized the signficance of this exhibition, and I extend my thanks to all of those whose generosity has made this project possible. I wish to acknowledge additional major gifts from Daniel R. and April S. Goldberg, Brenda Gruss and Daniel O.

Hirsch, Andrew E. and Marina W. Lewin, Clement and Susan Lewin, Tamar and Stephen Olitsky, and an anonymous donor in memory of their grandparents Oscar and Regina Gruss, the National Endowment for the Arts, the New York Council for the Humanities and the National Endowment for the Humanities, the Milton and Miriam Handler Foundation, and other generous donors. This beautiful catalogue has been published with the aid of a publications fund established by the Dorot Foundation.

My deep appreciation goes to the staff members of the museum who have devoted their intelligence and energy to *The Emergence of Jewish Artists in Nineteenth-Century Europe*. Many thanks and congratulations to Susan Goodman, whose tremendous and untiring efforts have resulted in this splendid exhibition. I also greatly appreciate the essential contributions of Richard Cohen, who has served as a consulting curator for this project. Added thanks as well to Ruth Beesch, Deputy Director of Program, and Michael Sittenfeld, Manager of Curatorial Publications. Finally, I must express my deep gratitude for the generosity and wise counsel of The Jewish Museum's superbly supportive Board of Trustees, chaired by Robert J. Hurst.

Joan Rosenbaum
Helen Goldsmith Menschel Director

Recovering a Lost Tradition: The Oscar and Regina Gruss Collection

In a recent article, art historian Reesa Greenberg examined three major art collectors whose attitudes toward collecting art and whose decisions about how to display it were shaped by the Holocaust. Her choices—Peggy Guggenheim, Philip Johnson, and Ydessa Hendeles—form an odd, even contradictory trio. Peggy Guggenheim was the champion of European modernists and American postwar art. Philip Johnson is renowned as a patron of Pop Art. And Ydessa Hendeles continues today as a supporter and curator of postmodern art and photography, much of which is overtly political or highly personal. The vision of each of these collectors was indelibly marked by the history of World War II and the Holocaust.[1]

Oscar and Regina Gruss, who narrowly escaped the war and the Holocaust and who lost many family members to the devastation in Europe, felt the tremendous impact of that history. They left Poland in May 1939 to come to New York and visit the World's Fair. In doing so, they were able to save their lives, and ultimately those of their three children. They returned to Poland in June 1939, but left again in September 1939 when the war broke out, escaping to Hungary. They subsequently returned to the United States in December 1939 on the visa they had used to travel to the World's Fair. All of their material possessions had to be left in their hometown, Lvov, in today's Ukraine, then in Poland, and at the time of each of their births, in the Lemberg of

the Austro-Hungarian Empire. There they collected objects of art, most of which had little to do with either their Jewish faith or with the rich Jewish culture that existed there for centuries. In addition to the visual arts, they were deeply interested in the Jewish theater. The Grusses were successful, modern people with a great respect for and devotion to their religion. But in that intoxicating moment in the late wake of European emancipation of Jews and their close connection with the local culture, the Grusses did not need art to remind them of who they were.

After Oscar Gruss reestablished his banking company as a New York Stock Exchange firm, the Grusses started once again to collect art. However, this time their collecting interest would be much more focused, its meaning central to their family traditions and, not least, to the devastating effects of world history. The Grusses began to collect what had been called "Jewish art," a term I find too narrow to encompass the richness of Jewish culture in prewar Europe and the diversity of styles in which it was made. Apart from their collection of Jewish ceremonial art, mostly works in silver, their collection focused on painting, with particular emphasis on two great Jewish artists of the nineteenth century, the German artist Moritz Daniel Oppenheim and the Austrian Isidor Kaufmann, both of whom are central to this exhibition. They took advantage of the fact that at mid-century, such realist

nineteenth-century masters as Oppenheim and Kaufmann, along with such symbolists as Lesser Ury and late Eastern European Impressionists like Jehudo Epstein, were far from fashionable. It was only during the 1980s and 1990s that we saw a revived interest in art by nineteenth-century realist and academic masters. The Grusses assembled a very rich and beautiful collection of paintings, stunningly virtuosic works by Kaufmann and the historically significant suite of paintings of Jewish life by Oppenheim. The Oppenheim paintings were brought to the United States from Germany by the descendants of Hermann Cramer, who had owned these works for decades. The Jewish Museum was offered the paintings in 1948. At the time the newly relocated institution could not find funds to purchase them, and the curators were only contemplating the purchase of a small selection from the group of fourteen. Thanks to the Grusses' generosity, these paintings were kept as a suite, and eventually entered the museum's collection in 1999.

Although these paintings may have been a good value at the time, they were by no means inexpensive by period standards. A letter in the archives of The Jewish Museum indicates that the dealer was asking between $250 and $1,000 for some of the paintings.[2] At the time, these were not minor sums. Remember that John Rockefeller bought a major Monet *Water Lilies* that same year for only $8,000.[3] In fact,

Oscar and Regina Gruss's apartment in New York. The large painting above the sofa is Isidor Kaufmann's *Hearken Israel* (1910–15; pl. 21), featured in this exhibition.

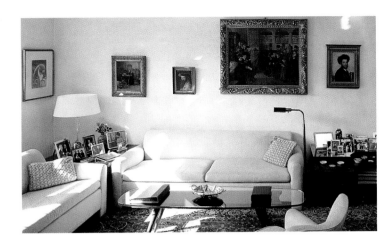

Mrs. Gruss reminisced that in the beginning she questioned her husband about the works they were buying, and thought she might prefer that they acquire some Impressionist works as well. In the end, she admitted to me that if they had gone the Impressionist route, she would have had a second-rate art collection. Instead, the Grusses assembled a collection that, in light of revisionist art history, is of great importance.

Their collection became an integral part of their very gracious but somehow modest home. No one could walk into that apartment at Riverside Drive and Seventy-Fifth Street without being moved and affected by these paintings and the atmosphere they created. It was a place for family and for friends, and the art, which focused on Jewish life and ritual, confirmed the Grusses' values at the same time as they reminded us of the remarkable life that was lost in Europe.

At times, the Grusses' eyes were larger than the walls of their apartment. In a desire to save and assemble significant works by early Jewish artists, particularly works with traditional Jewish subjects, they took advantage of the appearance on the market of larger-scale pictures. Their space shortage ultimately worked to the benefit of The Jewish Museum when, in 1955, the Grusses donated Solomon Alexander Hart's *The Feast of the Rejoicing of the Law at the Synagogue in Leghorn, Italy* (1850; pl. 10), featured in this

exhibition, and Leopold Pilichowski's *Sukkoth* (1894–95). In fact, the Hart painting has become one of the chestnuts of our collection, continually on view and reproduced widely. Upon Mrs. Gruss's death at the age of 100 in 1998, the Oscar and Regina Gruss Foundation donated the entire suite of Oppenheim paintings to the museum.

I had the good fortune to know Regina Gruss since 1975, just a short time before her husband died in 1976, and I got to know her, her family, and her collection in personal and intellectual ways. Like so many other museum supporters who generously give money and works of art, Mrs. Gruss used her resources solely to help advance the mission of this institution. She was unusual, however, in her insistence on a direct, but very respectful, relationship with the curatorial staff. She encouraged ambitions for our professional lives and the institution in which she believed so fervently. Mrs. Gruss always said she was exceedingly proud of the museum's growth over the last twenty years (and in fact claimed that The Jewish Museum was her favourite charity). Likewise, we are proud to have been associated with her and to have been the beneficiaries of her family's largesse.

Norman L. Kleeblatt
Susan and Elihu Rose Curator of Fine Arts

NOTES

1. Reesa Greenberg, "Private Collectors, Museums, and Display: A Post-Holocaust Perspective," *Jong Holland*, no. 1 (2000): 29–41.

2. Letter from Stephen S. Kayser, curator at The Jewish Museum, to Harry G. Friedman, 21 May 1948, Archives of The Jewish Museum, New York.

3. See Gerald Reitlinger, *The Economics of Taste: The Rise and Fall of Picture Prices, 1760–1960*, 3 vols. (New York: Holt, Rinehart and Winston, 1964).

Preface

In the hindsight of the century since the founding of The Jewish Museum in 1904, tastes have changed and we have gained a renewed appreciation of some of the very artworks that were popular a century ago but subsequently receded from view. These works have not been afforded the rigorous scholarship or attention in exhibitions that they deserve. We trust that eventually these artists will be integrated into the proper art-historical context and that this exhibition will serve as a first step in this process, encouraging further scholarship and additional exhibitions.

The Emergence of Jewish Artists in Nineteenth-Century Europe arose from a need to examine the ways in which religion, history, politics, and aesthetics affected the careers and identities of particular artists across a continent. As the exhibition and catalogue took shape, it became clear that Jewish artists in England, France, Italy, Germany, Holland, Austria-Hungary, and Poland produced paintings of great distinction as they struggled to comprehend the meaning of their new freedoms. At the present time, when many art historians are reevaluating the course of nineteenth-century European painting, it seems necessary more than ever to examine the long-neglected artists you will find in these pages.

In early-nineteenth-century Europe, Jewish artists were rare, but they gradually became more numerous until, by the beginning of the twentieth century, they were largely accepted as part of the cultural scene. Our selection of the twenty-one artists of Jewish origin included in this catalogue is certainly not a definitive gathering—a vast number of Jewish artists plied their craft in Europe at this time. As we debated the number of painters to include in the exhibition, we recognized that it would be impossible to provide a rounded sense of each artist's oeuvre.

What *The Emergence of Jewish Artists in Nineteenth-Century Europe* does provide is an argument for the importance of artists who have been marginalized for too long as Jewish artists. Painters such as Brancia Koller-Pinell, Maurycy Gottlieb, Samuel Hirszenberg, Jozef Israëls, and Simeon Solomon merit serious study simply as artists. But while this catalogue calls for a rethinking of the canon of nineteenth-century European painting, it also demonstrates the role of Judaism in the lives of the artists gathered here. To acknowledge this essential fact is to declare that art does not exist in a vacuum but instead develops in a complex social, historical, psychological, and political matrix.

In formulating a new perspective on both the art and the history of a complex century, I have benefited from the assistance of Richard I. Cohen, Senior Exhibition Consultant for this project. His pioneering work on many of the artists in the exhibition was significant, particularly his 1998 book *Jewish Icons: Art and Society in Modern Europe*, and his insights and advice were invaluable in the exhibition conception and planning. My sincere thanks to Norman Kleeblatt, the Susan and Elihu Rose Curator of Fine Arts at The Jewish Museum, whose vision and understanding of the significance of nineteenth-century art by Jews has enriched The Jewish Museum in perpetuity. His belief in this subject and recognition of the need for such an exhibition must be acknowledged as the initial source of this project.

The exhibition could not have been realized without the confidence and encouragement of Joan Rosenbaum, the Helen Goldsmith Menschel Director of The Jewish Museum. Her understanding of the significance of this project was essential to its completion. Our entire Board of Trustees, in particular the Exhibition Committee, chaired by Axel Schupf and Francine Klagsbrun, supported the project throughout.

I would like to join Joan Rosenbaum in expressing my gratitude to those lenders, public and private, who welcomed the idea of the exhibition with enthusiasm and agreed to lend important works by the artists represented. The art was gathered from institutions and private collections in many countries, and I have relied on the cooperation of a large number of museum professionals and scholars in Europe, Israel, and the United States, who have been generous with their expertise, providing important sources and

invaluable advice. They include Ziva Amishai-Maisels; Inka Bertz at the Stiftung Jüdisches Museum, Berlin; Stanley Batkin; Emily Bilski; Emily Braun; Jenö Eisenberg of Vera Eisenberger KG, Vienna; Bill Gross; Nathalie Hazan-Brunet at the Musée d'art et d'historie du Judaïsme, Paris; Gabrielle Kohlbauer-Fritz of the Jüdisches Museum der Stadt Wien GmbH, Vienna; Doron Lurie at the Tel Aviv Museum of Art; Jane Nowosadko of the Yale Center for British Art, New Haven, Connecticut; Ursula Prinz at the Berlinische Galerie, Berlin; Bernhard Purin of the Jüdisches Museum, Franken, Furth, and Schnaittach; Judith Spitzer and Shlomit Steinberg at The Israel Museum, Jerusalem; Edward van Voolen of the Joods Historisch Museum, Amsterdam; Annette Weber at the Jüdisches Museum, Frankfurt am Main; Julia Weiner of the Courtauld Institute of Art, London; and Angelika Wesenberg at the Staatliche Museen, Berlin.

Organizing an exhibition and producing a catalogue are collaborative endeavors and require the dedication and commitment of a superb group of Jewish Museum associates. I am particularly grateful for the wise counsel as well as practical advice provided by Ruth Beesch, Deputy Director of Program, through all the stages of this project. My deep appreciation to Jessica Williams, Administrative Assistant, who has tirelessly devoted her talents to coordinate every aspect of the exhibition and catalogue. Thanks to both Sally Lindenbaum and Yoheved Muffs. Both have shown extraordinary dedication, and it has been a pleasure to work with them on this exhibition. Mrs. Muffs has graciously and adeptly handled numerous research and administrative work, and Mrs. Lindenbaum has performed countless tasks with tremendous skill and verve. Interns Cara Zwerling and Juliana Ochs also made invaluable contributions. Michael Sittenfeld, Manager of Curatorial Publications, was indispensable in bringing the catalogue to fruition. His sensitivity to the issues confronting us and his fundamental help with all levels of interpretation were extremely important and greatly appreciated.

Numerous other colleagues at The Jewish Museum and their respective staffs provided invaluable expertise and advice, particularly Marilyn Davidson, Manager of Product Development and Licensing; Debbie Schwab Dorfman, Director of Merchandising; Tom Dougherty, Deputy Director for Finance and Administration; Jeffrey Fischer, Director of Development; Al Lazarte, Director of Operations; Linda Padawer, Director of Special Events; Grace Rapkin, Director of Marketing; Marcia Saft, Director of Visitor and Tourist Services; Anne Scher, Director of Communications; Deborah Siegel, Director of Membership and Annual Giving; Fred Wasserman, Associate Curator/Core; Aviva Weintraub, Director of Media and Public Relations; Elana Yerushalmi, Director of Program Funding; Stacey Zaleski, Buyer; and Carole Zawatsky, Director of Education.

The installation design, which so appropriately reflects the theme of the exhibition, was conceived and created by Lana Hum and graphic designer Nerissa Vales.

My sincere appreciation goes to the authors of the catalogue, whose profound knowledge of the period under consideration has greatly enhanced our understanding of the art. Thanks to Ellen R. Feldman for her sensitive and intelligent editing of the catalogue, and to William Zeisel for his insightful work on several of the essays. Jody Heher, Coordinator of Exhibitions at The Jewish Museum, stepped in at a critical moment to assist us in gathering the visual materials for the catalogue. She did this with extraordinary skill and good spirit. Merrell Publishers has handled the logistics of catalogue publication with expertise and efficiency in producing this handsome book.

Personal thanks must go to my husband, Jerry Goodman, who supported my efforts on this project over such a long period of time.

Susan Tumarkin Goodman
Senior Curator-at-Large

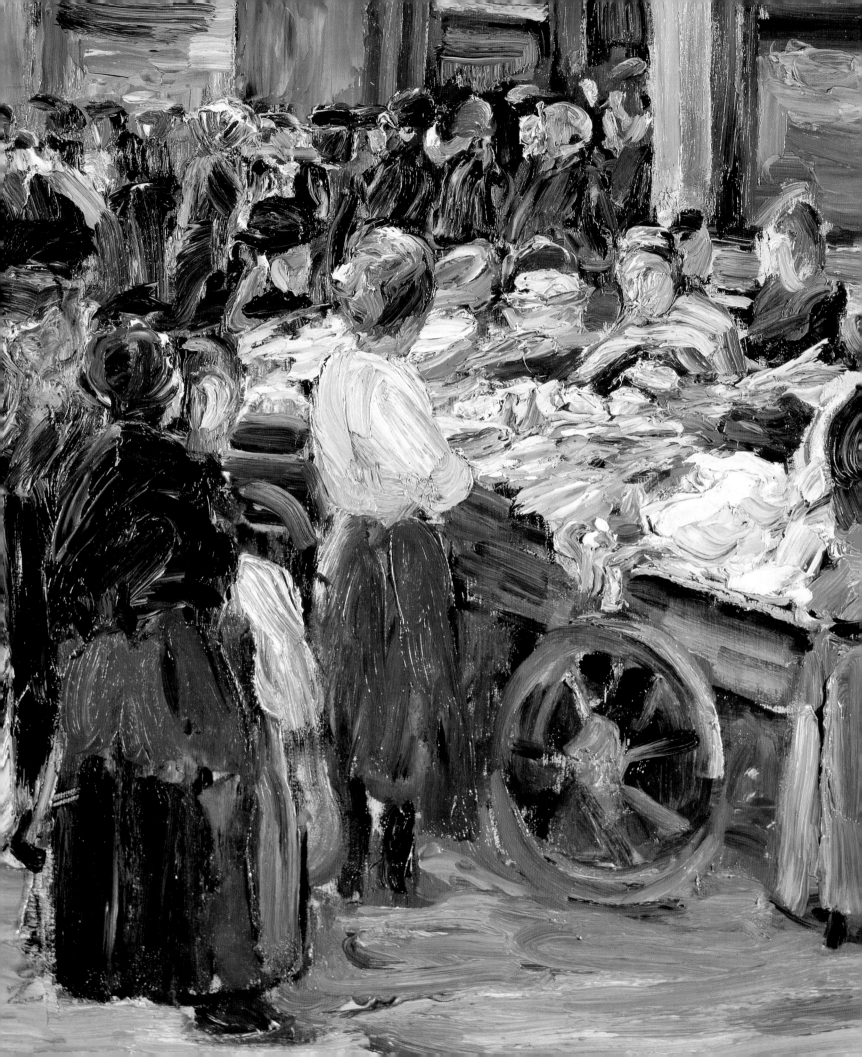

Max Liebermann. *Jewish Street in Amsterdam* (detail), 1908. See pl. 52.

Susan Tumarkin Goodman

Reshaping Jewish Identity in Art

The preoccupation with definitions of identity that exists as an ongoing debate among Jews today can be traced to the nineteenth century, when a confluence of phenomena transformed the political status of European Jews and raised fundamental questions about the role of the individual and the artist in society. For centuries, Jews throughout Europe had maintained distinct communal and personal identities based on religion, deeply rooted traditions, and the desire of the larger societies in which they lived to keep them distinct and separate. Not until the last decades of the eighteenth century did governments begin to remove the legal restrictions that had confined Jews to certain occupations, excluded them from most educational institutions, and otherwise marginalized them in predominantly Christian society. Only then did it become possible for Jewish artists to enter the mainstream and acculturate to the dominant modes of society. In so doing, some found it necessary—for reasons of preference and expedience—to relinquish the Jewish world, while others continued to revel in it as a source of inspiration and despaired over its decline.

There were those who believed that a Jew whose aim was to succeed in his or her chosen profession had no choice but to accommodate, whether consciously or unconsciously, to the expectations and thinking of the national majority. Often, drawing closer to the majority

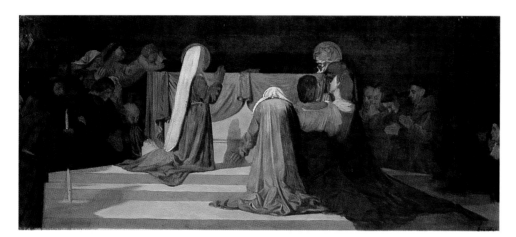

FIG. 1. Jacques-Émile-Edouard Brandon (French, 1831–1897). *The Death of Saint Brigitte*, n.d. Oil on canvas; 21¼ × 48¾ in. (54 × 124 cm). Musée des Beaux-Arts, Brest, France.

population entailed adopting the prevailing styles of dress and behavior and learning the language of their nation. However, while Jews understood that this would expand their opportunities and experiences, they also saw that it posed a dilemma: How much would their entry into the larger society require them to mute, or even deny, their Jewishness? And how could they function as loyal, engaged citizens of the countries where they had just achieved a measure of freedom and equality while remaining faithful to their own traditions?

Jewish artists of the period answered the question of acculturation in two general ways, and both were expressed through their art. One was to embrace change and adapt eagerly; the other was to resist it or to allow only minimal change within a Jewish framework. Most nineteenth-century Jewish artists oscillated between secular themes and Jewish sources, in an internal dialogue that engaged them throughout their lives. Their art makes visible their responses, struggles, and accommodations in an age of great change within both Jewish life and the broader society. An examination of the work of these artists can help to elucidate this pivotal era.

Creating an Art Form out of Jewish Tradition

The tension between acculturating, on the one hand, and retaining a hold on a perceived Jewish world, on the other, is reflected in paintings that depict the growing distance between "authentic," traditional Jewish experience and contemporary Jewish life. The rapid pace of European urbanization and industrialization was transforming the physical and psychic environment of Jews and non-Jews alike. Jewish artists sought to hold on to or to reclaim their vanishing past by returning to it visually, making use of its themes through genre subjects that depicted rituals intended to evoke an authentic Jewish experience. A keen wish to retain the Jewish experience as a primary source informs the paintings of Moritz Oppenheim in Germany, Edouard Moyse in France, and Isidor Kaufmann in Austria. Although their works faithfully depict religious study and ritual, they are not religious paintings as such but rather attempts to evoke the devout lifestyle of their forebears before acculturation, a way of linking past with present.

Kaufmann wished to create a visual expression that would accurately reflect the Jewish experience in its historical as well as its daily manifestations. He saw an indissoluble connection with his people, based on a deep commitment to the Jewish heritage, which he

believed had been preserved for centuries primarily in the shtetl, the provincial town characteristic of Jewish life in Eastern Europe. Traveling to the small towns of western Hungary, Galicia, Moravia, and the Russian part of Poland, he chronicled traditional Jewry and its customs in exhaustive detail to capture an authentic way of life that he believed had been lost in the West. Paintings such as *Hearken Israel* (1910–15; pl. 21) and *Sabbath Rest*, with their faithful renderings of Jewish life-cycle events, helped to connect urban, acculturated Viennese Jews to a bygone era untouched by modern life.

Storytelling pictures made for Jews by Jews appealed to the growing art consciousness of the emerging Jewish middle class during the mid-nineteenth century. Such pictures also reminded them of traditions and customs they had known and generally observed during childhood, an important function in constituting identity, particularly for those Jews who mixed with non-Jews and engaged in social activities in the community at large. Jews had also begun to travel abroad, where they encountered other lifestyles. For them, traditional practice began to lose much of its appeal as a daily reality but retained its importance as an aspect of cultural identity. An easy way to express one's heritage was to decorate a room with Moritz Oppenheim's *Scenes from Traditional Jewish Family Life*, reproductions of events from the Jewish life

cycle as well as Sabbath and festivals. Oppenheim made these genre scenes for conservative Jewish viewers during the 1860s and had them published in book form using grisaille, a technique of rendering color images in shades of gray to facilitate their mass reproduction.[1] By placing his scenes of family life in the Frankfurt ghetto during the late eighteenth century, he enabled acculturated middle-class Jews in Central and Western Europe to recall and identify with their vanishing past, and to envision the ghetto as a place evoking nostalgic memories of the world of their grandparents. As the scholar Ismar Schorsch has noted, "With Oppenheim, Jewish iconography emerged as a wholly new and unexpected resource in the battle to preserve Jewish identity."[2]

Simeon Solomon in England and Jacques-Émile-Edouard Brandon in France were among the earliest artists to treat Jewish life directly. Solomon was raised in a prosperous Jewish family, and his Orthodox upbringing instilled in him a reverence for the Hebrew Bible, while his interest in spirituality, ritual, and exoticism led to varied religious themes, including those of the Christian Bible. He expressed these interests in remarkably different artistic ways. *Carrying the Scrolls of the Law* (1867; pl. 41), depicting a young rabbi lovingly holding the Torah, conveys rapt devotion to Jewish tradition, while the roughly contemporaneous *Two Acolytes Censing* (1863;

pl. 42) shows an attachment to church vestments and rituals. He was drawn to the Pre-Raphaelites, who also were enamored of church ritual and often used it thematically as part of their effort to purify what they perceived as the decadence of academic art. Solomon adopted the Pre-Raphaelites' close observation of nature and idealization of beauty, creating images of deeply felt spirituality unique in British art.

In France, Brandon, like Simeon Solomon, made forays into Christian themes, focusing primarily on female subjects, much in demand during the prosperous reign of Napoleon III (fig. 1; see also fig. 37). Brandon later returned to his cultural roots, possibly out of a commitment to his family, one of the most prestigious and wealthy Sephardic Jewish families in France. Turning his attention to Jewish synagogue and schoolroom interiors, he made several paintings of the impressive Amsterdam Portuguese Synagogue. In *Silent Prayer, Synagogue of Amsterdam, "The Amidah" ("La Guamida")* (1897; pl. 11), Brandon provides a wide-angle view of the majestic building's complex architectural interior, evoking its grandeur at the moment of the chanting of the *Amidah*, or Silent Prayer, part of the traditional daily and holiday services.[3]

Solomon Alexander Hart, the first Jewish member of the Royal Academy of London, who usually alternated his Jewish themes with

FIG. 2. Solomon Alexander Hart (British, 1806–1881). *The Scala Santa at the Benedictine Monastery, Subiaco,* 1841–42. Oil on canvas; $35\frac{3}{4} \times 24\frac{1}{2}$ in. (90.8 × 62.1 cm). Victoria and Albert Museum, London.

Christian and English ones deriving from Shakespeare and English history, proudly displayed his Jewish heritage in *The Feast of the Rejoicing of the Law at the Synagogue in Leghorn, Italy* (1850; pl. 10). The procession takes place in a richly decorated eighteenth-century Italian synagogue in Leghorn

FIG. 3. Solomon J. Solomon (British, 1860–1927). *Election of the Chief Rabbi of England*, 1906. Watercolor on paper; 12 × 15 in. (30.5 × 37.9 cm). The Jewish Museum, New York; Gift of Robert Wishnick, JM 90-55.

(Livorno) and expresses a Romantic vision of the exotic dress of Sephardic Jews as they parade the Torah scrolls. Hart drew the synagogue from sketches made on his grand tour of the Continent around the middle of the century, for, like so many of his countrymen, he visited Europe to broaden his horizons.[4] The elaborate drawings of historical sites and architectural interiors made on that tour provided material for a number of his later paintings (fig. 2).

Whether referring to Jewish history, life, and culture or drawing from the world at large, the Jewish artist mirrored the cultural dichotomy resulting from the new opportunities that opened up after emancipation. Paintings by Moritz Oppenheim and Solomon J. Solomon speak to the retention of Jewish tradition in an acculturated world while also reflecting the participation of Jews in the life of their nation (fig. 3). In *Yahrzeit Minyan*

(pl. 6), from 1875, Oppenheim depicts the required ten men gathered in a French farmhouse to conduct the afternoon prayer service marking the anniversary of the death of a family member. The setting—a battlefield during the Franco-Prussian War—is at odds with such a sacred ceremony. To emphasize this point, the artist made certain that the viewer notice the cross on the wall, which has been covered for the occasion, and the local non-Jewish girls peering with curiosity through the window.

Oppenheim's *Sabbath Rest* (1866; pl. 4) also addressed the experience of Jews as they navigated between the old and new traditions. Here, the doorpost in the painting bears the date 1789, the year of the French Revolution, which ushered in equality in France and announced the end of the era. Two very different lifestyles adapt to each other: The older woman observes the day of rest while

poring over a traditional Yiddish text read on the Sabbath by women who did not know how to read Hebrew. The younger woman, representing the next generation, is deep in the interior of the house, likely reading a contemporary novel or other secular text. In *High Tea in the Sukkah* (pl. 25), painted in 1906, Solomon J. Solomon represents another by-product of acculturation—the adaptation of the English custom of high tea to the Jewish practice of eating in a temporary booth during the holiday of Sukkot. Tradition and acculturation coexist, as Jews with uncovered heads and Britain's chief rabbi accommodate each other's ways within the sukkah setting.

The Dutch artist Jozef Israëls also attempted to steer a middle course between unbending Orthodoxy and radical acculturation. In *A Jewish Wedding* (1903; pl. 49), one of three major works with Jewish content that he made late in life, Israëls applied the same humanistic concerns to Jewish themes that he addressed to working peasants and fishermen. More than forty years earlier, in 1861, Moritz Oppenheim had painted *Wedding* (pl. 5). Set in the courtyard of the old synagogue of Frankfurt, built in 1711, it conveys a sense of the harmony and cohesiveness of pre-emancipation Jewish life. Much as in the Israëls painting, the couples, who wear eighteenth-century dress, stand under a tallith, or prayer shawl, which serves as a *huppah* (wedding canopy).

Challenging Tradition

As artists felt more confident of their ability to live and work in the broader society, many chose to leave what they perceived to be the confines of the Jewish community. Some even converted to Christianity, either to smooth their career paths to the new opportunities within their reach or simply to conform to the dominant society for reasons of personal or religious belief. Even the many who did not go to this extreme relaxed their ties to religion and favored a general education over the traditional Jewish one. As Jews were redefining their identity in European society, traditional practice could not sustain the commitment of persons who were genuinely attracted to the dominant culture of the age. In other cases, the loosening of tradition was simply the product of indifference in a world in which it was no longer necessary to adhere to a specific religious way of life.

No works more fully display the personal discomfort or ambivalence that confronted artists than the paintings by Polish artists Maurycy Gottlieb and Maurycy Minkowski. Gottlieb's complex composition *Jews Praying in the Synagogue on Yom Kippur* (1878; pl. 15) includes portraits of twenty individuals who figured importantly in the artist's life. He also depicts himself conspicuously three times within the work, at different moments in the ceremony. The solemnity of the day gives the artist a moment to assess his own life and to affirm his participation within the Jewish community. With seeming prescience, he inscribed the Torah scroll with a Hebrew memorial dedication that refers to himself both as a scholar and as deceased: "Donated in memory of the late honored teacher and rabbi Moshe Gottlieb of blessed memory, 1878."[5] Minkowski, in the 1910 painting *He Cast a Look and Went Mad* (pl. 31), created one of the few works of art that illustrates a passage from the Talmud in representational form. Its title comes from a passage that describes an incident in the second century C.E. about four sages in a garden. Intended as a parable about temptation as represented by the garden, it confronts the problem of choosing between adherence to the faith and the attraction of mystical speculation on the divine as well as temptations of the secular world engendered by the new era. The inclusion of several clean-shaven students, together with others who are traditionally dressed, alludes to the changing nature of Jewish society, wrought by modernization.[6]

Artworks of the period express the growing trend among Jews to negotiate and engage in a dialogue about what was seen as a disappearing Jewish world. But often the paintings go beyond a nostalgic rendering of an earlier era and seek to confront modernity head-on. Oppenheim represents an overt expression of that push and pull in *The Return of the Jewish Volunteer from the Wars of Liberation to His Family Still Living in Accordance with Old Customs* (pl. 1). This painting, from 1833–34, is emblematic in its illustration of the shifting attitudes toward the observance of Jewish tradition. A soldier, in military dress and without a head covering, has just returned to his Orthodox family on the Sabbath after fighting against the Napoleonic armies in the 1813–14 war of liberation from France. He wears a military decoration, the Iron Cross, a Christian symbol that held conflicting symbolism for observant Jews.[7] Oppenheim boldly addresses the conflict between loyalty to the state and Jewish tradition as a generational issue, and conveys the overriding sensibility of two different lifestyles attempting to reach an accommodation. Although set in a bygone era, the painting was nevertheless quite daring politically in its choice of a military career for Jews in Germany. From the late eighteenth century, critics had questioned whether Jews could become fully emancipated, as they had lost the ability to fight and were unable to do so because of their observance of the Jewish Sabbath. By having the soldier return to his house specifically on the Sabbath, it seems as if Oppenheim confronts this critique, upholding the desire of Jews to do battle for their country even if it forces them to desecrate the Sabbath. The lengthy title of the painting may have been a means to protest the fact that, after the

FIG. 4. Max Liebermann (German, 1847–1935). *The Twelve-Year-Old Jesus in the Temple*, 1879. Oil on canvas; 58⅞ × 51½ in. (149.6 × 130.6 cm). Hamburger Kunsthalle, Hamburg.

Jews. Both Gottlieb, in *Christ Preaching at Capernaum* (1878–79; pl. 18), and Max Liebermann, in *The Twelve-Year-Old Jesus in the Temple* (fig. 4), confronted contemporary antisemitism by reminding the viewer that Jesus was a Jew and that antisemitic persecution was a perversion of his teachings. Gottlieb attempted to come to terms with his roles as artist, Jew, and resident of multinational Galicia through this monumental painting, which locates Jesus in a Jewish place of worship, surrounded by Jews.[9] By portraying Jesus as a biblical prophet, wrapped in a tallith and addressing fellow Jews with a message of reconciliation for all of humanity, not as a rebel against Judaism or the embodiment of a new religion, *Christ Preaching at Capernaum* combines an expression of pride in the Jewish past with a plea for tolerance and mutual respect. Gottlieb emphasizes his involvement when he includes a self-portrait in the lower right of the painting, among the Jews listening to the sermon.[10] Liebermann portrayed Jesus as a modestly dressed boy who respectfully engages the scholars in the Temple, yet he underestimated the extent to which he might freely express himself. There were limits to the Christian themes that a Jewish artist might depict, and representing Jesus as a Jew was especially problematic.[11] Liebermann's work was removed from the International Art Show in Munich in 1879 amid much public

war, a conservative reaction to revolutionary ideas of previous years set in; one result was that German Jews, including those who had fought as volunteers, were again deprived of their rights.[8] Oppenheim created another revealing history painting in 1856, *Lavater and Lessing Visiting Moses Mendelssohn* (pl. 9), which looks back to the time of Moses Mendelssohn (1729–1786), the distinguished Jewish philosopher considered the father of the Jewish Enlightenment. Johann Caspar Lavater, a Swiss Lutheran clergyman, sits facing the German Jewish philosopher, challenging him to prove the superiority of

Judaism over Christianity or to renounce it. The presence of noted Christian playwright and Enlightenment thinker Gotthold Ephraim Lessing, who stands behind the two protagonists, is intended to convey his support for his friend, a respected Jewish intellectual and man of the world who maintained his commitment to Jewish culture.

Some artists became interested in demonstrating that traditional Judaism could coexist with philosophical and scientific learning and even with Christian themes and images—an attempt that often led to a collision with widely held prejudices of non-

outrage, and the artist vowed not to undertake other biblical subjects.

Burdens of Identity in a Changing World

Images of a world in flux emanated from Jews throughout Europe, but in particular from those in the East, who came into more immediate contact with the hardships occasioned by pogroms, poverty, and despair. In the East, Jews continued to live without political emancipation, save for the Jews of Galicia, who received it in 1867 as part of the emancipation in the Austro-Hungarian Empire. There, the great social and intellectual changes that enabled Western Jews to acculturate and feel part of their nation were only minimally felt. In Poland, Jewish intellectual and artistic life was deeply intertwined with political developments. Expressions of the dramatic circumstances of life around them appeared in the visual language of Jewish artists as their art began to confront secular issues relating to Jewish marginality and vulnerability. Samuel Hirszenberg offered an openly political statement in *The Black Banner* (pl. 27), painted in 1905, which depicts masses of Hasidic men carrying the coffin of a pogrom victim. The horizontal band of Jews projects intense fear and anguish, as if they had personally witnessed the devastating persecutions that swept Eastern European

Jewry during the late nineteenth and early twentieth centuries. The black banner covering the coffin may be Hirszenberg's means of denouncing the Black Hundreds, the czarist-endorsed antisemitic bands who were so destructive during the pogroms of 1905.[12] Hirszenberg further exposes the plight of his fellow Jews in *The Jewish Cemetery* (1892; pl. 29). His rendering of overwrought mourners in a neglected cemetery, its carved stones and decayed grave markers overgrown with grass, is a symbolic mourning for those traditional Jews who have suffered from persecution.

The presence of thousands of forlorn Jewish refugees fleeing from czarist Russia also left an indelible impression on the young Polish artist Maurycy Minkowski. Although deaf and mute, he attained considerable prominence for his realistic and poignant chronicles of Polish Jewish life during the last decades of czarist domination. In 1905, after personally experiencing a pogrom in Bialystok, Minkowski presented a searing depiction of a Jewish family uprooted from their home. *After the Pogrom* (pl. 30) conveys the sheer exhaustion and despair of a group of Jews who have stopped to rest—only one small part of a great exodus from Eastern Europe.

The compelling need to emigrate brought the destinies of Jews in the East and the West closer together, and certain Jewish artists of the period turned to the predicament of

homelessness and wandering in a metaphorical manner. Hirszenberg personifies the endless struggle with Christianity and the rootlessness of displaced Jews in his painting *The Wandering Jew* (see fig. 46), which reversed the meaning of a Christian legend that the Jews had been cursed and condemned to eternal wandering because of their refusal to assist Jesus on his way to Calvary.[13] This tragic fate obviously touched a chord with Jewish artists from Eastern Europe, who were struggling to find their own place in a volatile environment.

As full participants in society, Jewish artists in the West could now portray those who represented various aspects of Jewish life in the diaspora. In *A Son of the Ancient Race* (c. 1889; pl. 48), Jozef Israëls depicts the resignation of Jews who live in the dreary Jewish quarter of Amsterdam. But the artist, who was widely hailed in his lifetime as a "second Rembrandt," in no way felt that it was inevitable for Jews to live in poverty and isolation. Rather, by showing downtrodden conditions, he sought to strengthen public determination to eliminate social abuses.

Creating an Individual Identity

A good way to gauge the nineteenth-century Jewish encounter with modernity is to observe how artists portrayed themselves and others. Before the nineteenth century, the number of portraits commissioned by Jews was rather

FIG. 5. Jacob Meyer de Haan (Dutch, 1852–1895). *Is the Chicken Kosher?*, c. 1880. Oil on cardboard; 8¾ × 9⅝ in. (22 × 24.5 cm). Jewish Historical Museum, Amsterdam.

small. This was due in part to their stringent interpretation of the Second Commandment prohibition against graven images as well as to their limited acculturation to this form of expression. It also reflected a concern that Christian society might regard public forms of Jewish self-representation as provocative if they documented a social position more elevated than was seemingly appropriate for people who were not yet fully accepted.[14] Nevertheless, the tempo of artistic self-examination greatly accelerated in the nineteenth century as painters translated the preoccupation with the self, whether their own or another's, onto canvas or paper in the guise of aesthetic self-revelation. Jewish portraits express the search for personal identity and reflect the break with an earlier community-oriented milieu.

A formal self-portrait is an autobiography, created for various motives, and invariably relates to an inner self-examination on the part of the artist. Professional considerations, aesthetic orientation, character traits, or the lust for fame may enter into its making. However private its origins, the self-portrait

has a cultural dimension and is saturated with contemporary values and fashions, even when done in defiance of a dominant style. Despite their different national origins, Max Liebermann (1911; pl. 50) in Germany and Solomon J. Solomon (c. 1896; pl. 24) in England seem to suggest the serious nature of their profession by painting themselves in the act of painting. Each artist grasps a brush and palette stiffly in a posture that underscores his sense of vocational importance. Edouard Moyse (1869; pl. 14) and Vito d'Ancona (c. 1860; pl. 44) engage the viewer by portraying themselves full front, with head and shoulders almost filling the frame, closely cropped to focus all attention on the face. Academic in style, d'Ancona's painting offers no hint of his future as one of the leaders of the innovative Macchiaioli style that emerged in Italy.

Some self-portraits ventured beyond the pale of bourgeois respectability and transmitted the artist's search for self in idiosyncratic and revealing guises. The agitated brushstrokes and expressive colors in Simeon Solomon's *Head (Saint Peter or "Help

Lord or I Perish")* (pl. 38), painted in 1892, thirteen years before his death, reveal the turmoil and torment that afflicted him at this period in his life. Solomon's talents were recognized at an early age, and he began to exhibit at the Royal Academy in London. He developed close ties with the Pre-Raphaelites, whose influence would play a strong and ultimately destructive role in his personal life, since open homosexuality and the flouting of social mores were not tolerated in Victorian society. After a devastating arrest for indecency in 1873 and a subsequent public trial, friends and family ostracized him. Although Solomon continued his art, his early success was cut short, and he ended his days as a destitute alcoholic in a London workhouse. In this self-portrait, Solomon abandons disguises and attests to his pain, an emotion he wished his viewers to perceive.

Jacob Meyer de Haan's *Self-Portrait* (1889–91; pl. 60) presents a new type of artist, the bohemian Jew, who abandoned the bourgeois life and family business, in this case the de Haan matzo and bread factory in Amsterdam, to pursue art. The self-portrait,

FIG. 6. Paul Gauguin (French, 1848–1903). *Portrait of Meyer de Haan by Lamplight, 1889.* Oil on wood; 31¼ × 20⅜ in. (79.6 × 51.7 cm). Private collection.

FIG. 7. Solomon J. Solomon (British, 1860–1927). *Miss Grace Stettauer*, 1901. Oil on canvas; 47⅝ × 34½ in. (121 × 87.5 cm). Sotheby's, London.

made in the south of France, represents a dramatic shift from de Haan's earlier period, which was marked by a preference for Dutch realist style and color. Paintings such as *Portrait of a Young Jewish Girl* (c. 1886; pl. 58) and *Is the Chicken Kosher?* (fig. 5) locate him firmly within the Amsterdam Jewish community. Subsequently, de Haan became a close companion of Paul Gauguin, whom he joined during the late 1880s in the remote Breton fishing village of Le Pouldu. Gauguin's interest was piqued by de Haan's origins as an Orthodox Jew and by his knowledge of biblical and Jewish history. Gauguin perceived him as being representative of Hebrew culture.[15] Under Gauguin's influence, de Haan broke from convention. In his *Self-Portrait*, he reveals himself newly liberated, dressed in Breton costume and wearing a colorful bandana— with a skullcap. Like his mentor, de Haan sought to project the image of an avant-garde artist, which he accentuated by placing his image against a brightly colored background with decorative flat planes evocative of Japanese prints. It is revealing to compare this

self-portrait with portraits of de Haan by his contemporaries, in particular Gauguin, which refer in a derogatory manner to his ethnic identity and play on what were considered stereotypically "Jewish features." In fact, Gauguin made four portraits that concentrate on identifying his pupil's prominent physical characteristics. In one of the paintings, *Portrait of Meyer de Haan by Lamplight* (fig. 6), the artist transforms the redheaded, bearded, and physically misshapen young man into a satyr with hooflike feet. Some interpreters, however, have taken such sinister, animal-like images to be expressions of Gauguin's jealousy of de Haan's relationship with the woman who owned the inn where they both resided.[16]

Two aging masters, Jozef Israëls and Camille Pissarro, brought wisdom and mastery of style to their late self-portraits. Israëls manifested his loyalty to two cultures by sharing his personal visual space with the biblical heroes Saul and David, a recognition of their role in the redemption of the Jews and an overt assertion of his identification with early Jewish history (1908; pl. 46). At the

same time, Pissarro's last *Self-Portrait* (1903; pl. 64), created at his apartment in Paris overlooking the Pont-Neuf, shows a visage that contemporaries likened to that of a biblical prophet with long white beard.[17] In both self-portraits, the artists endow themselves with the force of their personalities crafted throughout a lifetime.

Portraits

Artists, who usually looked askance at the world of the social ghetto from which they had emerged, were particularly attracted to portrait painting. Wealthy Jews often preferred the services of Jewish artists for such portraits, which often show the sitter as thoroughly acculturated, at least in public appearance. Some have such profound psychological depth and physical accuracy that they can be read as a record of the artist's emotional relationship with the sitter. The penetrating gaze and powerful pose that engage the viewer of Moritz Oppenheim's posthumous portrait *Ludwig Börne* (1840; pl. 3) seem to intimate Börne's role as a

FIG. 8. Moritz Daniel Oppenheim (German, 1800–1882). *Meyer Carl von Rothschild as Huntsman*, 1839. Oil on canvas; 16¼ × 13½ in. (41.3 × 34.3 cm). Private collection, London.

staunch defender of civil rights and human dignity.[18] The eminent political journalist and theater critic was raised in Frankfurt under the name Loeb Baruch, later changed to Ludwig Börne as he made his way in the wider world. Börne's ability to publish widely was undoubtedly aided greatly by his conversion to Protestantism. As early as 1818, he was one of the most zealous protagonists of Jewish emancipation in Germany. Nevertheless, he was not fully accepted by either Germans or Jews. "For eighteen years I have been baptized and it doesn't help at all," he wrote. "One group holds it against me that I am a Jew, a second forgives me for it, a third even praises me for it, but all think about it. It is as if they are caught up in this magic Jewish circle and no one can get out of it."[19]

Börne's complaint spoke for many Jews whose conversion to Christianity did not seem to free them from their origins. Others were able to find their acculturation and even radical assimilation more satisfying. So it would appear from the way Moritz Oppenheim portrayed Fanny Hensel-Mendelssohn. In his straightforward portrait (1842) of the descendant of Moses Mendelssohn, Fanny, who, like her brother, Felix, was baptized and brought up Protestant, is shown as a gifted musician and composer in her own right, seemingly at peace with her new identity.

Oppenheim offers a very different approach in a work done only a few years earlier, *Meyer Carl von Rothschild as Huntsman* (1839; fig. 8). Meyer Carl, who directed the affairs of the Rothschild bank in Frankfurt with his brother Wilhelm, is depicted here as a rather affected young man in hunting clothes, surrounded by the attributes of a luxurious, aristocratic lifestyle. He gazes dreamily out of the frame. The portrait, completed shortly before Rothschild's marriage, was probably commissioned as an engagement present.[20] In keeping with evolving mainstream notions about the idealization of the family and its flowering in the private sphere, the Rothschilds, like many wealthy Jews, began commissioning

portraits; and like many Europeans they seem to have distinguished between famous portrait artists, whom they commissioned to create works in the grand style, and artists such as Oppenheim, whom they regarded as a family intimate (pls. 7–8).[21]

As the newly affluent merchant class sought to memorialize themselves, much like the aristocracy of the previous generations, Jewish artists accommodated themselves to the desire, often achieving the grand-manner likenesses with painterly virtuosity. Thus, portraiture of notable individuals in society, politics, business, journalism, and the arts

flourished (fig. 7). Vittorio Corcos shows a mastery of human character in his portrayal of the less-than-perfect physique of the Jewish publisher Emilio Treves, who founded the most important Italian publishing company in Italy at the end of the nineteenth century (1907; pl. 54). Isidor Kaufmann depicts an imposing gentleman of about sixty, the stockbroker Isidor Gewitsch, who was a prominent member of Vienna's Jewish community (c. 1900; pl. 20). The direct gaze and scrupulously detailed rendering of his simple, dark attire convey the sitter's integrity and seriousness. Lesser Ury painted the influential economist and statesman Walther Rathenau in 1896, years before he would become the German foreign minister and subsequently be assassinated by antisemites (see fig. 23). Each of these formal portraits offers a penetrating character study, and in each the choice of sitter and details of presentation reveal an extraordinary degree of integration into the broader culture.

Some portraits are revealing for what they do not show. De Haan and Gottlieb applied similar titles to their portraits of young women. The women are particular individuals—de Haan's subject was from the Orthodox community in Amsterdam, painted before his period in Pont-Aven; Gottlieb's was from a traditional Jewish environment in Warsaw—whom the artists could have identified by name. But the painters chose to

leave them anonymous under the titles *Portrait of a Young Jewish Girl* (c. 1886; pl. 58) and *Portrait of a Young Jewish Woman* (1879; pl. 17), emphasizing not their mainstream appearance but their ethnicity. Combining Romanticism with realism, the artists drew both women in modest, high-necked dresses, without jewelry and devoid of artifice. The paintings set a meditative mood and penetrate the personality of their subjects, indicating that although the women may have acculturated in their visual appearance, demeanor, and appurtenances, they remain fundamentally a part of the group into which they were born.

Establishing a Secular Realm

The evolution of an identity no longer defined in relation to a distinct Jewish community enabled artists to regard the Jewish experience in the broader perspective of the secular nation-state. Some of the very painters who created the icons of Jewish art also created paintings of a completely secular nature—a not uncommon disjunction between secular scenes and Jewish themes. A 1906 exhibition at the Whitechapel Art Gallery in London, which included work relating to Jewish history, life, and art, indicated that Anglo-Jewish artists believed themselves to be more English than Jewish, identifying entirely with their adopted country and showing little differentiation in

attitude or artistic theme from their fellow non-Jewish countrymen.[22] Motivated by a desire to belong to the culture of their country, they shared in a preoccupation with larger currents defined by majority models and tastes, and they retained a faith in the process of acculturation.

As Jews fashioned new forms of cultural identity, many artists began to paint the world around them, with few or no Jewish references, focusing on landscapes, cityscapes, and social issues. Even Isidor Kaufmann, well known as a Jewish genre painter, made use of non-Jewish subjects and pure landscapes at all stages of his career (pl. 23). His genre scenes explore secular situations of social interaction that take place in a private domestic setting. Treasured for their homely everyday simplicity, works such as *There's No Fool Like an Old Fool* (c. 1887–88; pl. 22), where an elderly bald suitor sits across from a young seamstress, must be viewed not merely as storytelling but as visual exemplars of an anecdote or morality story that illuminates an everyday incident. Max Liebermann, by contrast, personifies the artist who acculturated totally to European society. His imagery after 1900 reveals the transposition of French Impressionism into German art as he took up depictions of the leisured class partaking in such activities as polo and horseback riding. The fact that Liebermann could create the carefree beach scene of

Bathing Boys (1900; pl. 53), of innocent youth existing in harmony with nature, indicates the seemingly endless opportunities and limitless themes now pursued by Jewish artists.

Probably the greatest break from Jewish artistic tradition came with the opportunity to depict the nude. Before the nineteenth century, this subject was simply unacceptable for Jewish artists living in a traditional society, whereas this theme now could be considered emblematic of falling religious barriers for Jews. Emancipation and acculturation brought a loosening of religious constraints, and artists began studying and painting the human figure, a basis of traditional art-academy education.

Initially, rigorous academic painting was considered the appropriate form in which to render the nude, but subsequently artists began approaching the human figure using a myriad of styles. Late in the century, some artists drew the nude with a more stylized approach that anticipated twentieth-century modernism. In the small work *Nude* (1873; pl. 43) by Vito d'Ancona, the figure's ecstatic repose on a bed conveys a more sensual image than the pure academic model. It differs markedly from Lesser Ury's *Reclining Nude* (1889; pl. 67), in which the rich, painterly surface texture describes the figure's languid grace with a mixture of coolness and voluptuousness. An entirely different manner of representing the nude is seen in *Sitting (Marietta)* (1907; pl. 72) by Broncia Koller-Pinell, who employs the style prevalent in Vienna to paint a dignified Jugendstil beauty whose angular form is set off by a patterned, flat background. The artist captures the isolation of the figure caught in an airless space, but she remains psychologically removed.

Landscapes and Cityscapes

Urbanization and industrialization transformed nineteenth-century Europe and deeply altered the relationship between people and their environment. Increasingly, as the century wore on, cities replaced the countryside as the defining physical place, and the rural locale began to assume the picturesque, nostalgic characteristics of a lost, and mythical, realm. Artists developed both the countryside and the city as aesthetic ideals, as if the sudden exuberance of urban society required a corresponding amount of attention to rural life. As the belief became common that the physical world, especially in its natural state, held profound philosophical significance, Europeans began to insist that landscape be considered as a serious artistic theme. As the public—which included increasing numbers of acculturated Jews— searched for secluded retreats of the mind, landscape painting gained great popularity, and many Jewish artists found a new genre for their talents.

In Italy, where the emancipation of the Jews began even before the unification of Italy in 1870, acculturation advanced rapidly. Artists in Florence, including d'Ancona and Serafino De Tivoli, founded an influential group called the Macchiaioli, from the Italian word for "patch" or "spot." The group had strong ties to the Risorgimento, a movement for the liberation and unification of Italy, and Jewish artists thus placed great emphasis on their Italian roots and the modernity of contemporary Italian life. Working outdoors, they insisted that Italy's trees, lakes, and mountains should be considered as important sources for artistic interpretation.[23] D'Ancona's *View of Volognano* (pl. 45), painted in 1878, depicts the estate of the artist's uncle outside of Florence. The family retreat, with its fertile slopes and olive trees, could only be created after the lifting of restrictions forbidding Jews from owning property. Reacting to the centuries of cramped and communal quarters, Jews who could afford to do so acquired villas in the city and country.[24]

By the late nineteenth century, a subjective, stylized approach to landscape often displaced the more objective realism of previous decades. Jacob Meyer de Haan's landscapes, with free-floating patches of bright color, hint at the radical innovations and pictorial revolutions fostered by Gauguin, as well as by other pioneers of abstraction. The culmination of de Haan's work with Gauguin is the rural scene *Breton Women Scutching Flax (Labor)* (1889; pl. 59), created as a mural for the dining room of the small inn where the artists lived. Clearly expressing his assimilation of the principles of the school of Pont-Aven, the broad curvilinear contours delineate the figures and present them in a simplified friezelike arrangement, set against flattened areas of brilliant color describing the haystacks in the background. Pissarro's 1867 landscape *Jallais Hill, Pontoise* (pl. 62) is part of an important group of early paintings of Pontoise, where Pissarro lived between 1866 and 1868. In this work, the artist explored the full compositional possibilities of a landscape in which the eye is drawn to the relationship between the foreground and the rising hills in the background.

Europe's urbanization, which began in the western countries and moved eastward, offered new challenges and opportunities for the portrayal of city life and its panoramas. The fact that the modern industrial city had no historical antecedent, and thus no artistic model, provided artists with a new theme to explore. Ury and Pissarro rendered the elegance and sophistication of urban life in impressionistic views of the grand boulevards of Paris and Berlin. Both artists probed the poetic mysteries of form, space, light, and atmosphere and attended only incidentally to documentary considerations of place or incident. A major consideration of Pissarro's urban pictures is the use of spatial depth. In *Avenue de l'Opéra, Place du Théâtre Français: Misty Weather* (pl. 65), which depicts the intersection visible from his window in 1898, the vortex of the composition appears to be veiled in smoke. The densely populated painting consists of individuals who are only suggested, so that Pissarro's subjects retain a sense of anonymity and distance. A composition similar in its deep perspective is Ury's *Unter den Linden after the Rain* (pl. 66), painted a decade earlier. Like much of his most typical

FIG. 9. Max Liebermann (German, 1847–1935). *Garden of the Old Men's Home in Amsterdam*, 1881. Oil on wood; 21¾ × 29⅝ in. (55.3 × 75.2 cm). Private collection.

work, it was inspired by the people and physical surroundings of the German capital, especially the passersby, who almost fade into the mist that rises from the rainy streets.

The nineteenth-century city, by its very nature a new social creation, helped to draw a sharp line between the modern era and traditional ways. This was especially significant for Jews, who, since emancipation, could move freely within and across national borders. As Jewish artists and students gained the opportunity to study art in the cultural centers of Europe, they gained greater self-awareness of both the new cities and the old Jewish communities. Max Liebermann traveled within Germany, his native country, and also to Paris and Holland, where he was exposed to many stylistic influences. He included few specifically Jewish subjects in his work, except during 1905–9, when he created a series of oil paintings, drawings, pastels and prints entitled *Jewish Street in Amsterdam* (1908; pl. 52), based on observations from a rented room in Amsterdam's Jewish section. Liebermann's fluid technique and strong surface quality convey the intense human activity in the street—the lively market and bustling crowds circulating around carts heaped with vegetables.[25] The visual richness of Amsterdam's three-hundred-year-old quarter also attracted Viennese artist Tina Blau, whose painting of the same area evokes a different sensibility, focused on a painterly

description of the physical space rather than its human dimension (1875–76; pl. 57).

Social Commentary

Between the glitter of the cityscapes and the beauty of the landscapes lay a bleak terrain of social and economic inequity that many Jewish artists explored in genre works focusing on the poor and downtrodden. The nineteenth century marked the beginning of large-scale social reform movements, many of them the outgrowth of efforts to address the problems arising from massive migration to the cities and the rise of the working class. These problems attracted the attention of socially concerned artists throughout Europe. In Holland, Jozef Israëls's painting in the tradition of the Hague school of realist artists exemplifies his interest in genre scenes linked to the hardships of peasants and fishermen. The artist's frequent depiction of tragic subjects such as loneliness, death, and bereavement is vividly demonstrated in *The Last Breath* (1872; pl. 47), as he captures the taut atmosphere in which the moment of death transpires.

While working in Barbizon and then in Holland, Max Liebermann came in contact with the Dutch realists, including Israëls. During the 1880s he was another artist drawn to scenes that were brutally truthful and conveyed a sense of humanity. In *Women Plucking Geese* (1871–72), the artist portrays the harsh reality of peasant women plucking live birds to obtain their down feathers. Sitting in a dimly lit room, a group of women demonstrates the drudgery of a task that at the same time reflects the cruel and painful exploitation of animals.[26] Liebermann's familiarity with artists of the Hague school in Holland is clear, as reflected in his focus on figural genre scenes such as *Garden of the Old Men's Home in Amsterdam* (fig. 9). Capturing the effects of light as it animates the scene and dapples the figures, the influence of Impressionism is clear. Liebermann's tender scene of aged men taking the sun is a remarkably explicit rendering of a theme rarely addressed in art of the period, with no attempt to provide anecdote or to relieve the oppressive monotony of individuals doomed to live out their lives in this setting.

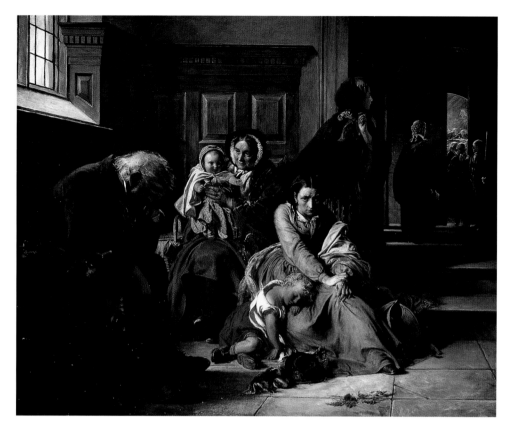

FIG. 10. Abraham Solomon (British, 1823–1863). *Waiting for the Verdict*, 1857. Oil on canvas; 33½ × 43¼ in. (85 × 110 cm). The Tate Gallery, London.

which had the man and woman flirting openly while the woman's chaperone slept, drew praise for its execution when it was shown at the Royal Academy in London in 1854 but caused a scandal for depicting unseemly behavior. Bowing to morality, the artist repainted the scene with the guardian awake and seated between the woman and the young man. By juxtaposing the first- and second-class situations, the artist may be implying that those rich enough to travel first class will have a secure and successful future, while those in second class will likely meet insecurity and distress.[28]

Conclusion

The growing social acceptance of Jews, and their widespread migration to the cities of European culture, coincided with a general quest for new forms of thought and expression. Through their works, Jewish artists expressed their contradictory experiences as they navigated and intersected with the broader society. They were remarkably well placed to serve as intermediaries, by transmitting aspects of Jewish life and tradition as well as secular experience, in ways that non-Jews would comprehend. Their dual identity as both Jews and participants in a broader society enabled them to see more than one side at a time. They understood the need to adapt their aesthetic response and therefore became adept at communicating in the prevailing visual language. Thus, Jewish artists served as vital connectors among the conflicting currents of social and political change throughout nineteenth-century Europe.

As social responsibility and inequity became new material for painting, certain Jewish artists championed the rights of the citizen confronted with a harsh and arbitrary legal system to which they themselves had only recently been subjected. Thus, in *Waiting for the Verdict* (fig. 10) by Abraham Solomon, the brother of Simeon, and *The Arrest of the Deserter* (1861; pl. 32) by their sister, Rebecca Solomon, the artists explore the compelling themes of arbitrary arrest and victimization by the judicial system. In accord with Victorian taste for work bearing a strong message and a close observation of nature, Rebecca's painting *The Governess* (1851; pl. 34) conveys a poignant visual tale of social inequity illustrating duty, devotion to family, and hard work. It calls attention to the plight of the approximately 25,000 governesses in Britain who occupied awkward and unstable positions within the family that employed them and within society at large. Usually well educated and genteel, and always unmarried, they found their social status

compromised by lack of money and the constant need to work.[27]

Abraham Solomon was especially noted in his own time for the innovative use of two connected paintings to tell a contemporary story, in this case the rise of a poor boy to affluent manhood. *Second Class—The Parting "Thus part we rich in sorrow, parting poor"* (pl. 35), from 1855, depicts the boy in a second-class railroad carriage on the first stage of a long trip that will involve joining the navy and traveling to faraway places. He is accompanied by his widowed mother, who sends him off to a future that she knows is uncertain but hopes will offer promising opportunities. Years later the boy returns, a handsome, unmarried sailor, successful enough to buy a first-class train ticket. In *First Class—The Meeting and at First Meeting Loved* (pl. 36), from 1854, Solomon depicts the young man in the presence of a young woman, with whom he shares an evident mutual interest. Behind this chaste depiction lies a subplot, however. The original version of this painting,

NOTES

1. Andreas Gotzmann, "Traditional Jewish Life Revived: Moritz Daniel Oppenheim's Vision of Modern Jewry," in *Moritz Daniel Oppenheim: Jewish Identity in Nineteenth-Century Art*, ed. George Heuberger and Anton Merk, exh. cat. (Frankfurt am Main: Jüdisches Museum der Stadt Frankfurt am Main, 1999), 239.

2. Ismar Schorsch, "Art as Social History: Oppenheim and the German Jewish Vision of Emancipation" in *Moritz Oppenheim: The First Jewish Painter*, exh. cat. (Jerusalem: The Israel Museum, 1983), 54.

3. Norman L. Kleeblatt and Vivian B. Mann, *Treasures of The Jewish Museum* (New York: Universe Books, 1986), 162.

4. According to a communiqué by the late Rafi Grafman, as referenced by Richard Cohen, it appears that the Torah objects he depicted were based on objects he had seen at synagogues in London, such as Bevis Marks and Hambro.

5. Nehama Guralnik, *In the Flower of Youth: Maurycy Gottlieb, 1856–1879*, exh. cat. (Tel Aviv: Tel Aviv Museum of Art and Dvir Publishers, 1991), 39.

6. Norman L. Kleeblatt, "Maurycy Minkowski," in *Bilder sind nicht verboten*, ed. Jürgen Harten, Marianne Heinz, and Ulrich Krempel, exh. cat. (Düsseldorf: Städtische Kunsthalle Düsseldorf und Kunstverein für die Rheinlande und Westfalen, 1982), 254–55.

7. Norman L. Kleeblatt, "Departures and Returns: Sources for Moritz Oppenheim's Masterpiece, *The Return of the Volunteer*," in *Moritz Daniel Oppenheim*, 113–30.

8. Nachum T. Gidal, *Jews in Germany from Roman Times to the Weimar Republic* (Cologne: Könemann, 1998), 167.

9. Guralnik, *In the Flower of Youth*, 51.

10. Ziva Amishai-Maisels, "The Jewish Jesus," *Journal of Jewish Art* 9 (1982): 98.

11. Chana C. Schütz, "Max Liebermann as 'Jewish' Painter: The Artist's Reception in His Time," in *Berlin Metropolis: Jews and the New Culture, 1890–1918*, ed. Emily D. Bilski, exh. cat. (New York: The Jewish Museum; Berkeley and Los Angeles: University of California Press, 1999), 153.

12. Kleeblatt and Mann, *Treasures of The Jewish Museum*, 166.

13. Avraham Ronen, "Kaulbach's Wandering Jew: An Anti-Jewish Allegory and Two Jewish Responses," *Assaph: Studies in Art History*, sec. B, no. 3 (1998): 243–55.

14. *Moritz Daniel Oppenheim*, 187.

15. Bogomila Welsh-Ovcharov, "Paul Gauguin's Third Visit to Brittany, June 1889–November 1890," in *Gauguin's Nirvana: Painters at Le Pouldu 1889–90*, ed. Eric M. Zafran, exh. cat. (New Haven, Conn.: Wadsworth Athenaeum Museum of Art in association with Yale University Press, 2001), 27.

16. Ibid., 28.

17. *Pissarro*, exh. cat. (Boston: Museum of Fine Arts, Boston, in conjunction with the Arts Council of Great Britain, 1980), 91.

18. *Moritz Daniel Oppenheim*, 192.

19. Ludwig Börne, *Collected Writings*, vol. 3 (Dusseldorf: J. Melzer, 1964–68), 510; cited in Michael Meyer, ed., *German-Jewish History in Modern Times, 1600–1945*, vol. 2 (New York: Columbia University Press in affiliation with the Leo Baeck Institute, 1996–98), 239 n. 35.

20. *Moritz Daniel Oppenheim*, 174.

21. Ibid., 175.

22. Julia Weiner, "A Brush-Up for Anglo-Jewry," *Manna* 58 (winter 1998): 28–30.

23. Emily Braun, "From Risorgimento to the Resistance: A Century of Jewish Artists in Italy," in *Gardens and Ghettos: The Art of Jewish Life in Italy*, ed. Vivian B. Mann, exh. cat. (Berkeley and Los Angeles: University of California Press, 1989), 139.

24. Ibid., 143.

25. Bilski, *Berlin Metropolis*, 103.

26. Gabriel Weisberg, *Beyond Impressionism: The Naturalist Impulse* (New York: Harry N. Abrams, 1992), 195.

27. Deborah Cherry, *Painting Women: Victorian Women Artists* (New York: Routledge, 1993), 166.

28. From an unpublished paper by Beverly Cole, "Critical Analysis of Two Paintings from the Period 1850–70," The National Railway Museum, York, England, c. 1998.

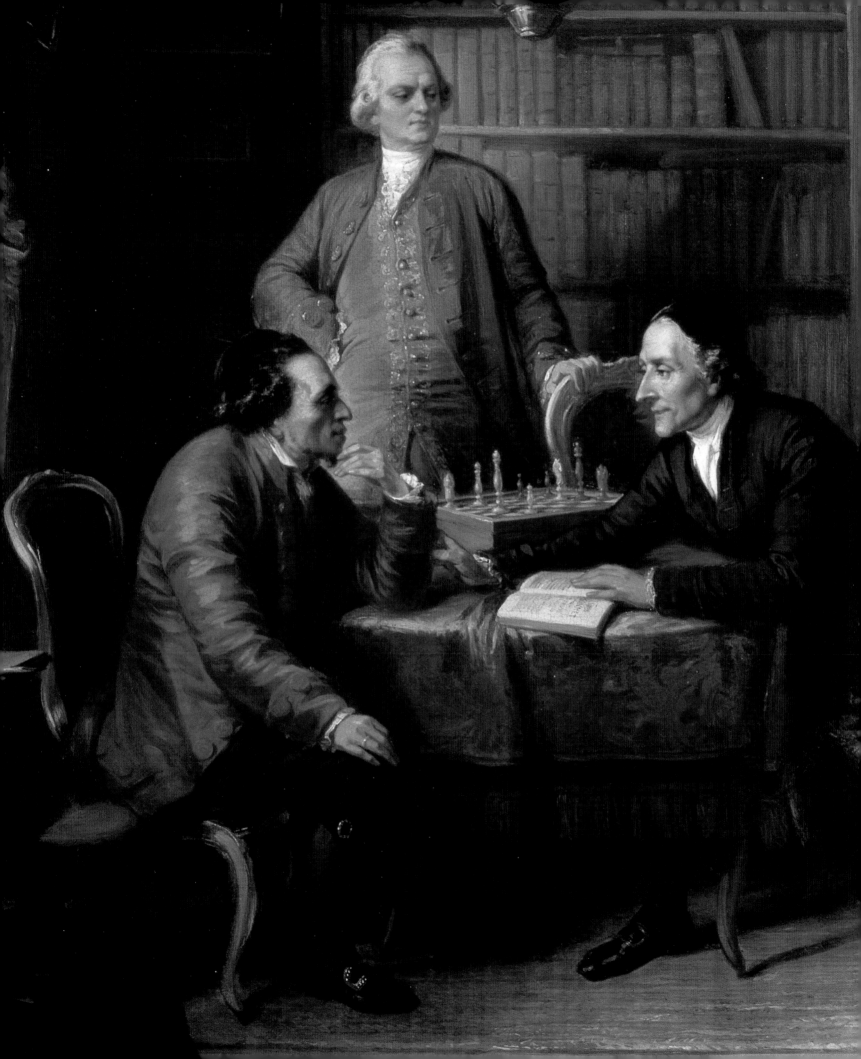

Moritz Daniel Oppenheim. *Lavater and Lessing Visiting Moses Mendelssohn* (detail), 1856. See pl. 9.

Paula E. Hyman

Acculturation of the Jews in Nineteenth-Century Europe

During the course of the "long" nineteenth century, which stretched from the French Revolution of 1789 to the outbreak of the First World War in 1914, European Jews experienced a profound transformation of their status and identity. As the historian Isaac Marcus Jost remarked in 1833 of his generation of German Jews, "All of us who were still children thirty years ago can testify to the incredible changes that have occurred both within and outside us. We have traversed, or better still, flown through a thousand-year history."[1] That statement is an exaggeration; it reflects the view of an educated Jewish intellectual, not of the masses of German or other European Jews. But it captures the sense of the trauma perceived by some Jews as they encountered both secular culture and new socioeconomic opportunities. Many of the artists whose work is shown in this exhibition would have subscribed to Jost's interpretation of the consequences of living in an era of emancipation. They had been borne by a liberating movement into the best of European culture.[2] Some struggled to find a way to express visually the tension between Jewish tradition and modern European culture; others preferred to present themselves as no different in style or sensibility from their fellow artists.

Jews were always the "other" in medieval and early modern Christian societies, but in the modern period they could in theory erase

or blur their otherness without converting to Christianity. The development of Enlightenment thought by the end of the eighteenth century offered Jews the possibility of political and social equality. Enlightenment thinkers asserted that all men could become citizens of the states in which they lived. States, they proclaimed, existed to advance the good of citizens, not the cause of one religious sect or another. Jews could acquire the rights and responsibilities of citizenship, at the price of ceding their privilege of self-government that they had enjoyed from the Middle Ages. To be sure, Jews had already seen the powers of their communities whittled away with the strengthening of state authority during the eighteenth century. Communities that had enjoyed the rights of taxation and self-government under Jewish law lost some of their entitlements, while Jews still faced discriminatory levies and residential and occupational restrictions. Jews therefore took advantage of the new intellectual and political climate first to lobby for easing the restrictions under which they labored and ultimately to press the claim for equal status. In 1790 and 1791 the French Revolution conferred citizenship on all Jews living in France and thereby ushered in, for all European Jews, the era of what became known as "emancipation."

Emancipation

Emancipation has both a narrow and a broad meaning. In narrow terms, it refers to the changes in legal status that citizenship entailed. In broader terms, however, it refers to all the social, cultural, and psychological changes and challenges that accompanied the idea that Jews could be fully at home where they lived. Those changes can be subsumed under the terms "acculturation" and "integration"—the processes of adapting to the standards and customs of the larger society and being accepted into its institutions. The status of the Jews thus depended on a complex interplay of the conditions established by the polity in which they lived and the choices that

they made as individuals and members of a recognized collectivity. Acculturation depended on the will of members of the minority group to change; integration required a willingness on the part of the majority population to welcome those previously excluded. Acculturation included not only changes in behavior but also, and perhaps more important, changes in self-definition, especially vis-à-vis the larger society. When the Jewish "notables" who were summoned to Paris by Napoleon in 1806 answered his question about their attitude toward non-Jewish Frenchmen with the resounding statement that "a French Jew considers himself in England as among strangers though he may be among Jews," they were asserting—indeed creating—a new primary identity that became the touchstone of the emancipated Jew.[3] European Jews saw the high culture of the societies in which they lived as attractive and sought to participate in its shaping. As they settled in the major cities of their countries of residence, they proceeded to do so.

Most European Jews presumed that civic equality did not necessitate the abandonment of their particular identity as Jews but rather its reconceptualization. Most gentile supporters of Jewish emancipation, on the other hand, expected that Jews would ultimately disappear as a recognizable collectivity. In Western and Central Europe Jews defined themselves as members of a religious group, with no national aspirations, but even nonpracticing Jews continued to speak about themselves in terms of a shared descent, a shared history, and a shared fate. Although the concept of ethnicity did not yet exist, some Jews implicitly thought of themselves as an ethnic group. For example, the French Jewish journalist Lévy-Bing, writing in the newspaper *Archives Israélites* in 1864, described the Jews as "a people completely dispersed for eighteen hundred years throughout all parts of the world without anywhere merging or blending with the populations in whose midst they live."[4]

Over the course of the century, most Jews in Western and Central Europe abandoned traditional Jewish observance and developed liberal versions of Judaism. When Jews did maintain traditional observance—and about 15 percent did in the West at the end of the nineteenth century—their forms of religious expression reflected social class and the prevailing cultural style of their country. In Eastern Europe, including Poland and Galicia, where both social and political conditions were different and where the confrontation with secular culture began later, modernizing Jews often adopted secular Jewish identities.

Acculturation usually did not lead to complete assimilation. Some Jews did convert to Christianity, or had their children baptized, but generally not out of religious conviction. Conversion was most often a response to perceived blockages in social mobility, and it stemmed from the recognition of highly assimilated Jews that adherence to Judaism, whose myths and rituals they had rejected, led to social and professional disabilities. Consequently, conversion was far greater, for example, among German Jews, who did not achieve citizenship until 1871, than it was in France. French Jews in the mid-nineteenth century could make their careers in the civil service and the university; German Jews could do so only if they chose baptism.[5] Some Jews who no longer adhered to the tenets of Judaism saw conversion as a way, they thought, to become fully a part of the secular society with which they identified. Why remain Jewish when Jewish identity separated one from Western culture, whether Christian or secular? In the poet Heinrich Heine's famous phrase, baptism was the "admission ticket to European culture" (fig. 11).[6] His colleague Ludwig Börne, political essayist, universalist, and prominent member of the liberal group Young Germany, fused both motives when he converted in 1818.

Because European Jews lived in a variety of nations throughout the Continent and began the nineteenth century with different Jewish cultural legacies, their confrontation

FIG. 11. Moritz Daniel Oppenheim (German, 1800–1882). *Portrait of Heinrich Heine*, 1831. Oil on paper laid down on canvas; 17 × 13⅜ in. (43 × 34 cm). Hamburger Kunsthalle, Hamburg.

with the challenges and opportunities of modernity varied. Generally speaking, emancipation moved from west to east, but the distinctions among individual countries demand a much finer analysis. Individual Jews, like Jost, found the encounter with secular European culture immediately transformative. For the historian of European Jewry, emancipation—in both political and cultural terms—was a more gradual phenomenon, varying by country and by regions within countries. Legal emancipation and acculturation did not necessarily march hand in hand. Moreover, the Jews themselves were divided by social class, gender, and level of urbanization, and those divisions were reflected in their social behavior and identities. Middle-class Jewish women in Western and Central Europe, for example, sustained more religious behavior within the home than their husbands did in public.[7]

Jewish emancipation was closely linked to the political evolution of modern states.[8] The nature of the Jewish population of each country also shaped the pace and level of subsequent acculturation. In France, where the legacy of the Revolution of 1789 never completely disappeared, legal emancipation came early to the Jewish population, most of whom were Yiddish-speaking peddlers and petty merchants living in the eastern provinces of Alsace and Lorraine. With the exception of the Sephardic Jews of Bordeaux and Bayonne and the increasing number of Jews who migrated to Paris, full acculturation was not achieved until the second half of the nineteenth century. Emancipation thus preceded acculturation for most French Jews. Despite sporadic riots in revolutionary periods and the antisemitism accompanying the Dreyfus Affair at the very end of the century,

the citizenship of French Jewry was never seriously challenged, except for the discriminatory decrees passed by the emperor Napoleon in 1808, which lapsed in 1818. Not surprisingly, France was the first country in Europe to have nonbaptized Jews in ministerial positions in the government. The most notable of these, Adolphe Crémieux, also held important roles as a Jewish communal leader, including the presidency of the Alliance Israélite Universelle, a French-based international Jewish defense agency.[9]

Political emancipation was seldom as straightforward as in France. Far more common was the situation of Jews in Germany, Italy, and the Netherlands, where a stratum of non-Jews and Jews, influenced by Enlightenment ideas and by the achievements of the French Revolution, pressed for the emancipation of the Jews. Emancipation came, however, in the wake of victorious French armies. When Napoleon's troops entered the Italian states in 1796–98, they literally broke down the walls of the ghettos and

promulgated emancipation. In the Netherlands, already a pluralistic society, the occupying French forces established the Batavian Republic in 1795, which emancipated the Jews a year later. In the German lands (there was no unified Germany), Napoleon's conquest of the western states led to the establishment of puppet regimes and to emancipation. Other German cities and states followed suit. As a consequence of French triumphs and of revolutionary ideals, for example, reformers in Prussia, the largest German state, succeeded in conferring civic rights on the Jews in 1812, although Jews remained ineligible for "public services and state offices."[10] The status of the Jews in the Habsburg Empire, on the other hand, was unaffected by Austria's defeat by the French armies. The Galician Jews who lived in the eastern end of the empire had not even been included in Emperor Joseph II's Edict of Toleration of 1782, which removed some economic disabilities and offered opportunities for secular education but did not grant Jews full civic equality. In 1789, though, an Edict of Toleration aimed specifically at the Jews of Galicia and seeking their modernization offered them greater rights than enjoyed at that time by any European Jews while subjecting them to military draft.[11]

The defeat of Napoleon, however, led to the reversal of Jewish emancipation in Germany and Italy and blocked efforts of Austrian Jews to achieve civic equality. When the French armies retreated from Italy, ghettos were reestablished. The Congress of Vienna, an international meeting held in 1814–15 to restore the prerevolutionary order, annulled the emancipation of the Jews inspired, and often imposed, by the French. Jewish emancipation was considered a progressive measure out of step with the conservative tenor of the times. Only in the Netherlands did Jews continue to enjoy equal rights in law, though there were occasional lapses in enforcement.

Not until the last decades of the century did the Jews of Austria, Germany, and Italy

achieve full citizenship. With the establishment of the Kingdom of Italy in 1861 and of the German Empire in 1871, Jews in those newly unified nations became citizens. (The Jews of Prussia had been emancipated in 1869, when the constitution of the North German Confederation extended equality irrespective of religious affiliation.) Similarly, the new 1867 constitution of the Habsburg Empire of Austria-Hungary conferred equal citizenship on all Jews, including those of the backward province of Galicia. These changes in status had been anticipated by the revolutions of 1848, in which the Jews of Italy, Germany, and Austria had been active. The revolutionary forces had supported Jewish emancipation, but their defeat in Germany and Austria had reversed Jewish gains. In Italy, the Risorgimento (the movement for national unification), in which Jews were heavily involved, resulted in the emancipation of the Jews of Piedmont in 1848 and the extension of emancipation as the forces of Risorgimento moved southward. The city of Rome was not captured by the armies of the Kingdom of Italy, and its Jews thereupon emancipated, until 1870.[12]

The situation in England was more complicated still. Jews there achieved rights piecemeal. They were not fully emancipated until 1858, after a thirty-year battle to repeal the requirement to swear an oath "on the true faith of a Christian" in order to take a seat in Parliament. Tories regarded the oath as the last symbol of England as a Christian nation. With its abandonment, Lionel de Rothschild, first elected as a representative from London in 1847 and reelected four times subsequently, was finally admitted to Parliament. The liberal conception of the state had triumphed.[13] Despite this delay in securing legal equality, from the eighteenth century British Jews were as acculturated as any in the West and integrated into many British institutions.[14] Often they did not wait for formal authorization to participate in civic acts and institutions that were not supposed to be available to them. Jews voted in British

parliamentary elections even before 1835, for example, because the then legal stipulation of the Christian oath as a prerequisite for voting was not enforced. Some of them attended Oxford and Cambridge Universities well before 1871, when they became legally entitled to be elected as fellows there.[15] The English situation thus provides evidence of the disparity in the timing of social and legal emancipation. In most cases, Jews were granted legal rights that were not fully enforced; those legal rights did not confer social acceptance. In the case of England, social acceptance exceeded legal rights and acculturation preceded complete emancipation.

The Jews of Poland lived in a far different world, most under Russian czarist rule. A smaller, though still substantial, number were incorporated into the Habsburg Empire as residents of Galicia, and a smaller number still into Prussia. As noted above, Galician Jews, although sharing the social and religious characteristics of other Jews from Poland, were legally emancipated in 1867 and the Jews of Prussia in 1869. Recently, historians have asserted that the model of emancipation as applied to Jews in Western and Central Europe is inappropriate to the Russian Empire.[16] Although Jews sought improvements in their legal status, and many were affected by secular culture in the second half of the century, the Russian Empire remained a corporate state, which allocated rights to groups, generally social classes, rather than to individuals. The legal situation of the Jews varied with different regimes, but the hope for expanded rights was disappointed as Jews experienced pogroms, increased poverty, and restrictive legislation at the end of the nineteenth century and into the twentieth.

Polish and Galician Jews were far more numerous and embedded in a Jewish milieu than Jews living to their west. They formed a substantial proportion of the population of Polish and Galician market towns and cities, continued to speak Yiddish, and retained Hebrew as the language of educated males.

Traditional Jewish elites and their institutions also remained strong. The confrontation of Polish and Galician Jews with secular culture was all the more fraught with tension as they tried to balance the values of European culture and politics with the ethnic Jewishness that was a fundamental aspect of their identity, even when they had left traditional Jewish belief and practice behind. Their break with traditional Judaism led many to collective Jewish politics—whether Zionist or Jewish socialist—as a strategy for refashioning their self-definition and for resolving the ever more pressing "Jewish question."

The eruption of antisemitism in most European countries called into question the promises of emancipation, but Jews in Western and Central Europe viewed antisemitic public expression and occasional incidents as atavisms, left over from the past and destined to disappear. They counted on the protection of the law. For the most part, they did not understand the new message of late-nineteenth-century political antisemitism, although they established defense organizations. Eastern European Jews had fewer illusions.

Acculturation

During the nineteenth century, Jews who intended to become "respectable" looked to the native middle classes as their reference group. Sharing the tastes of the urban bourgeoisie, Jews began dressing like their gentile peers, acquiring the language of their neighbors, and sending their children to public schools. From the end of the eighteenth century, *maskilim* (men of the Jewish Enlightenment) promoted the acquisition of secular education and culture among their fellow Jews. Some form of western Yiddish persisted into the second half of the century in rural areas like Alsace, or in villages in Germany, or among some Dutch Jews, but by then most Jews in England, France, Germany, and the Netherlands had abandoned Yiddish for the vernacular. In Italy, Jews had been at

home in Italian even in premodern times. In Poland and to a lesser extent in Galicia, on the other hand, Jews retained Yiddish as their mother tongue well into the twentieth century, and only the growing minority who had acquired secular education knew Polish and Russian or German well (and not just for commercial contacts with gentile customers).

Jews were well positioned to take advantage of the economic possibilities offered by the development of capitalism, owing to their high rates of urbanization, their background in commerce, and their historical exclusion in most places from agriculture and artisan guilds. Taking advantage, as minorities often do, of opportunities in new economic sectors, they became heavily involved in capitalist finance and in the building of railroads, as well as in the development of the textile industry. They also pioneered the building of department stores. Many succeeded in acquiring middle-class incomes, and some became truly wealthy, fueling the antipathy of those of their countrymen who lost status in capitalist society. In Germany, for example, tax records suggest that Jews started the nineteenth century poorer than their neighbors and finished it more prosperous. In 1871 more than 60 percent of German Jews were in the middle and higher income groups while 5 to 25 percent, depending on region, were in the lowest group.[17] In Western Europe, only the Jews of the Netherlands were an impoverished population. Although they acculturated to Dutch language and dress, and abandoned traditional religious practice, most Dutch Jews formed a proletariat concentrated in Amsterdam, more likely to be found at socialist rallies than in religious celebrations.[18] Dutch Jewish artists, however, tended to derive from middle-class or well-to-do families. The Rothschilds in Germany, France, Britain, Italy, and Austria became the symbols of Jewish wealth as well as a touchstone for antisemitic resentment.

Jews defined themselves as citizens of their respective countries, in some cases even while waiting for full legal emancipation.

Once emancipation made them a part of state and society, they expressed a sense of patriotism. Jews served in European armies from the time of the Napoleonic wars. In France, Jews regularly became army officers, and some Alsatians even turned their conscription numbers into religious wall decorations, combining the *tricolore* with a Hebrew liturgical phrase.[19] In the battles for the unification of Italy, Jewish volunteers for the Piedmontese army far outnumbered the proportion of Jews in the population.[20] In a painting from the 1830s, Moritz Oppenheim used the subject of a Jewish soldier's return home from the Napoleonic wars with a medal in the form of a cross on his uniform to depict the warmth of the traditional Jewish family, its acceptance of the notion of patriotic duty, and its ability to accommodate, however hesitantly, to the entry of Christian symbols into its domain, in this case the Iron Cross decoration on the uniform (1833–34; pl. 1).[21]

Participation in the intellectual, cultural, and political movements that flourished in nineteenth-century Europe was a true manifestation of European Jews' liberation from the constraints of both discriminatory state regulations and traditional religion. Perhaps because of their historical experience, perhaps because of their social aspirations, Jews flocked to the cities, whose excitement and energy they valued, and to which they contributed. Wealthy and middle-class Jews were significant participants in cultural production and consumption. They took part in all aspects of urban culture in the cosmopolitan centers of Paris, Vienna, Berlin, and London (fig. 12). In Germany and Austria especially, Jews were key figures in the growth of the liberal press. The *Berliner Tageblatt*, the *Frankfurter Zeitung*, and the Viennese *Neue Freie Presse*, for example, were all published by Jews. Jews were visible and also worked behind the scenes in the theater, music, and art, where they were often cultural mediators: theater producers, directors, and actors, orchestra conductors, art dealers and collectors. Jewish publishing houses that

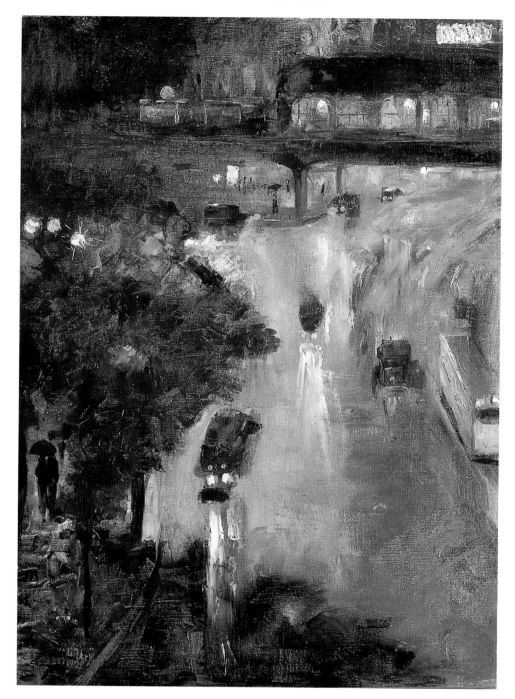

FIG. 12. Lesser Ury (German, 1861–1931). *Nollendorfplatz in Berlin*, 1901–02. Oil on canvas. Nationalgalerie, Staatliche Museen, Berlin.

As one Frenchman wrote in 1885, and not as a compliment, "Today the barons of Israel represent luxury . . . charity . . . the arts . . . the smart set . . . fashion's latest style."[23] In a far different tone, the German writer and critic Theodor Fontane, in a letter, affirmed the cultural role of Jews: "At least in Berlin all that is liberty and great culture has been brought to us essentially by rich Jews. It is a fact that must be finally admitted, and as an artist or a man of letters, admitted with pleasure."[24] Indeed, it was hard to imagine the urban landscape without Jews, who thronged the galleries, the concert halls, and urban thoroughfares. Like other middle-class residents of Berlin, for example, they enjoyed promenading on Unter den Linden.

As Jews in Europe fashioned a modern identity, they either framed their Jewishness as irrelevant to who they were, for the minority who aspired to complete assimilation, or as fully in step with the values of the culture of the larger society in which they lived, whether that society was Austrian, British, Dutch, French, German, or Italian. However, only a minority of Polish Jews became Polish or Russian patriots, because of their limited acculturation and the hostility of

aimed for a general rather than a Jewish audience emerged in the mid-nineteenth century. Jewish publishers began to be significant in Germany by the mid-1830s, specializing in the writings of the liberal Young Germany group. By the end of the century, the Mosse firm was prominent, and S. Fischer Verlag became known for its avant-garde publications; the Ullstein publishing house was the largest publisher of books and newspapers in the world.[22] In France, Félix Alcan and the Lévy brothers (later Calmann-Lévy) began publishing in the 1840s, while in Italy the greatest publishing company in the country, Fratelli Treves, established in 1864, was owned by two Jewish brothers.

Jews became known as patrons of the arts and as likely investors in cultural endeavors.

FIG. 13. Tina Blau (Austrian, 1845–1916). *Spring in the Prater*, 1882. Oil on canvas; 96 × 115¾ in. (244 × 294 cm). Österreichische Galerie Belvedere, Vienna.

FIG. 14. Eduard Bendemann (German, 1811–1889). *The Mourning Jews in Babylonian Exile*, 1852. Oil on canvas; 22½ × 39¼ in. (57 × 99.5 cm). Anger-Museum, Erfurt, Germany.

the government to their aspirations. Many young Polish Jews were swept up instead by Russian revolutionary movements.

Like other acculturated European Jews, most Jewish artists, therefore, addressed themselves primarily to general subjects that were in fashion—landscapes, still lifes, and portraits (fig. 13). Max Liebermann, the best known of European Jewish artists, was typical in choosing to address universal themes. Many Jewish artists, however, also incorporated Jewish subjects in their oeuvre. When Jewish intellectuals, communal leaders, and artists dealt with Jewish culture, they carefully chose to display those aspects of Jewish culture that were shared with European Christians or were a source of particular pride. In the first generations of emancipation, those were most likely to be the Hebrew Bible and the Jewish family. Because the cultural formation of artists was suffused with Christian motifs, it is not surprising that their depictions of biblical scenes, such as Eduard Bendemann's 1852 painting *The Mourning Jews in Babylonian Exile* (fig. 14), lacked a Jewish interpretive framework.[25] The Jewish family was a more "usable" subject because it offered possibilities of depicting scenes of Jewish particularity that

were suffused with generally celebrated bourgeois values of domestic harmony.

The depiction of the Jewish family also reflected the growing nostalgia of acculturated Jews in Western and Central Europe for what was comfortably located elsewhere—in the past or in the distant village of one's childhood.[26] Jewish artists gave visual expression to that cultural spirit by focusing on traditional Jewish rituals and customs. Interestingly, Italian Jewish artists, who came from communities where the ghetto was a vivid memory, did not share this nostalgia.[27] Elsewhere, Jewish artists chose to depict Jewish rituals that were fast disappearing, much as general artists portrayed peasant routine. In both cases, the paintings anchored their middle-class audiences in a romanticized version of homey practices that were safely divorced from their own daily experiences. They provided an emotional attachment to origins while also reminding viewers that they had succeeded in fashioning for themselves a better form of life. Some Jewish artists, like Jacques-Émile-Edouard Brandon and Edouard Moyse, both French, depicted with great dignity Jewish rituals that were still widely practiced but composed their paintings in such

a way that they appeared timeless rather than contemporary (1897, c. 1860; pls. 11, 13).

The willingness of Jewish artists to expose to public gaze the differentness apparent in their religious traditions demonstrates powerfully that acculturated European Jews did not abandon all aspects of their particularity. Rather, they had a complex attitude toward Jewish ritual and the Jewish past. Further evidence of this lies in the popularity of Moritz Oppenheim's paintings that celebrated Jewish domestic life and rituals, reproduced in a book entitled *Scenes from Traditional Jewish Family Life*, which became common in Jewish homes in Germany (fig. 15).[28]

Jews born into traditional communities in Poland or Galicia, who were rooted in Jewish customs and rituals even if they had received secular education and had broken with religious observance, had a more intense personal struggle over the meaning of Jewishness and the relation of Judaism and Christianity. For them, ritual practice was too close to be distanced through nostalgia. Polish Jewish artists studied art with gentile teachers both in Poland and abroad and experienced a conflict between their attraction to general artistic styles, on the one hand, and to Jewish

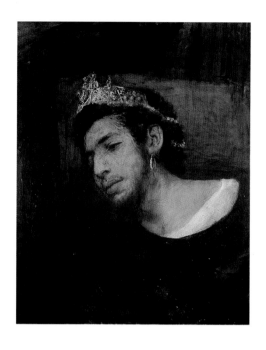

FIG. 15. Moritz Daniel Oppenheim (German, 1800–1882). *Seder (The Passover Meal)*, 1867. Oil on paper laid down on canvas; 24½ × 18 in. (62.2 × 45.7 cm). The Jewish Museum, New York; Gift of the Oscar and Regina Gruss Charitable and Educational Foundation (JM 1999-88).

FIG. 16. Maurycy Gottlieb (Galician, 1856–1879). *Self-Portrait as Ahasuer*, 1876. Oil on canvas; 24¾ × 20 ⅞ in. (63 × 53 cm). National Museum, Kraków.

issues, on the other. Secular culture was seductive, but it was potentially corrosive of Jewish identification. In a still largely traditional Jewish society in which emancipation was still a dream, or, in the case of Galicia, granted but recently, and discrimination was common, the price of secularization—being at home nowhere—was all too apparent. Perhaps the strongest expression of internal struggle appears in the paintings of Maurycy Gottlieb, born and raised in Galicia and given a secular public school education (fig. 16). In *Christ Preaching at Capernaum* (1878–79; pl. 18) the young artist depicts a distinctly Semitic Jesus, garbed in a traditional Jewish prayer shawl and preaching in a synagogue. Through this representation Gottlieb addresses the figure of Jesus, a subject not treated sympathetically in traditional Jewish life, and also recuperates him as a Jew.

Eastern European artists were not only immersed in a Jewish society still debating the impact of secularization and the best political

options; they experienced, or closely followed the news of, persecution and physical violence directed against Jews in the Russian Empire. The pogroms of 1881–82 were followed by periodic eruptions of violence, especially in the years leading up to the abortive 1905 revolution. Unlike the Jews in Western and Central Europe, who were optimistic about their future, those in the East felt much more vulnerable and regarded their future uncertainly. Polish Jewish artists responded to this situation with a variety of images, some turning to Zionism and others depicting the poverty and despair of the impoverished Jews of their region. The most powerful representations of Jewish victimization depict Jews in the aftermath of pogroms. Samuel Hirszenberg's *The Black Banner* (1905; pl. 27), for example, presents traumatized Jewish men and boys, garbed in traditional clothing, wandering seemingly without purpose, presumably fleeing a pogrom.[29]

During the nineteenth century, European Jews became full participants in the cultures

and economies of their countries. By the fin-de-siècle, most Jews in Western Europe and a significant segment in Eastern Europe were fully acculturated to their surroundings. Yet, with all the variations noted above, and with all their acculturation, Jews continued to differ from their fellow citizens. On the whole, they were more urban, more middle class (particularly in Western and Central Europe), more liberal, and better educated. Living in the century of emancipation, they constructed complex self-definitions that melded identification with their native land and a sense of connection, however vague, to Jewish culture.

NOTES

1. Cited in Ismar Schorsch, "From Wolfenbüttel to Wissenschaft: The Divergent Paths of Isaak Markus Jost and Leopold Zunz," *Leo Baeck Institute Yearbook* 22 (1977): 110.

2. For the best treatment of Jewish artists and their role in European society, see Richard I. Cohen, *Jewish Icons: Art and Society in Modern Europe* (Berkeley and Los Angeles: University of California Press, 1998).

3. "The Assembly of Jewish Notables: Answers to Napoleon," cited in *The Jew in the Modern World*, ed. Paul Mendes-Flohr and Jehuda Reinharz (Oxford: Oxford University Press, 1980), 119.

4. Cited in Phyllis Cohen Albert, "L'Intégration et la persistance de l'ethnicité chez les juifs dans la France moderne," in *Histoire politique des juifs de France*, ed. Pierre Birnbaum (Paris: Presse de la Fondation Nationale des Sciences Politiques, 1990), 233.

5. See Pierre Birnbaum, *Jews of the Republic: A Political History of State Jews in France from Gambetta to Vichy* (Stanford, Calif.: Stanford University Press, 1996); Todd M. Endelman, "The Social and Political Context of Conversion in Germany and England," in *Jewish Apostasy in the Modern World*, ed. Todd M. Endelman (New York: Holmes and Meier, 1987), 83–107.

6. *Encyclopaedia Judaica* (Jerusalem: Keter Publishing House, 1971), 8:272.

7. See Marion Kaplan, *The Making of the Jewish Middle Class: Women, Family, and Identity in Imperial Germany* (New York and Oxford: Oxford University Press, 1991), and Paula E. Hyman, *Gender and Assimilation in Modern Jewish History: The Roles and Representation of Women* (Seattle: University of Washington Press, 1995), 10–49.

8. For a survey of the politics of Jewish emancipation, see *Paths of Emancipation: Jews, States, and Citizenship*, ed. Pierre Birnbaum and Ira Katznelson (Princeton, N.J.: Princeton University Press, 1995).

9. Paula E. Hyman, *The Jews of Modern France* (Berkeley and Los Angeles: University of California Press, 1998).

10. Werner E. Mosse, "From 'Schutzjuden' to 'Deutsche Staatsbürger Jüdischen Glaubens': The Long and Bumpy Road of Jewish Emancipation in Germany," in *Paths of Emancipation*, 70.

11. On the Jews of Galicia, see William O. McCagg, Jr., *A History of Habsburg Jews, 1670–1918* (Bloomington: Indiana University Press, 1989), esp. 105–22.

12. Dan V. Segré, "The Emancipation of the Jews of Italy," in *Paths of Emancipation*, 206–37.

13. M. C. N. Salbstein, *The Emancipation of the Jews in Britain* (East Brunswick, N.J.: Associated University Presses, 1982); David Feldman, *Englishmen and Jews: Social Relations and Political Culture* (New Haven, Conn.: Yale University Press, 1994), 28–47; Richard Davis, *The English Rothschilds* (Chapel Hill: University of North Carolina Press, 1983), 73–87.

14. See Todd M. Endelman, *The Jews of Georgian England 1714–1830: Tradition and Change in a Liberal Society* (Philadelphia: Jewish Publication Society, 1979), and *Radical Assimilation in English Jewish History, 1656–1945* (Bloomington: Indiana University Press, 1990).

15. Geoffrey Alderman, "English Jews or Jews of the English Persuasion: Reflections on the Emancipation of Anglo-Jewry," in *Paths of Emancipation*, 128, 136.

16. Eli Lederhendler, "Modernity without Emancipation or Assimilation? The Case of Russian Jewry," in *Assimilation and Community: The Jews in Nineteenth-Century Europe*, ed. Jonathan Frankel and Steven J. Zipperstein (Cambridge: Cambridge University Press, 1992), 324–43; Michael Stanislawski, "Russian Jewry and Jewish Emancipation," in *Paths of Emancipation*, 262–83.

17. Jacob Toury, *Soziale und politische Geschichte der Juden in Deutschland 1847–1871* (Düsseldorf: Droste, 1977), 114, and "Der Eintritt der Juden in deutsche Bürgertum," in *Das Judentum in der deutschen Umwelt 1800–1850*, ed. Hans Liebeschütz and Arnold Paucker (Tübingen: J. C. B. Mohr [Paul Siebeck], 1977), 139–242; Avraham Barkai, "The German Jews at the Start of Industrialization: Structural Change and Social Mobility 1835–1860," in *Revolution and Evolution: 1848 in German-Jewish History*, ed. Werner E. Mosse, Arnold Paucker, and Reinhold Rürup (Tübingen: J. C. B. Mohr [Paul Siebeck], 1981), 123–45.

18. Hans Daalder, "Dutch Jews in a Segmented Society," in *Paths of Emancipation*, 46–47.

19. One souvenir conscription number/decorative plaque from 1855 is in the collection of the Musée de la Ville de Strasbourg.

20. Segré, "The Emancipation of the Jews of Italy," 226–27.

21. Ismar Schorsch, "Art as Social History: Oppenheim and the German Jewish Vision of Emancipation," in *Moritz Oppenheim: The First Jewish Painter*, exh. cat. (Jerusalem: The Israel Museum, 1983), 31–61; reprinted in Schorsch, *From Text to Context: The Turn to History in Modern Judaism* (Hanover, N.H.: Brandeis University Press and University Press of New England, 1994), 93–118.

22. Jacques Ehrenfreund, *Mémoire juive et nationalité allemande: Les juifs berlinois à la Belle Époque* (Paris: Presses Universitaires de France, 2000), 55.

23. Cited in Eugen Weber, *France, Fin de Siècle* (Cambridge, Mass.: Harvard University Press, 1986), 131.

24. Cited in Ehrenfreund, *Mémoire juive*, 56.

25. Cohen, *Jewish Icons*, 160.

26. Ibid., 155–85, and Paula E. Hyman, "Traditionalism and Village Jews in 19th-Century Western and Central Europe: Local Persistence and Urban Nostalgia," in *The Uses of Tradition: Jewish Continuity in the Modern Era*, ed. Jack Wertheimer (New York: Jewish Theological Seminary of America, 1992), 191–201.

27. Emily Braun, "From the Risorgimento to the Resistance: One Hundred Years of Jewish Artists in Italy," in *Gardens and Ghettos: The Art of Jewish Life in Italy*, ed. Vivian B. Mann (Berkeley and Los Angeles: University of California Press, 1989), 144.

28. Cohen, *Jewish Icons*, 167–69; Schorsch, "Art as Social History."

29. For an elaboration of this theme, see Cohen, *Jewish Icons*, 221–55.

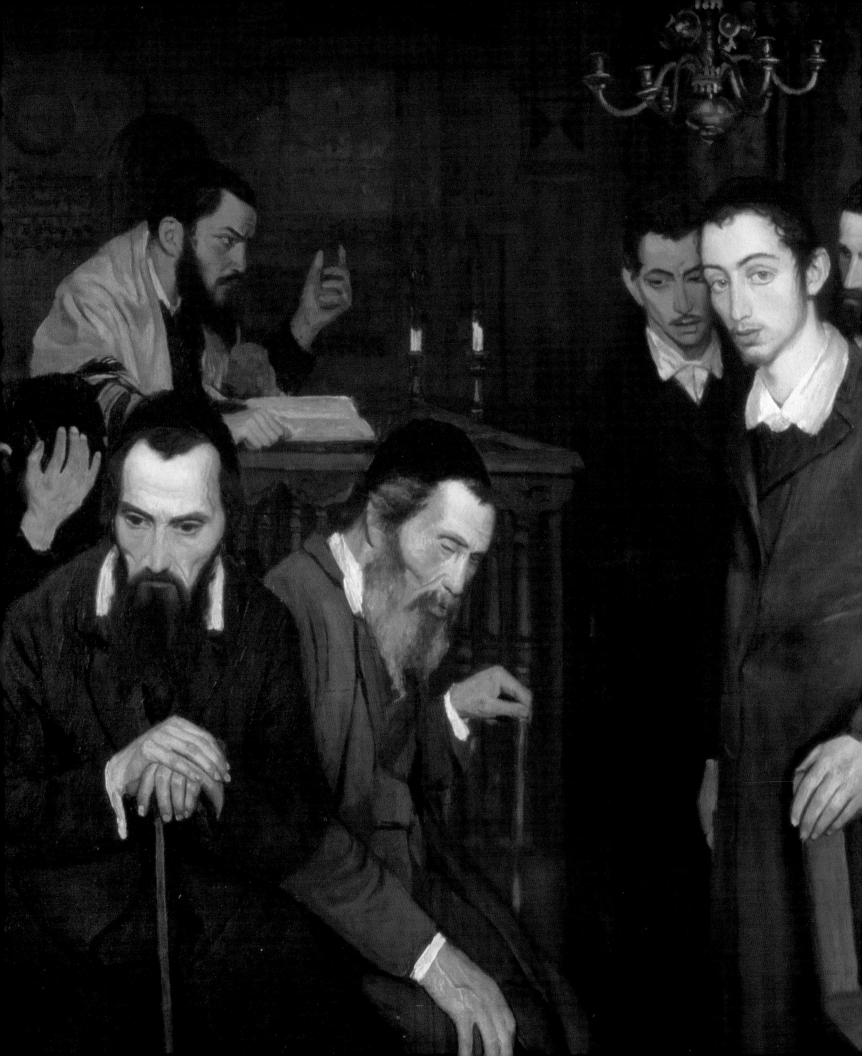

Nicholas Mirzoeff

Inside/Out: Jewishness Imagines Emancipation

Left: Maurycy Minkowski, *He Cast a Look and Went Mad* (detail), 1910. See pl. 31.

Below: FIG. 17. Jacques Louis David (French, 1748–1825). *The Oath of the Tennis Court, June 20, 1789*, 1791. Oil on canvas; 160 × 264 in. (400 × 660 cm). Musée national du château et des Trianons, Versailles.

Imagine yourself for a moment in the National Assembly of France in Paris, 23 December 1789 (see fig. 17). Inconceivable things are being done. The duties of the subject have been replaced by the rights of the citizen. The revolutionary leader Saint-Just is about to make a declaration: "Happiness is a new idea in Europe."[1] On this day, a new kind of being is to be imagined. The absolutist monarchy of France had demanded conformity to its limited range of social roles, enforced with often spectacular punishment. Today, taking a "leap into the open air of

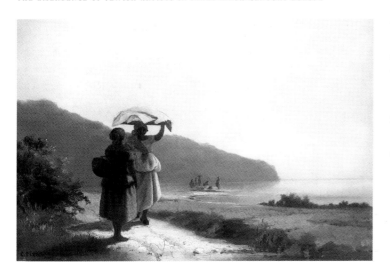

FIG. 18. Camille Pissaro (French, 1830–1903). *Two Women Chatting by the Sea, Saint Thomas*, 1856. Oil on canvas; 11¾ × 16⅛ in. (27.9 × 41 cm). National Gallery of Art, Washington; Collection of Mr. and Mrs. Paul Mellon.

FIG. 19. Anonymous. *Camille Pissarro Dressed as a Venezuelan Bandit*, c. 1854. Photograph. The Ashmolean Museum, Oxford.

history," the Assembly will argue that citizens have the right to be inconsistent. Since the Middle Ages, actors were regarded throughout Europe as immoral because they pretended to be people they were not. On the other hand, Jews were outside the boundaries of the community because of who they were. This day's debate finessed the problem of these citizens' rights by asking the Jews to become actors. Actors were then emancipated in a logical continuation of the day's work. That is to say, the Assembly emancipated the Jews on the condition that they not behave or appear like Jews. This performative gesture held good until racial "science" denied the possibility of such a double life.

In a moment, Jews gained the right to representation in both the political and the cultural sense. Jewish art exploded in the era of emancipation not because the age-old prohibitions of the Second Commandment were all of a sudden ignored but because the question of appearances had now become paramount. The drama of this inside/out tension was heightened by the new demands of modern art that the best art should manifest the interior thoughts and emotions of the artist. The practiced formulas of the academies of painting came to seem like desiccated ritual to those who chased after Wordsworth's dream of "emotion recollected in tranquillity." The modern bohemian artist set about finding visual means to express the interior drama that was to be given a series of analytic names by Sigmund Freud. It is no accident that the dramatic painting of Vincent van Gogh has come to be seen as the greatest expression of art in the period, in terms of both artistic achievement and salesroom price. Jewish artists faced a paradox: To be artistic required expressing interior life, while to be an emancipated Jew required concealing that interior life. Their art tries to imagine this paradox, sometimes in a utopian effort to resolve it, sometimes in denial. If it seems unexciting to eyes accustomed to expressivity as the only cardinal virtue in art, that is because we have lost the faculty of imagining this drama.

Enlightened Emancipation

In 1784 the Berlin periodical *Berliner Monatschrift* published two essays in response to their question: What is Enlightenment? One was by the German Jewish philosopher Moses Mendelssohn, the other by Immanuel Kant. The Jewish *Haskala* and the German *Aufklärung* met in the "imagined community" of print culture as related parts of the same process.[2] Mendelssohn split education into two categories, culture and enlightenment. While all humans have some form of culture, enlightenment requires hard work: "Hail to the nation whose refinement is the effect of culture and enlightenment, whose external splendor and elegance is based upon an internal, solid genuineness."[3] In a similar vein, Kant's well-known formula defined enlightenment as "mankind's quitting its nonage," that is to say, humanity's coming of age, its emancipation. But this emancipation was far from universal. For women, Africans, and Jews, emancipation was a goal still to be achieved. Kant imposed a precondition for such emancipation. The emancipated man—gender intentional— would be free in his use of public reason but restricted in its private use. That is to say, free speech and the right to criticize authority were conditional on that man accepting his role as "a cog in a machine," paying taxes, taking on civic responsibilities, and so on.

Mendelssohn is said to have advised the Jews: "Be a Jew on the inside and a man on the outside." He represented the drama of emancipation in Enlightenment terms as one of an inside/out. In the National Assembly debate of 1789, Count Stanislaw de Clermont-Tonnere took the same approach: "As a nation the Jews must be denied everything, as individuals they must be granted everything."[4] In the more radical Commune of Paris, speakers drew a chain of connection between the abolition of "feudal slavery," already carried out by the National Assembly, the "hardest of all slaveries" to which the Jews were subjected, and the "abominable slavery of the blacks."[5] This argument would lead to full

emancipation of the Jews in 1791 and abolition of colonial slavery in 1794. Its ghost would come back to haunt the emancipated in the nineteenth century.

However, the paradox remains that to be a cog in the Jewish community and in the machine of modern life would often involve a contradiction. The German Jewish painter Moritz Oppenheim represented this contradiction in his major work, *The Return of the Jewish Volunteer from the Wars of Liberation to His Family Still Living in Accordance with Old Customs* (1833–34; pl. 1). The painting has long been recognized as a drama of the old and new Jewishness. A modern Prussian soldier dominates the feminized space of the interior as the symbol of public manhood over private Jewishness. Oppenheim accentuates the distinction in his title by describing the family as "still living in accordance with old customs." Here emancipation confronts primitivism. Yet, in accordance with the prescription that the emancipated be disciplined, Oppenheim elides the continuing prohibition on Jewish promotion to officer rank.[6] The volunteer may be the dominant figure in his private familial world, but he will always be a subordinate in the public sphere of the army.

In the mid-nineteenth century, Jewish artists were able to make intriguing use of the tension between interior and exterior notions of the self, before pseudoscientific racism began to make such a distinction suspect and ultimately criminal. Oppenheim's *Self-Portrait* (1822; pl. 2) is a conventional Romantic portrait, offering little but a sense of what Mendelssohn called "exterior refinement." By the 1850s, a young Sephardic artist from the Caribbean island of Saint Thomas was challenging the inside/out formula. Camille Pissarro, the future Impressionist, found his first diasporic reflection in the African peoples of the Caribbean, depicted in his many drawings on Saint Thomas and in later paintings such as *Two Women Chatting by the Sea* (fig. 18).[7] Subsequently, he drew inspiration from the hybrid, mestizo peoples of

FIG. 20. Nadar (Gaspard-Félix Tournachon) (French, 1820–1910). *Sarah Bernhardt.* Photograph. Musée de la Ville de Paris, Musée Carnavalet, Paris.

Latin America. In 1854–55 he had himself photographed in Montevideo, Uruguay, while visiting a branch of the family business (fig. 19). Far from being a conventional portrait, the photograph shows him in the costume of a *llanero*, or cowboy, in line with his recent theatrical appearance in Caracas, Venezuela. The *llanero* was an outlaw hero, famed for his rough ways and wild drinking, as well as for his political involvements. Pissarro's performance as a Jewish diaspora artist shows a bearded man carrying a lasso and smoking a cigarette. The horse blanket on his shoulders conveys an interesting ambiguity, as it could easily be mistaken for a Jewish prayer shawl, or tallith. In fifty years, French Jews (Pissarro was educated in France; his father was originally from Bordeaux) had gone from being emancipated on the same day as actors to performing complex games of identity.

For the Eastern European Orthodox, emancipation changed nothing. The old prohibition against acting or going to the theater was still in force because, as the Orthodox rabbi Moshe Sofer declared, "Never say 'The times have changed.' "[8] The British artist Rebecca Solomon nevertheless made theater the subject of her work in *The Arrest*

of the Deserter (1861; pl. 32), although her family considered itself religious. The small genre painting shows a scene from William H. Murray's two-act comedy *Dominique the Deserter*, written in 1844 and revived at Astley's Theatre in 1859.[9] The play was a ninety-minute romp through theatrical cliché, complete with ghosts, death bells, and the devil—the last a case of mistaken identity— that became a favorite for amateur theatricals.[10] In Solomon's painting, the extravagant seventeenth-century costume of the "deserter" alerts the viewer to the theatricality of the scene, in which Dominique wears a black feathered hat as directed by Murray. The precise identity of the piece is confirmed by a poster for the Theatre Royal in the background, for *Dominique the Deserter* was first performed in the Theatre Royal, Edinburgh. These accurate details contradict any notion of Victorian women living sheltered from the public world. Indeed, Solomon's work was shown in 1861 at the Royal Academy annual exhibition, the most prestigious British art venue. Solomon's practice thus consistently challenged tradition, from her very act of painting as a woman to her choice of subject matter and her public

FIG. 21. Gian Lorenzo Bernini (Italian, 1598–1680). *Ecstasy of Saint Theresa of Avila* (detail), 1645. Marble and bronze. Cornaro Chapel, Saint Maria della Vittoria, Rome.

FIG. 22. Eugène Delacroix (French, 1798–1863). *Jewish Wedding in Morocco*, 1839. Oil on canvas; 41⁵⁄₁₆ × 55⅛ in. (105 × 140 cm). Musée du Louvre, Paris.

exhibition of her work. This was, after all, the era of the great Jewish actresses Rahel and Sarah Bernhardt (fig. 20).

Other Jewish artists of the period used figures from the biblical past or Jewish tradition in trying to define a new Jewish identity, such as Simeon Solomon's *Carrying the Scrolls of the Law* (1867; pl. 41) and Maurycy Gottlieb's *Self-Portrait as Ahasuer* (1876; see fig. 16). These paintings operate a complex play on identity and sexuality that refuses to be entirely legible. Simeon Solomon, Rebecca's brother, was operating at an intersection of identities as a gay Jewish artist. In the small exploratory painting, the young man does not so much carry scrolls as embrace them in a mystical ecstasy, reminiscent of that depicted in Bernini's famous statue of Saint Theresa (fig. 21). His coded references to same-sex desire were sufficiently legible in the period that Oscar Wilde hung a Solomon

drawing of Eros in his study. A similar sensuousness pervades Gottlieb's self-portrait in the guise of Ahasuer, the biblical king of Persia who first sentenced the Jews to death and then reprieved them on learning that his wife, Esther, was Jewish. Instead, he massacred the enemies of the Jews, making him an interesting choice of alter ego. For though Ahasuer was certainly powerful, he was not Jewish. Gottlieb's portrait used the visual language of orientalism to convey this sense of otherness, in line with well-known paintings like Eugène Delacroix's *Jewish Wedding in Morocco* (fig. 22). While Delacroix represented a scene that he had witnessed as a tourist, Gottlieb reversed the mirror traditionally used by artists in making self-portraits to imagine a world in which the other was a source of safety and protection. In a sense, he anticipated the Jewish philosopher Emmanuel Levinas, who argued that the sense of self

must come from a respect for the other person in what he calls the "face-to-face" encounters of everyday life.

Works such as these were nonetheless exceptional, even within the limited coterie of Jewish artists. It was far more common for artists to represent either the internal world of Jewish life or the wider public sphere without explicit reference to Jewishness, just as the enlightened process of emancipation envisaged. Public paintings like Lesser Ury's *Unter den Linden after the Rain* (1888; pl. 66) seem to insulate themselves from any reproach that interior Jewishness might have contaminated the work. Edouard Moyse felt confident enough to depict a circumcision, the source of so much antisemitic prejudice, in *The Covenant of Abraham*, painted around 1860 (pl. 13), the same year that the Alliance Israélite Universelle was founded. The Alliance sought to promote assimilation by

maintaining a carefully balanced mix of public and private identities. Moyse's scene, interior and internal, represents biblical tradition, as suggested by the title, in a timeless space. In Samuel Hirszenberg's *The Sabbath Rest* (1894; pl. 28), a Jewish family rests as ordained by religion. More exactly, the men rest while a woman watches over them. The bright light of the central window suggests the external world from which the family has voluntarily sequestered itself for the Sabbath. Even here, in the apparently Orthodox setting, there are hints of change. At top right, pictures can be seen, presumably family portraits. One seems to be a photograph. At first glance, the painting seems to depict tradition, but a sideways look shows that modernity is finding its way into even these interior spaces.

Race and Representation

In an essay written at about the same time as Hirszenberg's painting was made, the German industrialist and intellectual Walther Rathenau exhorted his fellow Jews: "Look at yourself in the mirror! Nothing, unfortunately, can be done about the fact that you all look frighteningly alike, that your individual vices, therefore, are attributed to all of you." He looks with horror at "an alien and isolated race of men."[11] Rathenau saw his exterior as betraying the once private Jewish interior. In Lesser Ury's *Portrait of Walther Rathenau* (fig. 23), he looks every inch the respectable businessman, except that his body is curiously placed at the left side of the painting, as if Ury wanted viewers to detect Rathenau's sense that he did not quite belong. Mendelssohn's distinction between exterior and interior no longer held good. From the complex mirrors of identity used by Pissarro and Gottlieb has come a single, isolated fact. That fact was "race."

From the abolition of the legal distinction between Europeans and their enslaved others in the mid-nineteenth century arose the chimera of a pretended scientific distinction

between peoples that claimed to be based on fact. Just as the Jews had been emancipated in a logic that connected them to enslaved Africans, so were they racialized in a manner that linked them to free and colonized Africans, and vice versa. The Jews were seen as being like Africans, except that they lived where the other Europeans did and in increasing numbers. For a racial polemicist like Max Stirner, the Enlightenment settlement in which a person could be in the state but not of it was unacceptable. Writing in 1882, Stirner created a nationalist, Hegelian antisemitism that theorized two principal stages of human history. The first, "Negro stage of the soul" was that of antiquity, and the second, Christian era was the Mongol phase that was then about to end. The exceptions to this dialectical history were the Jews, who had not passed out of this "Negro stage of the soul."[12] Stirner argued that the inside and the outside must now be the same: The Jewish interior was alien to the racialized state and must be excluded in order for the state to cohere.

That logic cut at the very basis of acculturation and emancipation. Perhaps for this reason Jewish critics were often severe opponents of any form of modernism in the visual arts. Writing in 1869 in the *Archives Israélites*, the journal of the Alliance Israélite Universelle, Isidore Cahen saw a connection between the Impressionist style and so-called

northern race theory. He dismissed the Impressionist-influenced *Après déjeuner* by the Jewish artist Henri-Michel Levy as "Wagner in painting," referring to the composer's notorious antisemitism: "Wagner has thus sought to excite the passions of the crowd, to exploit the prejudices of the masses; now in these cases, the first resource of the mediocrity is to attack the Jews."[13] In Cahen's view— more strongly felt than argued—it seems that modernity engendered antisemitism. By adopting modernist styles of representation, Jews were undoing the inside/outside settlement of emancipation. Since the settlement could be imagined only in the arts, the issue was not trivial. By 1889, the pro-Impressionist critic Jules Laforgue would claim that "[t]he Impressionist eye is, in short, the most advanced eye in human evolution. No longer an isolated melody, the whole thing is a symphony, which is living and changing, like the 'forest voices' of Wagner, all struggling for existence in the great voice of the forest."[14] Cahen's fears had been realized. The modernist aesthetic was now being explicitly racialized in terms that could only exclude and marginalize Jews, especially Jewish artists.

It is perhaps not surprising, then, that Camille Pissarro radically changed his artistic style in 1889. In a moment of crisis following the death of his mother and a downturn in finances, he mused that his problems were "[a] matter of race, probably; until now, no Jew has

FIG. 23. Lesser Ury (German, 1861–1931). *Portrait of Walther Rathenau*, 1896. Pastel on paper; 18⅞ × 27⅜ in. (48 × 69.5 cm). Leo Baeck Institute, Jerusalem.

made art here, or rather no Jew has sought to make a disinterested art of sensation; I believe that this could be one of the causes of my bad luck. . . . I cause too much surprise and break too much with acquired habits."[15] Pissarro had been led to question whether the antisemites were right and that his race was in some way impeding his efforts to create an "art of sensation." His first response was to embrace antisemitism himself. In a series of rather simplistic cartoons made for his very sophisticated English niece Esther Isaacson, Pissarro adopted what Bernard Lazare would call "economic antisemitism [which] is bound up with ethnologic and national antisemitism."[16] In his caricatures, Pissarro represented capital as a Jewish banker with the "characteristic" Jewish nose.

It seems that these private cartoons were cathartic, and Pissarro rebounded with a new lease on artistic life. Whereas he previously had concentrated on landscapes and scenes of peasant life, his last works were dominated by an extraordinary and prolific focus on the modern city. These works were made from the inside out. For Pissarro had come to suffer from an eye condition that made it difficult for him to paint outdoors in classic Impressionist style. His city paintings were made inside, in rented apartments that looked out onto city streets. This personal problem was thrown into acute relief by racialized theory that Jews were particularly subject to weaknesses of the eye, especially color blindness.[17] If there is an element of nostalgia in these late works, it stems in part from the loss perceived in the twenty-five years between the first Impressionist show of 1874, in which two Sephardic Jews participated (Pissarro and Brandon), and the period of Dreyfus, in which Haussmann's boulevards were the domain of antisemitic mobs. At the height of the agitation over the Dreyfus case, Pissarro found himself in a situation that expressed the peculiarity of being a Jewish artist in the 1890s: "Yesterday going to Durand's at five o'clock on the boulevards, I found myself in the middle of a group of little thugs, followed

by hooligans, crying 'Death to the Jews, down with Zola!' I passed tranquilly through the middle of the group, and they did not even take me for a Jew!"[18] He went inside his studio and resumed painting. The Enlightenment strategy of concealing external Jewishness worked in the individual case of Pissarro, even as it was patently collapsing in the wider culture. In his last decade, Pissarro often turned to self-portraiture in a series of works in which he again seems to defy categorization and at times to approach invisibility. He had read and agreed with Bernard Lazare, who claimed that "race is a fiction."[19] How, then, could the mob have taken Pissarro for a Jew if there was nothing to see? Modern Jewishness has been haunted by this fear that the interior mind will be betrayed by the external body.

The Uncanny

A decade later, another Jewish intellectual was forced to confront his own image, as Rathenau and Pissarro had done in different ways: "I was sitting alone in my *wagon-lit* compartment when a more than usually violent jolt of the train swung back the door of the adjoining washing cabinet, and an elderly gentleman in a dressing gown and a travelling cap came in. . . . Jumping up with the intention of putting him right, I at once realized to my dismay that the intruder was nothing but my own reflection in the looking-glass on the open door. I can still recollect that I thoroughly disliked his appearance."[20] Sigmund Freud (fig. 24) concluded that he had not so much been scared by the encounter with his "double" as he had failed to recognize it. He was too self-aware not to suggest that his mistake held a trace of what he called the "uncanny." The uncanny is a rough English equivalent to the complicated German word *unheimlich*, which Freud himself glossed as meaning "everything is *unheimlich* that ought to have remained secret and hidden but has come to light."[21] In Freud's case, the secret is very often his own Jewishness. Did Freud's

FIG. 24. Sigmund Freud, 1909.

uncanny encounter with his own image cause him to make a mistake because the person in the reflection seemed to be Jewish? At the end of the Enlightenment settlement, the doubled Jew became two people in a process that Freud called "a doubling, dividing and interchanging of the self."[22] The Jew, divided between inside and outside, now became two people, or, more exactly, one person and a ghost, with neither sure which he really was. In this uncanny moment, no one strategy for resolving the dual identity that constituted being a Jewish artist emerged to replace the Enlightenment settlement.

On the one hand, an artist like the English painter Solomon J. Solomon might try to shrink difference to a barely perceptible minimum. In his *High Tea in the Sukkah* (1906; pl. 25), he reduces the Sukkot theme to background decoration, and the only person who looks (stereo)typically Jewish is the rabbi in the foreground. Many other faces are obscured, but a man at center left has an impeccably classical profile, complete with arrow-straight nose. Jewishness here is a remainder from past time,

circulating as an amusement for refined English people. It is surely no coincidence that, during World War I, Solomon, a lieutenant colonel in the Artist Volunteers, promoted the use of strategic camouflage. Seventy-odd years after Oppenheim imagined a Jewish volunteer proudly displaying his modern difference to his hidebound family, a Jewish artist volunteered his skills in camouflage that had been learned in English high society. He was rewarded at the end of the war with the presidency of the Royal Society of British Artists in 1918, an honor he felt he ought to accept "because I am a Jew."

On the other hand, the Polish Jewish artist Maurycy Minkowski made uncanniness the very subject of his work. In his mystical work *He Cast a Look and Went Mad* (1910; pl. 31), Minkowski represents a figure divided within and against himself. The title refers to a passage from the Talmud: "Four entered the garden. One looked and died. One looked and lost his mind. One looked and hacked down the shoots. One entered in peace and left in peace." Minkowski's painting shows no sign of a garden, which is understood to be a metaphor. The subject of the metaphor might be taken to be the conflicting and divergent possibilities of being Jewish in the early twentieth century, for all the figures seem to be variations on the central figure of the young man, the only one to look out and acknowledge the presence of the spectator. The four outcomes available lead to death, madness, destruction, or an unchanging peace. We see men of different ages—the younger ones to the right, the older ones to the left. At the rear on the left, a middle-aged man reading or studying Torah seems to cast the whole space as a yeshiva. But it is not clear that the space is to be interpreted so literally, as the age divide makes clear. Do the figures to the left represent an older, even dying religious form, while those to the right connote modernity and assimilation? Indeed, the younger men are clean shaven or have cut their beards and therefore cannot be Hasidim.

Yet the power of visible Jewishness-as-Judaism is such, in the racialized context of the period, that it dominates the image. Even as Minkowski makes Jewishness visible and problematic, he calls it into question by his very act of imaging and imagination. The painting is very heavily framed, and the title engraved in Hebrew calls attention to the work of representation within, rather than trying to pass it off for reality. Minkowski refuses to be either inside or outside but puts both in the same frame. Stepping aside from the grand polemics of construction (whether modern or Zionist) and destruction (whether by acculturation or archaism), Minkowski uncannily imagines a deconstruction of Jewishness—that is to say, neither the inside nor the outside, neither destruction nor construction. Rather, such a Jewishness would, in the words of North African Jewish philosopher Jacques Derrida, be "open to a future radically *to come*, which is to say indeterminate, determined only by this opening of the future to come."[23] When the "time is out of joint," such imagining is not without its risks, and Minkowski asserts that his double, the painter, like Hamlet, has gone mad. But there is method in this madness and it is still to come.

NOTES

1. As quoted by Greil Marcus in *Lipstick Traces: A Secret History of the Twentieth Century* (Cambridge, Mass.: Harvard University Press, 1989), 347.

2. As argued by Michel Foucault, "What Is Enlightenment?" in *The Foucault Reader*, ed. Paul Rabinow (Harmondsworth: Penguin, 1984), 33.

3. Moses Mendelssohn, "On the Question: What Does 'to Enlighten' Mean?" in *Philosophical Writings*, ed. and trans. Daniel O. Dahlstrom (Cambridge and New York: Cambridge University Press, 1997), 314.

4. David Vital, *A People Apart: The Jews in Europe 1789–1939* (New York and Oxford: Oxford University Press, 1999), 44.

5. *Archives parlementaires de 1787 à 1860*, ed. J. Madival, Première Série (1787 à 1799), vol. 10 (Paris, 1878), 761–78.

6. Vital, *A People Apart*, 173.

7. See Nicholas Mirzoeff, "Pissarro's Passage: The Sensation of Caribbean Jewishness in Diaspora," in *Diaspora and Visual Culture: Representing Africans and Jews*, ed. Nicholas Mirzoeff (London and New York: Routledge, 2000), 57–75.

8. Vital, *A People Apart*, 116.

9. William H. Murray, *Dominique the Deserter, or, The Gentleman in Black*, translated from the French (London: Thomas Hailes Lucy, [1844]).

10. The play was published in the Lacy's Acting Edition series by Samuel French.

11. Vital, *A People Apart*, 258.

12. Max Stirner, *Der Einzige und sein Eigenthum* (Leipzig, 1882), 22, 25, 31, 69; analyzed by Bernard Lazare in *Antisemitism: Its History and Causes* (New York: International Library Publishing, 1903), 223.

13. Isidore Cahen, "Le Judaïsme dans les arts: Le Salon de 1869," *Archives Israélites*, 15 June 1869, 335–38.

14. Quoted in Linda Nochlin, ed., *Impressionism and Post-Impressionism 1874–1904: Sources and Documents*, (Englewood Cliffs, N.J.: Prentice-Hall, 1966), 17; translation modified.

15. *Correspondance de Camille Pissarro*, ed. Janine Bailly Herzberg (Paris: Éditions de Valhermeil, 1980), vol. 2, letter 525 (1 May 1889), 270.

16. Lazare, *Antisemitism*, 220.

17. For further details, see Mirzoeff, "Pissarro's Passage."

18. *Correspondance de Camille Pissarro*, vol. 4, letter 1503 (1888), 434–35.

19. Lazare, *Antisemitism*, 227.

20. Sigmund Freud, "The Uncanny," in *The Standard Edition of the Complete Psychological Works of Sigmund Freud*, ed. and trans. James Strachey, vol. 17 (London: Hogarth Press, 1955), 248 n. 1.

21. Ibid., 225.

22. Ibid., 234.

23. Jacques Derrida, *Archive Fever: A Freudian Impression*, trans. Eric Prenowitz (Chicago: University of Chicago Press, 1996), 70.

The Emancipation of
European Jewry
1789–1918

Dates indicate when Jews were given full civil equality.

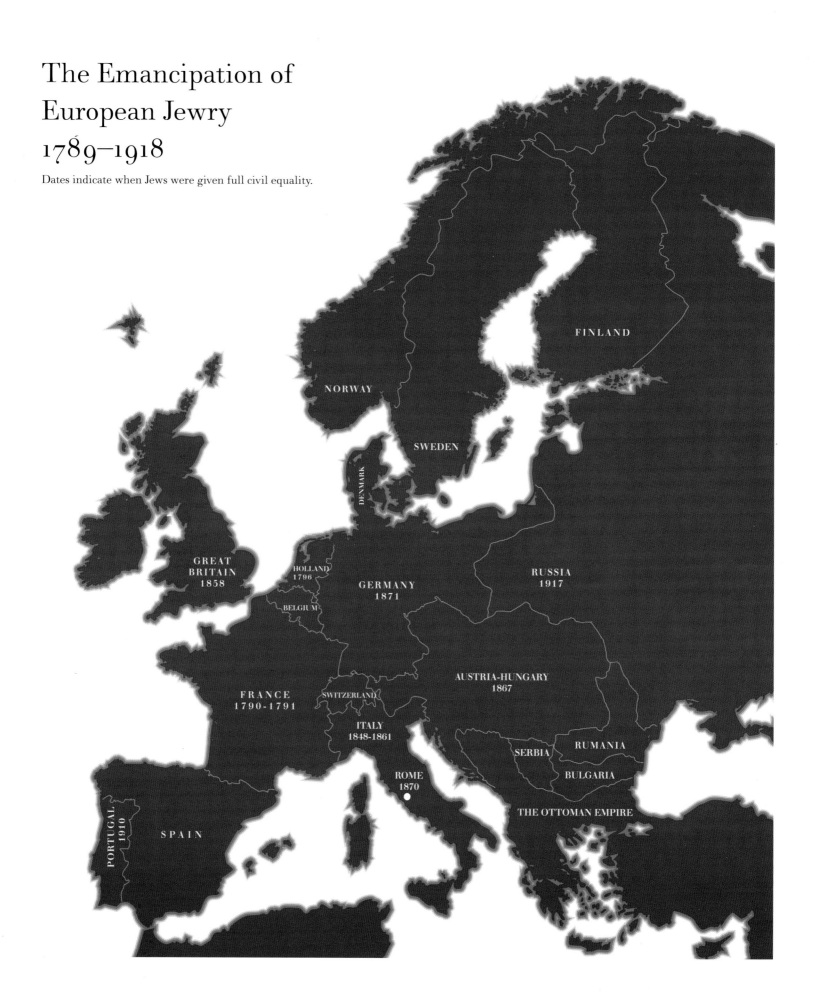

FINLAND

NORWAY

SWEDEN

DENMARK

GREAT
BRITAIN
1858

HOLLAND
1796

GERMANY
1871

RUSSIA
1917

BELGIUM

FRANCE
1790-1791

SWITZERLAND

AUSTRIA-HUNGARY
1867

ITALY
1848-1861

RUMANIA

SERBIA

BULGARIA

ROME
1870

THE OTTOMAN EMPIRE

PORTUGAL
1910

SPAIN

The Plates

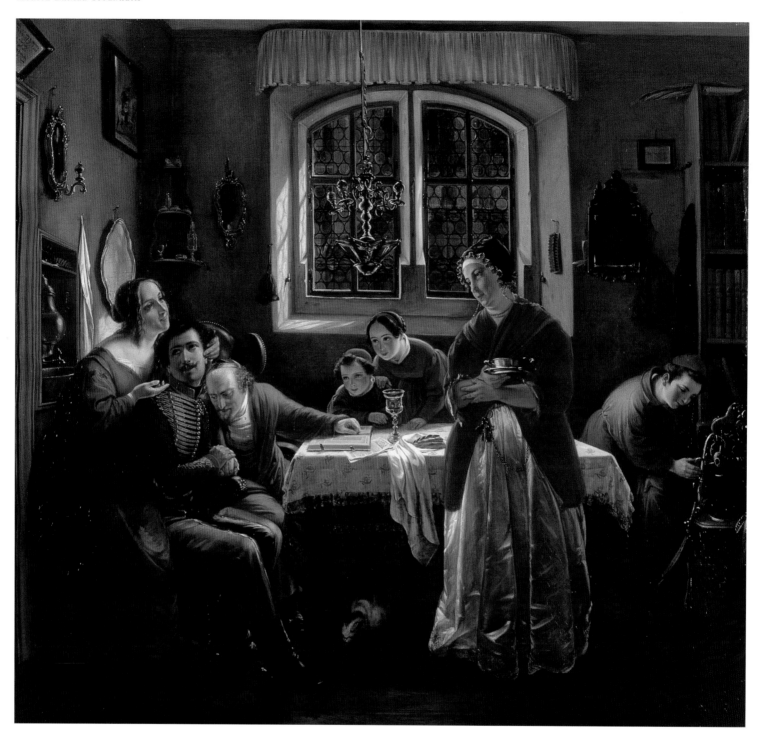

1
MORITZ DANIEL OPPENHEIM
(German, 1800–1882)

*The Return of the Jewish
Volunteer from the Wars of
Liberation to His Family Still
Living in Accordance with
Old Customs,* 1833–34
Oil on canvas
34 × 36 in. (86.4 × 91.4 cm)
The Jewish Museum, New
York; Gift of Richard and
Beatrice Levy, 1984-61

The Return of the Volunteer
illustrates the shifting
attitudes toward the
observance of Jewish
tradition. It depicts a
wounded soldier in a Hussar's
uniform and without head
covering, who has just
returned to his Orthodox
family on the Sabbath, after

defending Germany against
the Napoleonic armies in the
1813–14 Wars of Liberation
from France. He is adorned
with his military decoration,
the Iron Cross, a Christian
symbol that could hold
conflicting meaning for
observant Jews. Moritz
Daniel Oppenheim has

boldly addressed the conflict
between Jewish tradition and
loyalty to the state via
military service, portraying
the two generations with
their different lifestyles
attempting to live in
harmony.

2

MORITZ DANIEL OPPENHEIM
(German, 1800–1882)

Self-Portrait, 1822
Oil on canvas
17⅜ × 14⅜ in.
(44 × 36.5 cm)
The Israel Museum,
Jerusalem; Gift of Dr. Arthur
Kauffmann, London
Through the British Friends
of the Art Museums of Israel

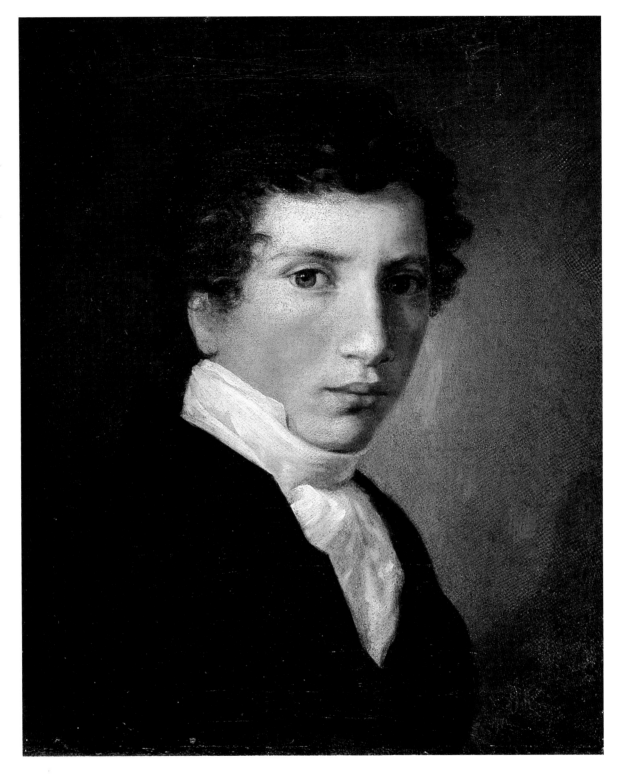

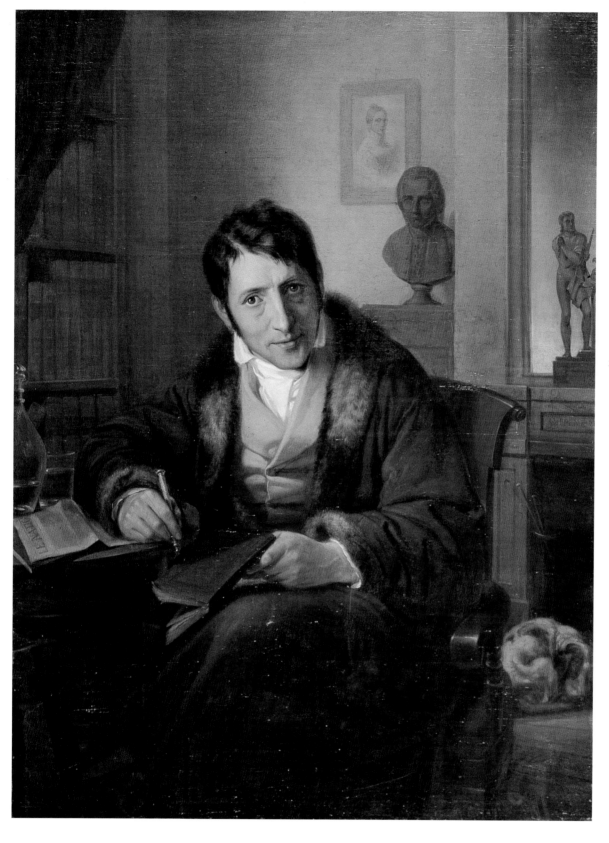

3
MORITZ DANIEL OPPENHEIM
(German, 1800–1882)

Ludwig Börne, 1840
Oil on canvas
46⅞ × 35½ in.
(119 × 90 cm)
The Israel Museum,
Jerusalem; Received through
IRSO

Moritz Daniel Oppenheim
painted at least five
portraits of Ludwig Börne
(1786–1873), who was born
in Frankfurt as Loeb Baruch.
Although Börne converted to
Protestantism in 1818, he
was a zealous supporter of
Jewish emancipation in
Germany. Börne was not
embraced by Germans or
Jews throughout his life,
even though he
was respected as an eminent
political journalist and
theater critic. Although
Börne's ability to publish
widely was undoubtedly
aided greatly by his religious
conversion, his words seem
to express the condition of
many Jews whose conversion
to Christianity did not seem
to free them from their
origins. "For eighteen years
I have been baptized and it
doesn't help at all," he wrote.
"One group holds it against
me that I am a Jew, a second
forgives me for it, a third
even praises me for it, but all
think about it. It is as if they
are caught up in this magic
Jewish circle and no one can
get out of it."

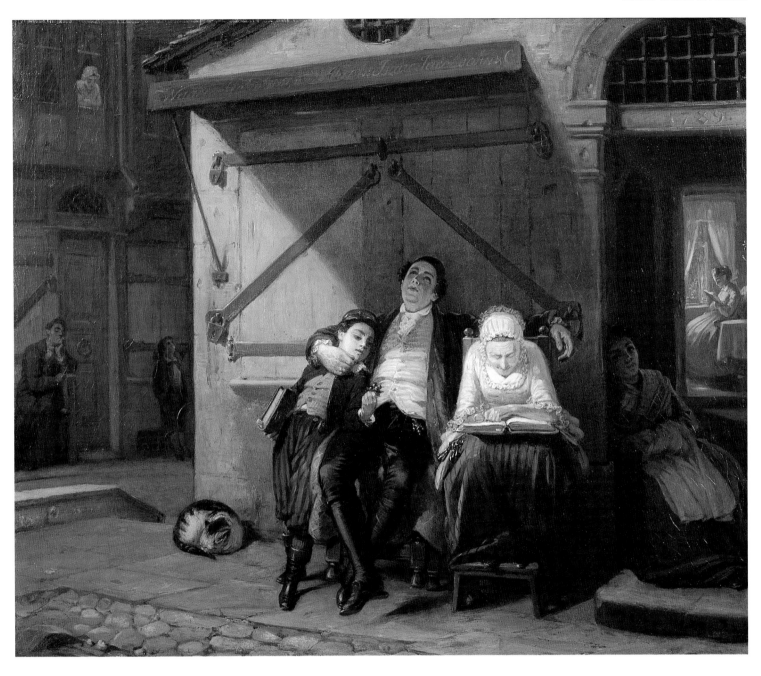

4

MORITZ DANIEL OPPENHEIM
(German, 1800–1882)

Sabbath Rest, 1866
Oil on canvas
20½ × 23 in.
(48.9 × 58.4 cm)
The Jewish Museum, New
York; Gift of the Oscar and
Regina Gruss Charitable and
Educational Foundation,
1999-86

This work embodies the
adaptation of Jews as they
navigated between the old
and the new traditions. The
doorpost in the painting
bears the date 1789, the year
of the French Revolution,
which ushered in the period
of the emancipation of the
Jews in Europe and

announced the end of the
era portrayed in the painting.
On the Sabbath, all shops,
including the Warenhaus von
Abraham Isaak Jacobsohn (a
pointed reference, on the
façade of the shop, to the
patriarchs), were closed.
Here two lifestyles adapt
to each other, as the older

woman observes the day
of rest by apparently pouring
over the traditional Yiddish
text read by women on the
Sabbath. The young lady
shown deep in the interior of
the house, separated from the
others, is probably reading
a contemporary novel
or another secular text.

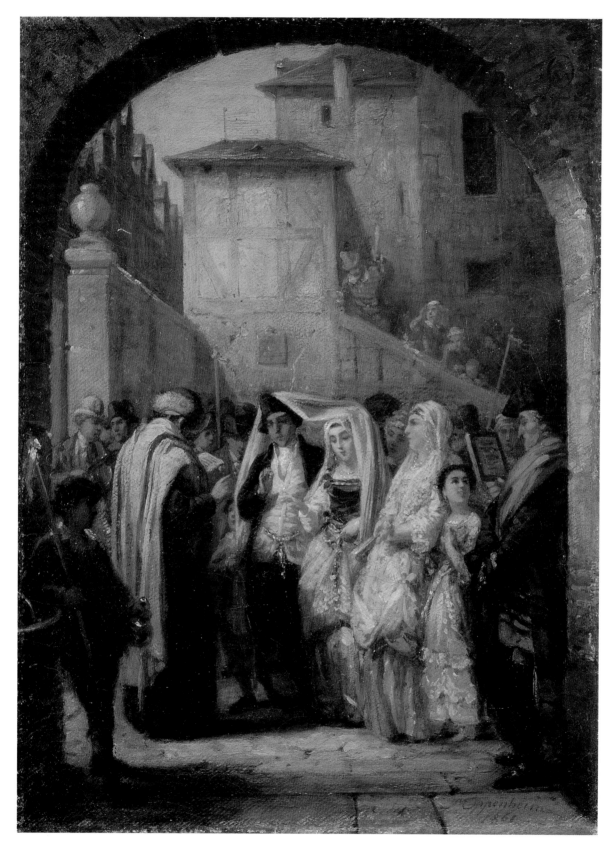

5
MORITZ DANIEL OPPENHEIM
(German, 1800–1882)

Wedding, 1861
Oil on canvas
14¾ × 11¼ in.
(37.5 × 28.5 cm)
The Israel Museum,
Jerusalem

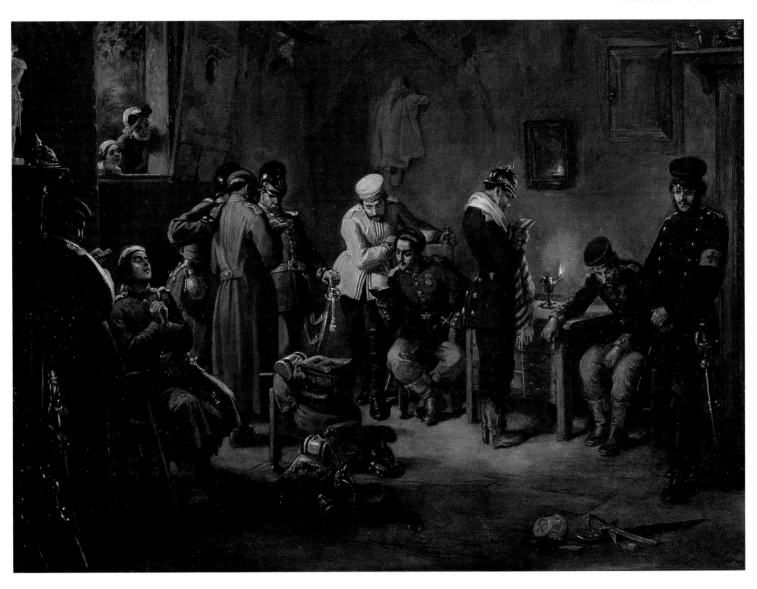

6

MORITZ DANIEL OPPENHEIM
(German, 1800–1882)

Yahrzeit Minyan, 1875
Oil on canvas
20½ × 26⅜ in.
(52 × 67 cm)
Private collection, New York

This painting depicts an imagined observance of a *yahrzeit* service somewhere on the battlefield during the Franco-Prussian War of 1870. The requisite ten soldiers have assembled in a war-torn French farmhouse to conduct the afternoon prayer service marking the anniversary of the death of a family member. *Yahrzeit Minyan* portrays the retention of a Jewish tradition in an acculturated world, while also reflecting on the participation of Jews in the life of their nation. To stress the loyalty of Jews both to their country and to their religious tradition, the event is portrayed as taking place in the midst of battle. The artist made certain that the viewer notice the cross on the wall, which has been covered for the occasion, and the local non-Jewish girls peering with curiosity through the window.

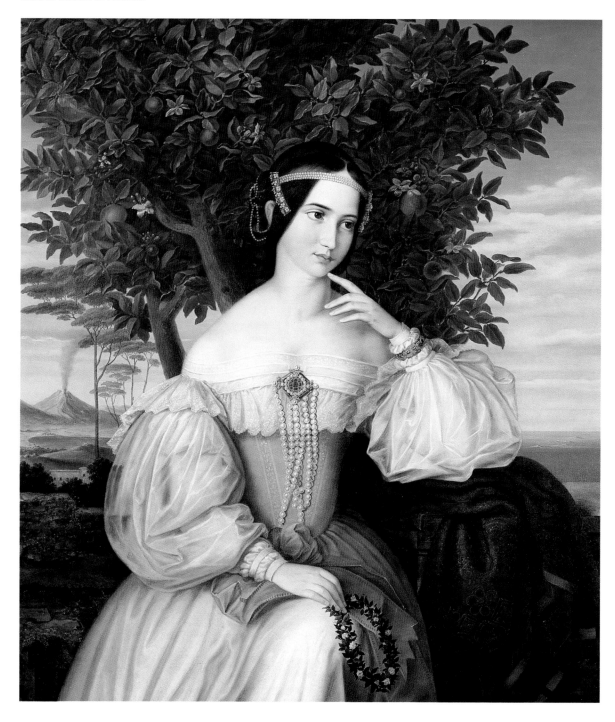

7

MORITZ DANIEL OPPENHEIM
(German, 1800–1882)

*Charlotte von Rothschild as
Bride*, 1836
Oil on canvas
46⅞ × 40½ in.
(119 × 103 cm)
The Israel Museum,
Jerusalem; Received through
IRSO

Charlotte von Rothschild
married Lionel, her cousin
from London, when she
was seventeen. The 1836
wedding was celebrated in
Frankfurt, and this painting
and its counterpart, *Lionel
Nathan de Rothschild as
Bridegroom*, were painted
for the occasion. It shows
Charlotte seated in front of
Mount Vesuvius, a reference
to the bank in Naples owned
by her father.

8

MORITZ DANIEL OPPENHEIM
(German, 1800–1882)

*Lionel Nathan de Rothschild
as Bridegroom*, 1836
Oil on canvas
47 × 40⅛ in.
(119.5 × 102 cm)
The Israel Museum,
Jerusalem; Received through
IRSO

Charlotte von Rothschild
and her cousin Lionel were
married in 1836. Their
portraits were painted on
the occasion of their wedding
in Frankfurt, sumptuously
celebrated in the presence of
all five Rothschild brothers.
The wedding was a European
media event and made
history with Nathan's sudden
death shortly thereafter.
This work shows the groom
seated in front of a typical
English park with the ruins
of a medieval castle in the
background referring to the
London bank of his father.

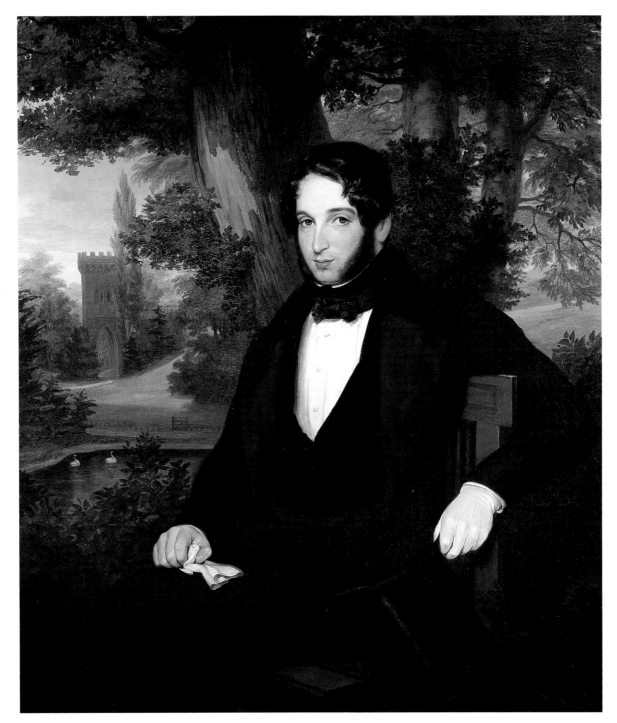

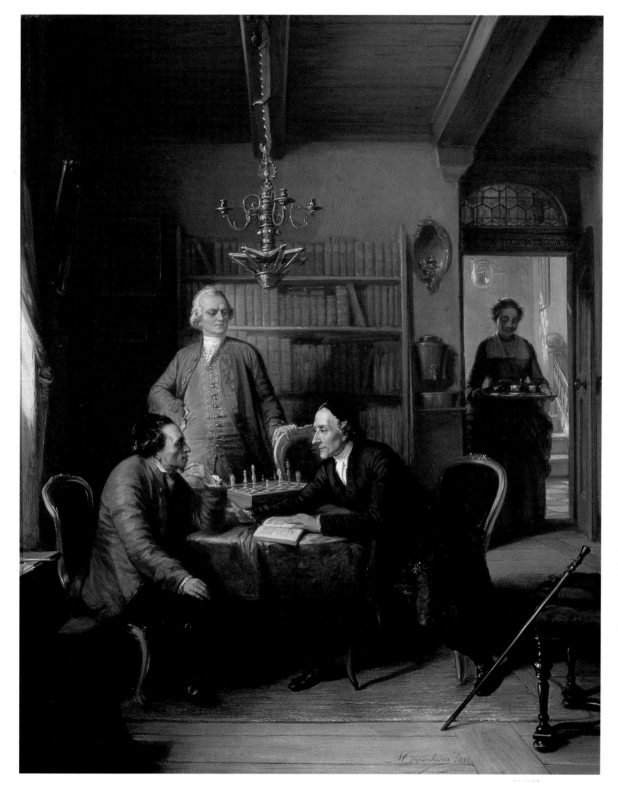

9
MORITZ DANIEL OPPENHEIM
(German, 1800–1882)

*Lavater and Lessing Visiting
Moses Mendelssohn*, 1856
Oil on canvas
27½ × 23½ in.
(70 × 60 cm)
Judah L. Magnes Museum,
Berkeley, California; Gift of
Vernon Stroud, Eva Linker,
Gerda Mathan, Ilse Feiger
and Irwin Straus in memory
of Frederick and Edith
Straus

This history painting looks
back to the period prior to
emancipation to an
imaginary encounter
between Johann Caspar
Lavater, Gotthold Lessing,
and Moses Mendelssohn, the
distinguished Enlightenment
philosopher considered to be
the first modern Jewish
thinker. Lavater, a Swiss
Lutheran clergyman, sits
before Mendelssohn,
challenging him to prove the
superiority of Judaism over
Christianity or to renounce it.
Lessing, a Christian
playwright and German
Enlightenment thinker,
stands behind the two,
assuming the role of
mediator and underscoring
the respect of the tolerant
Christian for his Jewish
friend. Lessing's play *Nathan
the Wise* promoted tolerance
for the Jewish religion.

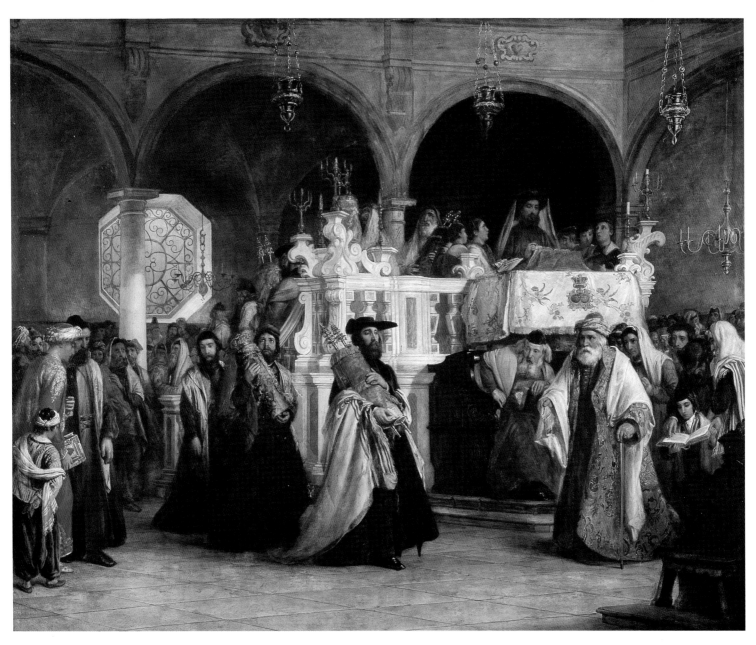

10

SOLOMON ALEXANDER HART
(British, 1806–1881)

*The Feast of the Rejoicing of
the Law at the Synagogue in
Leghorn, Italy,* 1850
Oil on canvas
55⅝ × 68¾ in.
(141.3 × 174.6 cm)
The Jewish Museum, New
York; Gift of Mr. and Mrs.
Oscar Gruss, JM 28-55

Like many of his
countrymen, Solomon
Alexander Hart did a grand
tour of the Continent in
the early nineteenth century,
making elaborate drawings
of historical sites and
architectural interiors,
which in later years became
the basis for a number of

paintings. In this work, the
procession takes place in a
richly decorated, eighteenth-
century Italian synagogue in
Leghorn (Livorno), Italy.
Hart captures a romantic
vision of the exotic dress of
his fellow Sephardic Jews as
they parade the scrolls of the
law on Simhat Torah, the

Feast of the Rejoicing of the
Law. This marks the end of
the fall harvest festival,
Sukkot, and is the holy day
on which the yearly cycle of
reading the Pentateuch ends,
immediately beginning
again with Genesis.

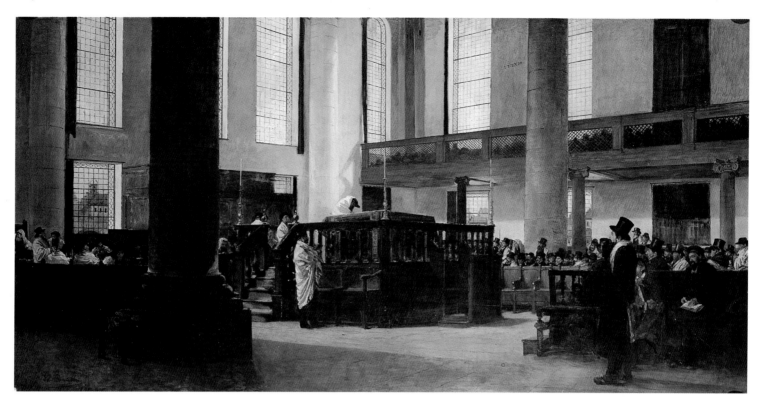

11

JACQUES-ÉMILE-EDOUARD
BRANDON
(French, 1831–1897)

*Silent Prayer, Synagogue of
Amsterdam, "The Amidah"*
(*"La Guamida"*), 1897
Oil on panel
34½ × 68½ in.
(87.7 × 174 cm)
The Jewish Museum,
New York; Gift of Brigadier
General Morris C. Troper in
memory of his wife Ethel
G. Troper and his son Murray
H. Troper, JM 78-61

During the early 1860s,
Jacques-Émile-Edouard
Brandon showed a series of
paintings in the annual Paris
Salon, establishing that this
was a venue in which Jewish
painters could exhibit.
Brandon painted a number of
versions of the Portuguese
Synagogue of Amsterdam,
one of the most impressive
synagogues in Europe.
Constructed between 1671
and 1675, it is still one of
Amsterdam's landmarks. The
painting spans the complex
architectural interior of the

majestic synagogue, evoking
the grandeur of the interior
at the moment of chanting
the *Amidah*, or Silent Prayer.
Brandon most likely did not
make studies from direct
observation because it was
prohibited under Jewish
law to draw on the Sabbath
or holidays, when this work
would have been recorded.

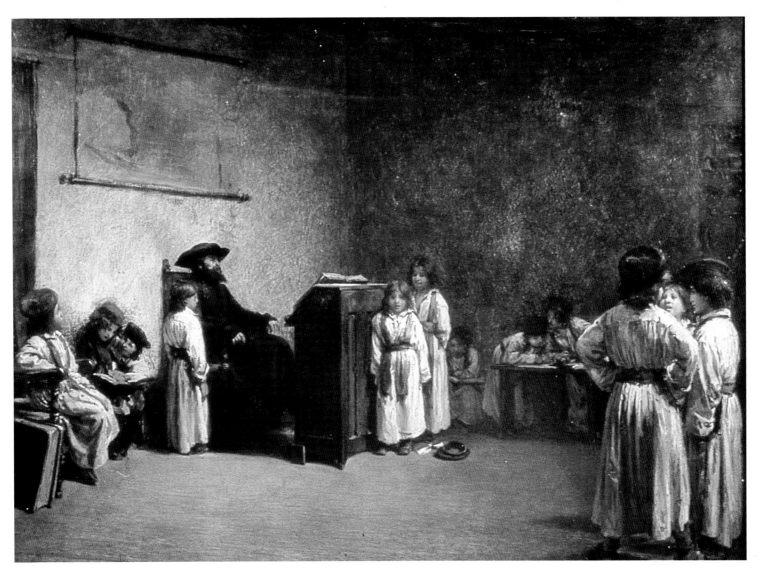

12

JACQUES-ÉMILE-EDOUARD
BRANDON (French,
1831–1897)

Heder, 1870
Oil on panel
13¾ × 18⅛ in.
(35 × 46 cm)
The Israel Museum,
Jerusalem

By focusing his painting on
the training of young Jews,
Jacques-Émile-Edouard
Brandon tried to present the
mores of the community in a
positive light by showing
how young boys attended
Jewish school and how their
lessons were recited. Brandon
was following a well-
established French model

designed to demonstrate how
the young were trained in
school and how religious
instruction was significant
for the people of France.

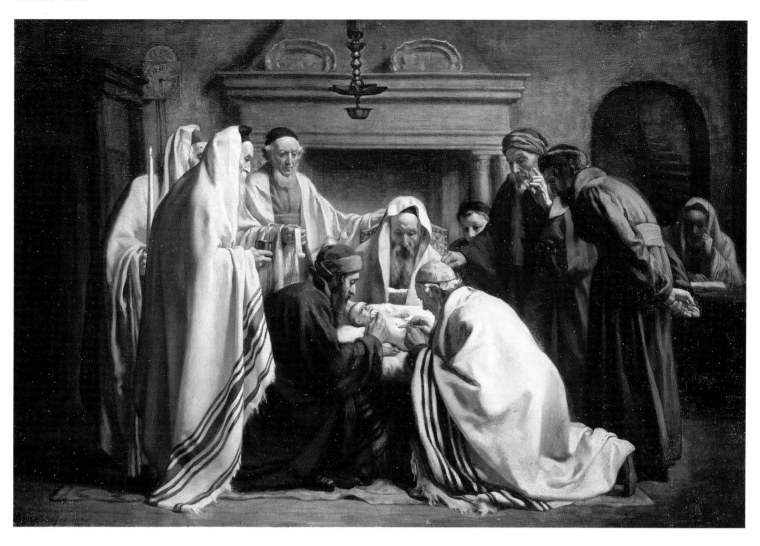

13

EDOUARD MOYSE
(French, 1827–1908)

The Covenant of Abraham,
c. 1860
Oil on canvas
22¾ × 33¾ in.
(58 × 86 cm)
Collection Reuven and Naomi
Dessler, Cleveland, Ohio

According to the Book of
Genesis, God commanded
Abraham and his descendants
to be circumcised. This has
been regarded as the
supreme obligatory sign of
loyalty and adherence to
Judaism. It is performed on
all male Jewish children on
the eighth day after birth,
as well as on all male

converts to Judaism. As
the sign of the covenant
with God (Heb., *brit*),
circumcision (Heb., *milah*)
came to be known as *brit
milah* (or "covenant of
circumcision").

14

EDOUARD MOYSE

(French, 1827–1908)

Self-Portrait, 1869

Oil on canvas

27¾ × 22¾ in.

(70.5 × 58 cm)

Musée d'art et d'histoire

du Judaïsme, Paris; Gift of

Mrs. Weill

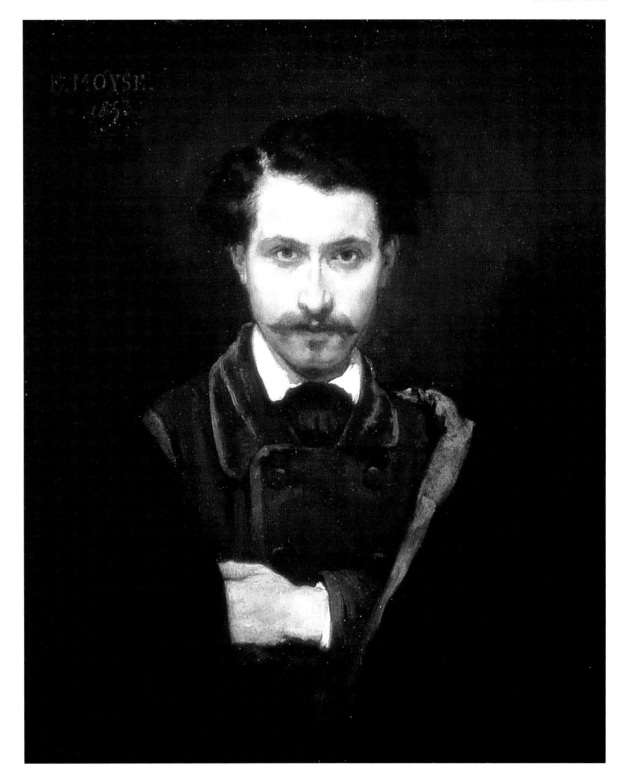

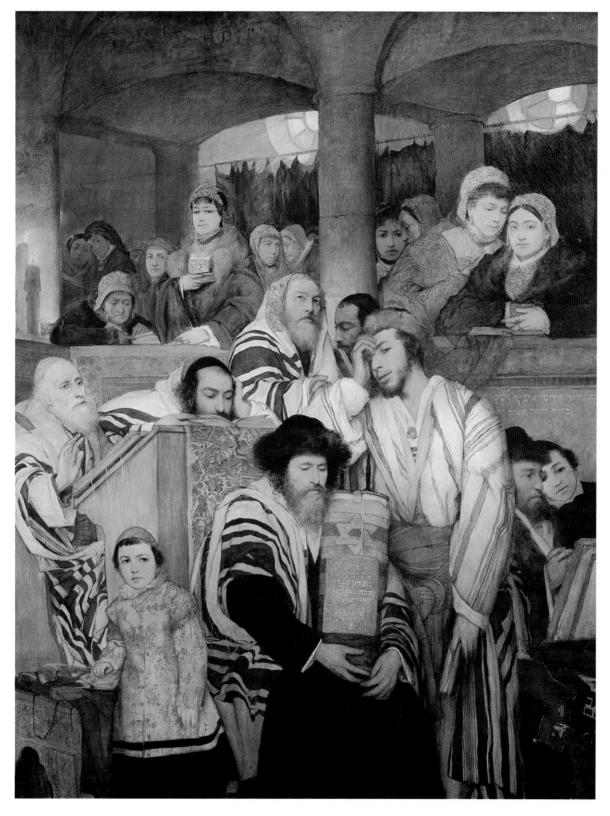

15

MAURYCY GOTTLIEB
(Galician, 1856–1879)

*Jews Praying in the
Synagogue on Yom Kippur,*
1878
Oil on canvas
96½ × 75½ in.
(245 × 192 cm)
Tel Aviv Museum of Art, Tel
Aviv; Gift of Sidney Lamon,
New York

*Jews Praying in the
Synagogue on Yom Kippur*
is based on the artist's
memories of the synagogue
in the town of his birth.
This complex composition
includes portraits of
individuals who played
a role in the artist's life,
among them his parents,
his fiancée, members of her
family, and even Maurycy
Gottlieb himself at different
stages in his life. In one of
these portrayals he appears
as a young man at his actual
age standing to the right
of the Torah, deep in thought
and looking outward as he
turns away from the prayers
that absorb the congregation.
The artist makes use of the
solemn moment during
the prayers to assess his own
life and to affirm his
participation within the
Jewish community. Strangely,
the painting anticipates
Gottlieb's death the following
year in the Hebrew
inscription on a panel affixed
to the Torah: "*Donated in
memory of the late honored
teacher and rabbi Moshe
Gottlieb of blessed memory,
1878.*"

16
MAURYCY GOTTLIEB
(Galician, 1856–1879)

Self-Portrait, 1878
Oil on canvas
31⁷⁄₁₆ × 25³⁄₁₆ in.
(79.8 × 63.9 cm)
Weizmann Institute of
Science, Rehovot, Israel;
Gift of the Michael and Dora
Zagaysky Foundation

Maurycy Gottlieb was born
in 1856 into a wealthy
Orthodox Jewish family
in the Polish town of
Drohobycz, Galicia, when
it was part of the Austro-
Hungarian Empire. Gottlieb
and his siblings were among
the few Jewish students to
attend the German-speaking
public schools of the Austro-
Hungarian Empire because
their father thought it would
prepare them for "modern
life," which demanded
interaction with non-Jews.

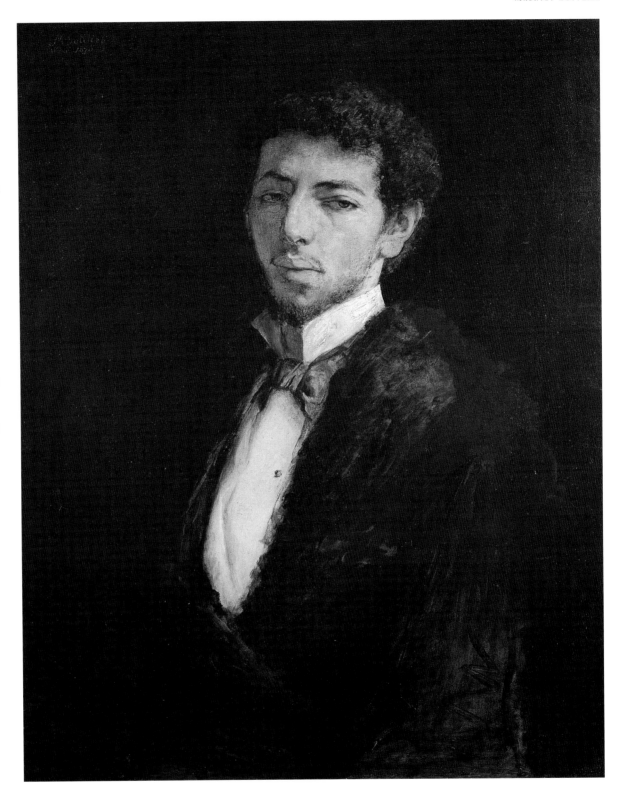

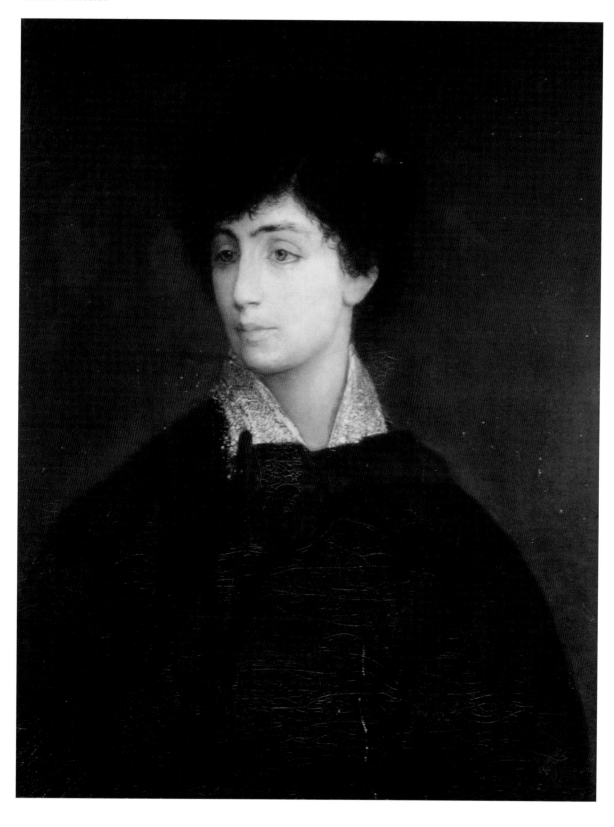

17
MAURYCY GOTTLIEB
(Galician, 1856–1879)

Portrait of a Young Jewish Woman, 1879
Oil on canvas
24½ × 20 in. (62.2 × 51 cm)
Muzeum Narodowe w
Warszawie, Warsaw

18

MAURYCY GOTTLIEB
(Galician, 1856–1879)

*Christ Preaching at
Capernaum*, 1878–79
Oil on canvas
106⅞ × 82¼ in.
(271.5 × 209 cm)
Muzeum Narodowe w
Warszawie, Warsaw

Jesus is presented in this
painting as a biblical
prophet wrapped in a tallith,
addressing his fellow Jews
with a message of
reconciliation for all
humanity and not as one
rebelling against Judaism
or bringing word of a new
religion. The artist's
involvement is emphasized
by the inclusion of a self-
portrait among the Jews
listening to the sermon.
Maurycy Gottlieb confronts
contemporary antisemitism
by stressing the fact that
Jesus was a Jew and that
antisemitic persecution was
a perversion of his teachings.

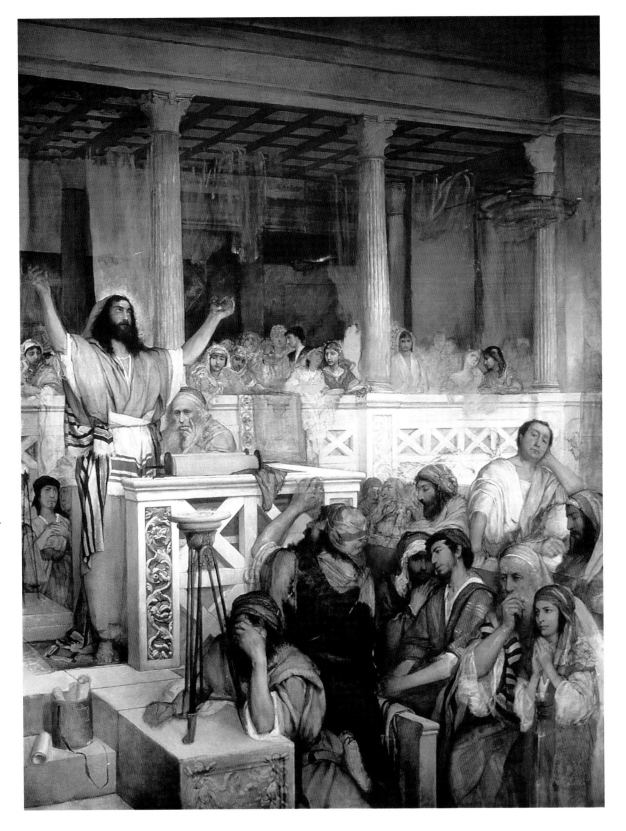

19

ISIDOR KAUFMANN
(Austrian, 1853–1921)

Blessing the Sabbath Candles,
c. 1900–10
Oil on wood
18⅞ × 23⅝ in.
(48 × 60 cm)
Private collection, New York

Isidor Kaufmann's
meticulous depictions of
religious life-cycle events
served to link past with
present, evoking the pious
lifestyle of his forebears,
which had been preserved for
centuries, primarily in small
towns. Traveling to western
Hungary, Galicia, Moravia,
and the Russian part of

Poland, he chronicled
traditional Jewry and its
customs in exhaustive detail
in order to capture an
"authentic" way of life he
believed to have been lost in
the West. Kaufmann's works
became popular with the
acculturated and cosmopolitan
Jewish bourgeoisie of fin-de-
siècle Vienna.

In *Blessing the Sabbath
Candles,* the woman who is
absorbed in her prayer raises
her hands to cover her eyes
in order to say the blessing
over the candles. Above the
bed, covered in a white quilt,
a picture of Moses with the
Tablets of the Law hangs on
the wall.

20

Isidor Kaufmann
(Austrian, 1853–1921)

Portrait of Isidor Gewitsch,
c. 1900
Oil on panel
18 × 14⅝ in.
(45.9 × 37.1 cm)
The Jewish Museum, New
York: Gift of Mr. and Mrs.
M. R. Schweitzer, JM 3-63

This imposing gentleman
of about sixty years of age,
depicted by the artist with
scrupulous attention to
detail, is the stock-exchange
broker Isidor Gewitsch,
a prominent member of
the Jewish community of
Vienna.

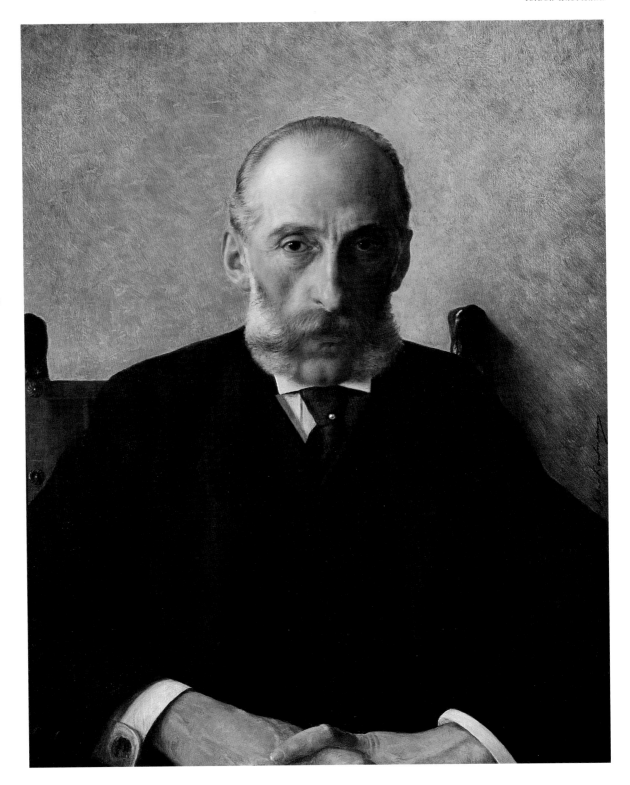

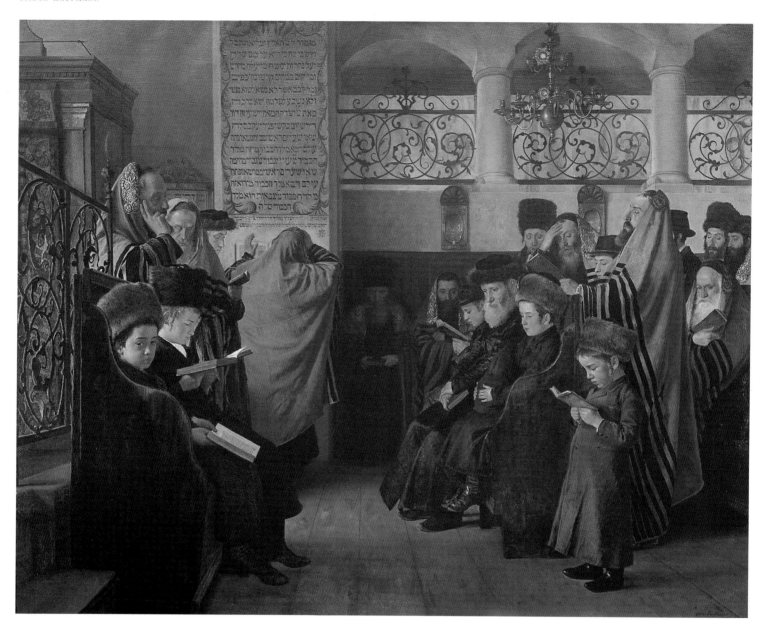

21

ISIDOR KAUFMANN
(Austrian, 1853–1921)

Hearken Israel, 1910–15
Oil on canvas
30⅜ × 39 in. (77 × 99 cm)
Private collection, Maryland

Isidor Kaufmann's art
constitutes a precise
reflection of middle-class
society in Galicia at the
height of its prosperity and
sympathetically describes
Orthodox Jewish prayer. In
Hearken Israel, the artist

chronicles Jewish customs as
he portrays the congregants
in the synagogue saying the
Shema, a Jewish prayer that
is recited several times daily.
The elders of the synagogue,
as well as the men and boys,
are all absorbed in religious

meditation. Kaufmann
actually painted *Hearken
Israel* in his studio in
Vienna and used his youngest
son, Eduard, as a model for
the praying boy in the front
section of the painting.

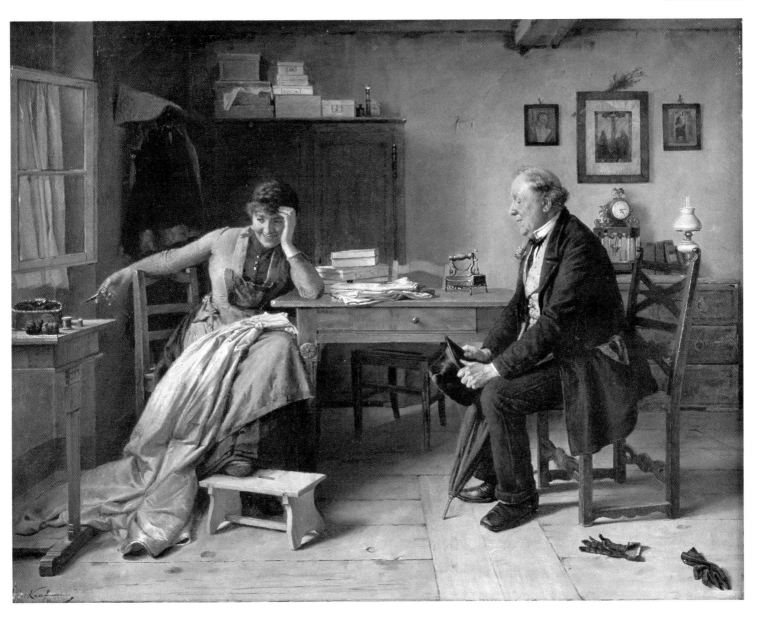

22
ISIDOR KAUFMANN
(Austrian, 1853–1921)

*There's No Fool Like an Old
Fool*, c. 1887–88
Oil on wood
11⅜ × 14½ in.
(29 × 37 cm)
Collection Vera Eisenberger
KG, Vienna

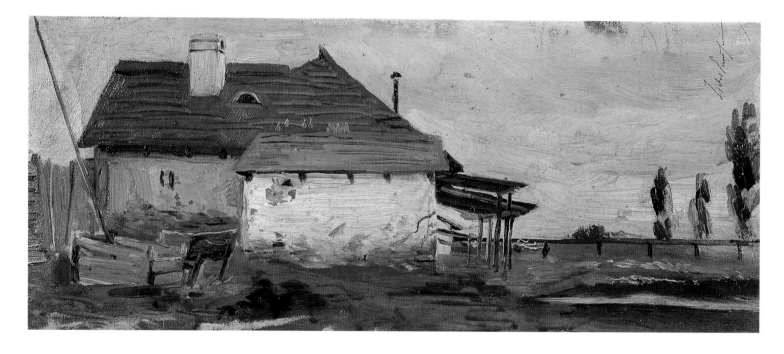

23

ISIDOR KAUFMANN
(Austrian, 1853–1921)

Two Views of a Farm, n.d.
Oil on canvas
upper panel:
3½ × 11¾ in. (9 × 30 cm);
lower panel:
5 × 11¾ in. (12.5 × 30 cm)
The Israel Museum,
Jerusalem; Gift of Mr.
Michael M. Zagaysky

24

SOLOMON J. SOLOMON

(British, 1860–1927)

Self-Portrait, c. 1896

Oil on canvas

39 × 29½ in.

(99 × 74.9 cm)

Private collection, London

25

SOLOMON J. SOLOMON
(British, 1860–1927)

High Tea in the Sukkah, 1906
Ink, graphite, and gouache
on paper
15½ × 11½ in.
(39.4 × 29.2 cm)
The Jewish Museum,
New York; Gift of Edward
J. Sovatkin, JM 91-55

In the drawing of
Dr. Herman Adler, the chief
rabbi of Great Britain,
in his sukkah (booth), the
artist has represented the
adaptation of English custom
to the Jewish holiday of
Sukkot. This harvest festival
marks the time when the
children of Israel were
commanded to live in a
sukkah for seven days in
remembrance of their
liberation from Egypt.
Celebration of the holiday
became more prevalent in
England with the large
immigration of Eastern
European Jews at the end
of the nineteenth century.
Tradition and acculturation
coexist in Solomon
J. Solomon's painting, as Jews
with uncovered heads and
the chief rabbi accommodate
each other's ways.

26

SOLOMON J. SOLOMON
(British, 1860–1927)

Lilian Friedländer, 1905
Oil on canvas
51¼ × 39⅜ in.
(130 × 100 cm)
Collection Carmel
Friedländer Agranat,
Jerusalem

Lilian Friedländer was
Solomon J. Solomon's niece.
Her mother, Susan, who
was Solomon's sister, married
Herbert Bentwich, an
important English Zionist
leader. The couple later
settled in Palestine in the
1920s. In 1905, Lilian
married Israel Friedländer, a
scholar of the Hebrew Bible
who taught at the Jewish
Theological Seminary in
New York. Israel Friedländer
was murdered while on
a relief mission for the Joint
Distribution Committee
in the Ukraine in 1920.

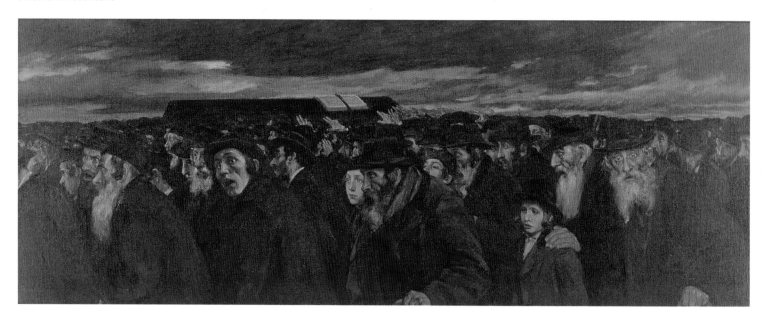

27

SAMUEL HIRSZENBERG
(Polish, 1865–1908)

The Black Banner, 1905
Oil on canvas
30 × 81 in. (76.2 × 205.7 cm)
The Jewish Museum, New
York; Gift of the Estate of
Rose Mintz, JM 63-67

Samuel Hirszenberg was one of the first artists to expose the plight of his fellow Jews in Russian-dominated Poland during the early years of the century. By the time that he exhibited *The Black Banner* in the 1906 Salon of the Société des Artistes, he was established as a frequent exhibitor at Paris-based exhibitions. *The Black Banner*, in which Hirszenberg depicts masses of Hasidic men carrying a black-draped coffin to which an open book has been strapped, can be seen as a forthright political statement. Painted in 1905, it alludes to the victims of a pogrom and evokes the intensified devastation during the early years of the century. Two terrified faces stare out at us, the one on the left most likely the artist's self-portrait. It has been suggested that the black banner covering the coffin is Hirszenberg's means of decrying the Black Hundreds or the czarist-endorsed antisemitic bands who were so destructive during the pogroms following the failed Russian revolution of 1905.

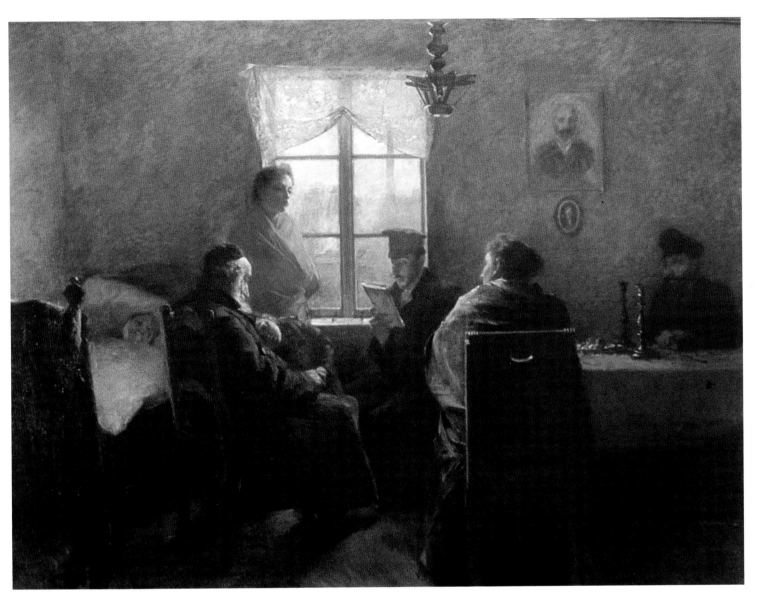

28
SAMUEL HIRSZENBERG
(Polish, 1865–1908)

The Sabbath Rest, 1894
Oil on canvas
59½ × 78 in.
(151 × 198 cm)
The Ben Uri Gallery, The
London Jewish Museum
of Art

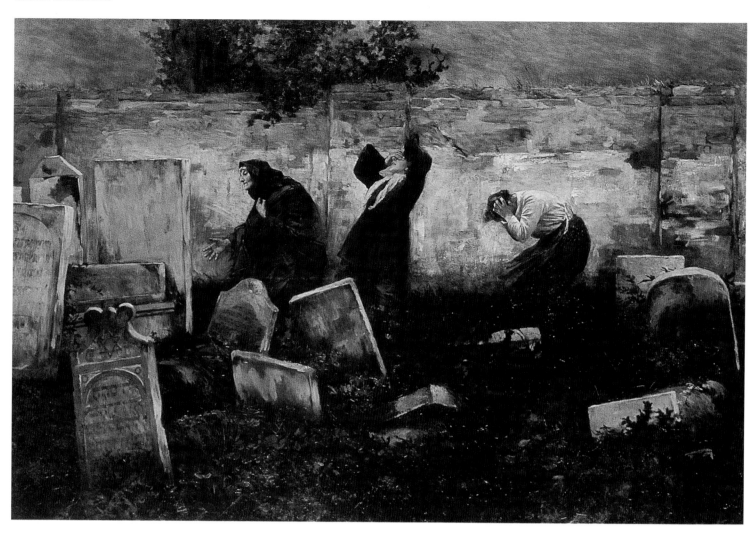

29
SAMUEL HIRSZENBERG
(Polish, 1865–1908)

The Jewish Cemetery, 1892
Oil on canvas
78 × 117 in. (200 × 297 cm)
Musée d'art et d'histoire du
Judaïsme, Paris; Gift of Mr.
and Mrs. Lenemann and
Mr. C. P. Kelman

This painting, with its carved
stones and decayed grave
markers overgrown
with grass, was inspired by
memories of the Jewish
cemetery of Kraków. The
rendering of overwrought
mourners in this consecrated
space is a vivid expression of
the critical economic and

social conditions of Jews
following the pogroms in
Russia in the early 1880s.

30

MAURYCY MINKOWSKI
(Polish, 1881–1930)

After the Pogrom, 1905
Oil on canvas
58¼ × 44¾ in.
(148 × 113 cm)
Tel Aviv Museum of Art, Tel
Aviv; Gift of Zagaysky,
Warsaw, c. 1936–37

Maurycy Minkowski was
deaf and dumb, which may
explain his focus on themes
of solitude and dislocation.
His figures are isolated from
one another, even as they
share a common fate and
situation. After personally
experiencing a pogrom,
Minkowski created this
searing depiction of a
Jewish family uprooted
from their home, poignantly
transmitting the sheer
exhaustion and despair of a
group that has stopped for
a rest.

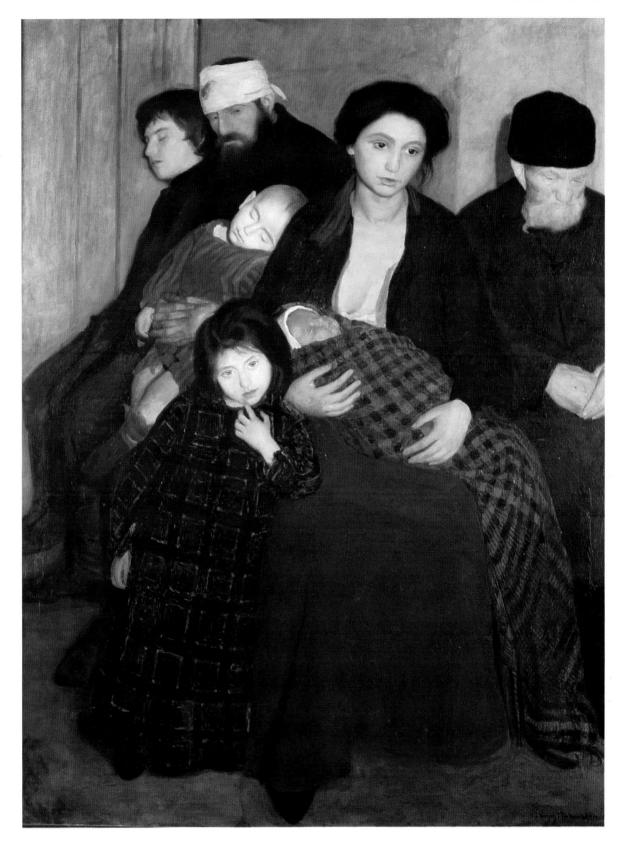

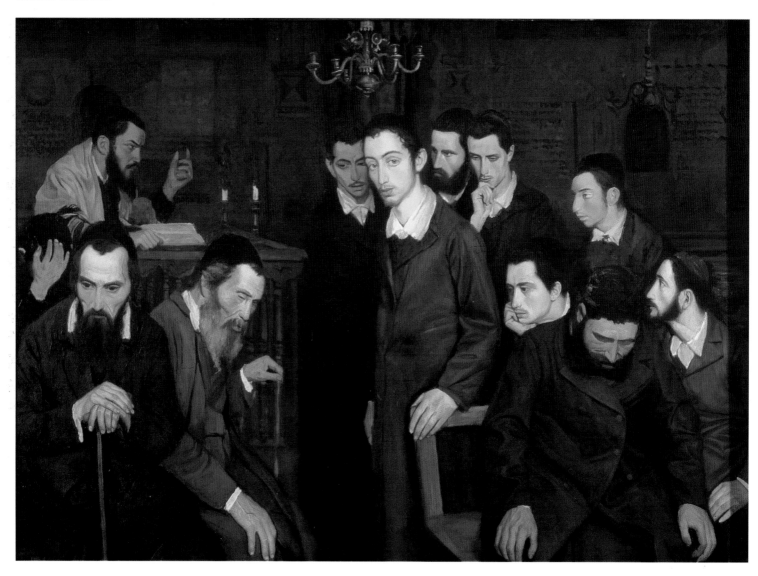

31

MAURYCY MINKOWSKI
(Polish, 1881–1930)

*He Cast a Look and Went
Mad*, 1910
Oil on canvas
29 × 41⅝ in.
(73.6 × 105.8 cm)
The Jewish Museum, New
York; Gift of Mrs. Rose
Mintz, JM 14-75

This work is one of the few
artistic representations of
a talmudic narrative. Its
title comes from a passage
describing an incident in the
second century involving four
sages in a garden. Intended
as a parable about temptation
as represented by the garden,
it confronts the problem of
choosing between adherence
to faith, the attraction of

mystical speculation, and the
temptations of the secular
world. The inclusion
of several clean-shaven
students, together with
others who are traditionally
dressed, alludes to the
changing nature of Jewish
society wrought by
modernization.

32
REBECCA SOLOMON
(British, 1832–1886)

The Arrest of the Deserter,
1861
Oil on canvas
43⅜ × 33½ in.
(110 × 85 cm)
The Israel Museum,
Jerusalem; Gift
of Mrs. Stella Permewan,
Liverpool
Through the British Friends
of the Art Museums of Israel

The Arrest of the Deserter
depicts an episode from
William H. Murray's 1844
comedy *Dominique the
Deserter* in which two
soldiers lead away their
handcuffed captive. Members
of the audience watch as the
principal lady pleads for the
deserter's release. The
extravagant seventeenth-
century costume of the
"deserter," complete with
breastplate and plumed
helmet, enhances the
theatricality of the scene.
A poster in the background
confirms the identity of the
play, which was first
performed by the Theatre
Royal in Edinburgh.

33
REBECCA SOLOMON
(British, 1832–1886)

The Love Letter, 1861
Oil on canvas
21¼ × 16½ in.
(54 × 41.9 cm)
The Forbes Magazine
Collection, New York

The delivery or receipt of
a love letter was a long-
standing motif in art, and it
was invariably the female
who was shown receiving
notes or love letters. Rebecca
Solomon heightens the
tension in this scene
by portraying a man of
unknown nature who appears
in the doorway. The
development of the penny
post and improved postal
service in Victorian England
led to an increase in letter
writing, making it a frequent
artistic subject. Often, as
in this painting, the letter
referred to unknown events,
yet the letters in the wall
holder and tucked into
the mirror suggest the
possibility of a romantic
involvement.

34
REBECCA SOLOMON
(British, 1832–1886)

The Governess, 1851
Oil on canvas
26 × 34 in. (66 × 86.3 cm)
Edmund J. and Suzanne
McCormick Collection, New
Haven, Connecticut

In accord with the Victorian taste for narrative and the close observation of nature, *The Governess* is a poignant depiction of social inequity illustrating the weight of duty, devotion to family, and hard work. The governess occupied an awkward and unstable place within both society and the family that employed her. Usually well-educated and genteel, and always unmarried, her social status and womanly virtue were compromised by her lack of money and consequent need for work. By 1851 there were approximately 25,000 governesses in Great Britain, and a number of Victorian artists chose to emphasize the isolation of their station in life.

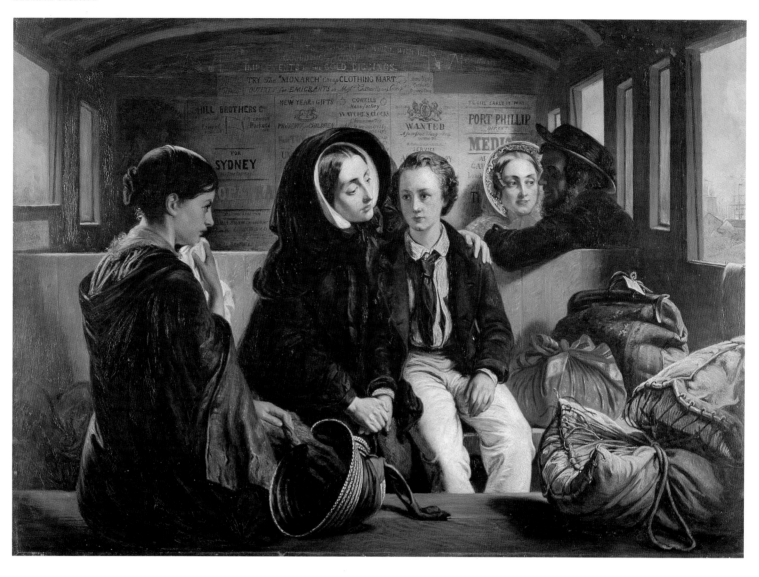

35

ABRAHAM SOLOMON

(British, 1824–1862)

Second Class—The Parting
"Thus part we rich in sorrow,
parting poor," 1855
Oil on canvas
27 × 38 in. (68.5 × 96.5 cm)
The National Railway
Museum, York, UK

Abraham Solomon is known
for the use of two connected
paintings to tell a story. This
painting refers to an earlier
period in the life of the
young man in the companion
piece, *First Class* (pl. 36). In
Second Class, Abraham
Solomon portrays a poor
youth with his recently
widowed mother who is

taking him by train to meet
his ship. The scene is full
of visual clues, and it
corresponded with the
Victorian focus on artwork
bearing a strong message,
meticulous craftsmanship,
and a true-to-nature
approach.

The posters on the
cabin walls suggest that the

boy may be going to sea
to earn his fortune. One
poster advertises Sydney and
another promotes gold-
digging equipment, which
suggest that his destination is
Australia, although he could
also have been going to
the Americas. Traveling
third-class, the youth is also
accompanied by a tearful

sister while an old sailor
looks on, perhaps
remembering his own youth.
The mother is probably
a widow, a popular subject in
Victorian paintings. This
scene takes place within the
confines of a railway carriage
at a time when train travel
was relatively new.

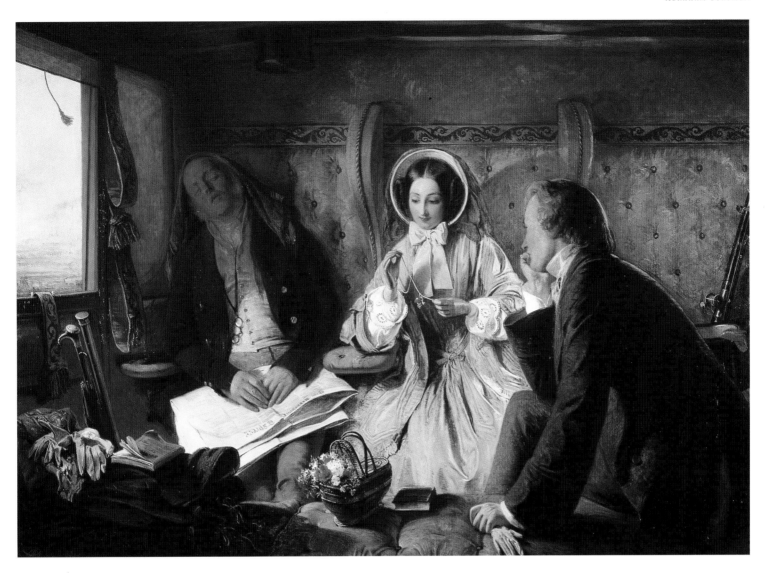

36

ABRAHAM SOLOMON
(British, 1824–1862)

*First Class—The Meeting
and at First Meeting Loved,*
1854
Oil on canvas
27¼ × 38⅛ in.
(69.2 × 96.8 cm)
National Gallery of Canada,
Ottawa; Purchased 1964

The artist painted two versions of this work, of which this is the first. It was exhibited in London at the Royal Academy in 1854. Although praised for its execution, it caused a scandal because the young woman and man were depicted as blatantly flirting, while the woman's guardian, oblivious, was asleep in the corner of the carriage. The artist, bowing to contemporary morality, subsequently repainted the scene, the second time with the guardian awake and seated between the woman and the young man, who has become a naval officer.

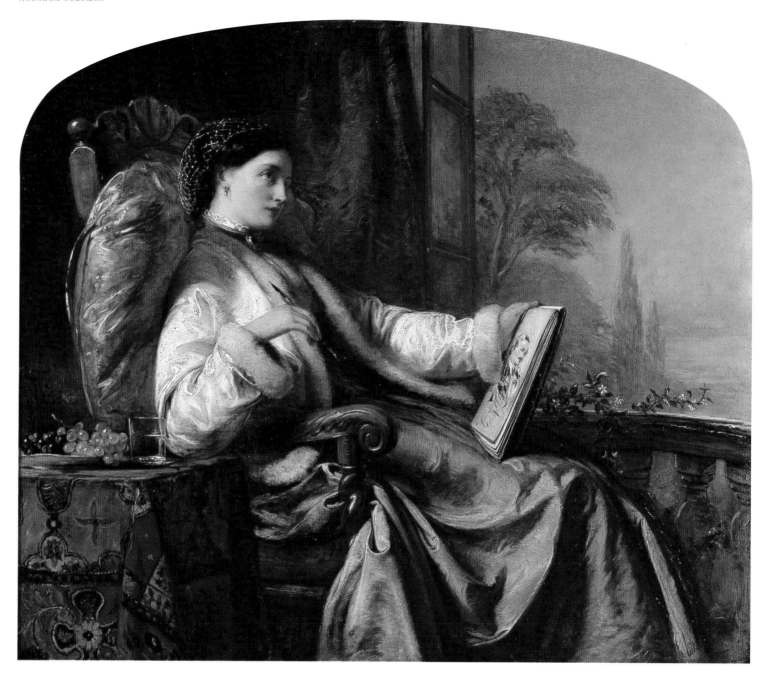

37
ABRAHAM SOLOMON
(British, 1824–1862)

*Young Woman Drawing
a Portrait*, 1851
Oil on canvas
11½ × 13½ in.
(29.2 × 34.3 cm)
The Forbes Magazine
Collection, New York

38
SIMEON SOLOMON
(British, 1840–1905)

Head (*Saint Peter or "Help Lord or I Perish"*), 1892
Oil on canvas
23⅝ × 17¾ in.
(60 × 45 cm)
Tel Aviv Museum of Art, Tel Aviv; Gift of the Ben Uri Society, London, early 1930s

This self-portrait, painted in 1892, thirteen years before the artist's death, reflects the turmoil that afflicted Simeon Solomon at this time. As an important member of the British Symbolist school, Solomon's talents were recognized at an early age and he began to exhibit at the Royal Academy in London. At the same time he developed close ties with the Pre-Raphaelite artists, whose influence played a strong and ultimately destructive role in his personal behavior, since open homosexuality and the flouting of social mores were not tolerated in Victorian society. After Solomon endured a devastating public trial, his friends and family ostracized him. Although Solomon continued to practice his art, his early success was cut short, and he ended his days as a destitute alcoholic in a London workhouse.

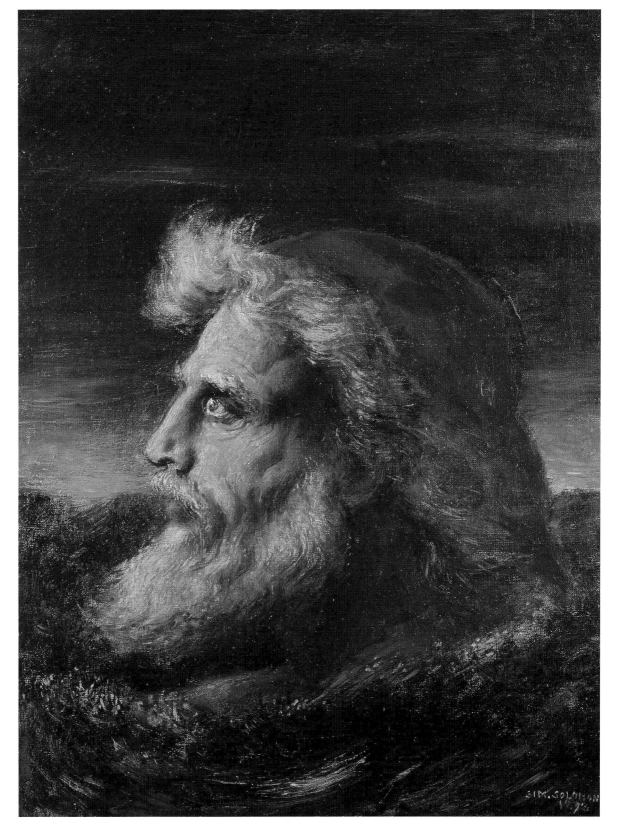

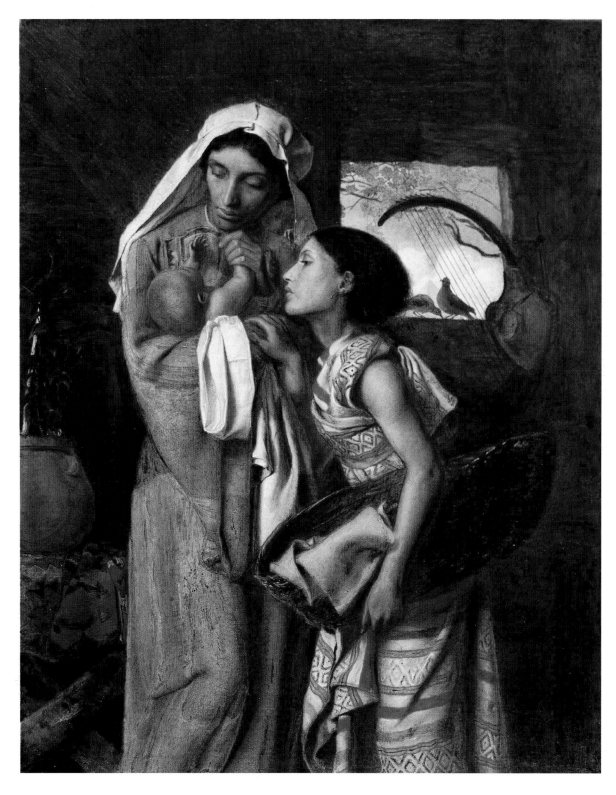

39
SIMEON SOLOMON
(British, 1840–1905)

Moses in His Mother's Arms,
1860
Oil on canvas
23½ × 19 in.
(59.7 × 48.3 cm)
Delaware Art Museum,
Wilmington; Bequest of
Robert Louis Isaacson, 1999

This moment of maternal
intimacy was painted when
Simeon Solomon was twenty
years of age, when much of
the artist's work was derived
from the Hebrew Bible. His
use of Jewish subjects
was quite natural for a youth
who, coming from an
eminent Orthodox Jewish
family, was steeped in the
traditions of his faith. In his
attempt to depict authentic
ethnic types and
accoutrements, Solomon is
following the Pre-Raphaelite
ideal of truth-to-nature as
seen in the paintings of
William Holman Hunt and
Ford Maddox Brown during
the 1850s.

40

SIMEON SOLOMON
(British, 1840–1905)

*The Drought: "Judah
mourneth, and the gates
thereof languish..."
(Jeremiah 14:2–3)*, 1866/72
Watercolor, bodycolor and
chalks on paper
15⅜ × 8 in. (39 × 20.3 cm)
The Jewish Museum,
New York; Museum purchase
with funds provided by the
Fine Arts Acquisitions
Committee, 1999-68

Some years before
Nebuchadnezzar, King of
Babylon, besieged and
conquered Jerusalem in 586
B.C.E., the area suffered from
a devastating drought. It
was the prophet Jeremiah's
description of this
catastrophe that inspired
Simeon Solomon's drawing:
"Judah is in mourning, Her
settlements languish. Men
are bowed to the ground,
the outcry of Jerusalem rises.
Their nobles sent their
servants for water; they came
to the cisterns, they found no
water. They returned, their
vessels empty. They are
shamed and humiliated, they
cover their heads."

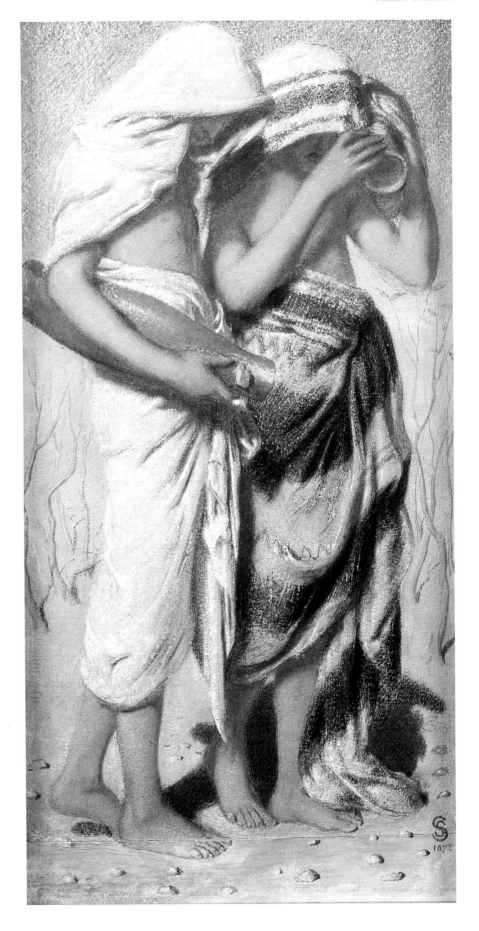

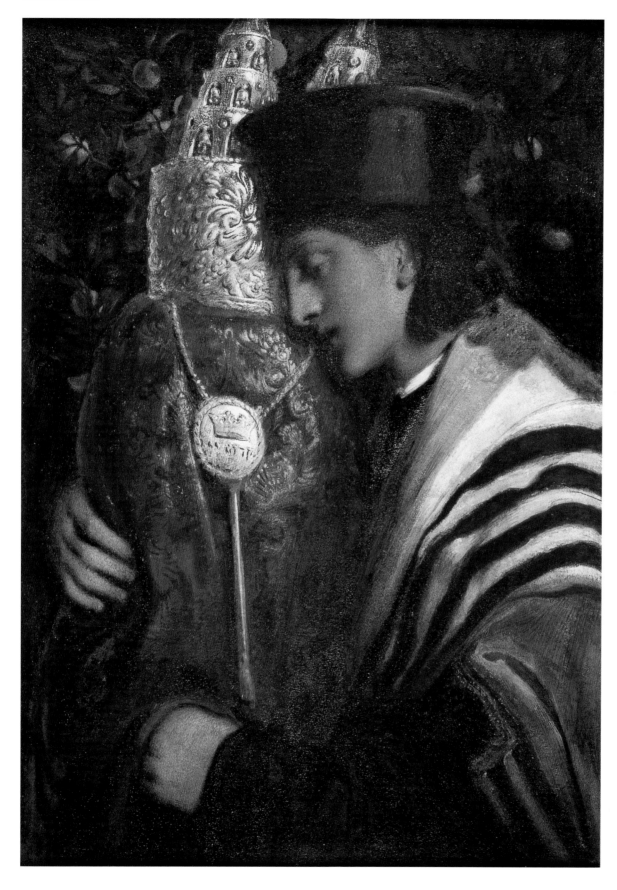

SIMEON SOLOMON
(British, 1840–1905)

Carrying the Scrolls of the Law, 1867
Watercolor and gouache,
varnished
14 × 10 in. (35.7 × 25.5 cm)
The Whitworth Art Gallery,
The University of
Manchester

Raised as an Orthodox Jew,
Solomon grew up within the
Jewish community of
London's East End, and his
long familiarity with Jewish
religious ritual made the
subject of this painting quite
personal for him. In its
portrayal of a young religious
dignitary lovingly holding
the Torah, *Carrying the
Scrolls of the Law* reflects the
influence of the Pre-
Raphaelites, who sought to
purify what they perceived of
as the decadence of academic
art by emulating an earlier
Renaissance style. The rapt
devotion of the young man,
an idealized male beauty at a
moment of religious sanctity,
is comparable in spirit to
other works by Simeon
Solomon that convey his
attraction to Christian ritual.

42
SIMEON SOLOMON
(British, 1840–1905)

Two Acolytes Censing, 1863
Watercolor on paper
$15\frac{3}{4} \times 13\frac{3}{4}$ in.
(40.2 × 35 cm)
The Ashmolean Museum,
Oxford; Visitors of the
Ashmolean Museum

Two Acolytes Censing has
been identified as the
painting called *A Deacon*
exhibited in London at the
Royal Academy in 1864.
The painting shows two
young men taking part in
an Anglican church service.
They are either two acolytes
or a deacon and an acolyte
wearing rich vestments.
In the Anglican, Roman
Catholic, and Eastern
Orthodox Churches, a deacon
is a cleric ranking just below
a priest, and an acolyte assists
the priest or deacon in the
performance of liturgical
rites. The container that they
are swinging is a censer
containing incense. *Two
Acolytes Censing* may have
been influenced by his
friends in the Pre-Raphaelite
movement, with whom he
shared an intense interest in
Christian religious ritual.

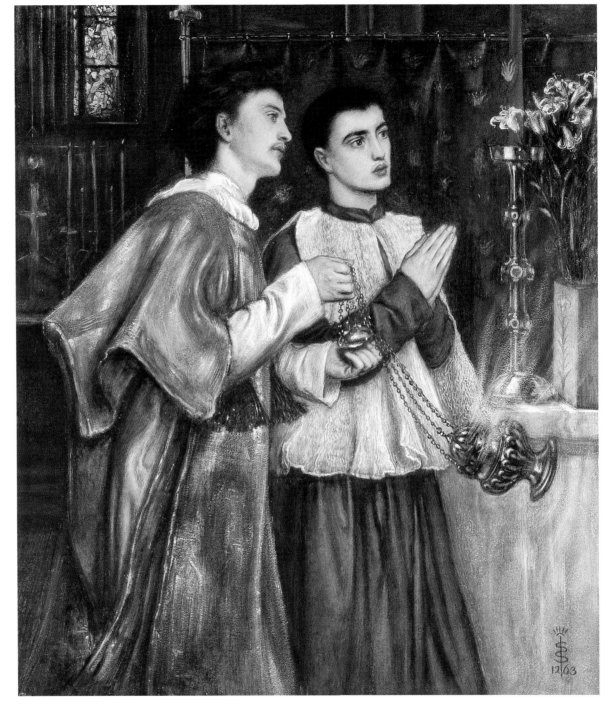

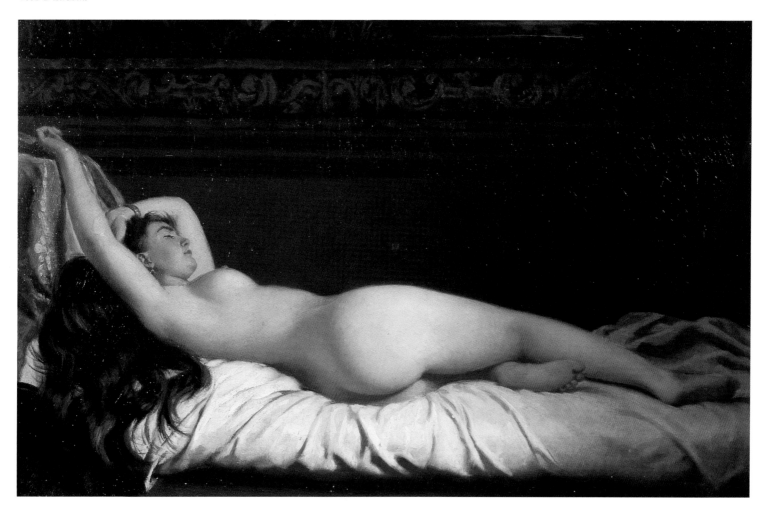

43
Vito d'Ancona
(Italian, 1825–1884)

Nude, 1873
Oil on canvas
10⅜ × 16⅛ in.
(26.5 × 41 cm)
Civica Galleria d'Arte
Moderna, Milan

44
VITO D'ANCONA
(Italian, 1825–1884)

Self-Portrait, c. 1860
Oil on canvas
16⅛ × 13 in. (41 × 33 cm)
The Israel Museum,
Jerusalem; Gift of Prof.
Paolo d'Ancona, Milan

VITO D'ANCONA
(Italian, 1825–1884)

View of Volognano, 1878
Oil on canvas
15 × 10¼ in. (38 × 26 cm)
Istituto Matteucci, Viareggio,
Italy

View of Volognano depicts
the estate of the artist's uncle
outside Florence. Painted in
1874, this family retreat,
with its fertile slopes and
olive trees, could only be
built after the lifting of
restrictions forbidding Jews
to own property. Freed from
centuries of cramped and
communal quarters, Jews
invested in villas in the city
and country.

46
JOZEF ISRAËLS
(Dutch, 1824–1911)

*Self-Portrait (with Saul and
David in the Background)*,
1908
Oil on canvas
38⅛ × 27½ in.
(97 × 70 cm)
Stedelijk Museum,
Amsterdam

This is Jozef Israëls's last
major painting. By invoking
the Hebrew Bible heroes
Saul and David, he expresses
his identification with early
Jewish history and his loyalty
to two cultures. In his youth,
Israëls had learned the
ancient Jewish legend that
David would play a leading
role in the redemption of
his people; later, he learned
from Theodor Herzl that this
could be infused with new
life.

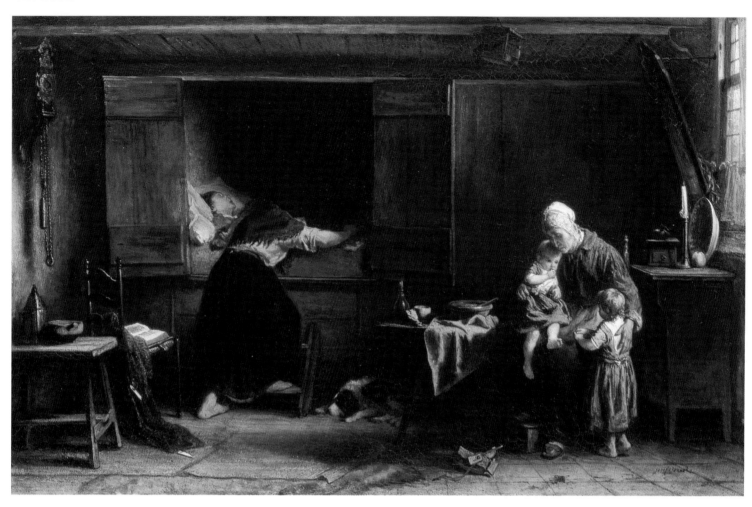

47
JOZEF ISRAËLS
(Dutch, 1824–1911)

The Last Breath, 1872
Oil on canvas
44 × 69½ in.
(112 × 176.5 cm)
Philadelphia Museum of
Art, Philadelphia; Given by
Ellen Harrison McMichael
in memory of C. Emory
McMichael

Jozef Israëls painted in the
tradition of The Hague
School of realist artists,
frequently depicting tragic
subjects such as loneliness,
death, and bereavement.
In *The Last Breath*, the artist
captures the reality of those
who toil under the burden
of the life they must bear.
Israëls evokes the taut
atmosphere in which the
moment of death transpires.

48

JOZEF ISRAËLS

(Dutch, 1824–1911)

A Son of the Ancient Race,
c. 1889
Oil on canvas
43½ × 33¼ in.
(110.5 × 85.7 cm)
The Jewish Museum,
New York; Museum purchase
through The Eva and Morris
Feld Purchase Fund,
1985-123

A Son of the Ancient Race
represents a secondhand-
clothes peddler seated outside
his shop in Amsterdam's
dreary Jewish quarter. But
the artist, who was widely
hailed in his lifetime as a
"second Rembrandt," in no
way felt that it was inevitable
for Jews to live in poverty
and isolation. Rather,
by showing downtrodden
conditions, he sought
to strengthen public
determination to eliminate
social inequities.

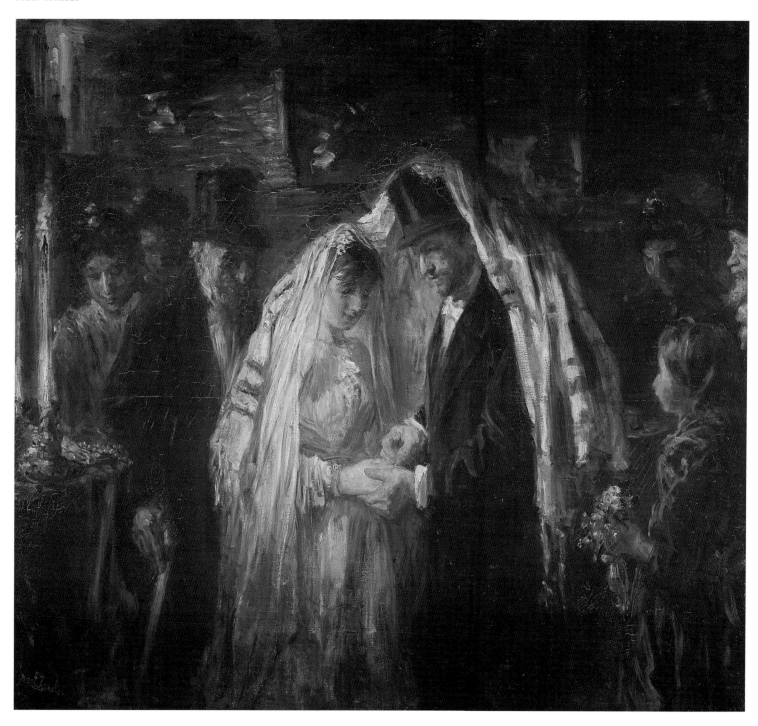

49

JOZEF ISRAËLS
(Dutch, 1824–1911)

A Jewish Wedding, 1903
Oil on canvas
54 × 58¼ in.
(137 × 148 cm)
Rijksmuseum, Amsterdam

In the final phase of his career, Jozef Israëls revealed the same humanistic concerns for Jewish subjects that he had applied to working peasants and fishermen. As he employed a looser brushstroke and more subtle chiaroscuro, and as his palette darkened, his subjects grew less distinct. He did not seek physical beauty or mere surface effects as much as an emotional impact, reflecting the influence of French artists and Rembrandt. In *A Jewish Wedding*, the whiteness of the tallith, which envelops the couple, sets them apart and contributes to the intimacy of the moment.

50

MAX LIEBERMANN
(German, 1847–1935)

*Self-Portrait with Straw Hat
(Panama Hat)*, 1911
Oil on wood
31¾ × 25½ in.
(80.8 × 64.8 cm)
Akademie der Künste, Berlin;
Acquired with support of
BHF-BANK
Aktiengesellschaft Berlin and
the society of friends of the
Akademie der Künste, Berlin

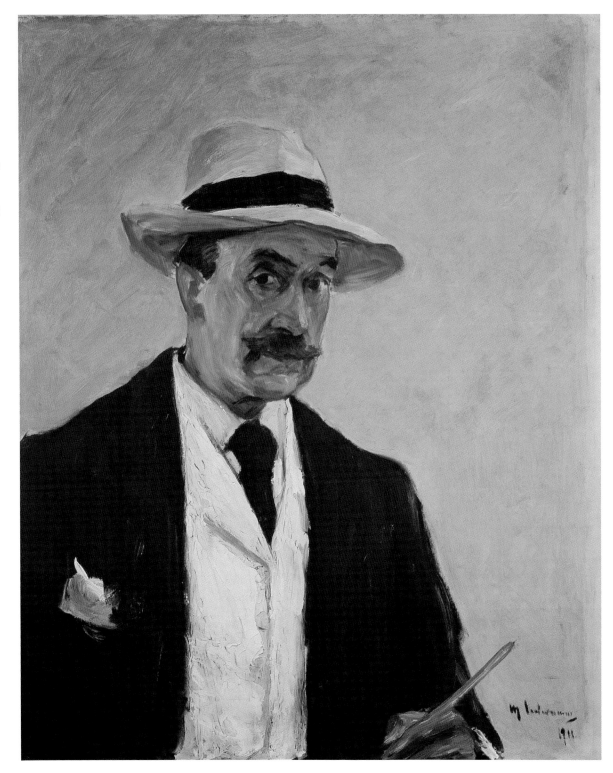

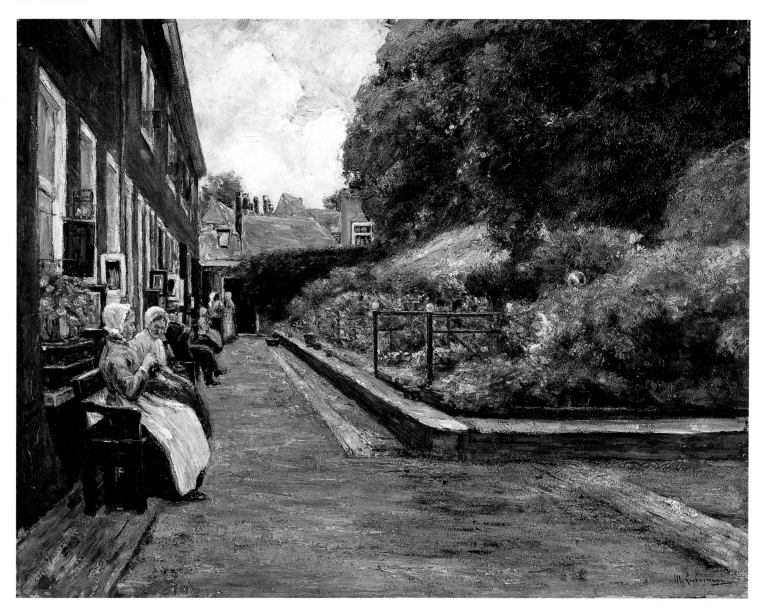

51
Max Liebermann
(German, 1847–1935)

Stevensstift in Leiden, 1890
Oil on canvas
31 × 40 in. (78.5 × 101.5 cm)
Kunsthandel Wolfgang
Werner, Bremen/Berlin

52
MAX LIEBERMANN
(German, 1847–1935)

Jewish Street in Amsterdam,
1908
Oil on wood
29 × 24¾ in. (74 × 63 cm)
Städtische Galerie im
Städelschen Kunstinstitut,
Frankfurt

There are few specifically
Jewish subjects in Max
Liebermann's work except
for a series of oil paintings,
drawings, pastels, and prints
executed between 1905 and
1909 depicting a Jewish
street in Amsterdam. During
those years, Lieberman
returned to the Jewish
Quarter, renting a room from
which to observe the
activities of the street, with
its lively market and bustling
crowds circulating around
carts heaped with vegetables.
He spent three consecutive
summers working there,
producing sixteen paintings
and many drawings. In this
painting, Liebermann depicts
the crowd rather than
individuals. His fluid
technique, melding Realism
with Impressionism, creates
a strong surface quality
that conveys the intensity of
human activity on the street.

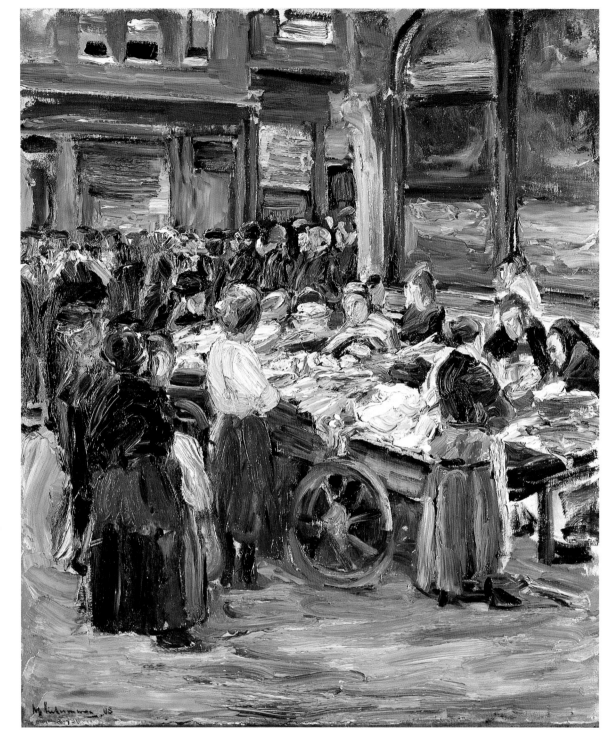

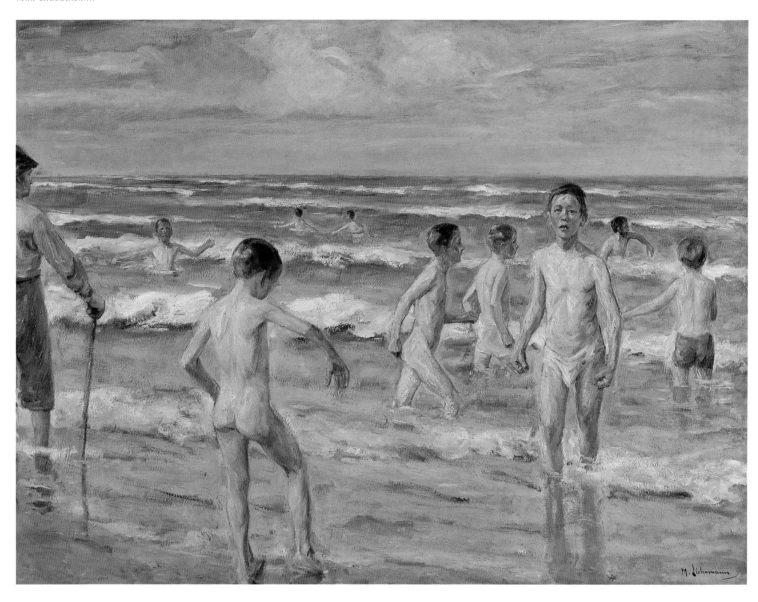

53
MAX LIEBERMANN
(German, 1847–1935)

Bathing Boys, 1900
Oil on canvas
44½ × 59¾ in.
(113 × 152 cm)
Stiftung Stadtmuseum Berlin

After 1900, Max Liebermann
infused his German art
with aspects of French
Impressionism as he
abandoned working-class
themes and took up
depictions of the leisured
class partaking in such
activities as polo, horseback
riding, and seaside revelry.
Bathing Boys evokes

a carefree scene of boys
frolicking in the sea, in
which innocent youth exists
in harmony with nature.
Emancipation had opened
up and guaranteed endless
opportunities to Jews, even
those social experiences that
would previously have been
highly restricted.

54
VITTORIO CORCOS
(Italian, 1859–1933)

Portrait of Emilio Treves,
1907
Oil on canvas
53½ × 31½ in.
(136 × 80 cm)
Studio Paul Nicholls, Milan

With his mastery of human
character, the Italian-born
Vittorio Corcos painted
the Jewish publisher Emilio
Treves, who was the founder
of the most important
publishing company in Italy
at the end of the century and
one of several prominent
firms in Jewish hands. Treves
fought as a volunteer with
the Italian patriot Giuseppe
Garibaldi in Naples before
establishing his publishing
house in Florence in 1861.

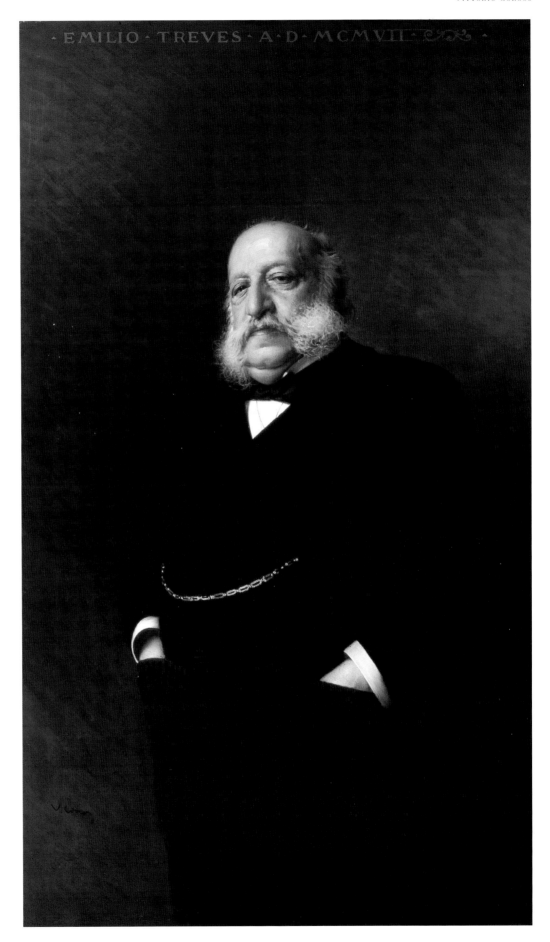

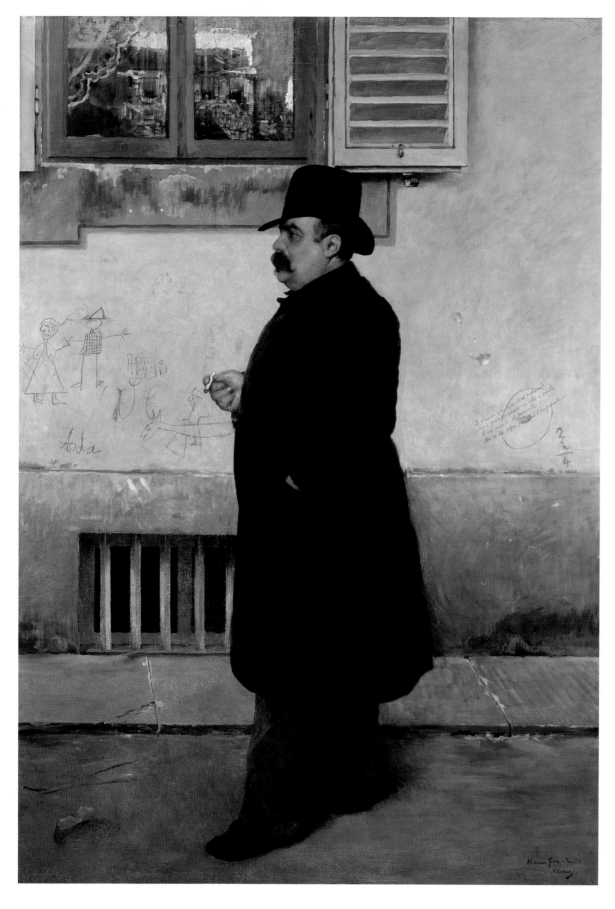

55
VITTORIO CORCOS
(Italian, 1859–1933)

Portrait of Yorik, 1889
Oil on canvas
78⅜ × 54⅜ in.
(119 × 138 cm)
Museo Civico Giovanni
Fattori, Livorno, Italy

There is little flattery in
Vittorio Corcos's depiction
of his close friend, the drama
critic Pietro Ferragni, who
was better known by the
pen name Yorik. The text
scribbled on the wall to the
right reads: "If the likeness
of the man painted here isn't
young, graceful, tall, and
slender, you can blame the
paintbrush! For heaven's
sake, you can't find fault
with the original!"

56
TINA BLAU
(Austrian, 1845–1916)

In der Krieau, 1882
Oil on canvas
42 × 33½ in (107 × 85 cm)
Vienna City Museum, Vienna

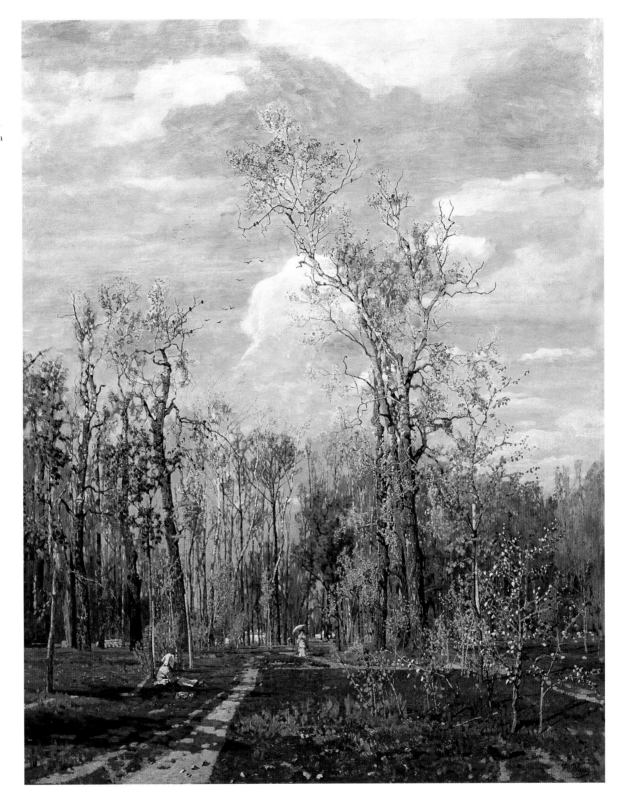

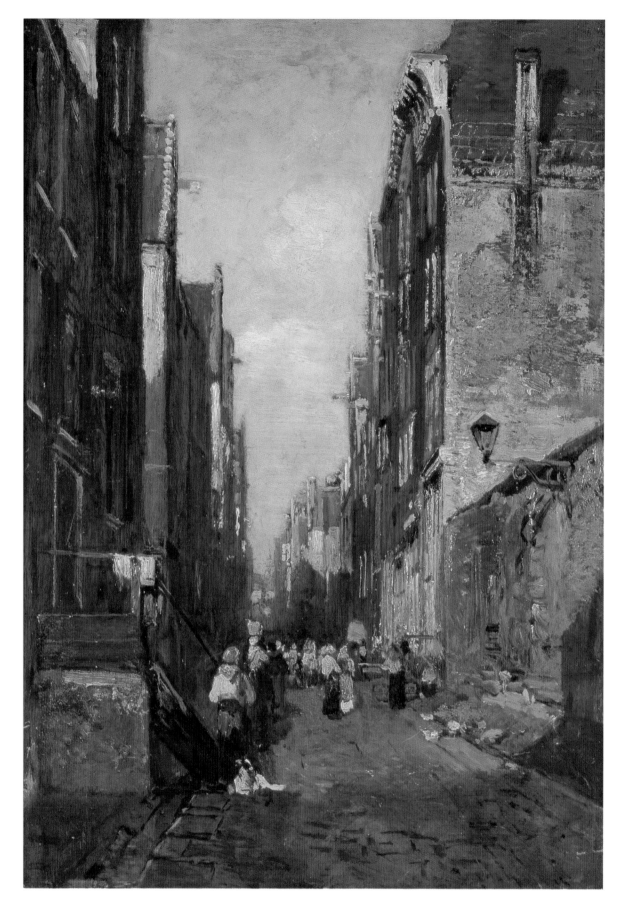

57
TINA BLAU
(Austrian, 1845–1916)

Jewish Street in Amsterdam,
1875–76
Oil on wood
14 × 10 in. (35 × 25 cm)
Collection Vera Eisenberger
KG, Vienna

58
JACOB MEYER DE HAAN
(Dutch, 1852–1895)

*Portrait of a Young Jewish
Girl*, c. 1886
Oil on canvas
53 × 39⅝ in.
(135 × 100.5 cm)
Joods Historisch Museum,
Amsterdam

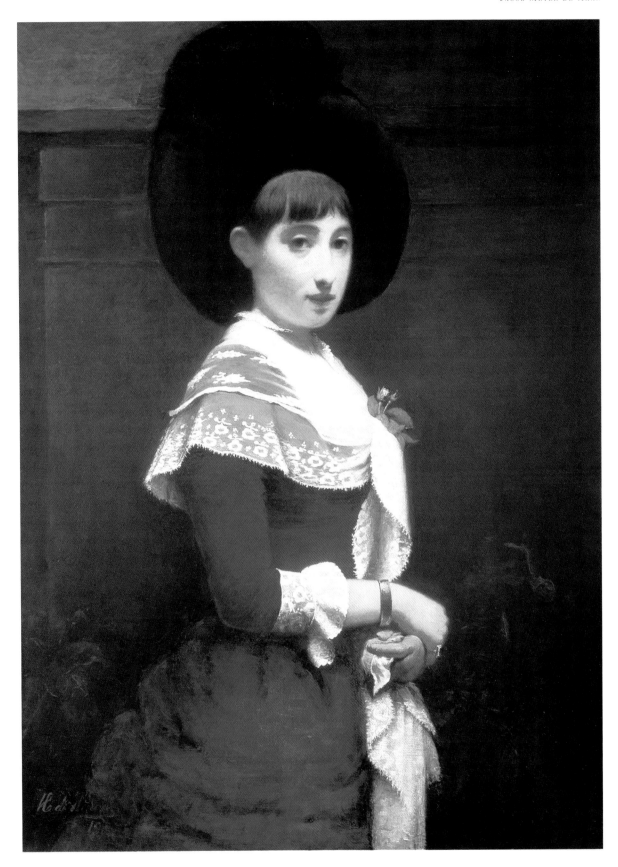

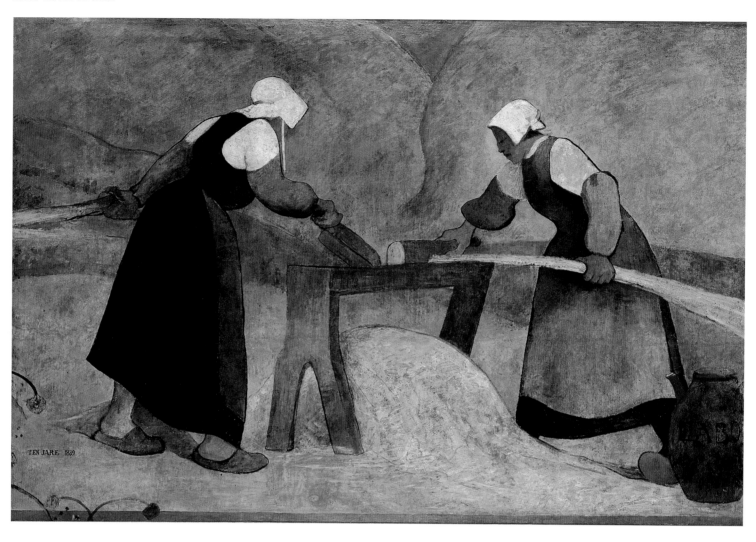

59

JACOB MEYER DE HAAN
(Dutch, 1852–1895)

*Breton Women Scutching Flax
(Labor)*, 1889
Oil on plaster transferred
to canvas
52½ × 79¼ in.
(133.4 × 201.3 cm)
Private collection; Courtesy
of Nancy Whyte Fine Arts

Paul Gauguin and Jacob
Meyer de Haan lived in
Marie Henry's inn in
Le Pouldu, where they
decorated the dining room
with murals. Clearly
expressing the artists'
assimilation of the principles
of the School of Pont-Aven,
the broad curvilinear
contours in this painting
delineate the figures and

present them in a simplified,
friezelike arrangement,
set against flattened areas of
brilliant color that describe
the haystacks in the
background. In 1924, this
fresco was discovered under
several layers of wallpaper
at the inn. It was removed,
apparently by Abraham
Rattner, an American painter,
and mounted onto canvas.

60

Jacob Meyer de Haan
(Dutch, 1852–1895)

Self-Portrait, 1889–91
Oil on canvas
12¾ × 9⅝ in.
(32 × 25 cm)
Collection Mr. and Mrs.
Arthur G. Altschul, New York

Jacob Meyer de Haan
portrays himself in Breton
costume after his move with
Paul Gauguin to the south
of France, where he was part
of the Pont-Aven circle
of artists. This self-portrait
reveals his new liberation
from conventional dress,
which he had arrived at by
late 1889, under Gauguin's
guidance. He projects the
image of the avant-garde
with his colorful bandanna
and Breton cap, serving as
a skullcap. It was probably
painted in the large studio-
attic de Haan rented for
himself and Gauguin in
a villa at Le Pouldu. On the
walls were lithographs by
Gauguin and Émile Bernard
as well as Japanese prints,
one of which appears in the
background of this self-
portrait.

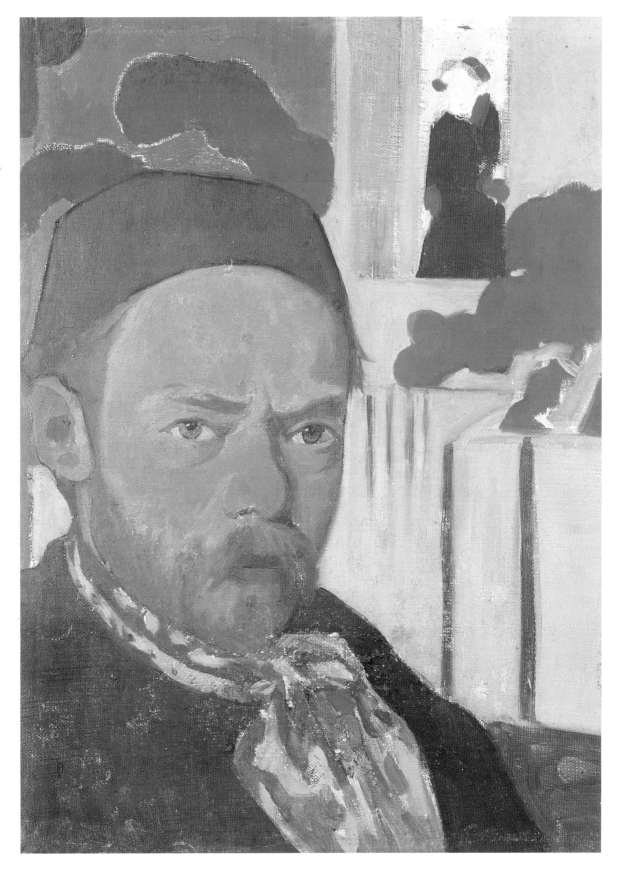

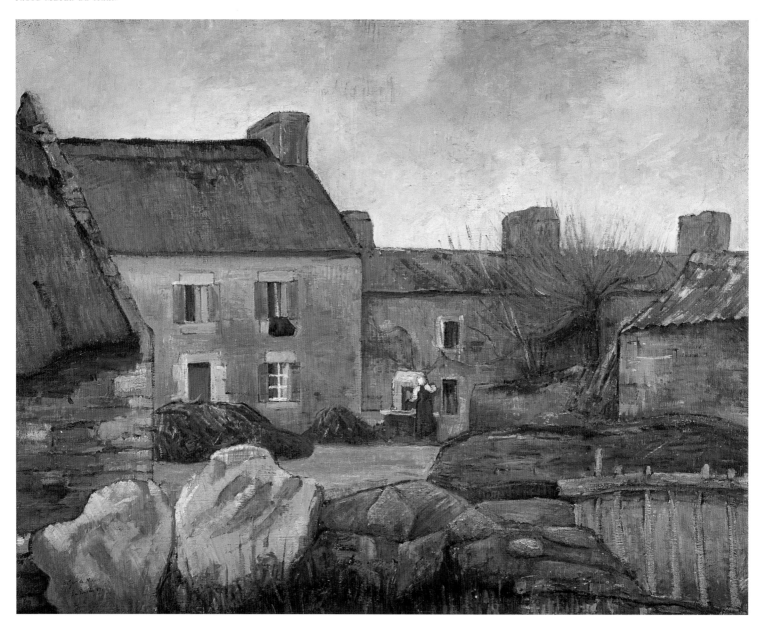

61

JACOB MEYER DE HAAN
(Dutch, 1852–1895)

Kerzellec Farm, Le Pouldu,
1889
Oil on canvas
28⅞ × 36⅜ in.
(73.5 × 93 cm)
Kröller-Müller Museum,
Otterlo, Holland

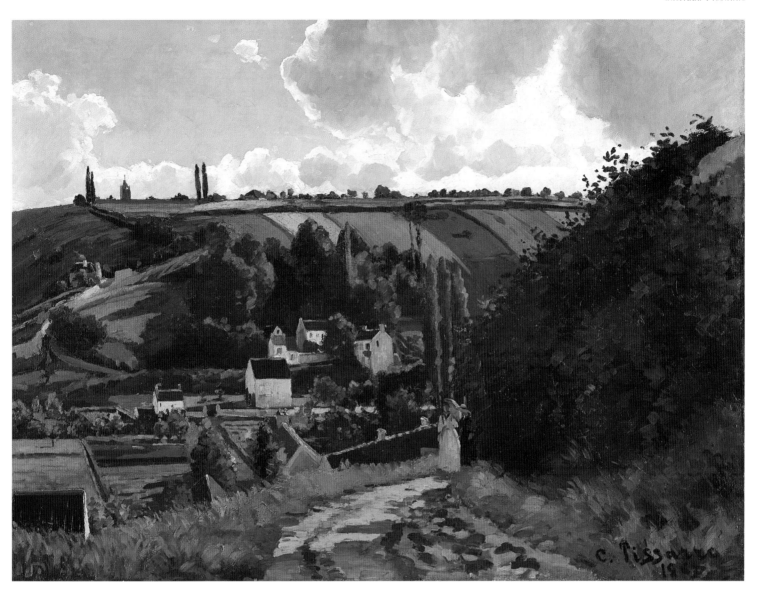

62

CAMILLE PISSARRO
(French, 1830–1903)

Jallais Hill, Pontoise, 1867
Oil on canvas
34¼ × 45¼ in.
(87 × 114.9 cm)
Metropolitan Museum
of Art, New York; Bequest
of William Church Osborn,
1951

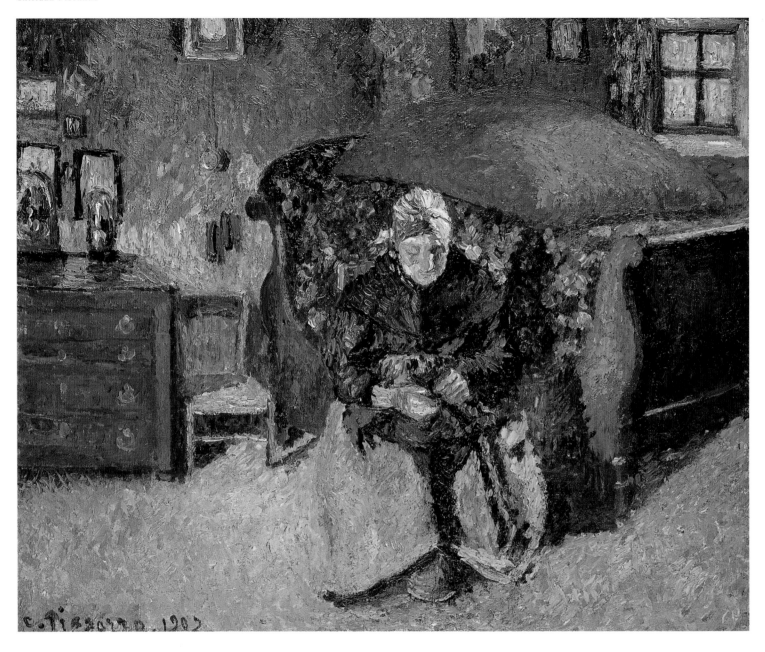

63

CAMILLE PISSARRO

(French, 1830–1903)

Elderly Woman Mending
Old Clothes, 1902
Oil on canvas
21¼ × 25½ in.
(54 × 65 cm)
Collection Sara and Moshe
Mayer, Tel Aviv

64

CAMILLE PISSARRO

(French, 1830–1903)

Self-Portrait, 1903
Oil on canvas
16⅛ × 13 in. (41 × 33 cm)
The Tate Gallery, London;
Presented by Lucien Pissarro,
the artist's son, 1931

Camille Pissarro's last
self-portrait, created at
his apartment in Paris
overlooking the Pont-Neuf,
reinforces his image, likened
by his contemporaries to that
of a biblical prophet with
a long flowing white beard.
The artist endows himself
with the force of personality
that he developed over
a lifetime.

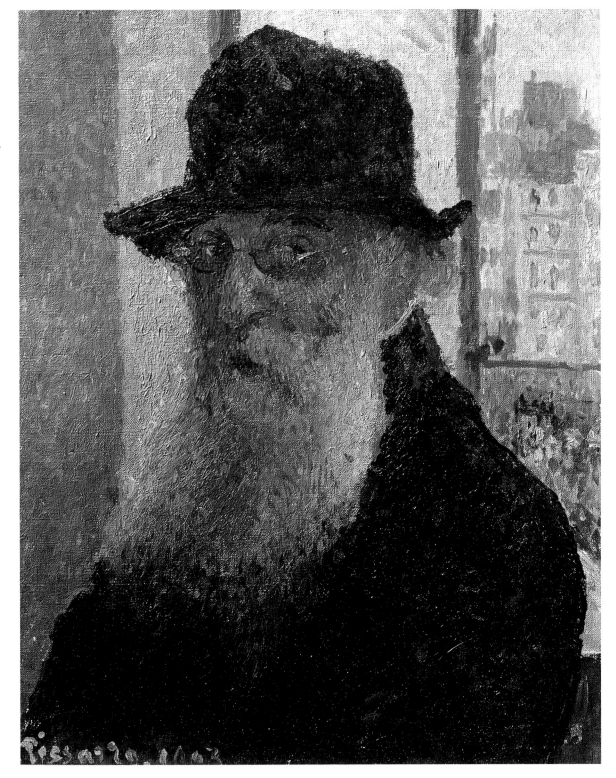

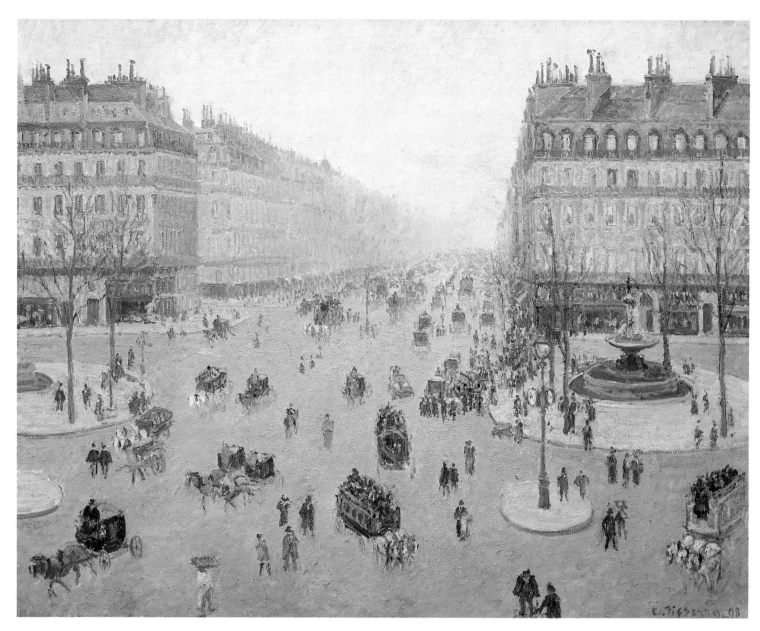

65

CAMILLE PISSARRO
(French, 1830–1903)

*Avenue de l'Opéra, Place
du Théâtre Français: Misty
Weather,* 1898
Oil on canvas
29⅛ × 36 in. (74 × 91.5 cm)
Collection Mr. and Mrs.
Herbert Klapper, New York

The vast panorama of
Avenue de l'Opéra in Paris
could be viewed by Camille
Pissarro from the window of
his hotel. In 1898, he painted
the view defined by the
intersection and inverted
V of the avenue. Although
the painting is densely
populated, individuals are
only suggested, so that

Pissarro's subjects retain
a sense of anonymity and
distance. His urban pictures
are concerned primarily
with spatial depth, and in
this work the vortex of the
composition appears to be
veiled with smoke.

66

LESSER URY

(German, 1861–1931)

*Unter den Linden after the
Rain*, 1888
Oil on canvas
19 × 14½ in. (48.3 × 37 cm)
Collection Friede Springer,
Berlin

Much of Lesser Ury's most
characteristic work
was inspired by the life and
physical surroundings
of Berlin, the people he
observed, and the cityscapes
with their rainy streets. His
work depicted the ephemeral
phenomena of light and
weather, as well as the
movement of rushing
pedestrians and horse-drawn
carriages that almost fade
into the surrounding mist
that rises from the shiny
sidewalks.

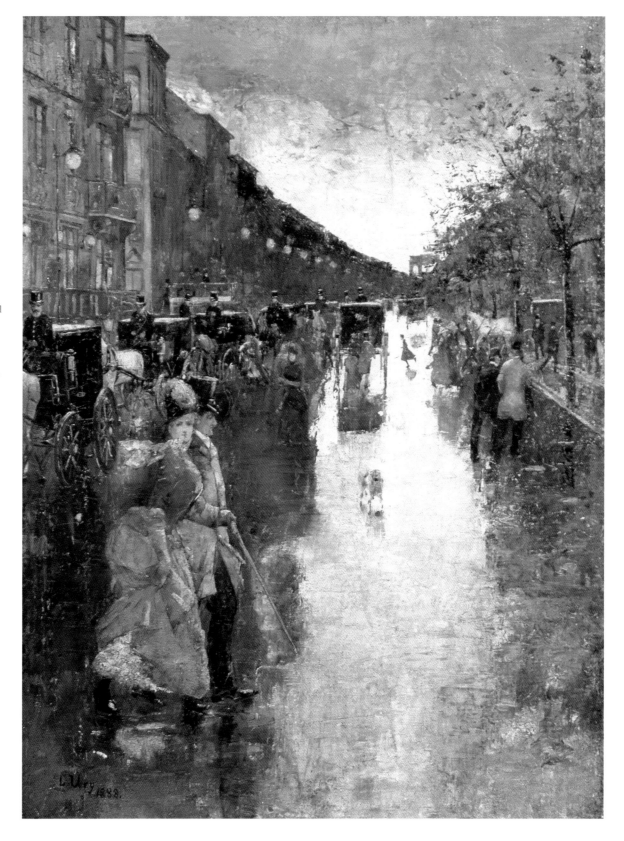

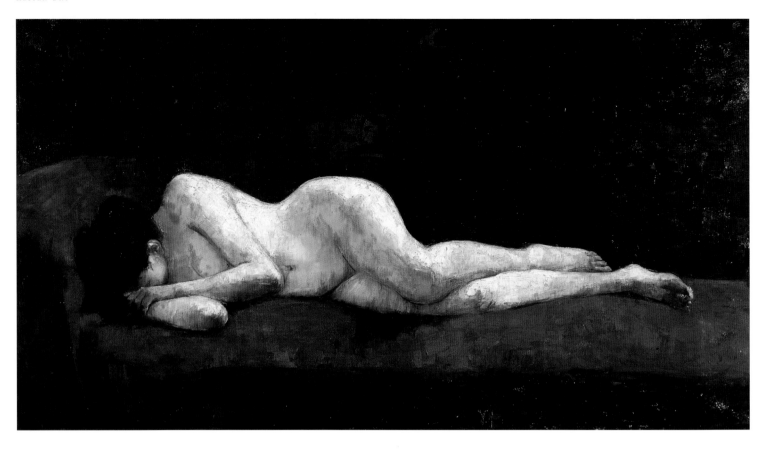

67
LESSER URY
(German, 1861–1931)

Reclining Nude, 1889
Oil on canvas
37 × 69¼ in.
(96.3 × 177.5 cm)
Berlinische Galerie,
Landesmuseum für moderne
Kunst, Photographie und
Architektur, Berlin

Probably the greatest break
from Jewish artistic tradition
at the time of emancipation
came with the opportunity
to expand the depiction of
the nude as a model. Before
the nineteenth century, this
subject was simply
unacceptable for Jewish
artists living in a traditional

society, but this theme could
now be considered
emblematic of falling
religious barriers for Jews.
In Lesser Ury's *Reclining
Nude*, a rich, painterly
surface texture is used to
describe the figure's languid
grace with a mixture of
coolness and voluptuousness.

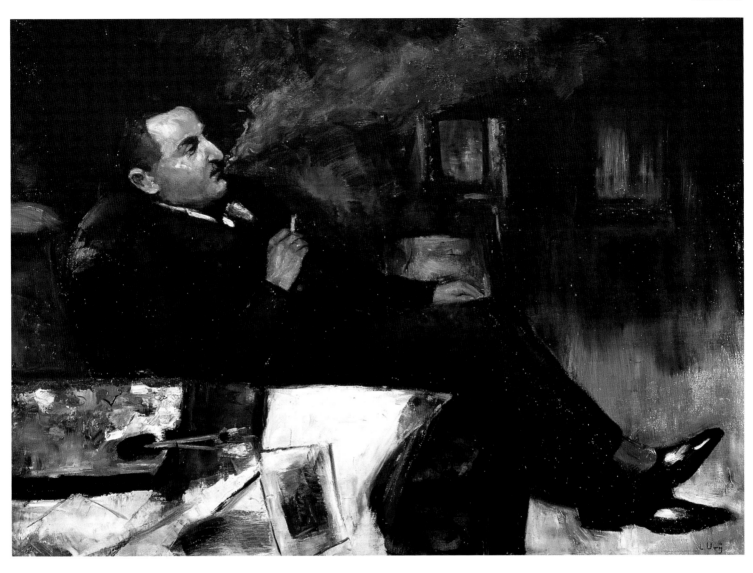

68

LESSER URY
(German, 1861–1931)

Lesser Ury Smoking in the Studio, 1912
Oil on canvas
28 × 39½ in.
(71 × 100.5 cm)
Private collection, Freiburg, Germany

Lesser Ury was a member of the Berlin Secession, an artists' organization that promoted new art forms, and was influenced by international art and exhibitions outside of academy salons. During the nineteenth century, as artists struggled to establish their own place in society, the studio remained the symbolic center of artistic life. There the artist could dress as he wished in work smocks for painting, or as a fashionable dandy when he met with his public. As the century evolved, there was an increasing need for artists to display their work not only in the annual public salons, but on a regular basis in their studios so that potential clients would be able to see a range of their works.

69
LESSER URY
(German, 1861–1931)

Girl in a Roman Café, 1911
Oil on canvas
18⅛ × 22½ in. (46 × 57 cm)
Nationalgalerie, Staatliche
Museen, Berlin

70

LESSER URY

(German, 1861–1931)

Rebecca at the Well, c. 1908
Oil on canvas
26¾ × 19⅞ in.
(68 × 50.5 cm)
Stiftung Jüdisches Museum,
Berlin

When portraying biblical
characters, Lesser Ury
focused on the qualities
of the individual rather than
the stories in which they
appeared. *Rebecca at the Well*
refers to the episode in
Genesis when Abraham has
sent a servant to find a wife
for his son Isaac. The servant
will know that he has found
the right woman if she not
only gives him water, but also
offers a drink to his camels.
Ury eliminates the narrative
elements from the
composition; only the well
and the pitcher allude to
the biblical story. Rebecca
is depicted as strong and
robust, perhaps to counter
the prevailing image of the
Jew as physically weak.

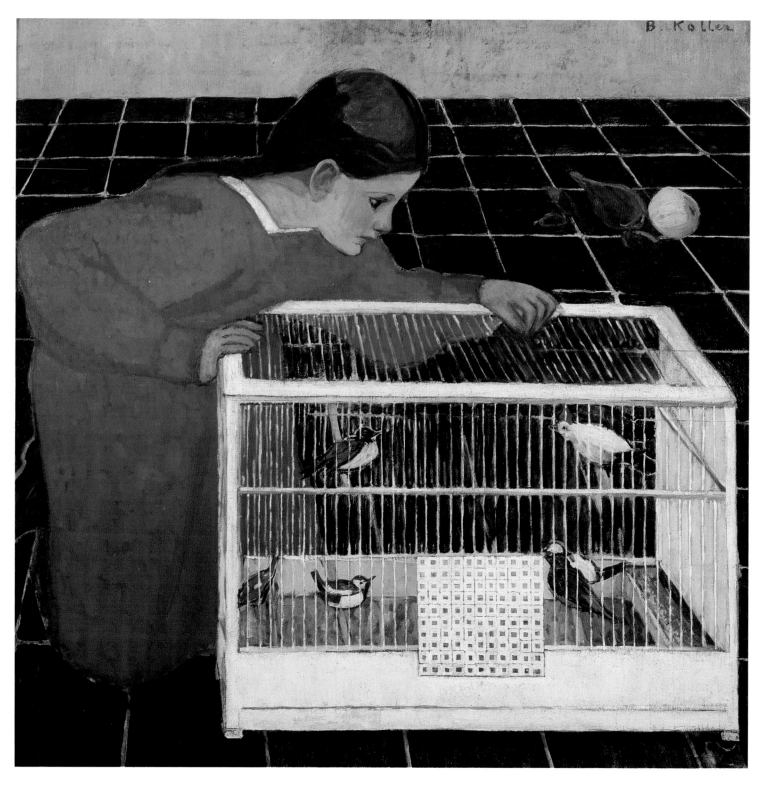

71
BRONCIA KOLLER-PINELL
(Austrian, 1863–1934)

Sylvia Koller with Birdcage,
1907–8
Oil on canvas
39⅜ × 39⅜ in.
(100 × 100 cm)

Collection Vera Eisenberger
KG, Vienna

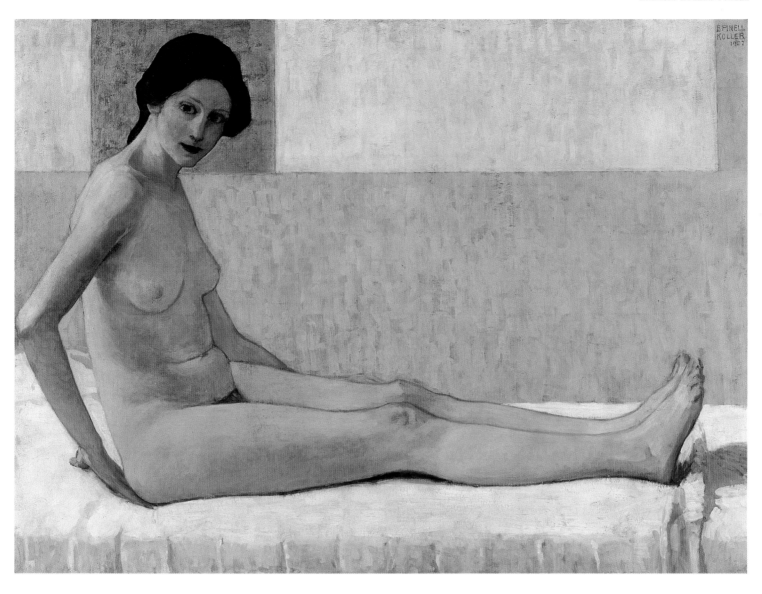

72
BRONCIA KOLLER-PINELL
(Austrian, 1863–1934)

Sitting (Marietta), 1907
Oil on canvas
42⅜ × 58½ in.
(107.5 × 148.5 cm)
Collection Vera Eisenberger
KG, Vienna

In *Sitting (Marietta)*, Broncia
Koller-Pinell employs the
style prevalent in fin-de-
siècle Vienna to paint a
dignified Jugendstil beauty
whose angular form is set

off by a flat, patterned,
decorative background. The
nude occupies a sizable area
of the richly ornamented
surface, which is enhanced
by its near abstraction. As

captured by Koller-Pinell,
the psychologically
remote figure is alone in
an airless space.

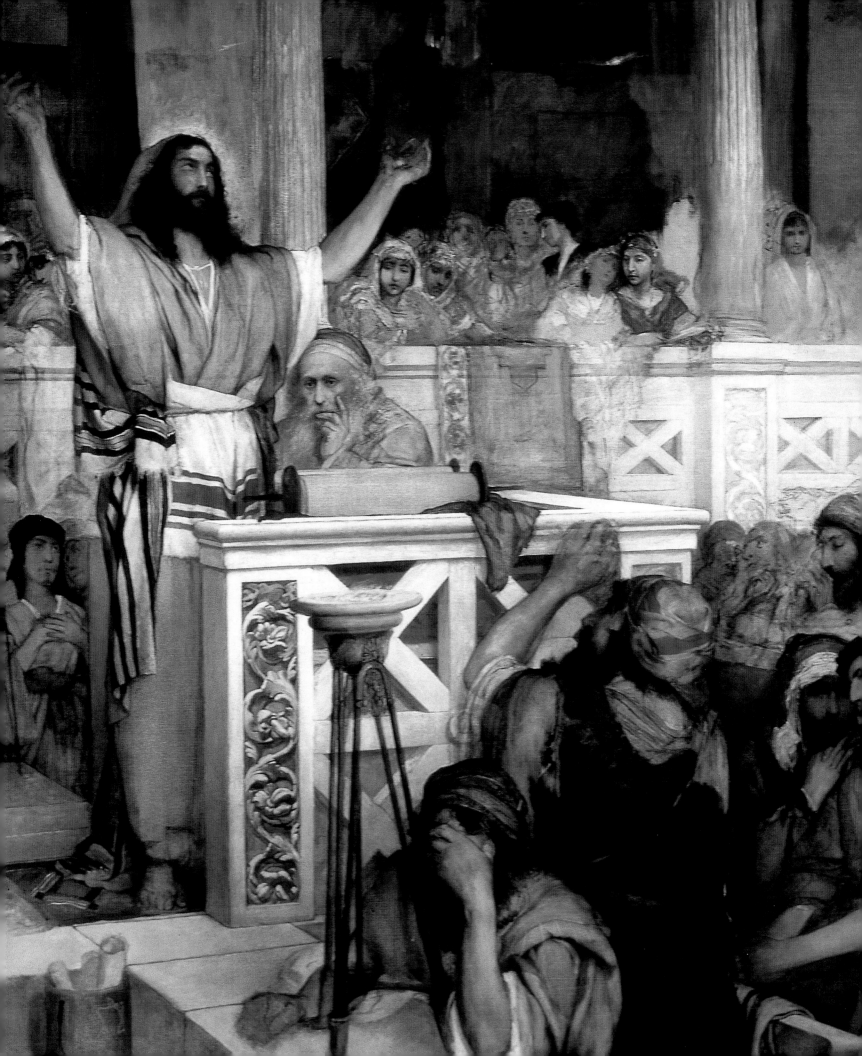

Larry Silver

Between Tradition and Acculturation: Jewish Painters in Nineteenth-Century Europe

The seemingly contradictory concept of the "Jewish painter" could only emerge out of the larger historical phenomenon of Jewish emancipation over the course of the nineteenth century. Jewish painters were certainly more numerous and achieved greater public success later, during the twentieth century, on both sides of the Atlantic. Yet the pioneering efforts of these ambitious outsiders to the dominant artistic culture—including such celebrated names as Moritz Oppenheim, Jozef Israëls, Camille Pissarro, and Max Liebermann, as well as less familiar but notable painters featured in this exhibition— deserve closer scrutiny. These painters had to make serious choices about how much to assert or embrace their religious and ethnic heritage (and whether they defined their Jewish identity as primarily religious or ethnic), even as they made their individual ways across the contested cultural terrain of contemporary artistic movements, played out in public exhibitions as well as private galleries in an increasingly international European arena.[1] Because individual solutions varied considerably by region and period, this essay will focus on particular artistic careers and will consider for each situation both the artist and his audience as formative for his chosen visual themes.

Maurycy Gottlieb. *Christ Preaching at Capernaum* (detail), 1878–79. See pl. 18.

FIG. 25. Moritz Daniel Oppenheim (German, 1800–1882). *Sarah Leads Hagar to Abraham*, c. 1824. Oil on paper; 8¼ × 6⅜ in. (20.8 × 16.2 cm). The Israel Museum, Jerusalem; Bequest Alfred M. Oppenheim, London, via British Friends of the Art Museums of Israel.

FIG. 26. Moritz Daniel Oppenheim (German, 1800–1882). *Felix Mendelssohn Plays for Goethe*, 1864. Oil on canvas; 33½ × 24½ in. (85 × 62 cm). Jüdisches Museum, Frankfurt; Lent by Alexander Tesler.

Pioneers: Oppenheim and Gottlieb

The artist with the strongest claim to be considered "the first Jewish painter" is Moritz Oppenheim (1800–1882), whose career spanned most of the nineteenth century and coincided with emerging Jewish emancipation.[2] Today Oppenheim is remembered principally for his series of images of Jewish life, particularly family life, based on paintings but also reproduced for mass distribution in the form of inexpensive prints, produced in photographic reproductions in Frankfurt during the 1850s. But Oppenheim was also a noted portraitist, particularly well supported by the Rothschilds, the wealthy Jewish banking family. He had begun his

career doing history paintings, following a mainstream trajectory defined by German artists from the first half of the nineteenth century.

Oppenheim was born in Hanau, a ghetto community near Frankfurt that was abolished under the Napoleonic reforms to the country during its French occupation. After a traditional Jewish education, the young Moritz followed the opportunity occasioned by emancipation to attend art schools, including the recently established Staedel Art Institute in Frankfurt. Although he also spent some time in Paris, his formative study experience lay in Rome, where he lived from 1821 to 1825. An influential cluster of German artists had, by 1810, established a "colony" there, which

they called the "Nazarenes" or the "Lukasbund" (Brotherhood of Saint Luke, traditional patron saint of painters).[3] Like the Pre-Raphaelite Brotherhood in England later in the century, these determined artists admired the spirituality in medieval religious art and the early Italian Renaissance, but they also adopted a "retro," countercultural lifestyle—dressing in archaic costumes, wearing their hair long, and living in monastic isolation. They resisted the changes wrought by industrialization and other forms of modernization with a pictorial emphasis on simple piety, depicted with a high finish and crisply descriptive realism that the Nazarenes derived from art of the Renaissance era. Oppenheim's own version of archaizing

religious pictures treated Old Testament themes, such as *Sarah Leads Hagar to Abraham* (fig. 25). He created a Jewish equivalent of the traditional Christian holy family in *The Family of Abraham* (c. 1822; Jerusalem, Israel Museum), whose composition echoes the celebrated holy-family complexes of Raphael (particularly the 1507 *Canigiani Holy Family*, which Oppenheim had been able to study in Munich).[4] Another study, the pencil composition *Christ and the Woman of Samaria* (1823), speaks to the reconciliation of differing religious groups under grace.[5]

Although Oppenheim suffered discrimination as a Jew in Rome, he also had the opportunity (in Naples) to make the acquaintance of a branch member of the Rothschild family, Baron Carl Meyer von Rothschild, who purchased and commissioned religious works from the artist. Oppenheim also established ties with Philip Veit, a descendant of Moses Mendelssohn, the epitome of Jewish enlightenment.[6] Thus, it is hardly surprising that Oppenheim would later commemorate Mendelssohn's role-model life in an imaginary scene of Jewish history, which recounts a famous disputation between a Christian proselytizer, the famous Swiss clergyman and physiognomist Johann Caspar Lavater, and Mendelssohn (1856; pl. 9).[7] Oppenheim stages the event (based on actual conversations in Berlin, 1763–64) at Mendelssohn's house (note the Hebrew inscription over the doorway) in the company of his good friend and defender, the poet and playwright Gottfried Ephraim Lessing, whose renowned Enlightenment drama *Nathan the Wise* (1779) makes an impassioned plea for tolerance and parity among the major religions of Judaism, Christianity, and Islam. Lessing's benign presence underscores the respect of the tolerant Christian for his Jewish intellectual friend. Their learned, respectful exchange would be a model for the images of Jew and gentile in Oppenheim's later representations of Jewish life.

As *Lavater and Lessing Visiting Moses*

Mendelssohn reveals, Oppenheim embraced both aspects of his German Jewish heritage after his return from Rome, and he finally succeeded in obtaining citizenship from Frankfurt in the wake of the 1848 revolution (1851). From his Frankfurt base, he worked continuously for the entire Rothschild family as portraitist of three generations.[8] He also painted portraits of a number of famous Jewish and cultural figures, including Ludwig Börne, the journalist and critic who had become a Protestant convert (1840; pl. 3); the poet Heinrich Heine, likewise a convert (1831; see fig. 11); and his close friend Gabriel Riesser (1806–1863), a leading advocate of Jewish emancipation.[9]

Moreover, Oppenheim also engaged deeply with contemporary German high literary culture, exemplified by Goethe (see fig. 26, which depicts a moment when the renowned author heard Moses Mendelssohn's precocious musical grandson, Felix, when the composer was twenty-one in 1830). In fact, Oppenheim had already made his own pilgrimage to Goethe at Weimar in 1827 for an audience that was far more meaningful to the painter than to the "prince of poets."

The kind of cozy domestic interior that Oppenheim used for the Börne portrait as well as the Lavater-Mendelssohn encounter became a kind of stock-in-trade for him. Beginning in the 1830s, he produced genre pictures for the German, bourgeois equivalent of the Victorian era, known as Biedermeier.[10] His themes, however, still resolutely combined Jewish and German activities, as if to reconcile pictorially any tension or perceived contradiction between these two cultures.

His first such genre subject makes the agenda clear: *The Return of the Jewish Volunteer from the Wars of Liberation to His Family Still Living in Accordance with Old Customs* (1833–34; pl. 1).[11] Suspicions that attached to Jewish volunteers during the Napoleonic period had led to repressive measures after 1815. In his painting Oppenheim reasserted the valor of and contributions by German Jews in the all-

important Prussian military. The Jews of Baden presented Oppenheim's painting to Gabriel Riesser in 1835 for his defense in public pamphlets (after 1831) of their legal rights and equality as well as duties to the state as citizens. It makes clear that the returning son has served officially as well as nobly; his entire family solicitously interrupts what is obviously a Sabbath observance to welcome their hero back home. This is an image of living Judaism in an emancipated, German present. Riesser praised the image for its "enthusiastic love of the fatherland paired with deep devotion to religious family life."[12]

Building upon this success, Oppenheim embraced his Jewish identity. In the 1850s he went on to produce a memorable genre series, *Scenes from Traditional Jewish Family Life*.[13] Here both home and synagogue provide the settings. The popularity of this series led the Frankfurt publisher Heinrich Keller to commission copies in tones of gray (grisailles) for photographic reproduction and distribution as prints (editions in 1866, 1868, 1874, 1882, and 1888). Unlike the picturesque and relatively timeless depictions of Orthodox Jewish ritual painted by later Jewish artists (such as Isidor Kaufmann; see below), Oppenheim's images sometimes involve non-Jewish figures. For instance, *Jahrzeit* (1871) features an observance at the front in the midst of the Franco-Prussian War; it is respectfully witnessed by gentiles. In *Sukkot* (*Tabernacles*) (fig. 27), several curious, blond, obviously gentile schoolboys peer curiously into the humble but richly decorated and furnished booth, where the Jewish family has assembled for a festive meal.

Interaction with gentile surroundings colors another image, entitled *Village Vendor*.[14] Father and son emerge from their markedly Jewish home (Hebrew inscriptions and a mezuzah on the doorpost). The father, well dressed but in traveling clothes with a walking stick, is clearly a peddler, the "vendor" of the title (he is vital and erect in carriage, nothing like the impoverished and broken-down figure in a later vendor image, Jozef Israëls's

FIG. 27. Moritz Daniel Oppenheim (German, 1800–1882). *Sukkot (Tabernacles)*, 1867. Oil on canvas; 25½ × 22 in. (64.7 × 55.9 cm). The Jewish Museum, New York; Gift of the Oscar and Regina Gruss Charitable and Educational Foundation, 1999-92.

picturesque but affecting *A Son of the Ancient Race*; c. 1889; pl. 48 and comments below). Another image from this series, *Sabbath Rest* (1866; pl. 4), shows three generations sitting together outside the family residence on a ghetto street. This picture reinforces the idea that Jewish learning is conveyed from generation to generation; it also, significantly, shows Jewish women studying together, using a Yiddish-language text.[15] Such Sabbath images form the core of the *Jewish Family Life* series. Details like the spice box in *Sabbath Afternoon* (c. 1866; Los Angeles, Skirball Museum), for example, speak to the "authenticity" of Oppenheim's representations, which serve as demonstration pieces of Jewish life for those outside the community while also asserting to Jewish insiders the richness and dignity of traditional Jewish life, now comfortably situated within the larger German culture.

Oppenheim's depiction of Jewish life has an air of nostalgia and quaintness about it, as it evokes a well-tended ghetto, by this time a generation or two outdated because of emancipation and urban expansion, and a distinctive Frankfurt setting. It is a world of observance and of learning, steeped in tradition but also set firmly within family life, transmitting that tradition to (numerous) children of the new generation. Unlike most artists of Jewish life, Oppenheim gave dignity and importance to the role of women, showing them with keys (and food) as the guardians of the hearth and capable of study within their standard gendered roles.

But this series also has something ethnographic about it. It charts the specifics of Jewish customs in contemporary Germany and offers them to an audience of Jews and gentiles alike, much as the previous century

had featured Christian curiosity and examination of Jewish life in the form of illustrated printed books.[16] Indeed, the depiction of gentile observers or witnesses to these Jewish events makes an implicit claim for mutual tolerance as well as integration of the Jewish cultural minority into the German majority (Oppenheim's portraits of renowned Jewish converts, such as Börne and Heine, show how easy assimilation into the majority culture had become).

If Oppenheim was able to negotiate German Jewish emancipation through his warm genre pictures of Jewish life, the young Polish painter Maurycy Gottlieb (1856–1879)

elected instead to pursue the original path of Oppenheim's youthful history paintings, to seek acceptance, even as a Jewish artist, in the ambitious field of history painting.[17] Gottlieb, too, had to invent the concept of what it meant to be a Jewish artist, particularly in the field of history painting, and he devised unique solutions. He was born in a Galician industrial crossroads, Drohobycz, and initially trained in the nearby provincial capital of Lvov (Lemberg). The son of a refinery owner in the early days of oil exploration, he was educated in German-speaking schools of the Austro-Hungarian Empire before training as an artist. Gottlieb's brothers also studied art, and his

sister married a Polish painter, Mieczyslaw Jakimowicz; his much younger brother, Leopold Gottlieb (1879–1934), became a distinguished painter in his own right, principally of portraits.

Gottlieb turned to the leading history painters in his region for his advanced training. After a sojourn in Vienna during the World's Fair art exhibition of 1873, he first sought out Jan Matejko in Kraków, followed by Karl von Piloty in Munich. From these examples, he absorbed the desire to paint literary or historical themes of great significance, on a large scale, with elaborate casts of characters, using dramatic gestures and well-studied period costumes in lavish settings. Through Matejko, he also discovered Polish history and nationalism, one of the subcultures of resistance in later-nineteenth-century Austria-Hungary.[18] Despite considerable support and encouragement from Matejko, Gottlieb complained of antisemitic discrimination from his fellow students and left Kraków for the German-speaking art centers.

In Munich, the young artist adopted an expressive combination of lighting and costume to create mood from the self-portrait tradition of Rembrandt, which he was discovering in his local academic training.[19] Rembrandt's numerous studies of bearded, philosophical old men, who were often identified in the later-nineteenth-century "Rembrandt boom" as "Jews" (allegedly produced from living models out of the Dutch artist's own neighborhood), offered Gottlieb a model for the depiction of Jewish faces.[20] Perhaps most moving of his studies of heads and costumes during this Munich period is a moody, almost dreamy self-portrait in three-quarter profile, signed and dated 1876 (Kraków, National Museum) and identified in Gottlieb's title as *Ahasuer* (see fig. 16). This name suggests the non-Jewish king of Persia from the Book of Esther, which would accord with the "orientalist" costume details of gilded crown and earring.[21] However, Ahasuer is also the name given to the legendary Wandering Jew, cursed until the end of time

FIG. 28. Maurycy Gottlieb (Polish, 1856–1879). *Uriel d'Acosta Abjuring Beliefs*, 1877. Oil on canvas; 15¾ × 12¼ in. (40 × 31 cm). The Israel Museum, Jerusalem, Bequest of Dr. S. Goldflam, Jerusalem.

for his rejection of Christ (see fig. 46, for Hirszenberg's representation of this haunted figure).[22] The shadowy and oblique presentation of his head suggests brooding self-consciousness, surely more appropriate to the Wandering Jew than to the Persian king. Moreover, Gottlieb has emphasized within his self-portrait the caricatural aspects of the Jewish stereotype in his own features— prominent nose and puffy lips as well as a general "feminization" and suggestion of hypersensitivity.[23] As a result, the artist seems to be taking on the weight of his entire "nation" (as Jews were basically defined among other ethnic groups in Gottlieb's Poland), as signaled by the crown on his head.

Gottlieb's principal preoccupation in his Munich exploration of history painting was finding appropriately serious Jewish literary themes and characters for pictorial inter- pretation. He began with an image of the Jewish moneylender Shylock, from Shakespeare's *Merchant of Venice*, portraying

the bearded old man as a doting father deceived by his scheming daughter, Jessica (1876; Kraków, Jewish Museum).[24] Like his Ahasuer, Gottlieb's Shylock is dressed in dark garments and seen in three-quarter profile, which emphasizes his prominent nose, (white) beard, and small, thoughtful eyes.

Gottlieb followed his success with Shakespeare (which he doubtless knew from the German translation) in 1877 with a full series of grisaille illustrations of Lessing's classic drama *Nathan the Wise*, commissioned by the Munich publisher Bruckmann (but never produced).[25] While Oppenheim characteristically showed Lessing the author in a historical genre scene, Gottlieb produced a history painting series of the play itself. For both artists, Lessing's message represented toleration and the dignity and worth of the Jewish religion, as personified by the wise hero of the drama.

One final grisaille image of 1877 (fig. 28) for the same publisher, again never produced, shows the seventeenth-century Portuguese Jewish protagonist of a tragedy by German playwright Karl Gutzkow, *Uriel d'Acosta* (1847), on the *bima* of the Amsterdam synagogue, renouncing his unconventional views to seek restitution after excommunication.[26] In the context of the Jewish enlightenment, or Haskalah, this play and its real hero advocate an extension of the rationalist spirituality of Moses Mendelssohn, suggesting that for Gottlieb universalist issues of doctrine and ultimate reconciliation between Christians and Jews, in the manner of Lessing's ideal, were becoming increasingly important.

During his final two years (Gottlieb died tragically young in 1879 and was buried in the Jewish cemetery in Kraków), the artist spent most of his time shuttling between Vienna and Kraków, where he again took up with his mentor, Matejko, as well as visiting his hometown in Galicia. In his final full year of work, while he was located closer to home, Gottlieb produced a work that is filled with personal reference and significance:

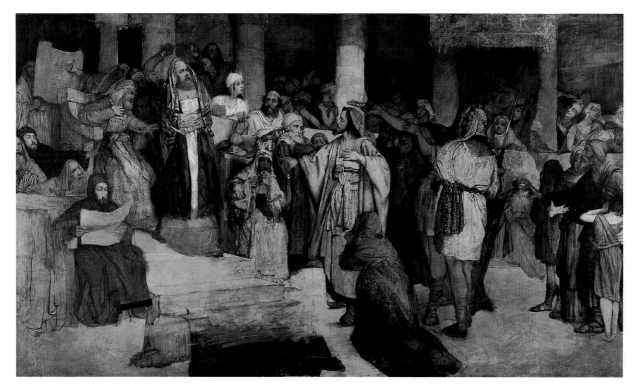

FIG. 29. Maurycy Gottlieb (Polish, 1856–1879). *Christ before His Judges*, 1877–79. Oil on canvas; 63 × 111⅛ in. (160 × 283 cm). The Israel Museum, Jerusalem, The Stieglitz Collection, donated with the contribution of Erica and Ludwig Jesselson, New York, through American Friends of The Israel Museum, 1985.

Jews Praying in the Synagogue on Yom Kippur (1878; pl. 15).[27] The artist conspicuously inserts a melancholy, meditative self-portrait amid this monumental work, which depicts the period of ultimate reflection on one's life and deeds. Nehama Guralnik believes that the round-faced boy at the left, who wears a dazzlingly embroidered holiday outfit, is also a youthful self-portrait, because he wears the same medallion around his neck, bearing the initials "M.G." Eerily prescient of his death in the following year, Gottlieb has inscribed the Torah scroll with a Hebrew memorial dedication that suggests he is both a scholar and deceased: "Donated in memory of the late honored teacher and rabbi Moshe Gottlieb of blessed memory 1878." Gottlieb was quoted as saying about this painting that he "imagined that the shadows of members of my family who were already dead returned to the land of the living and surrounded me."[28] Along with his Hebrew inscription, this quotation suggests that the artist was using this picture to bear visible and permanent witness (however

uneasy, to judge by his body language and discordant garment) to his participation in the faith (encircled by family and acquaintances), in contrast to the awkward reconciliation he had depicted in *Uriel d'Acosta Abjuring Beliefs*. This Yom Kippur scene engages the particular participation of the artist, without sentiment or address to a broader audience of either Jews or gentiles. Perhaps no other artist in this exhibition ever personalized so deeply his engagement with the Jewish community as did Gottlieb in this particular painting.[29]

Two large and ambitious works of religious art show Gottlieb trying to come to terms with his multiple roles as artist, Jew, and citizen of largely Catholic Poland (still part of Austria-Hungary). *Christ before His Judges* (fig. 29) stages this scene from the New Testament Passion as a full-fledged orientalist history painting, with all the variety of a costume epic.[30] The Roman presence is signaled by a shadowy secular figure in the background under a canopy of honor bearing the inscription of the imperial authority,

SPQR; but the principal staging of the scene suggests that the judges who condemn Christ are Jewish. Behind them, the raised and unfurled Torah scroll gives them their sanctioned authority. This is another scene of strict doctrinal conflict, reminiscent of the synagogue recantation by Uriel d'Acosta after similar charges of heresy (d'Acosta's suicide seems to echo Christ's dignified resignation). Here the community of elders, who seemed so pious in the Yom Kippur setting, can be viewed as prosecutors and persecutors of Christ.

Significantly, Gottlieb portrays Christ as Jewish, wearing a distinctive and large, turbanlike skullcap as well as side curls and a prayer shawl beneath his *kittel*, the white outer garment worn on solemn occasions and also used for burial of observant Jewish men. The source for this historical interpretation of Jesus as the victim of religious politics and rigid doctrine may be Heinrich Graetz's multivolume *History of the Jews*, published in German in 1875, to which Gottlieb would have had ready access during his year in Munich

(1876). According to Graetz, the high priest of the Sanhedrin, Caiaphas, led the religious court in declaring Christ's views blasphemous, and the death verdict was carried out by the Roman governor, Pontius Pilate, in part for rebellion against the authority of the empire. In this reading, Christ could be understood to be a good Jew as well as a positive teacher, whose condemnation was a political act of division (thus making later Christians' antisemitic comments on Christ's death at the hands of the Romans a misreading of both history and Christ's teachings).

In this way, Gottlieb used his own staging of history to argue for a more inclusive and universal religion, where the Jewish world of Christ could be reconstructed and made the basis of reconciliation between modern Christians and Jews. Gottlieb also personalizes this vision by including a self-portrait, in shadow but just above the shoulder of Christ and beneath the crown of thorns. Poised thus between Jesus and the state authority of the empire (perhaps a veiled criticism of Austria-Hungary), he listens attentively to the spiritual message of humility and universal brotherhood as set against the shrill rigidity of even Jewish religious authority.

Gottlieb's final large-scale work of history painting, which he did not live to complete, was another New Testament scene from the life of Christ: *Christ Preaching at Capernaum* (1878–79; pl. 18).[31] Here Gottlieb could concentrate on Christ's prophetic qualities and teachings, deriving a message of reconciliation for all humankind. He took the overall composition from Rembrandt etchings, in particular the so-called Hundred-Guilder Print (*Christ Teaching and Healing*, completed c. 1649, B. 74) and "La Petite Tombe" (*Christ Preaching*, c. 1652, B. 67), which show the varied responses of different ages and classes to the message of Christ.[32] Gottlieb again presents Christ as Jewish, with a skullcap and tallith as well as an open Torah scroll, from which Christ has been reading. Once more the artist includes a self-portrait in the lower center, clearly based upon the earlier *Self-*

Portrait as Ahasuer and perhaps with some of the same implications of bearing a burden of reconciliation for his whole people. The responses by the rest of Gottlieb's congregants to this message vary—from bored indifference to thoughtful, even fervent prayer. Here, as in the Yom Kippur image, there is a women's balcony, so this is clearly a synagogue, despite its fluted classical columns and templelike ornament, which serve to locate this interior in the ancient world. The orientalizing costume of the congregation strongly suggests that this is historical Palestine. Gottlieb emphasizes the Jewish dress and Hebrew Scriptures, signaling that this message is addressed to the Jewish community—from within.

During his study trip to Rome in late 1878, Gottlieb wrote to a friend, "How deeply I wish to eradicate all the prejudices against my people! How avidly I desire to uproot the hatred enveloping the oppressed and tormented nation and to bring peace between the Poles and the Jews, for the history of both people is a chronicle of grief and anguish!"[33] In the crossroads geography of Galician Jewish life, where Haskalah met Hasidism, Gottlieb—a German-speaking, well-educated, bourgeois son of Jewish emancipation—chose to invent his own form of integration, at once religious and political. He advocated this new society through history painting, the largest, most ambitious, and most prestigious form of art-making available to him.

Independents and Secession: Paris and Berlin

The ultimate representative of an artist of Jewish heritage who abandoned his past when he charted his career was Camille Pissarro (1830–1903).[34] So immersed was Pissarro in the upstart world of the Impressionists that he was the only artist to participate faithfully in all of their group exhibitions between 1874 and 1886, and he held an "elder statesman" role as the adviser to a host of younger artists, including notoriously difficult personalities such as Cézanne, Gauguin, and van Gogh, all

of whom came to visit him in his country studio. This independence of spirit stemmed in part from his origins.

Pissarro was born with the name Jacob Pizarro, a Danish citizen in the Caribbean colony of Saint Thomas in the Virgin Islands. His father was a prosperous Frenchman from Bordeaux, a Sephardic Jew of Portuguese origin. The young Camille was largely self-taught. After a period of work in Venezuela, where he chiefly produced drawings of local settings and figure groups, he moved to Paris in 1855, the very time when French art was shifting away from history painting and toward "realist" genre.[35] For the bulk of his career, Pissarro focused intently on rural life in France, with particular attention to the peasants who inhabited the land. He lived in villages, chiefly Pontoise but also Eragny, from which he developed a particular sympathy for the simpler life of rural labor, which is vividly embedded in his technically inventive paintings, such as the sensuous *Summer Landscape, Eragny* (fig. 30), where the material texture of the paint suggests (with all of the vividness of van Gogh's textured strokes) the tangible, damp thickness of the mown hay in the fields. At the same time, in drawings, pastels, and prints Pissarro recorded with a suggestion of spontaneity the village life around him, such as the gouache and chalk *Poultry Market, Gisors* (fig. 31).

Pissarro's political views can be gleaned from his letters—he was a radical, an anarchist, for whom the peasants' offering of their homegrown wares in the market must have had resonance, as he was subject to the modern art market.[36] In contrast to the exploitation of factory labor, this kind of rural labor suggested to the painter harmony, tranquillity, and collectivity (something that Pissarro practiced in his own close collaboration with other artists, most notably the Impressionist group).

In the private album of twenty-eight drawings, *Turpitudes sociales* (1889), that Pissarro prepared for his nieces in London, Esther and Alice Isaacson, he details in the

FIG. 30. Camille Pissarro (French, 1830–1903). *Summer Landscape, Eragny*, 1877/1902. Oil on canvas; 22 × 26 in. (55.9 × 66 cm). Philadelphia Museum of Art; Gift of Mrs. William I. Mirkil.

form of allegory as well as genre imagery the degradation visited upon the laboring classes by privilege and money. In the very first image, "Capital," a dense crowd of thin faces looks up at a prosperous banker with a suit and muttonchops who is clinging to a large money bag. The caption reads, "The war of the weak against the strong." As Pissarro analyzes this scene in a letter to his nieces: "The statue is the golden calf, the God Capital. In a word it represents the divinity of the day in a portrait of a Fischoffheim, of an Oppenheim, of a Rothschild, of a Gould, whatever. It is without distinction, vulgar and ugly."[37] What is striking about this passage is its deliberate invocation of prominently wealthy Jewish bankers, who are also caricatured with the stereotype of large noses in the third drawing, "The Temple of the Golden Calf." Here well-

dressed bankers in top hats assemble outside the Paris Bourse. As commentators have pointed out, this is not Jewish self-hatred on the part of Pissarro; rather, this editorial drawing represents his full identification as a political radical, outraged with the class situation of the workers, especially in the city. Writing to his son Lucien, also a painter, Pissarro expresses amazement that the public focuses on the men's Jewishness rather than their banking, "The masses . . . dislike the Jewish bankers, and rightly, but they have a weakness for the Catholic bankers, which is idiotic."[38]

What, then, was Pissarro's relationship to his Jewish ancestry? It should not surprise us to find an ambitious artist more interested in the world of his career than in a Jewish community as such, especially in Western

Europe. After all, Ezra Mendelsohn characterizes (pre-Dreyfus) France as "a truly ideal environment for Jewish integration, the very model of a highly centralized nation-state with a brilliant high culture . . . [and a] secular, pluralistic revolutionary tradition."[39] However, as Nicholas Mirzoeff points out, Pissarro's Jewishness was a complex hybrid of religious and ethnic varietals. First, Pissarro was of Sephardic origin, not part of the dominant Ashkenazic Jewish culture of northern Europe. Moreover, the Jewish culture of the Caribbean was identified with African slave culture in the islands, both by the local Christian ruling class and the oppressed slave class. Indeed, Mirzoeff attributes the artist's political radicalism more to this colonial cultural resistance and drive toward emancipation than to any French exposure to

FIG. 31. Camille Pissarro (French, 1830–1903). *The Poultry Market, Gisors*, 1885. Gouache and black chalk on paper mounted on canvas; 32⅜ × 32⅜ in. (82.2 × 82.2 cm). Museum of Fine Arts, Boston; Bequest of John T. Spaulding.

European political theory. Within Caribbean Jewish culture, too, there were distinctions made between traditional religious observance and a more ethnic, or even racial, Jewish identity, which, in the words of one Jamaican rabbi, blended "reason with faith" to produce what Mirzoeff terms "a blend of Jewish monotheism with Enlightenment rationalism."[40] Although Pissarro's parents seem to have been relatively observant Jews by conventional standards, with the artist's own shifting sense of identity, it is understandable that he might embrace a more rationalist approach toward his heritage.

Certainly Pissarro's associates perceived him to be a Jewish ethnic, almost a prophet figure (some friends would greet him by saying "Hail to Moses"), even when describing him in affectionate terms, as in the vivid

portrait in words by the writer George Moore: "No one was kinder than Pissarro Pissarro was a wise and appreciative Jew, and he looked like Abraham; his beard was white and his hair was white and he was bald."[41] Pissarro, however, was resolutely secular in outlook; he even resented what were intended to be favorable comparisons between his images of peasant life and popular works by the older artist Millet. As he wrote to the critic Duret, "They are all throwing Millet at my head, but Millet was biblical! For a Hebrew, there's not much of that in me. It's curious!"[42] He could rise to defend himself against stereotyping, as in a harsh (if insecure) response to accusations by Renoir that he was a combination "socialist . . . revolutionary . . . Israelite": "The wretched Renoir has treated me in the worst way; it seems that I am a prime schemer without

talent, a mercenary Jew. . . . Is it because I am an intruder in the group?"[43]

Pissarro regarded all religion, including Judaism, as inappropriate to "our modern philosophy which is absolutely social, anti-authoritarian and anti-mystical." Writing to his son Lucien, he blasted the backsliding that he saw around him: "It is a sign of the times, my dear son. The bourgeoisie, frightened, astonished by the immense clamor of the disinherited, by the insistent demands of the people, feels that it is necessary to restore to the *people* their superstitious beliefs. Hence the bustling of religious symbolism, religious socialists, idealist art, occultism, Buddhism. . . . May this religious movement be only a death rattle, the last one. The Impressionists have the true position, they stand for a robust art based on sensation, and that is an honest

stand."[44] In his personal life, Pissarro was consistent with his non-Jewish stand. He married a Catholic woman, although he lived with her for many years before marrying formally and in a civil ceremony, and it is clear that he was aware that her religion displeased his parents, especially his mother. Moreover, when his third son, Félix, was dying of tuberculosis, he rejected all attempts at spiritual comfort by a well-meaning Christian in England. The artist resolutely pronounced, "We no longer believe in authority or God! . . . religion, government, etc., etc."[45] Amid this secular and modern outlook, Pissarro fervently believed that art should not serve any external message other than "sensation."[46]

For another Jewish artist, Jozef Israëls (1824–1911), political interests found expression in the culturally dominant visual idiom of peasant pictures. Israëls's long career in Holland provided a model of success.[47] He came from a bourgeois, observant Jewish family in Groningen, a provincial center, and moved to Amsterdam for further training at the Royal Academy before spending two years in Paris at the École des Beaux-Arts in the mid-1840s. His initial training was as a "history painter," the dominant form of "high art" in the early nineteenth century. But with the general shift in French Salon displays after mid-century, Israëls, too, changed artistic direction. He returned to the Dutch heritage he knew well, visualizing in trademark fashion the life of fishermen and peasants near the village of Zandvoort.[48] His principal themes were picturesque but moving scenes of rural poverty and hard work, and he rapidly gained international acclaim, including exhibitions at the French Salon of 1861 as well as the 1862 international London exposition, for one of his breakthrough works, *Fishermen Carrying a Drowned Man* (1861; London, National Gallery).[49] After working in Amsterdam during the 1860s, Israëls moved permanently to The Hague in 1871, where he became a principal figure in an emerging "school" of artists, including the brothers Maris, Anton Mauve, and Hendrik Willem Mesdag.

Many of Israëls's mature works are large-scale images in dark tones that evoke traditional Dutch genre interiors of peasant homes as well as the seventeenth-century colors and techniques of Rembrandt or the van Ostades.[50] His favored themes offer melodramatic and emotional scenes, such as deathbeds or isolated old people with pets, a good example being *The Last Breath* (1872; pl. 47).[51] The entire interior is suffused with dark shadows and spare furnishings; a chair draped with fishing nets suggests the larger world of fishing that preoccupied Israëls. Another favorite subject is the frugal cottage meal, often with grace before the meal (a theme also favored by seventeenth-century Dutch painters).[52]

Israëls had considerable influence on later generations of Jewish artists, even Eastern European painters like Leopold Pilichowski and Samuel Hirszenberg (see below), as Richard Cohen has observed, and his works were included in the important early-twentieth-century exhibitions of Jewish painters, such as the 1907 exhibition in Berlin.[53] Later in his career, Israëls turned occasionally to more explicitly Jewish figures, usually old ones like his peasant types, and scenes from Jewish life, such as *A Jewish Wedding* (1903; pl. 49).[54]

Perhaps most emblematic of this hybrid Jewish genre in Israëls's oeuvre is his *A Son of the Ancient Race* (c. 1889; pl. 48), showing an aged, weary, and humble man seated at his own threshold. He is identified as a peddler of secondhand goods; his religious tradition is marked by the gold plate and candlesticks visible on a foreground side table. The dark shadows, broad brushwork, and expressive hands and face echo the venerated models of craggy old men by Rembrandt, so often identified as "Jews" in contemporary Rembrandt catalogues. The fame of this painting led to its conflation with its artist, who afterward came to be known as "the son of the ancient people." One critic, Taurel, described it as the emblem of all Jews: "It is a son of that age-old race, whose children

dispersed among the peoples like leaves driven along by the storm, but who have not mixed and become one."[55]

Israëls enjoyed the greatest success of any Dutch painter of his era. At a time when the Dutch seventeenth century was enjoying renewed popularity among French critics, Israëls came to be considered the living heir to his native tradition by such leading French observers as Thoré, noted today as the man who rediscovered Vermeer.[56] Comparisons to Rembrandt began to accumulate.[57] Israëls not only managed to find inclusion in the prestigious public French Salon displays and in the 1878 Exposition Universelle in Paris but also to participate in the "progressive" exhibitions of Secession art and Jewish art in Central Europe.[58] His long-term friendship with Max Liebermann gave him close contacts in Germany. In 1892 Israëls showed his art with the group that became the Berlin Secession, which later awarded him honorary membership; he became one of the early contributors to the international exhibitions in Berlin. Israëls enjoyed considerable honors all over Europe, including the royal order of the Dutch Lion. He was accorded a state funeral when he died in 1911.

Epitomizing the eventual successes attained by Jewish painters—indeed, by Jewish cultural figures in the broader "artworld"—at the turn of the twentieth century, the career of Max Liebermann (1847–1935) in Berlin provides a climax unlike the struggles by earlier nineteenth-century painters.[59] Despite the wishes of his wealthy Berlin business family, Liebermann studied art at the Weimar Academy.[60] He began by imitating contemporary French taste for peasant themes and rural landscapes.[61] Besides these favorite subjects, Liebermann adopted French forms, characterized by lively and broad broken brushwork as well as the simulation of figures seen in light and air.

Also deriving from his comfortable family background, Liebermann consistently aspired to "success," whether measured in terms of awards and laurels or in terms of financial

rewards, and contemporaries noted his lifelong discipline and industry in pursuit of these goals. Yet he was the founder and the first president (after 1899) of the breakaway Berlin Secession art movement, led by commercial galleries (chiefly the Jewish dealers Paul and Bruno Cassirer) and a local cultural elite in the capital.[62] In fact, this movement, too, was broadly based; opposed chiefly to the conservative art politics of the kaiser; and, led by Liebermann, open to the display and influence of foreign art, such as French or Dutch contemporaries. Indeed, the connections between Liebermann and those countries were forged earlier and deeply: He lived in Paris from 1873 to 1878, and after a first trip to Holland in 1871, he became a regular visitor, particularly to his close friend in The Hague, Jozef Israëls. Indeed, at the opening of the third Secession exhibition, Liebermann championed the work of the Dutch painters Israëls and Jacob Maris alongside Pissarro, Renoir, and Monet.[63] Liebermann, fully identified with the Secession, came to embody international and modern art at the turn of the century for Berlin.

If we follow the highlights of Liebermann's long and productive career, we find an early and abiding preoccupation with humble scenes and figures. Ramshackle corners of houses or open farm fields, often occupied by figures performing simple chores or crafts, dominate his pictures of the early 1870s. A good example of this interest is *Flax Spinners in Laren* (1887), a first version of his massive work (Berlin, Nationalgalerie) in dark colors. Here rural young women and children in distinctive folk costumes and linen caps are engaged in collective labor. Besides adapting popular peasant subjects from French artists, such as Millet, Liebermann also studied contemporary Dutch art and rural settings, such as the work of his friend Israëls, plus the newly revived traditions of seventeenth-century Dutch painting.[64] Both the large size of this painting and its local Dutch subject suggest the massive and active group portraits

of militia companies or regent groups, as painted by Frans Hals and Rembrandt during the "Golden Century" of Dutch painting.[65] Yet this painting is not exactly a group portrait; it also partakes of the Dutch tradition of "genre painting," that is, the depiction of scenes from "daily life," images of labor and leisure in picturesque settings.[66] In so doing, it presents a "cottage industry," a throwback to earlier times when modern industrialization had not yet been able to supplant either the traditional spinning wheels or the craftsperson's touch in the production of fiber from flax.

During this early period there are also glimmers of Liebermann's engagement with his Jewish identity.[67] A small canvas of 1876, *Synagogue in Amsterdam*, picturesquely depicts a corner near the *bima* as seen from the front pew, a cluster of dark-clad figures in the background.[68] While this smaller synagogue might have carried some resonance for Liebermann in terms of the century of Rembrandt and Spinoza, he manifestly does not choose to paint the grandiose Portuguese Synagogue of Amsterdam, preferring instead the more modest scale and materials of an Ashkenazic synagogue in the same area.

Liebermann's insertion of Jewish themes into his work was not overt but was still visible. His most striking image is his 1879 interpretation of biblical history, *The Twelve-Year-Old Jesus in the Temple* (see fig. 4), where he shows Jesus standing precociously before a group of bearded and learned rabbis in theological discussion. With his already characteristic naturalism and lively brushwork, Liebermann knowledgeably showed *tallitot* as well as the contemporary dark dress with fur hats of Ashkenazic Orthodox Jews surrounding the boyish figure of Jesus. This painting stirred up a maelstrom of hostile response. Antisemitic criticism of the painting as "blasphemous," by a "painter, who, as is well known, is not of the Christian confession," evoked a local scandal among self-professed "devout Christians."[69] Consequently, for the remainder of his career Liebermann avoided religious subjects.

Today scholars conclude that Liebermann's initial sympathetic orientation toward Holland's genre traditions as well as toward its contemporary figures of orphans and peasants soon became tempered by antisemitism. Julius Langbehn's popular *Rembrandt als Erzieher*, a fanatically nationalist pan-German and antisemitic polemic that attacked Dutch culture and freedom through the figure of Rembrandt, was published in 1890 (and often republished).[70] Advocating a religiously pure, imperial German, Christian culture, Henry Thode, professor of art history in Heidelberg and son-in-law of Richard Wagner, attacked the Secession and its internationalism with disparaging lectures on the (Jewish) art critic Julius Meier-Graefe in 1905.[71] The internationalist art orientation of Liebermann, Meier-Graefe, and the Berlin Secession represented to Thode a dangerous betrayal of religious and patriotic German art and culture by "foreigners." Going further, the poet Ernst Schnur, in the pamphlet *Der Fall Meier-Graefe*, characterized the Secession as an "art movement of specifically Jewish character." Liebermann addressed Thode in a letter in the *Frankfurter Zeitung*, accusing him of insinuations and the use of "other by now fairly rusty weapons from the armory of anti-Semitism," only to be accused in turn of being "un-German."[72] Thus the battle lines of this turn-of-the-century "culture war" in Berlin pitted what Fritz Stern called the German search for a "revolution against modernity" against internationalist, cosmopolitan modernism, exemplified by Max Liebermann, the Berlin Secession, and its supporters.[73]

Perhaps in response to these cultural currents, Liebermann's art shifted around the turn of the twentieth century toward more upscale images of bourgeois leisure: "equestrians riding on the beach, elegant families strolling through zoos, tennis players, and open-air restaurants and beer gardens."[74] His own bourgeois heritage might well have attuned him to these themes of bourgeois leisure and prosperity, which were then

emerging from Impressionist painters in France. In one such work, *Man and Woman Riding on the Beach* (1903), the elegant thoroughbred horses are expertly ridden by fashionably costumed figures. Once more this scene derives from the artist's frequent visits to Holland, but in this case he records the beaches and casinos of high society rather than the humbler sites frequented by peasants and fishermen. In similar fashion, Liebermann's *Avenue of Parrots* (second version, 1902; Bremen, Kunsthalle) follows a model of Parisian art running from Manet and Monet through Seurat in which weekend strolls in public parks, like this one in the Amsterdam Zoo, were captured in terms of both their light-filled vividness and their well-coiffed couture.[75]

Liebermann's portrait commissions increased after 1900 as well. He painted various important Berlin cultural figures, many of them Jewish (*Professor Hermann Cohen*, 1913), as well as self-portraits (he is inevitably well dressed and aware of his own eminence, even when he wields the tools of his profession; see, for example, his self-portrait of 1911; pl. 50). This was the actual world of Max Liebermann—an urbane and liberal cultural elite, which included prosperous and prominent Jews who had successfully acculturated into a liberal society without abandoning their religious beliefs.[76]

However, in a series of pictures painted in the first decade of the twentieth century, Liebermann made a point of returning to the Judengasse (Jewish street) in Amsterdam for a series of paintings and drawings (1908; pl. 52), where he emphasized the crowds and bustle of the busy site. These pictures are not charged with any religious overtones; rather, they offer the same combination of daily life scenes—chiefly markets—which ultimately derive from both Dutch traditions and nineteenth-century urban naturalism. They offer a cozy and much humbler counterpart to the new series of grand urban vistas of Paris produced at the same time by Camille Pissarro.[77]

These trends in Liebermann's work show how the artist accommodated himself to the demands of the contemporary Berlin art world and its connection to the larger currents defined by models and taste emanating from Paris. But as the backlash of conservative religious and nationalist German critics reveals, both Liebermann's Jewish identity and his internationalism remained visible and potentially controversial, despite his visible successes in the form of honors and awards.

Resistance in the East

Circumstances in Eastern Europe after the short career of Maurycy Gottlieb (d. 1879) became far more volatile for Jewish artists. After 1881, the disastrous series of pogroms within the czarist Pale of Settlement made the pictorial depiction of Jewish life in Polish-speaking regions nothing less than the depiction of unmitigated suffering. Compared with such disruptions, the institutional or cultural antisemitism faced by Liebermann becomes nearly insignificant. Samuel Hirszenberg (1865–1908), who emigrated to Palestine in his final year, provides the most powerful imagery of forced migrations.[78] His career offers the ultimate contrast to the bourgeois successes of Liebermann. Possibly born in Drohobycz, the home of Gottlieb, but reared in the large industrial city of Lodz, Hirszenberg was the eldest son of a weaver with a large family, so his background and sympathies clearly lay with the proletariat. His art studies took him to Warsaw and then to Kraków, the center of academic art, and (possibly following the pattern of Gottlieb) as far away as Munich. During the 1890s he worked in Lodz in a period of increasing distress, which appears in his paintings.

Hirszenberg's art emerges from his Jewish identity but eschews the nostalgia or sentimentality often stressed by other contemporary artists who specialized in Jewish subjects, such as Isidor Kaufmann. His early works show Jewish instruction (*Talmud Lesson*, 1887; Kraków), consecrated spaces (*The Jewish Cemetery*, 1892; pl. 29), or home

ritual (*The Sabbath Rest*, 1894; pl. 28), but in contrast to Oppenheim's festive ceremonies, they offer joyless figures who sit absorbed in lonely, individual isolation. The rooms are spare and dimly lit, without warmth or prosperity. Clinging to Jewish life and traditions in this eastern region at century's end looks precarious, even grim.

Even more stark is Hirszenberg's 1904 canvas *Exile* (fig. 32), which presents a frieze of ragged wanderers, huddled with shawls and hats against the snowy cold and gray skies through which they trudge. Emancipation has given way to persecution. This moving work had considerable exposure and success, but principally in the newly emerging specialized art world of international Jewish art exhibitions (London, 1906, and Berlin, 1907) rather than in the mainstream of artistic modernism.[79] This pictorial message of Jewish tragedy found a chiefly Jewish audience.

Another oversize canvas, *The Black Banner* (1905; pl. 27), again features a dreary sky, which forms the backdrop for figures, now in half length, in flight across a landscape. A crowd of Hasidic Jews in dark costume, all males and all ages, move cautiously and on the edge of panic, accompanied by a large bier with an open (prayer) book, toward which a number of hands outstretch. According to Norman Kleeblatt, both the title of the image and its black coloration respond to the formation that same year of a Russian antisemitic political movement, Union of the Russian People, with its armed Black Hundreds, and ultimately refer to recent pogroms (Kishinev and Homel, 1903; Zhitomir, 1905).[80] Here again, Jews are depicted as victims rather than as agents of their own lives and fates.

This is the same type of panic and anguish that Hirszenberg had already symbolized in his monumental 1899 painting *The Wandering Jew* (see fig. 46), which he took with him when he emigrated to Palestine in 1907.[81] In such a vision—and in the legend of the Wandering Jew—the relation between Jews and gentiles can only be conflicted, and

FIG. 32. Samuel Hirszenberg (Polish, 1865–1908). *Exile*, 1904. Oil on canvas; Present whereabouts unknown.

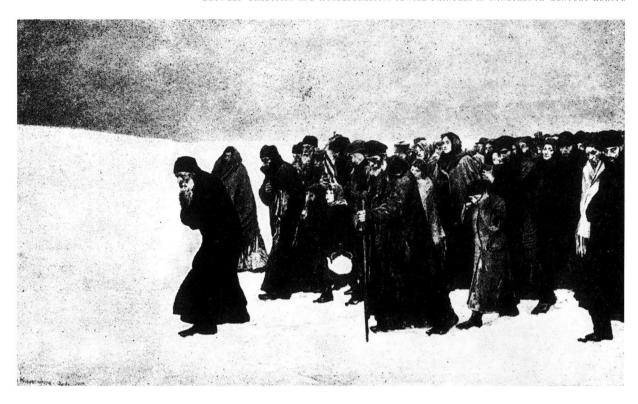

ceaseless. It is significant that Hirszenberg himself emigrated, pursuing an emerging Zionist resolution to the dilemma of Jewish suffering, posed by events but also signaled in his paintings. In the same "Holy Land" in which the Crucifixion took place, his *Wandering Jew* became a local Jerusalem icon, suggesting reconciliation and resolution in the new Eretz Yisrael.[82]

In contrast to Hirszenberg's harrowing later images of Jewish life in breakdown, other Jewish artists presented positive visions of their own religious heritage. Chief among them was Isidor Kaufmann (1853–1921), who grew up in the Rumanian corner of the Austro-Hungarian Empire and after 1875 based his career in Vienna.[83] Kaufmann, like Hirszenberg, responded to the precarious state of Eastern European Jewry (especially within Galicia and Hungary, parts of the empire, as well as the related Jewish communities of the Ukraine and Russian Poland) in the last quarter of the nineteenth century. He also reacted to the attenuation of traditional practices over a century of emancipation. Kaufmann's audience, like Hirszenberg's,

consisted primarily of Jews, but in his case they included the prosperous Vienna bourgeoisie. In effect, Kaufmann portrayed ghetto traditions, tinged with nostalgia, to those Jews who had already emerged from that environment; his art, too, was featured in the new exhibitions of Jewish paintings. These pictures are suffused with sentiment, even where they show the same kinds of spare furnishings and humble settings that Hirszenberg also recorded. Following more closely the precedent of Oppenheim, many of Kaufmann's works show ritual events either in the synagogue (*Hearken Israel*, 1910–15; pl. 21) or at home (*Friday Evening*, c. 1920) and emphasize either prayer or learning. Kaufmann also presents scenes of daily life, or genre scenes, in which colorful characters engage in business or take their leisure (for example, *Chess Problem*, c. 1889). The artist even designed a "Sabbath Room" in 1899 for the Vienna Jewish Museum, showing the degree to which he saw his mission as one of historical preservation of a lost or vanishing world.[84] Kaufmann declared, "Since it is my conviction that the strength of every artist is

rooted in his own people—I became the painter of Judaism . . . to reveal all its beauties and its nobility and . . . to make the traditions and institutions . . . accessible for Gentiles as well."[85]

Kaufmann's paintings straddle the worlds of genre and ethnography, partaking—from an insider's point of view—of the popular nineteenth-century phenomenon of orientalism. Here, however, instead of an exotic, Muslim world presented to an audience of French colonizers, Kaufmann's ghetto vignettes with their picturesque details pay nostalgic tribute to a vanishing ghetto or shtetl, depicting "foreigners at home" in the midst of a majority, modern, urban culture. The ambivalence of such imagery abides in its resistance to the dislocation or alienation of modernity, while still addressing an urban, bourgeois, modern audience whose lives can no longer resemble those of the figures depicted.

If we examine Kaufmann's late canvas *Friday Evening*, we see an emphasis on the embroidered costume with folk headdress of the seated woman; her traditional costume complements the pair of lighted Sabbath

candles, wine cup, covered challah, and prayer book on her table. Her candlelit chandelier adds to the sense of village nostalgia in an era of electrified lighting. The world Kaufmann depicts could not correspond to the Jewish life experienced by his collectors, cosmopolitan Jews of Vienna; instead, such pictures offered a comforting vision of an enduring tradition, which those now in the city may remember from an earlier generation but which is still maintained in "the provinces" beyond the capital. For Kaufmann, as for Hirszenberg, the religious dimension of Judaism remained the foundation of Jewish identity within Austria-Hungary. Significantly, this is also a world that remains free of disturbances, let alone the pogroms and forced exile of Hirszenberg's ragged crowds.

We have examined Jewish artists from Eastern Europe whose ethnic identity was clearly visible in their work. Whereas Kaufmann, like Liebermann, worked in liberal, German-speaking Vienna, both thought of the Jewish community as a minority subculture within a sophisticated imperial melting pot. Liebermann took an integrationist (or, more negatively viewed, an assimilationist) approach to art-making within a larger artistic community, whereas Kaufmann reaffirmed his own Jewish identity, ethnic as well as religious, through ethnographic engagement with much more traditional Orthodox Jewish life in the provinces of Austria-Hungary (although neither Kaufmann nor his audience ultimately identified with this depicted world). In contrast, Hirszenberg, with his proletarian roots, saw the Jewish community in industrial Poland as having more than a religious heritage; it functioned as a political entity, too, a "nation" seeking its rights and freedoms (including freedom from want and suffering), and was thus ultimately open to Zionism as a serious political and cultural option.[86]

Conclusions: Ethnics and Ethics

Our portrait of the end of the nineteenth century reveals a broad spectrum of responses to the novel situation of trying to be a Jewish artist. On the one hand, we see in Western Europe the possibility of an artist being fully assimilated into the art-world culture of his day, addressing the principal themes and using the predominant pictorial techniques. Such an artist's career could serve as the source of his personal identity, with no visible trace of his Jewish heritage in his art. The paradigmatic case is Camille Pissarro in France, whose universalist and modernist outlook, heavily flavored with political anarchism, underlies his depiction of rural settings and laboring peasants. It could also be argued that Pissarro remained perennially conscious of his outsider status, including his Jewish identity, and that his political activism (often in the form of socialism in the nineteenth century) is itself a traditional Jewish cultural outlook, as it is particularly oriented toward remedying the conditions of oppression.

By contrast, the situation could not be more different in Polish Eastern Europe, where Jews, as one of many ethnic groups, thought of themselves as constituting a "nation" with its own claims to rights and its own identity. Hence, it is hardly surprising to find artists featuring Jewish figures, usually Orthodox or Hasidic men, as the central themes of their art. Sometimes this attention takes nostalgic forms, such as the picturesque themes of shtetl life produced by Isidor Kaufmann for an altogether different kind of Jewish audience in Vienna. But for those artists who identified more specifically with their subjects, particularly as politically committed foes of oppression, the Polish world of Hirszenberg (or Pilichowski or Minkowski) becomes a visual record of pogroms, suffering, and exile. In this respect, the extremes of both geography and Jewish culture come together: Pissarro's universalizing political radicalism meets more parochial Jewish politics of oppression, often admixed with socialism or

communism, to combat antisemitism around the Pale of Settlement.[87]

In similar fashion, the availability of Jewish figures and activities as pictorial subjects varied enormously by country and period. We have seen the degree to which the biblical and mythic or historical themes that had previously been the hallmarks of serious art were eliminated in Western Europe during the last third of the nineteenth century. These were for the most part replaced by picturesque genre subjects, often of exotic flavor, which permitted artists to include Jewish costumes and customs amid other "oriental" groups from colonies in the distant Levant or closer to home (peasants, Gypsies). The career of Moritz Oppenheim epitomizes this art-historical trajectory, as he moves from Nazarene-influenced Old Testament subjects to themes of comfortable, virtuous, and observant Jewish life in modern Germany. Later in the century, Jozef Israëls specialized in genre scenes of humble peasant life; only in his later years did he include distinctly Jewish figures and activities.

In the twentieth century, increased oppression and a rising tide of antisemitism would influence art-making by many Jewish artists, even those who had become more acculturated. Moreover, they were now faced with the new choices posed by Zionism.[88]

Max Liebermann, who was born in 1847, lived two years into the regime of Adolf Hitler in Berlin. He would express his opinions in print several times on the issue of what constituted "Jewish art." In 1901, the same year he wrote an essay in praise of international artists at the Secession exhibition, he wrote an essay that praised Jozef Israëls specifically in terms of his "race": "With the great interiority of his nation and race Israëls immerses himself in Nature, where the expressions of a compassionate life are shown at their most naive: in the life of the poor and suffering . . . Israëls paints effort and work like the psalmist, who calls life precious if it comprised effort and work. Out of Israëls speaks atonement, something of the

serene peace of the philosopher, who renounces everything because he understands everything."[89] In 1909 the author Richard Dehmel (whose portrait Liebermann would paint that same year; Hamburg, Kunsthalle) wrote a dialogue between a fictional painter (Liebermann) and a fictional poet (Dehmel) entitled "Culture and Race" (*Kultur und Rasse*).[90] Whereas the poet defends cultural borrowings and mixtures as indispensable components of an artistic golden age, something generally human (*allgemein menschlichen*) or universal, the painter seems to advocate a racial dimension to artistic creativity, even as a quality or accomplishment that can be judged (an argument similar to those made by Liebermann's anti-Jewish detractors in real life).

Events would catch up with Liebermann in his later years. His works were associated with "degenerate art" (*entartete Kunst*) in the famous Nazi exhibitions of disgraced modern German art (though not in the famous 1937 Munich exhibition, reconstructed in Los Angeles in the early 1990s), and he left the academy a mere three months before Nazi laws would have compelled him to do so.[91] When the director of the Tel Aviv Museum issued him an invitation to follow the example of Hirszenberg and emigrate to Palestine, he revealed his acquired sympathy for Zionism but nevertheless declined the offer: "I always stood far from Zionism. Today I think otherwise. I have awakened from my dream, which I dreamed for my entire life. Next month I will be 86 years old, and since I am unfortunately such an old tree, it is impossible to transplant me."[92]

Even with the establishment of a Jewish homeland (not yet a sovereign state), dilemmas still remained for Jewish artists, even those who seemed most acculturated. Those who did not emigrate to Palestine or to the Gan Eden of America faced the ultimate persecution of a rising Nazi tide, which made life difficult for the aged Liebermann but would overwhelm succeeding generations of Jewish talent.[93]

NOTES

1. In many ways, the degree of embrace of one's religious tradition, in contrast to one's sense of Jewishness as a nationality or ethnic group, forms the first divide between these artists, just as it does for many of the Jewish political thinkers at the turn of the twentieth century. For an analytical overview of these issues in political (but also cultural) terms, see Ezra Mendelsohn, *On Modern Jewish Politics* (Oxford: Oxford University Press, 1993), where distinctions are made not only by outlook but also by the geographical, political, and cultural situations of Jews in different countries.

2. *Moritz Oppenheim: The First Jewish Painter*, exh. cat. (Jerusalem: The Israel Museum, 1983). For this period in German Jewish history, see the fine study by David Sorkin, *The Transformation of German Jewry 1780–1840* (Oxford: Oxford University Press, 1987).

3. Keith Andrews, *The Nazarenes: A Brotherhood of German Painters in Rome* (Oxford: Clarendon Press, 1964); William Vaughan, *German Romantic Painting* (New Haven, Conn.: Yale University Press, 1980), 163–91.

4. *Moritz Oppenheim*, 81, no. II.3 (oil on cardboard).

5. According to Oppenheim's *Reminiscences*, quoted in *Moritz Oppenheim*, 81–82, the revered Danish sculptor in Rome, Berthel Thorvaldsen, bought his 1823 *Return of Tobias* and recommended him to Count Ingenheim, half-brother of the king of Prussia, who commissioned the *Dismissal of Hagar*. *Christ and the Woman of Samaria* (1823; Jerusalem, The Israel Museum) as a contest piece for the Academy of Saint Luke in Rome. Oppenheim won the prize but drew protests for being both German and a Jew. On the theme of the Samaritan woman in Christian art up to the time of Rembrandt (for whom it was a favorite subject in the 1650s), see Donald McColl, "Christ and the Woman of Samaria: Studies in Art and Piety in the Age of the Reformation" (Ph.D. diss., University of Virginia, 1996).

6. Elisheva Cohen, "Moritz Daniel Oppenheim: His Life and Art," in *Moritz Oppenheim*, 7–29, esp. 15. Veit, a member of the Nazarenes in Rome, was a Catholic convert and a grandson of Moses Mendelssohn; he later became director of the Staedel Art Institute in Frankfurt and lived there between 1830 and 1845. On the general importance of Mendelssohn in German Jewish history, see Sorkin, *The Transformation of German Jewry*, esp. 8, 97–104. See also David Sorkin, *Moses Mendelssohn and the Religious Enlightenment* (Berkeley and Los Angeles: University of California Press, 1996).

7. Sorkin, *Moses Mendelssohn*, 25–30, recounts the dialogue between Lavater and Mendelssohn in the years 1769–70. The Christian offered his Jewish counterpart a "golden bridge" to conversion, challenging Mendelssohn to defend his faith against a French apology for revealed Christianity. Mendelssohn responded philosophically, defending toleration but repudiating revelation as foreign to philosophy. On the painting, see Richard I. Cohen, *Jewish Icons: Art and Society in Modern Europe* (Berkeley and Los Angeles: University of California Press, 1998), 163–66.

8. *Moritz Oppenheim*, 19–23, 80, nos. I.14, I.19–20.

9. Ibid., 79–80, nos. I.9–12, I.15. The correspondence between Oppenheim and Riesser is translated in ibid., 65–77. See also Sorkin, *The Transformation of German Jewry*, 144–46.

10. Fritz Novotny, *Painting and Sculpture in Europe 1780–1880*, 2d ed. (Harmondsworth: Penguin, 1970).

11. Ismar Schorsch, "Art as Social History: Oppenheim and the German Jewish Vision of Emancipation," in *Moritz Oppenheim*, 31–61, esp. 32, 39–40, 52. See also Elisheva Cohen, "Moritz Daniel Oppenheim," 23, 27; Richard I. Cohen, *Jewish Icons*, 163; Norman Kleeblatt's entry in Norman L. Kleeblatt and Vivian B. Mann, *Treasures of The Jewish Museum* (New York: Universe Books, 1986), 148–49; and Norman Kleeblatt, "Departures and Returns—Sources and Contexts for Moritz Oppenheim's Masterpiece, *The Return of the Volunteer*," in *Moritz Daniel Oppenheim: Jewish Identity in Nineteenth-Century Art*, ed. Georg Heuberger and Anton Merk, exh. cat. (Frankfurt am Main: Jüdisches Museum der Stadt Frankfurt am Main, 1999), 113–30. For Oppenheim and Goethe, see Liliane Weissberg and Georg Heuberger, "The Rothschild of Painters and the Prince of Poets" in ibid., 142–43, 368, cat. no. III.20. Goethe had first met Felix when the composer was a precocious twelve-year-old in 1821, and the musician eventually dedicated an 1825 quartet to Goethe and participated in its performance before its dedicatee. I am most grateful to my colleague, Prof. Weissberg, for sharing her researches prior to publication.

12. Quoted by Schorsch, "Art as Social History," 52.

13. Andreas Götzmann, "Traditional Jewish Life Revived: Moritz Daniel Oppenheim's Vision of Modern Jewry," in *Moritz Daniel Oppenheim*, 323–50; Barbara Gilbert, "Moritz Oppenheim's Illustrations to *Stories from Jewish Family Life* by Salomon Hermann Mosenthal," in *Moritz Daniel Oppenheim*, 251–58; Shalom Sabar, "In the Footsteps of Moritz Oppenheim: Hermann Junker's

Postcard Series of *Scenes from Traditional Jewish Family Life*," in *Moritz Daniel Oppenheim*, 259–72. The Frankfurt catalogue, 373, 404, also charts the illustrations to these *Bilder aus dem altjüdischen Familienleben*.

14. Schorsch, "Art as Social History," 50–51; Richard I. Cohen, *Jewish Icons*, 167–68, fig. 95.

15. Schorsch, "Art as Social History," 40–41, 43, identifies the book the old woman pores over as the *Ze'enah ure'enah*, "the Yiddish anthology of Rabbinic homily and exegesis for women in the Ashkenazi world."

16. This tradition is sensitively sketched by Richard I. Cohen, *Jewish Icons*, 10–67, esp. 52–67 for Germany in the eighteenth century.

17. The key work on Gottlieb is the catalogue by Nehama Guralnik, *In the Flower of Youth: Maurycy Gottlieb 1856–1879*, exh. cat. (Tel Aviv: Tel Aviv Museum of Art and Dvir Publishers, 1991). This should be supplemented with a pair of articles: Larry Silver, "Jewish Identity in Art and History: Maurycy Gottlieb as Early Jewish Artist," in *Jewish Identity in Modern Art History*, ed. Catherine M. Soussloff (Berkeley and Los Angeles: University of California Press, 1999), 87–113; Ezra Mendelsohn, "Art and Jewish History: Maurycy Gottlieb's *Christ Preaching at Capernaum*," *Zion* 62, no. 2 (1997): 173–91 (Hebrew). I am most grateful to Richard Cohen for calling the latter article to my attention and summarizing its contents. It has particularly nuanced sensitivity to the religious politics of Gottlieb's Poland, where the Association Shomer Israel and the broader Galician "integrationist" movement is adduced as important for the artist.

18. On the Polish orientation of Gottlieb, see Jerzy Malinowski, "Maurycy Gottlieb: A Polish Perspective," in *In the Flower of Youth*, 93–109. Polish art history is now reclaiming Gottlieb, just as Austrian art history is reclaiming Isidor Kaufmann.

19. On Rembrandt's self-portraits, with emphasis on their own role-playing and costumes, see Perry Chapman, *Rembrandt's Self-Portraits: A Study in Seventeenth-Century Identity* (Princeton, N.J.: Princeton University Press, 1989); on the importance of Rembrandt in the artistic formation of Gottlieb, see Silver, "Jewish Identity in Art and History." The nineteenth-century historiography of Rembrandt studies has yet to be studied, but for the vital importance of this artist as a paradigm of the emerging discipline of art history, a book-length analysis of the major late-nineteenth-century figures in Holland and Berlin is being completed by Professor Catherine Scallen.

20. Rembrandt served as a spiritual role model for Jewish artists after Gottlieb as well, including Marc Chagall,

whose *Self-Portrait with Brushes* (1909) not only has the gray tonalities of Rembrandt (and Frans Hals) but also the jaunty beret so often affixed to the Dutch artist's own self-portraits. Chagall inscribed Rembrandt's name in Hebrew letters on his painting (1915; Saint Petersburg, Russian Museum) and also referred to his idol in his early autobiography *My Life*: "Neither Imperial Russia nor Soviet Russia needs me. . . . I'm certain Rembrandt loves me." Monica Bohm-Duchen, *Chagall* (London: Phaidon, 1998), 46–47.

21. The term "orientalism" derives from the ideological critique of Western attitudes toward an Eastern "other," articulated initially by Edward Said, *Orientalism* (New York: Vintage, 1979). The nineteenth-century visual version of orientalism, chiefly directed toward Muslim Mediterranean culture in French art, is discussed by Linda Nochlin, "The Imaginary Orient," in *The Politics of Vision: Essays on Nineteenth-Century Art and Society* (New York: Harper and Row, 1989), 33–59.

22. Nehama Guralnik, "Maurycy Gottlieb: Ahasuer and Dreamer. A Polish-Jewish or Jewish-Polish Artist?" in *In the Flower of Youth*, 27–75, esp. 36–37.

23. Sander Gilman, *The Jew's Body* (New York: Routledge, 1991), esp. 60–104, 169–93; also Sander Gilman, *Jewish Self-Hatred: Anti-Semitism and the Hidden Language of the Jews* (Baltimore: Johns Hopkins University Press, 1986). For some of these stereotypical and caricatural images, see Michael Marrus, "Popular Anti-Semitism," in *The Dreyfus Affair: Art, Truth and Justice*, ed. Norman L. Kleeblatt (New York: The Jewish Museum; Berkeley and Los Angeles: University of California Press, 1987), 50–61; Gale Murray, "Toulouse-Lautrec's Illustration for Victor Joze and Georges Clemenceau and Their Relationship to French Anti-Semitism of the 1890s," in *The Jew in the Text*, ed. Linda Nochlin and Tamar Garb (London: Thames and Hudson, 1996), 57–82.

24. Guralnik, *In the Flower of Youth*, 52–54, fig. 25; Silver, "Jewish Identity in Art and History," 92–93. Gottlieb won a gold medal in Munich for this painting, which derives from act 2, scene 5 of Shakespeare's play. Here, female control of the household keys is the source of betrayal of trust; the daughter turns against her father at the behest of a Christian seducer. The young Oppenheim also produced an early image, currently unlocated, of this pair (*Moritz Daniel Oppenheim*, 368, no. IV.1).

25. Guralnik, *In the Flower of Youth*, 54–57.

26. Ibid., 57–59; Silver, "Jewish Identity in Art and History," 94–98, emphasizing the importance of Rembrandt etchings as a source for the Dutch costumes. The synagogue would have been the grand Portuguese

Synagogue, built just a block from Rembrandt's own house on the Jodenbreestraat in Amsterdam.

27. Guralnik, *In the Flower of Youth*, 38–42, 87.

28. Quoted in ibid., 39–40.

29. It is worth noting that in several small, broadly painted sketches of 1878–79, Gottlieb attempted to pursue the same kind of genre scenes as Oppenheim, but still with greater detachment and less sentiment. *In the Flower of Youth*, cat. nos. 50, 56 (both signed): *Jews in the Synagogue* (Lemberg, Painting Gallery), a subject of a small Rembrandt etching (B. 126, 1648); *Rabbi's Blessing* (Rehovot, Weizmann Institute of Science). Compare Oppenheim's *Rabbi's Blessing* (1866; New York, The Jewish Museum; illustrated in *Moritz Oppenheim*, 53, and *Moritz Daniel Oppenheim*, VI.9).

30. Guralnik, *In the Flower of Youth*, 44–49. See also Ziva Amishai-Maisels, "The Jewish Jesus," *Journal of Jewish Art* 9 (1982): 92–96.

31. Guralnik, *In the Flower of Youth*, 49–51; early references mention other, presumably lost, Gottlieb studies for works from the Christian New Testament, including a sketch for *Christ after the Flagellation* (1878). See also Malinowski, "Maurycy Gottlieb," 103 n. 10; Guralnik, "Maurycy Gottlieb: Ahasuer and Dreamer," 49 n. 31, suggests that some of these titles might be variants of the Capernaum composition, for which there were several studies, one of which apparently bore the inscription (in Hebrew): "Love thy neighbor as thyself " (51 n. 39).

32. Silver, "Jewish Identity in Art and History," 102–5, fig. 14.

33. Quoted by Guralnik, *In the Flower of Youth*, 51 n. 40.

34. Pissarro was one of the last major Impressionist figures to enjoy the boom of attention to the movement, but now a substantial literature exists. See, in particular, *Pissarro*, exh.cat. (Boston: Museum of Fine Arts, Boston, in conjunction with the Arts Council of Great Britain, 1980); Ralph Shikes and Paula Harper, *Pissarro, His Life and Work* (New York: Horizon, 1980); Christopher Lloyd, ed., *Studies on Camille Pissarro* (New York and London: Routledge, 1986); and Richard Brettell, *Pissarro and Pontoise* (New Haven, Conn.: Yale University Press, 1990).

35. For a view of Pissarro's early work, see Shikes and Harper, *Pissarro, His Life and Work*, 17–34; the exhibition catalogue *Pissarro*; and Brettell, *Pissarro and Pontoise*.

36. Shikes and Harper, *Pissarro, His Life and Work*, 226–41. The finest study of Pissarro and politics is John

Hutton, *Neo-Impressionism and the Search for Solid Ground* (Baton Rouge: LSU Press, 1994), esp. 67–68, 181–89; this supersedes Eugenia Herbert, *The Artist and Social Reform: France and Belgium 1885–98* (New Haven, Conn.: Yale University Press, 1961).

37. Quoted by Shikes and Harper, *Pissarro, His Life and Work*, 232, with the illustration of the drawing.

38. Quoted in ibid., 234. See also the illuminating essays in *The Dreyfus Affair*, esp. Linda Nochlin, "Degas and the Dreyfus Affair: A Portrait of the Artist as an Anti-Semite," 96–116 (Pissarro is discussed on 97–99).

39. Mendelsohn, *On Modern Jewish Politics*, 49.

40. Nicholas Mirzoeff, "Pissarro's Passage: The Sensation of Caribbean Jewishness in Diaspora," in *Diaspora and Visual Culture: Representations of Africans and Jews*, ed. Nicholas Mirzoeff (London and New York: Routledge, 2000), 57–75. I am most grateful to Professor Mirzoeff for sharing his stimulating paper prior to publication as well as for other ideas on this topic in friendly discussion.

41. Quoted in Shikes and Harper, *Pissarro, His Life and Work*, 142.

42. Quoted in ibid., 157. Millet was noted for his religious overtones in such paintings as *The Angelus*, which accorded with the humble piety generally associated with peasants in nineteenth-century art. See Richard and Caroline Brettell, *Painters and Peasants in the Nineteenth Century* (New York: Skira, 1983), esp. 100–101. Pissarro also later took exception to the religious themes of Gauguin.

43. Quoted in Shikes and Harper, *Pissarro, His Life and Work*, 178, who note that "[f]or all his close friendships, he still felt insecure, the outsider, the alien" (179). Surely this must have remained true for almost all Jewish artists, even those who, like Max Liebermann in Berlin and Jozef Israëls in Holland, achieved signal successes. As a Danish citizen as well as an immigrant from the Caribbean, however, Pissarro had a special burden of outsider consciousness. He sometimes spoke also of his "Creole temperament" (ibid., 193). According to Mirzoeff ("Pissarro's Passage," 64–67), there were subtle distinctions in Pissarro's France between "a fully assimilated French Jew, an *Israélite*, rather than the supposedly less refined, Eastern European *Juif*. Both terms were perceived as ethnic classifications, rather than referring to religion, which was often designated as *hébraïque*, or Hebrew." See also Aron Rodrigue, *Images of Sephardi and Eastern Jewries in Transition: The Teachers of the Alliance Israélite Universelle, 1860–1939* (Seattle: University of Washington Press, 1993). Mirzoeff also

notes that Renoir's antisemitic views were frequently bound up with the association of Jews with radical politics.

44. Quoted by Shikes and Harper, *Pissarro, His Life and Work*, 221.

45. Quoted by Joachim Pissarro, *Camille Pissarro* (New York: Rizzoli, 1992), unpag. Mirzoeff ("Pissarro's Passage," 60) notes, however, that Pissarro did sometimes sit *shiva*, the Jewish ceremony of mourning the dead, and that he occasionally observed Yom Kippur as well as gave help to young Jewish artists late in his career.

46. Mirzoeff ("Pissarro's Passage," 67–69) argues that Pissarro's concerted and ongoing experiments with recording vision, especially on a "modern" or "scientific" basis, was in part the product of his ethnic insecurity that color itself (like color blindness, a product of genes) was a racially inferior way of seeing, which he, as both southerner and Jew, could not otherwise overcome.

47. For Israëls, see *The Hague School: Dutch Masters of the Nineteenth Century*, ed. Ronald de Leeuw, John Sillevis, and Charles Dumas, exh. cat. (London: Royal Academy, 1983), 20–22, 33, 45, 77, 81, 92–94, 186–99; *Dutch Painting: The Age of van Gogh 1880–1895*, ed. Richard Bionda and Carel Blotkamp, exh. cat. (Glasgow and Amsterdam: Van Gogh Museum, 1990–91), 160–62. See, too, the definitive retrospective catalogue: *Jozef Israëls 1824–1911*, ed. Dieuwertje Dekkers (Groningen: Groniger Museum; Amsterdam: Jewish Historical Museum; Zwolle: Waanders Publishers; Groningen: Institute of Art and Architectural History [RuG], 1999).

48. This overall phenomenon is still much understudied relative to the scholarly (and popular) emphasis on landscape painting (leading to Impressionism), but there are some initial forays, most notably Patricia Mainardi, *Art and Politics of the Second Empire* (New Haven, Conn.: Yale University Press, 1987), esp. 154–97, where she discusses both "the death of history painting" and the "triumph of genre" between the two World's Fair expositions in Paris (1855 and 1867). See also Gabriel P. Weisberg, *The Realist Tradition: French Painting and Drawing, 1830–1900*, exh. cat. (Cleveland: The Cleveland Museum of Art, 1980); Linda Nochlin, *Realism* (Harmondsworth: Penguin, 1971). A good anthology of criticism is Elizabeth Gilmore Holt, *The Art of All Nations: 1850–1873* (New York: Doubleday, 1981).

49. *Jozef Israëls 1824–1911*, 150–52, no. 15.

50. Ronald de Leeuw, "Jozef Israëls and Rembrandt," in *Jozef Israëls 1824–1911*, 42–53.

51. Peter Sutton, *Northern European Paintings in the Philadelphia Museum of Art* (Philadelphia: Museum of Art, 1990), 133–35; from the same collection see also *Old Friends* (1877?), with a seated old man and his dog (136–37), and *The Fisherman's Family* (138–39).

52. For example, *The Frugal Meal* (1876; Glasgow); see *Jozef Israëls 1824–1911*, 191–93, no. 32. Israëls is usually cited in general studies of nineteenth-century art for his influence on the early van Gogh, particularly the latter's celebrated *Potato Eaters*. See, for example, Nochlin, *Realism*, 197, citing *The Frugal Meal*; also Brettell and Brettell, *Painters and Peasants*, 93–94, with illustrations. For the Dutch tradition, see Peter Sutton, *Masters of Seventeenth-Century Dutch Genre Painting*, exh. cat. (Philadelphia: Museum of Art, 1984), 307–8, no. 102, by Jan Steen (1662); Eddy de Jongh and Ger Luijten, *Mirror of Everyday Life: Genreprints in the Netherlands 1550–1700*, exh. cat. (Amsterdam: Rijksmuseum, 1997), 124–28, no. 20; more generally, Wayne Franits, "The Family Saying Grace: A Theme in Dutch Art of the Seventeenth Century," *Simiolus* 16 (1986): 36–49; P. J. J. van Thiel, "*Poor Parents, Rich Children* and *Family Saying Grace*: Two Related Aspects of the Iconography of Late-Sixteenth- and Seventeenth-Century Dutch Domestic Morality," *Simiolus* 17 (1987): 90–149.

53. Richard I. Cohen, *Jewish Icons*, 209, mentioning the Berlin exhibition of 1907; 238, 245, emphasizing the influence on Pilichowski.

54. Edward van Voolen, "Israëls: Son of the Ancient People," in *Jozef Israëls 1824–1911*, 54–70. For *A Jewish Wedding*, see ibid., 268–71, no. 66.

55. Van Voolen, "Israëls," 226 n. 7.

56. *The Hague School*, 80 n. 9. Thoré saw the work of Israëls at the 1867 Paris Exposition Universelle and in his review exclaimed, "Israëls takes the lead among his compatriots, and even, in my opinion, among his foreign rivals. . . . [in the] *Rabbi David*, a portrait study in the style of Rembrandt . . . Israëls paints what he sees and he paints it very well."

57. The influential French critic Duranty said of Israëls in 1878: "A man with his heart in the right place, a moved and moving artist, Israëls . . . adds to the genius of the old Dutch School something that, among the old masters, is to be found only in the great spirit of Rembrandt" (*The Hague School*, 81 n.15).

58. Robert Jensen, *Marketing Modernism in Fin-de-Siècle Europe* (Princeton, N.J.: Princeton University Press, 1994), 63, 139–44, includes Israëls within the broader European group of artists he characterizes as the *juste milieu*: "The

juste milieu came to believe that they worked exclusively to maintain the highest standards of art against the contemporary impoverishment of popular tastes and the traditional fare at the Salon or the Royal Academy [P]rofessing no vested interest except the calling of 'art' . . . they consistently asserted art's independence from the material and ideological conflicts of the day, whether it be between naturalism and academicism, or between Impressionism and Symbolism."

59. The general concept of the interlocking "artworld" derives from the work of sociologists of art, notably Howard Becker, *Art Worlds* (Berkeley and Los Angeles: University of California Press, 1982), and Raymonde Moulin, *The French Art Market*, trans. Arthur Goldhammer (1967; New Brunswick, N.J.: Rutgers University Press, 1987). For the philosophical underpinnings of the term "artworld," in which definitions of works of art are refined and revised against traditions and current practice, see Arthur Danto, "The Artworld," *Journal of Philosophy* 61 (1964): 571–84: "To see something as art requires something the eye cannot descry—an atmosphere of artistic theory, a knowledge of the history of art: an artworld" (580). See also George Dickie, *Art and the Aesthetic: An Institutional Analysis* (Ithaca, N.Y.: Cornell University Press, 1975).

60. A useful sketch in English can be found in Maria Makela, *The Munich Secession* (Princeton, N.J.: Princeton University Press, 1990), 81–89. The basic sources remain Erich Hancke, *Max Liebermann. Sein Leben und seine Werke* (Berlin: Cassirer, 1923), and Hans Ostwald, *Das Liebermann Buch* (Berlin: Franke, 1930). More recently, analytical treatments have been offered by the essays in *Max Liebermann in seiner Zeit*, exh. cat. (Berlin: Nationalgalerie, 1979), and *Max Liebermann— Jahrhundertwende*, ed. Angelika Wesenberg (Berlin: Alte Nationalgalerie, 1997).

61. Out of an entire library of literature on Impressionism, two interpretive touchstones remain T. J. Clark, *The Painting of Modern Life* (New York: Knopf, 1985), and Robert Herbert, *Impressionism* (New Haven, Conn.: Yale University Press, 1988). On peasant themes, a useful survey is Brettell and Brettell, *Painters and Peasants*, plus the seminal article by Robert Herbert, "City vs. Country: The Rural Image in French Painting from Millet to Gauguin," *Artforum* 8, no. 6 (1970): 44–55.

62. Peter Paret, *The Berlin Secession: Modernism and Its Enemies in Imperial Germany* (Cambridge, Mass.: Harvard University Press, 1980); Peter Paret, "Modernism and the 'Alien Element' in German Art," in *Berlin Metropolis: Jews and the New Culture, 1890–1918*, ed. Emily D. Bilski, exh. cat. (New York: The Jewish Museum; Berkeley and Los Angeles: University of California Press,

1999), 32–57. Nicolaas Teeuwisse, *Vom Salon zur Secession* (Berlin: Deutscher Verlag für Kunstwissenschaft, 1986). For the links between the Berlin Secession and the larger cultural nexus of galleries, museums, and other institutions, including international European links, see Jensen, *Marketing Modernism*, esp. 187–200. Jensen says of Liebermann's role in the Berlin Secession: "He was the society's president, its most prominent artist, and its initial source of prestige and cohesiveness. He was as close to an art prince as Berlin had produced Liebermann was the Secession" (191).

63. Jensen, *Marketing Modernism*, 194.

64. The revival in Parisian art criticism of Vermeer's reputation is just one manifestation of this revival of earlier Dutch painting as a model for realist and Impressionist French painting of the later nineteenth century. See Stanley Meltzoff, "The Rediscovery of Vermeer," *Marsyas* 2 (1942): 145–66; Francis Haskell, *Rediscoveries in Art* (Ithaca, N.Y.: Cornell University Press, 1976), 83–90; Christiane Hertel, *Vermeer: Reception and Interpretation* (Cambridge: Cambridge University Press, 1996); Frances Suzmann Jowell, "Vermeer and Thoré-Bürger: Recoveries of Reputation," in *Vermeer Studies*, ed. Ivan Gaskell and Michael Jonker (Washington, D.C.: National Gallery, 1998), 35–57. See also Frances Suzmann Jowell, "Thoré-Bürger and the Revival of Frans Hals," *Art Bulletin* 56 (1974): 101–17, and "The Rediscovery of Frans Hals," in *Frans Hals*, ed. Seymour Slive (Washington, D.C.: National Gallery, 1989), 61–86. Copies and variants after Hals and Rembrandt were popular exercises by leading artists, such as Courbet and Manet. Another index of the popularity of Dutch art to later-nineteenth-century French artists is the critical appreciation, published in 1882, by the painter Eugène Fromentin, *The Old Masters of Belgium and Holland* (New York: Schocken, 1963).

65. On this general tradition, see Seymour Slive, *Dutch Painting 1600–1800* (New Haven, Conn.: Yale University Press, 1995).

66. Good introductions to this tradition of depiction of either colorful or typical figures include Linda Stone-Ferrier, *Dutch Prints of Daily Life*, exh. cat. (Lawrence, Kans.: Spencer Museum, 1983); Sutton, *Masters of Seventeenth-Century Dutch Genre Painting*; Christopher Brown, *Scenes of Everyday Life: Dutch Genre Painting of the Seventeenth Century* (New York: Abbeville, 1984); de Jongh and Luijten, *Mirror of Everyday Life*.

67. Chana Schütz, "Max Liebermann as a 'Jewish' Painter: The Artist's Reception in His Time," in *Berlin Metropolis*, 146–64.

68. *Max Liebermann in seiner Zeit*, 192–93, no. 26 (Zurich, coll. Marianne Feilchenfeldt).

69. Marion Deshmukh, "Max Liebermann, ein Berliner Jude," in *Max Liebermann—Jahrhundertwende*, 59–64, esp. 61, fig. 2; Marion Deshmukh, "'Politics Is an Art': The Cultural Politics of Max Liebermann in Wilhelmine Germany," in *Imagining Modern German Culture: 1889–1910*, ed. Françoise Forster-Hahn (Washington, D.C.: National Gallery, 1996), 165–83. Liebermann's use of contemporary models for biblical figures as well as the absence of a halo for the young Jesus—described as "the ugliest, most impertinent Jewish boy imaginable"— shocked the conservative, Catholic parliament of Bavaria in Munich, where Liebermann was then living. See also Makela, *Munich Secession*, 33–34, fig. 14.

70. Matthias Eberle, "Max Liebermann zwischen Tradition und Opposition," in *Max Liebermann in seiner Zeit*, 11–40, esp. 36–37; Eberle also discusses the 1879 *Disputation in the Temple*, 31, with comparative works by Adolph Menzel (1852) and Heinrich Hoffmann, figs. 19–20. Makela, *Munich Secession*, 85. On Langbehn's book, see Fritz Stern, *The Politics of Cultural Despair: A Study in the Rise of the Germanic Ideology* (Berkeley and Los Angeles: University of California Press, [1961] 1974), 153–80.

71. Paret, *Berlin Secession*, 170–82; Jensen, *Marketing Modernism*, 235–63.

72. Liebermann's letter of 28 June 1905, printed 7 July 1905, quoted by Paret, *Berlin Secession*, 178 n. 38. In a rebuttal letter (19 July 1905, printed 21 July 1905), Thode says of Liebermann, "But if we ask from the point of view of the general approach we have followed here: is his art essentially German? We would have to say no. . . . Liebermann could just as easily work and live in Holland or France; he lacks any specifically German quality" (ibid., 179 n. 41).

73. Stern, *The Politics of Cultural Despair*.

74. Makela, *Munich Secession*, 85.

75. Herbert, *Impressionism*, 140–93.

76. Liebermann explicitly criticized the conversion of an uncle (Deshmukh, "Max Liebermann, ein Berliner Jude," 62). See Peter Paret's general discussion of the Berlin Jewish community and its cultural influence, "Jüdische Kunstsammler, Stifter und Kunsthändler," in *Sammler, Stiften und Museen. Kunstförderung in Deutschland im 19. und 20. Jahrhundert*, ed. Ekkehard Mai and Peter Paret (Cologne: Böhlau, 1993), esp. 181–84.

77. Richard Brettell and Joachim Pissarro, *The Impressionist and the City: Pissarro's Series Paintings*, exh. cat. (Dallas: Museum of Art, 1992). One might also compare Pissarro's slightly earlier works from the mid-1880s to the early 1890s, presenting rural market scenes around Eragny and Pontoise. Liebermann's site and his detachment from the figures in his scenes might be situated midway between Pissarro's rural and urban extremes.

78. A good introduction to Hirszenberg and related artists from Eastern Europe at the turn of the twentieth century is Richard I. Cohen, *Jewish Icons*, 221–45.

79. For these new Jewish art exhibitions in the early twentieth century, begun in association with Zionist Congresses, see ibid., 207–12.

80. Kleeblatt and Mann, *Treasures of The Jewish Museum*, 106–7.

81. Richard I. Cohen, *Jewish Icons*, 225–30, discusses both the painting and the theme.

82. Cohen (ibid., 213–18) mentions the importance of Hirszenberg's *Wandering Jew* as an icon of Zionism in its new home, the Bezalel Art Institute in Jerusalem.

83. Ibid., 170–75; *Rabbiner-Bocher-Talmudschüler. Bilder des Wiener Malers. Isidor Kaufmann, 1853–1921*, ed. G. Tobias Natter (Vienna: Jüdisches Museum der Stadt Wien, 1995), esp. the essay by Richard Cohen, "Nostalgia and *Return to the Ghetto*: A Cultural Phenomenon in Western and Central Europe," 43–90.

84. Bernhard Purin, "Isidor Kaufmann's Little World: The 'Sabbath Room' in the Jewish Museum of Vienna," in *Rabbiner-Bocher-Talmudschüler*, 145.

85. Quoted by Richard I. Cohen, *Jewish Icons*, 174–75. See also the essay by Cohen in this volume.

86. Recall here the complex movements of national identity in relation to local politics and Zionism as outlined by Mendelsohn, *On Modern Jewish Politics*, esp. 44, 46, 52–53, 60–61 (and for the later history, 63–78), where Poland serves as the most volatile and complex mixture.

87. Mendelsohn's arguments about the conditioning effects of Polish antisemitism on Jewish politics in that country, including six distinctive flavors of socialist Zionism, is worth noting in this regard; see *On Modern Jewish Politics*, 63–78.

88. The young Martin Buber was a powerful advocate of nurturing the Jewish, especially the Zionist, spirit through images. In a lecture given at the Fifth Zionist Congress in Basel (1901), he spoke of "Jewish art" as part of an overall cultural revival, which he felt could only find fulfillment in a Jewish Palestine. See Michael Berkowitz, *Zionist Culture and West European Jewry before the First World War* (Chapel Hill: University of North Carolina Press, 1996), 65–66, 90–91, 129–33; also Richard I. Cohen, *Jewish Icons*, 208; *'Eine neue Kunst für ein altes Volk': Die jüdische Renaissance in Berlin 1900 bis 1924*, exh. cat. (Berlin: Jewish Museum, 1991), esp. 8–9, and on Lesser Ury, an artist in this exhibition (pls. oo, yy), 23–28. For the most recent survey, see Inka Bertz, "Jewish Renaissance—Jewish Modernism," in *Berlin Metropolis*, 164–87, and Emily Bilski, "Images of Identity and Urban Life: Jewish Artists in Turn-of-the-Century Berlin," in ibid., 102–45, with special attention to Ury as well as Ludwig Meidner and Jakob Steinhardt.

89. Published originally in *Zeitschrift für bildende Kunst*, N.F. 12 (1901): 155; quoted in *Max Liebermann in seiner Zeit*, 406, in the entry on Israëls.

90. Deshmukh, "Max Liebermann, ein Berliner Jude," 62; the portrait (no. 75) is on 250.

91. Ibid., 64; *"Degenerate Art": The Fate of the Avant-Garde in Nazi Germany*, ed. Stephanie Barron, exh. cat. (Los Angeles: County Museum of Art, 1991).

92. Quoted in Deshmukh, "Max Liebermann, ein Berliner Jude," 64 n. 23. See also the catalogue from a 150th anniversary exhibition, entitled *Was von Leben übrig bleibt, sind Bilder und Geschichten*, exh. cat. (Berlin: New Synagogue Jewish Center, 1997), esp. the essays by Chana Schütz, " 'Weil ich ein eingefleischter Jude bin . . .': Zur Rezeption des jüdischen im Werk vom Max Liebermann," 67–79, and "Max Liebermann in Eretz Jisrael," 133–46. Schütz quotes Liebermann as saying in 1931: "If I am also not a Zionist—for I am from an earlier generation—so do I still follow the ideal goals, for which it strives, with great interest" (74).

93. For discussion of twentieth-century dilemmas faced by émigré artists, as well as opportunities afforded them, see the recent exhibition catalogue *Transformation: Jews and Modernity* (Philadelphia: University of Pennsylvania, Arthur Ross Gallery, 2001), with the following essays: Larry Silver, "Diaspora, Nostalgia and the Universal: Conditions of Modern Jewish Artists," 13–33; Juliet Bellow, "A Feminine Geography: Place and Displacement in Jewish Women's Art of the Twentieth Century," 35–55; and Harry Rand, "The Art of New York's Jews: A Delicate Lesson," 68–75. For more on Liebermann's Berlin, see Freyda Spira, "Marketing Identities: Works on Paper in Fin-de-Siècle Berlin," in ibid., 56–67.

Gabriel P. Weisberg

Jewish Naturalist Painters: Understanding and Competing in the Mainstream

When one examines the Jewish painters of the fin de siècle, a perplexing question arises. Were these artists divorced from nineteenth-century art because of their identity or were they merely painting another version of contemporary life, albeit one whose themes were somewhat different and sometimes even foreign? If the former, it would seem to make little sense to study them in the context of nineteenth-century non-Jewish art. If the latter, however, we would want to, indeed would have to, contextualize them within the broad currents of European art so as properly to understand their works at all. In choosing between the two possible answers to our question, we have to acknowledge that Jewish artists belonged to all the major schools of European art during the nineteenth and early twentieth centuries, so the issue is not one of style or artistic perspective as much as of how the artists saw themselves within the mainstream and how the broader society responded to them. As a true test of how to answer our question, we should select the most conservative part of the non-Jewish art world, the Salons of the great cities, especially Paris and London, and ask if they gave access and recognition to Jewish artists who painted Jewish scenes. And then, if we discover that Jewish artists did in fact participate in the artistic establishment, we must ask what that meant, not only to the artists but to the broader society.

Isidor Kaufmann, *Blessing the Sabbath Candles* (detail), c. 1900–10. See pl. 19.

To anticipate the examination somewhat, this essay will show that many highly talented Jewish artists responded to the general aesthetic call of critics throughout Europe to paint scenes and people that they knew. They became recorders of scenes of actuality. As they witnessed and studied the careers of other mainstream painters, they, too, wanted to belong, to participate in the recognition given to non-Jewish painters, and they did what was required of them: They studied at well-known art academies. Jewish painters traveled to Munich or Vienna, they went to Italy, they established active careers in England, and most often they took up residence in Paris. When they exhibited their Jewish themes in the Paris Salons, where they also competed for medals, they hoped to see their work accepted by the artistic establishment not only in their own countries of origin but in France, the art center par excellence. And most assuredly, perhaps naively during the 1890s (the era of the Dreyfus Affair in France), Jewish painters hoped that their works would be well received and collected, even by non-Jews.

The Allure of Paris

The desire to exhibit in Paris can be readily seen by looking at a specific case, that of Samuel Hirszenberg, a young artist born in Lodz, Poland.[1] When he exhibited his dark and somber painting *The Black Banner* (1905; pl. 27) at the 1906 Salon of the Société des Artistes Français, he had already established himself as a frequent exhibitor at Paris-based exhibitions, and as a painter following the paths of other Jewish artists who had left Eastern Europe to show their works in Italy or France.[2]

Although Hirszenberg's career was cut short by illness, it epitomizes the position of the Jewish painter at the beginning of the twentieth century: eager to expand his horizons, eager to be trained academically, and aware that it was essential to show works to the most sophisticated public audience in major

European centers in order to have his messages seen and understood not only by Jews but also by non-Jews. Hirszenberg exhibited his paintings at the Salons of the Société des Artistes Français, the most traditional of the Paris Salons, where paintings of decidedly naturalist inflection—scenes often dark in tone and portraying figural types from the urban proletariat—were still among the most important works on show as late as 1910.[3] What is also important is that Hirszenberg, like other Jewish painters of the era, was not afraid to exhibit decidedly Jewish scenes, often in works that contained urgent political messages or demonstrations of sympathy for the Jewish people in times of distress. These canvases were not pleasant viewing experiences. Often highly emotionalized, they conveyed a dramatic urgency that broke the mold of what was acceptable by focusing on the abhorrent ways in which Jews were often treated.[4] Hirszenberg's imagery stressed the suffering of the Jews, especially in Russia, and brought the violent specter of the pogroms directly to the eyes of the French Salon audience.[5] Hirszenberg's urgency, one of his hallmarks, appears again in *The Wandering Jew* (see fig. 46), shown at the Exposition Universelle of 1900, where he won a bronze medal.[6] The painting's theme carries an anxious mood, similar to the anguish and deprivation that the artist found in his own life, and which was being echoed by the unsettling treatment of Alfred Dreyfus in the law courts of France.

Along with other Eastern European Jewish painters, Hirszenberg succeeded in showing his dour, troubling scenes and in finding colleagues in the French establishment, some of them Jews, who sympathized with the themes. One of them would have been Jules Adler, a French Jewish painter who was also a stalwart member and exhibitor at the Salons of the Société des Artistes Français.[7] The suffering endured by the urban poor, their homelessness, was a theme that Adler addressed in a very moving painting, *The Mother* (fig. 33), exhibited at the 1899 Salon of the Société des Artistes

Français.[8] Adler did not seek to be identified as a Jew by the themes or scenes he painted. Rather, he was humanitarian in outlook, one of many French painters who focused on the underclass as a way of symbolically demonstrating that scenes of misery (fig. 34) were necessary in order to bring societal issues to the attention of a larger public audience, with the hope that something could be done to alleviate their condition.[9] Jewish painters appreciated the appeal of this emphasis and used it in their own compositions as a means of attracting favorable attention to Jewish issues, even when antisemitism in France was at a fever pitch.[10] Adler also served another role. His Jewish background, and the fact that his paintings of the impoverished were well received, provided a role model. Painters from outside France, such as Max Liebermann and Lesser Ury, were confirmed in their efforts to exhibit difficult scenes (linked to the plight of Jews) once Adler had won public acclaim for his representations of the poor. His *Mother* was so esteemed at the time that it was secured by a private collector and exhibited in a collection in Poznan, Poland, where it served as a model to be emulated and studied by Eastern European artists on their native soil.

The suggestive points raised above warrant a fuller examination of how Jewish naturalist, or narrative, painters (as distinguished from the modernist painters, who tended toward abstraction and later surrealism) tested their creative talents in the larger arena and showed works that recorded actual Jewish existence and presence in society. This will reveal a larger process of acculturation, as presented in the public exhibitions.

Establishing the Pattern

The careers of Moritz Oppenheim (1800–1882) and Jacques-Émile-Edouard Brandon (1831–1897) show how Jewish painters established themselves publicly and how painters working later in the century followed their example. Both artists recognized that in order to increase their options as

FIG. 33. Jules Adler (French, 1830–1903). *The Mother*, 1899. Oil on canvas; 67 × 51⅜ in. (170 × 130.5 cm). Muzeum Nardow, Poznan, Poland.

FIG. 34. Jules Adler (French, 1830–1903). *The Weary*, 1897. Oil on canvas; 71 × 98½ in. (180 × 250 cm). Musée Calvet, Avignon, France.

creators, they had to be trained in the best academic institutions of their time, and they had to travel, gain experience, and open themselves to the world. Oppenheim, whose career continued into the 1880s, first studied at the Art Academy in Munich. From there, as a trailblazer for Jewish artists, he went on to Paris, where he worked under Henri Regnault at the École des Beaux-Arts, before spending four years in Rome with the Nazarenes, a close-knit, religiously inspired artistic group.[11] In each place, Oppenheim was trained traditionally, worked from the model, and mastered the ways in which non-Jewish painters either referenced historical themes or focused on traditional religious iconography drawn from the life of Christ. As his own approach evolved, Oppenheim turned to the recording of Jewish themes in the early 1830s, when there was a heightened interest in genre painting both in Germany and in France. He maintained this inclination later in small compositions that recorded the Jewish heritage in scenes narrating crucial moments in the life of a Jew, from bar mitzvah to wedding.[12] But the question remains open as to how well Oppenheim's works were known in France and

whether he pursued a public career by showing his work in established venues.

The issue of consciously seeking public exposure can be more clearly determined by examining the career of Brandon, a painter who sought to exhibit in the Paris Salons. Even though Brandon came from a wealthy Jewish family of Spanish-Portuguese descent, he did not fall back on his connections to establish himself as an artist. Still, the fact that he was from a wealthy family gave him the opportunity to do what he wanted. By 1849, recognizing that he had to be competently trained, he entered the École des Beaux-Arts. He was a friend of the landscapist Camille Corot and also had the opportunity to study in Italy. Later, Brandon became an associate of Edgar Degas and was drawn into the circle of younger, adventurous painters who wanted to break with the tenets of tradition by the 1870s.[13] However, Brandon did not completely sever his very strong ties with the establishment. In fact, his early career reveals an admiration for religious genre compositions and large-scale scenes that had a strong public appeal. During the early 1860s, at the height of the Second Empire, he

exhibited a series of paintings at the annual Salon, thereby publicly establishing that this was an appropriate place for a Jewish painter to exhibit his work. Among his compositions were scenes dedicated to the canonization of Saint Brigitte and to her good works. These themes were drawn from Christian iconography and were consistent with the Second Empire's wish to find religious personalities, either past or contemporary, as models for demonstrating the power of religious healing and the need to show compassion toward mankind.[14] It was an era when painters, working closely with government officials, wanted to show a unity between church and state. One of this theme's principal painters was Isidore Pils, who had remarkable success creating scenes that focused on ways in which nuns who showed compassion for the poor were revered for their good work. His *Death of a Sister of Charity*, exhibited at the Paris Salon of 1850–51, became a model of this type of imagery (fig. 35). Later compositions by Pils also illustrated religious figures aiding the poor (fig. 36).[15] Given that painters often received commissions to produce images of this sort, it

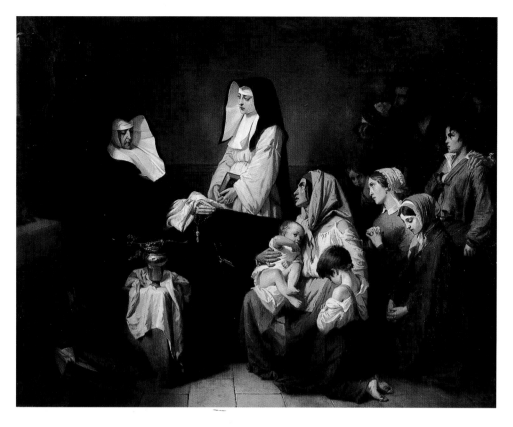

FIG. 36. Isidore Pils (French, 1813–1875).
The Prayer at the Hospice, 1853. Oil on canvas;
103⅞ × 78⅛ in. (263.7 × 198.4 cm). Musée de
l'Assistance Publique-Hôpitaux de Paris, Paris.

FIG. 35. Isidore Pils (French, 1813–1875). *The Death of a Sister of Charity*, 1850. Oil on canvas;
95 1/2 × 120⅞ in. (242.6 × 306.8 cm). Musée d'Orsay, Paris.

is not difficult to understand why Brandon painted similar themes. When he planned a cycle of images (shown at the Salon of 1865) that were to be used for wall paintings in the Oratory of Saint Brigitte, Brandon was working within the mainstream of religious genre painters, who wanted their compositions to be positioned in appropriate church settings.[16] The importance of this series in the evolution of Brandon's career is further highlighted by *The Last Mass of Saint Brigitte* (fig. 37), where, in the interior of a church in the presence of nuns and commoners, Saint Brigitte's body has been placed on a wooden bier. The ability to unite simple people with the life of a saint, and to make the work approachable for a public audience, was a hallmark shift in the category of religious genre art during the 1860s. The sense of piety, the simplicity of the setting, and the intensity of the emotion demonstrate how Brandon absorbed the message implicit in the works of

Pils while trying to reveal himself as a major painter in this category of art.

Along with these canvases Brandon began exhibiting scenes drawn from Jewish life and situated within the interior of a synagogue. Brandon painted very specific scenes, and he identified the synagogue he had visited and the date when the inspiration for the scene had occurred.[17] A work shown in 1867, *The Portuguese Synagogue at Amsterdam*, received the coveted Prix du Salon.[18] It was based on a sermon delivered in July 1866 by the Talmudist David de Jahacob Lopez Cardozo in the Amsterdam synagogue. By providing a sense of religious panoply, and recording the scale and light of the interior, Brandon created a canvas that could compete with the best historical re-creations of the ancient Roman past by Jean-Léon Gérôme, then a Salon favorite, or with works by artists from seventeenth-century Holland, such as Pieter Saenredam, who had similarly captured the

scope and holy atmosphere inside sacred buildings (in his case, churches). Brandon's 1867 painting, among others, helped to establish him as the principal painter of synagogue interiors and Jewish primary schools, categories that were unique for the Salon in Paris. He achieved considerable success during the closing years of the Second Empire. At the 1869 Salon, he exhibited *La Leçon de Talmud* and *La Sortie de la loi le jour de Sabbat*. The latter work appeared as an etching in the distinguished art periodical *Gazette des Beaux-Arts*, which reached a substantial non-Jewish audience.[19]

In spite of Brandon's ties with the establishment, he remained known for his open-mindedness and was linked with members of the Impressionist circle. Brandon maintained these ties by showing works in the first Impressionist exhibition, held in 1874 in the photographer Nadar's studio, which included *Première lecture de la loi* and *Le*

FIG. 37. Jacques-Émile-Edouard Brandon (French, 1831–1897). *The Last Mass of Saint Brigitte*, 1863. Oil on canvas; 83¼ × 68⅜ in. (208 × 171 cm). Musée des Beaux-Arts, Brest, France.

FIG. 38. François Bonvin (French, 1817–1887). *The School for Orphans*, 1850. Oil on canvas; 27⅗ × 35⅖ in. (70 × 90 cm). Musée Saint Didier, Langres, France.

Maître d'école. The latter painting, identified as a scene in a primary school,[20] has been overlooked in the examination of Impressionism. It is significant in revealing what Brandon was trying to achieve in the dissemination of Jewish imagery, associating the composition with traditional realist painting of the Second Empire. It was also lithographed for wide distribution. He showcased the mores of the community by showing how young boys attended school and recited their lessons. Central here are Brandon's ties—visually almost direct—with a well-known painting by the realist artist François Bonvin.[21] In 1850–51, when Bonvin exhibited his *The School for Orphans* at the Salon (fig. 38), he created a paradigm of religious educational training—albeit for young girls—that was widely admired; copies were commissioned from the artist and prints were distributed. Brandon was following this highly regarded model of how schooling and

religious instruction were important for France, and his reference to a well-known composition made his own work more understandable to all.[22] The fact that his painting was lithographed suggests that the Jewish community, through Brandon, had settled on a composition and theme that reused a standard educational setting to deliver its message to Jews and non-Jews: Training for young boys was at the core of Jewish life.

Although Brandon seldom showed at the Salons after exhibiting with the Impressionists, he did send *Prière pour Léopold II, roi des Belges, dans la synagogue de Bruxelles* to the 1889 Salon.[23] Generally regarded as another in the series of interior scenes, the painting had a more specific historical message in its depiction of the prayer offered in the synagogue, after the Torah reading, for the well-being of the local ruler and government. Brandon worked on this theme for several years in an effort to

create a painting that would memorialize the heightened status of Jews in Europe.

The career of Edouard Moyse (1827–1908) established another French painter committed to the depiction of Jewish life. A student of the genre painter Martin Drolling, Moyse had a lengthy Salon career, based on a traditional way of examining and recording daily life that extended even to his depictions of Old Testament scenes, such as *The Covenant of Abraham* (c. 1860; pl. 13). As with Brandon, Moyse often contrasted the Christian religion, through representations of monks, with Jewish figural studies.[24] His *Les Chants religieux* was well received at the World's Fair of 1900.[25] Since he often did paintings of the rabbinate, Moyse was in the vanguard when it came to drawing attention to Jewish themes and providing a voice for specific Jewish types in public exhibitions in Nancy and Paris from the 1870s onward.[26]

No matter their purpose, the paintings of

Oppenheim, Moyse, and especially Brandon were, above all, creating and publicizing Jewish imagery. Brandon's showings at Salons and with the Impressionists helped raise awareness of Jewish life by creating large-scale paintings that competed with non-Jewish reconstructions of the past.

England

Paralleling the careers of Jewish painters in France, members of the Solomon family—Abraham, Rebecca, and Simeon—forged a professional identity in Victorian England. As a scene painter, Abraham Solomon (1824–1862), the eldest painter in the group, was much influenced by the tone of propriety and morality that was at the core of contemporary Victorian painting, especially in the canvases of William Powell Frith, a favorite at the Royal Academy exhibitions. Abraham Solomon also found in modern transportation, such as the railway carriage and its occupants, the symbolic basis for an examination of contemporary mores. His *Second Class—The Parting "Thus part we rich in sorrow, parting poor"* (1855; pl. 35) was one of several scenes that raised a mood of intense social consciousness. His paintings reflect the era's narrative paintings without a strong influence from the Pre-Raphaelite group, an impact that was more visible in the canvases of his younger brother Simeon (1840–1905) and his sister Rebecca (1832–1886).

Rebecca Solomon was the first Jewish woman artist to achieve recognition in England, although she did not gain full public acceptance for her paintings at the Royal Academy until 1858. Her independence was limited by the activities of her brother, her association with members of the Pre-Raphaelite circle, and the fact that women, in general, were judged by a gendered critical standard applied to men.[27] It was Simeon Solomon, however, who revealed the most precocious talent in the family.[28] During the 1860s, contemporaneously with Brandon in France, he used Pre-Raphaelite aesthetic ideas

to create scenes of Judaic history and classical and allegorical themes. His figural types, which owe much to the work of Dante Gabriel Rossetti and Edward Burne-Jones, convey a repressed sexuality, a haunting sensuality that is found in any number of his figural studies and close-up portraits. His pursuit of the themes of homosexuality and lesbianism—imagery that is detectable in his work—led to his arrest for homosexuality in February 1873. He was shunned by his former Pre-Raphaelite friends, and his works (and perhaps by implication, those of his sister) were attacked for depicting unhealthy tendencies.[29] While he did create Jewish themes, it was his forbidden subjects that made him a man of his time—unfortunately for him, a pariah.

As history scene-painting became popular in England, especially during the 1830s and 1840s, Solomon Hart began documenting significant Jewish buildings and moments, similar to what Brandon was to do in France. With his *Interior of a Jewish Synagogue at the Time of the Reading of the Law* (1830), Hart believed that he could favorably influence Parliament toward the Jews. He became the first Jewish member of the Royal Academy. His *Feast of the Rejoicing of the Law at the Synagogue in Leghorn, Italy* (pl. 10), done in 1850, did not simply describe the ornate features of a Jewish synagogue interior but accurately recorded the procession that marked the end of Sukkot. His passion for describing events with great specificity, a trait also found in his imagery depicting English historical and literary scenes, mirrored how he had to balance his career between secular and religious themes, although he painted both in a similar visual style.

Solomon J. Solomon (1860–1927) brought the role of the Jewish painter in England to another level. Born into a cultured and well-established Anglo-Jewish family, Solomon was extremely well trained both in England and in France. By 1878 he was in Paris training with a leading academic, Alexandre Cabanel. Grounded in this tradition, Solomon was also much influenced by the works of Lord Leighton and Lawrence Alma-Tadema, key

members of the classical tradition in England. His *Samson and Delilah* (1887) established his position as a painter of Old Testament scenes. In 1900 he was well represented in the British section at the World's Fair with *Laus Deo*, a large work about a knight guarded by the angel of fame or sanctity.[30] His portraits reflect the grand manner of English, American, and French portraiture at the turn of the century; they linked Solomon to a tradition that allowed him to survive as a creative artist who opposed the growing new strains of abstraction.

Austro-Hungarian Ties

Many young Jewish painters believed in the urgency of creating a Jewish history painting. While Brandon attempted to create imagery based on synagogue scenes, Maurycy Gottlieb (1856–1879) struggled with the issues of visualizing historical reconstructions. The imagery of *Jews Praying in the Synagogue on Yom Kippur* (1878; pl. 15) reveals attention to precise detail and accurate facial types; it conveys a sense of monumentality and solemnity based on the importance of praying on the holiest day of the year. However, questions remain about the reception of Gottlieb's visual message. Were his works widely known at the time? Were his paintings hung publicly? Since there is no record of his ever having exhibited in Paris, his works remain closely allied with art circles and the Jewish community in the Austro-Hungarian Empire. The brevity of Gottlieb's life limits our knowledge about his role in the reception of nineteenth-century genre painting.

The study of Eastern European Jewish life reached a high point with the work of Isidor Kaufmann (1853–1921), who focused on simple activities including yeshiva boys engaged in their studies in a quiet domestic interior. In a direct, naturalistic style, he documented the white shirts and prayer mantles that young scholars wore and in this way maintained a quality of "magical realism," reminiscent of the way in which the

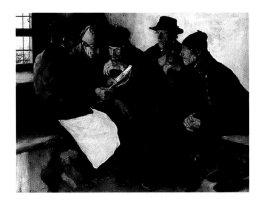

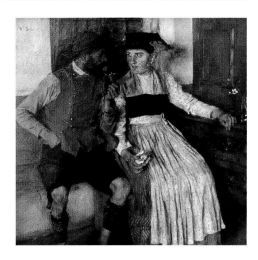

FIG. 39. Wilhelm Leibel (German, 1844–1900). *Village Politicians*, 1876–77. Oil on canvas; 29¾ × 38⅛ in. (75.6 × 96.8 cm). The Oskar Reinhart Foundation, Winterthur, Switzerland.

FIG. 40. Wilhelm Leibel (German, 1844–1900). *In the Rustic Room*, 1890. Oil on wood; 14½ × 15¼ in. (37 × 38.7 cm). Bayerische Staatsgemaldesammlungen, Neue Pinakothek, Munich.

German naturalist painter Wilhelm Leibel studied his elderly Bavarian villagers during the 1870s and 1880s.[31] Leibel's attention to detail, his awareness of the psychological dimension of his sitters, and his interest in detailing an environment (figs. 39–40) became valued examples for other artists. Leibel's impact was widespread and even reached France. Kaufmann's intense portrait studies, where the role and character of the model are carefully visualized, suggest that he was aware of Leibel as an instructive precursor. Since Kaufmann never emphasized moments of anguish in his works, he was able to create a rich repertoire of Jewish types that people could examine without thinking of their precarious position: a rabbi wearing a *kittel* and tallith, a Jewish bride, or a young woman seated in the corner of a synagogue.[32] Other carefully composed studies focused on a specific setting in a synagogue, without anyone present, or on the trades that Jews practiced.

With these works, which depicted a broad spectrum of the world of the shtetl, Kaufmann also continued a meticulous Germanic painting tradition that reached back as far as Hans Holbein. He conveyed a pride in Jewish daily life and prayer rituals in a manner that puts his Jewish naturalist aesthetic on a par with the aesthetic of leading non-Jewish painters in France and Germany. Kaufmann also provides another point of contact demonstrating that his works did not remain

locked in an Eastern European matrix. At the World's Fair of 1900, when Paris was inundated with artworks from all over the world, Kaufmann exhibited two paintings in the Hungarian section of the international exhibition.[33] *Sabbat* and *La Porte des rabbins* were similar in theme (and most likely in visual presentation) to the types of works that Kaufmann produced throughout his career. The fact that he was able to show these paintings in Paris in 1900 demonstrates that he, too, was aware of the significance of being seen in the City of Light. The exhibition of decidedly Jewish themes comes as no surprise, for Kaufmann was among many artists from throughout Europe who were using this moment, at the beginning of the twentieth century, to reveal ethnic themes.

A Return to Paris

Leopold Pilichowski (1869–1933), like Samuel Hirszenberg, was a painter from Lodz, Poland, who had a surprisingly successful career in Paris. After studying at the Académie Julian, Pilichowski was taught by Fernand Cormon, an academic painter with a very strong interest in naturalism.[34] This background must have been helpful, since Pilichowski exhibited a naturalistic painting, *Le Teinturier*, in the Russian section at the 1900 World's Fair.[35] Pilichowski also sought to establish himself as a portraitist—an unusual direction for a Jewish

painter at the time, the 1890s (see fig. 44). He showed portraits—obviously commissions—at the slightly more liberal and more fashionable Salons of the Société Nationale des Beaux-Arts, evidently in an effort to find additional clients.[36] His success as a portraitist is unknown, but he continued to pursue commissions, especially around the time of World War I, when he moved to London to work for very wealthy Jewish clients. In addition, his interest in recording scenes of Jewish daily life, often with a sense of intense observation based on knowing the hardships associated with the pogroms, was maintained in later imagery. The training he received under Cormon led him to treat the character of his Jewish sitters on a large scale, a characteristic clearly retained in his *Women in the Synagogue*.

The impact of revolution and firsthand experience of the pogroms shaped the art of Maurycy Minkowski (1881–1930). *After the Pogrom* (pl. 30), done in 1905, owes a debt to realism but also advances the way that Minkowski referenced what was possible from the art world around him.[37] Even though he was drawing on his own powerful memories of what had happened, Minkowski was determined to use references from the best-known naturalist images of the era. In the intimacy of its figures and their dominance in the composition, and in the cross section of ages, *After the Pogrom* establishes links with a well-known painting by Jean-François

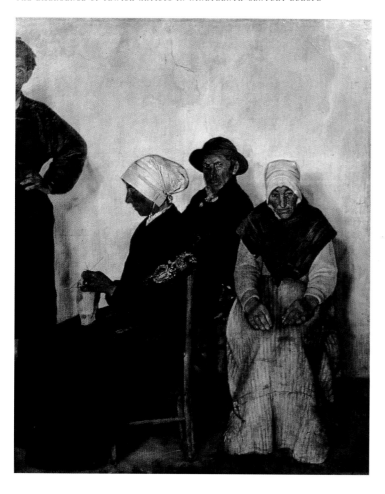

FIG. 41. Jean-François Raffaëlli (French 1850–1924). *The Family of Jean-le-Boîteux, Peasants from Plougansou-Finestère,* 1876. Oil on canvas; 59⅞ × 74 in. (152 × 188 cm). Hôtel de Ville, Le Quesnoy, France.

painters had a visible life on the international art stage in a more profound way than formerly believed.

NOTES

The author is indebted Yvonne M. L. Weisberg, Elizabeth K. Menon, and Elizabeth Mansfield for their suggestions and assistance in preparing this essay.

1. In the 1905 and 1906 Salon catalogues, Hirszenberg gave his official residence as Kraków (Austria) and his city of origin as Lodz. See *Société des Artistes Français, Salon de 1906, Explication des ouvrages de peinture . . . exposés au Grand Palais des Champs Elysées, le 1ᵉʳ Mai 1906* (Paris, 1906), 72. On Hirszenberg and the representation of Jewish life, see Richard I. Cohen, *Jewish Icons: Art and Society in Modern Europe* (Berkeley and Los Angeles: University of California Press, 1998), 223–36.

2. On the position of Jewish genre painters at this time, see Karl Schwarz, *Jewish Artists of the Nineteenth and Twentieth Centuries* (New York: Philosophical Library, 1949), 35–49.

3. While it is difficult to ascertain the number of works that Hirszenberg exhibited at the Société des Artistes Français, there are references to his work in 1889 (when he was noted as having won a bronze medal). Other references are found in the Salon catalogues from 1905 through 1907. In 1907 he showed two paintings, *La Fête au ghetto* and *Crépuscule dans la synagogue.* See *Société des Artistes Français, Exposition annuelle des Beaux-Arts, Salon de 1907, 1ᵉʳ Mai 1907 . . .* (Paris, 1907), 73, nos. 805 and 806.

4. Schwarz, *Jewish Artists,* 37. These paintings cannot be seen as pure genre imagery, as they contain little that is entertaining or sentimental—qualities found in the representative examples of traditional genre painting in the nineteenth century. For further reference to traditional genre scenes, see Gabriel P. Weisberg, *Redefining Genre: French and American Painting, 1850–1900* (Seattle: University of Washington Press; Washington, D.C.: The Trust for Museum Exhibitions, 1995).

5. For further reference to the suffering depicted in Hirszenberg's paintings, see Hyman Lewbin, *Rebirth of Jewish Art: The Unfolding of Jewish Art in the Nineteenth Century* (New York: Shengold Publishing, 1974), 71–75. Also see Cohen, *Jewish Icons,* 223.

Raffaëlli, *The Family of Jean-le-Boîteux, Peasants from Plougasnou-Finestère* (fig. 41), which was on display in the Musée du Luxembourg during Minkowski's stay in Paris. Minkowski used this icon as a reference—notably effective in the compactness and closeness of his figural grouping—to demonstrate, as others had done before him, that a Jewish theme should have visual relationship with a well-established tradition if it was going to be understood. His painting helps unite the ways in which many painters worked in order to gain the public recognition that was necessary to survive.

In Retrospect

European Jewish artists achieved a measure of public success by assimilating mainstream imagery, accepting established exhibition policies, and following the rules of the game. They and some of their French brethren expanded their horizons by finding ways to exhibit their naturalist paintings at the Royal Academy in London, the Salons of the Société des Artistes Français, the World's Fair in Paris (1900), and occasionally at the slightly more fashionable Salons of the Société Nationale des Beaux-Arts. In this way, scenes of everyday Jewish life, as well as portraits, were integrated into mainstream European artistic production. They competed with Jewish painters in France, such as Jules Adler—an artist with a broad following in 1900—and were effectively seen by Jews and non-Jews alike. In presenting traditional and historical Jewish scenes at such well-established exhibitions, Jewish painters demonstrated that they vied with their peers for recognition and that their approaches were timely and contemporary. They revealed their understanding of the Jewish experience in a visual language that was appropriate for the era, thereby demonstrating that Jewish

6. *Exposition internationale universelle de 1900, Catalogue général officiel*, Groupe II—Oeuvres d'art—Classes 7–10 (Paris, 1900), 529, no. 95. On the importance of this painting, see the exhibition catalogue *Bilder sind nicht verboten*, ed. Jürgen Harten, Marianne Heinz, and Ulrich Krempel (Düsseldorf: Städtische Kunsthalle und Kunstverein für die Rheinlande und Westfalen, 1982), no. 58.

7. Georges Denoinville, "Jules Adler," *L'Art et les artistes*, no. 53 (August 1909): 213–17. Adler's paintings focused on the themes of soup kitchens, wanderers in the countryside, and the urban poor. See also L. Barbedette, *Le Peintre Jules Adler* (Besançon: Editions Sequania, 1938), 39, where Adler's Jewish background is noted.

8. *Société des Artistes Français, Explication des ouvrages de peinture, sculpture, architecture, gravure et lithographie des artistes vivants exposés à la Galerie des Machines, le 1er Mai 1899 . . .* (Paris, 1899), 3, no. 12.

9. The societal implications were often ignored in reviews of Adler's work. See Denoinville, "Jules Adler," who notes: "Il n'y a pas d'art social, me disait, un jour, le maître . . . mais mieux un art s'inspirant de toutes les beautés infinies de la vie sociale." Denoinville admits, however, that Adler was a painter of the "popular" and an artist who focused on the daily life of the people, which suggests a democratic bias tinged with social reform.

10. The antisemitic press and its accompanying visual imagery were extremely pointed in Paris at this time. This fact is well documented in *The Dreyfus Affair: Art, Truth and Justice*, ed. Norman L. Kleeblatt (New York: The Jewish Museum; Berkeley and Los Angeles: University of California Press, 1987).

11. For a brief introduction, see *The Oppenheim Pictures: Depicting Jewish Ceremonial Life* (Cincinnati: The National Federation of Temple Sisterhoods, 1930).

12. Elisheva Cohen, ed., *Moritz Oppenheim: The First Jewish Painter* (Jerusalem: The Israel Museum, 1983).

13. Batsheva Goldman-Ida, "A Synagogue Interior by Edouard Brandon," *Tel Aviv Museum of Art Annual Review* 6 (1996–97): 63–64.

14. *Explication des ouvrages exposés au Palais des Champs Elysées, le 1er Mai 1861* (Paris: Charles de Mourgues Frères, Successeurs de Vinchon, 1861), 52, no. 403, under "Canonisation de Sainte-Brigitte." Another painting in this series, *La Charité de Sainte-Brigitte*, was exhibited at the 1864 Salon.

15. On the importance of Pils's compositions, see Gabriel P. Weisberg, *The Realist Tradition: French Painting and Drawing, 1830–1900*, exh. cat. (Cleveland: The Cleveland Museum of Art, 1980).

16. *Explication des ouvrages . . . 1865* (Paris, 1865), 303, nos. 2322 and 2323, under "Frise de l'oratoire de Sainte-Brigitte."

17. See the 1867 Salon catalogue, which gives 22 July 1866 as the date that was recorded by Brandon in his view of the interior of the Amsterdam synagogue.

18. Goldman-Ida, "A Synagogue Interior," 62. On the specifics of this painting, see William R. Johnston, *The Nineteenth-Century Paintings in the Walters Art Gallery* (Baltimore: Trustees of the Walters Art Gallery, 1982), no. 150, illus. 131.

19. "Salon de 1869," *Gazette des Beaux-Arts* 2 (1869): 5–23.

20. See *The New Painting, Impressionism 1874–1886* (San Francisco: The Fine Arts Museums of San Francisco, 1986), 199, with a republication of pages from the first Impressionist exhibition catalogue, listing the works shown by Brandon, including no. 32 bis, *Le Maître d'école*.

21. Gabriel P. Weisberg, *Bonvin* (Paris: Éditions Geoffroy-Dechaume, 1979), fig. 9.

22. On Bonvin's support by the state, see Gabriel P. Weisberg, "In Search of State Patronage: Three French Realists and the Second Empire, 1851–1871," in *Art, the Ape of Nature: Studies in Honor of H. W. Janson*, ed. Moshe Barasch and Lucy Freeman (New York: Prentice-Hall, 1981), 585–606.

23. See the Salon catalogue for 1889, *Société des Artistes Français. Explication des ouvrages de peinture, . . . exposés au Palais des Champs Elysées le 1er Mai 1889* (Paris: Paul Dupont, 1889), 29, no. 358. The painting is now lost. See also Goldman-Ida, "A Synagogue Interior," 62–73.

24. At the 1887 Salon, Moyse exhibited *Un Moine* in the yearly exhibition. This was reproduced in Émile Goutière Vernolle, *La Lorraine au salon* (Lorraine: Lorraine-Artiste, 1887).

25. *Exposition Internationale Universelle de 1900, Catalogue général officiel*, no. 1451.

26. *Cercle Artistique et Littéraire, Exposition de Peinture et de Sculpture de 1878* (Paris, 1878), 27, no. 192, "Rabbi Sichel" (étude).

27. Women painters in France challenged this standard by adopting male clothing and becoming skilled at selling their works. See the discussion of Rosa Bonheur in Gabriel P. Weisberg, "Rosa Bonheur's Reception in England and America: The Popularization of a Legend and the Celebration of a Myth," in *Rosa Bonheur: All Nature's Children* (New York: Dahesh Museum, 1998), 1–22.

28. See Christopher Wood, *Victorian Painting* (Boston and New York: Bullfinch Press, 1999), 170–72.

29. Ibid., 172.

30. *Exposition Internationale Universelle de 1900, Catalogue général officiel*, 410, no. 237.

31. On the importance of Leibel within a larger naturalist aesthetic, see Gabriel P. Weisberg, *Beyond Impressionism: The Naturalist Impulse* (New York: Harry N. Abrams, 1992), 191–94.

32. The appearance of Kaufmann's work at public auctions during the 1990s attests to a rich body of work and strong contemporary interest in securing his paintings.

33. *Exposition Internationale Universelle de 1900, Catalogue général officiel*, Groupe II—Oeuvres d'art—Classes 7–10, 130.

34. On Pilichowski and the plight of the Jews, see Cohen, *Jewish Icons*, 236–44. Chang Ming Peng, at the University of Paris IV, is writing a very erudite and detailed dissertation about Cormon. On ties with the Académie Julian, see Catherine Fehrer Robert and Elizabeth Kashey, eds., *The Julian Academy, Paris, 1868–1939* (New York: Shepherd Gallery, 1989), which lists students in the academy's classes.

35. *Exposition Internationale Universelle de 1900, Catalogue général officiel*, Groupe II—Oeuvres d'art, 534, no. 188. A small reproduction in the catalogue suggests that the painting built on the academic naturalist style of Cormon, who, as noted in the catalogue, was one Pilichowski's teachers.

36. *Explication . . . Salon de la Société Nationale . . . Champs de Mars* (Paris, 1891), 102, no. 731, *Portrait de Mlle L. P. . . .* Also see the Salon of 1892 with reference to *Portrait de Mlle. F. . . .*

37. For further information on Minkowski, see Cohen, *Jewish Icons*, 245–51.

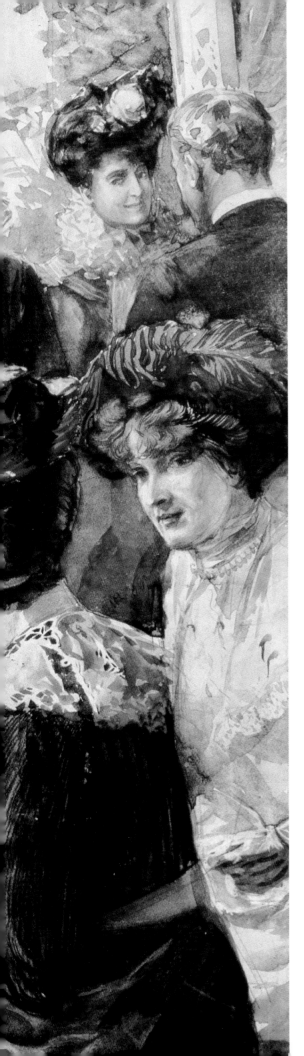

Solomon J. Solomon. *High Tea in the Sukkah*
(detail), 1906. See pl. 25.

Exhibiting Nineteenth-Century Artists of Jewish Origin in the Twentieth Century: Identity, Politics, and Culture

Richard I. Cohen

At the Fifth Zionist Congress in Basel in 1901, Martin Buber (fig. 42) made an impassioned plea for refashioning the Jewish soul through art. Arguing that art and aesthetics had been overlooked in the past, Buber minced no words: "The excess in soul power that we possessed at all times expressed itself in the exile merely in an indescribably one-sided spiritual activity that blinded the eyes to all the beauty of nature and of life. We were robbed of that from which every people takes again and again joyous, fresh energy—the ability to behold a beautiful landscape and beautiful people. . . . All things, from whose magic the literature spins its golden veil, all things, whose forms are forged through art's blessed hands, were something foreign that we encountered with an ineradicable mistrust."[1] Only by allowing art and aesthetics to reemerge as part of the mainstream of Jewish life could a Jewish renaissance evolve.

In claiming art as the ultimate way for Jews to be true to themselves, Buber was clearly inspired by the ways in which artists in Central Europe had given expression to their nationalist visions. History painting had become a common form of artistic expression among Central and Eastern European artists whose national identity had yet to be molded or fixed. Living in Berlin, Buber may also have been aware of and influenced by the debates that rocked the German cultural scene of his time. Heated discussions on the nature of

FIG. 42. Martin Buber (1878–1965).

FIG. 43. Alfred Nossig (Galician, 1864–1943). *The Wandering Jew*, c. 1901. Sculpture. Present whereabouts unknown.

"authentic" art fostered intense disagreement between the upholders of Gothic style and the proponents of Rembrandt or Dürer as the apotheosis of German creativity. Buber's speech gave voice to these perspectives. He attempted to define the nature of "national Jewish art" by commenting on the art of more than twenty artists of Jewish extraction, locating their "Jewish character" in their expressions of "perception and form." Buber called upon the congress to recognize "the peculiar appropriation of light and shadow, the play of the atmosphere around objects, the integration of individual items into the surrounding environment, the broad concept of space, the strange inward movement. Everywhere you will recognize elements of Jewish perception and formation."[2] Paintings did not have to possess a Jewish theme or concern to reflect the "Jewish spirit." All of Jozef Israëls's work was seen to possess "something deeply Jewish," while portraits and landscapes by Max Liebermann, the distinguished Berlin artist, were interpreted as having a particularly Jewish quality. In asserting the need for rejuvenation through art, Buber also echoed a controversy within the

Zionist camp, siding with those (for example, Micha Yosef Berdychewski) who viewed art as essential to Jewish life instead of those who hewed to the more pragmatic school of Zionism (for example, Max Nordau).[3]

Buber also initiated an exhibition of forty-eight works of art at the congress, featuring Alfred Nossig, Lesser Ury, Moses Ephraim Lilien, Hermann Struck, Jehudo Epstein, and Jozef Israëls. This was the first exhibition of its kind—a show that brought together only contemporary artists of Jewish origin (save *The Mourning Jews in Babylonian Exile* by the Nazarene artist Eduard Bendemann [see fig. 14], who converted to Christianity) in order to celebrate Jewish artistic creativity and promote a Jewish renaissance through art.[4] The idea probably would have stunned individual artists in the nineteenth century, who were by and large motivated to succeed within their national settings and did not necessarily see themselves as "Jewish artists." Within this spirit, Buber edited a book entitled *Jüdische Künstler*, which promoted the work of the six Jewish artists (Israëls, Ury, Lilien, Liebermann, Epstein, and Solomon J. Solomon) whom he viewed as the

finest exponents of this desired renaissance. The volume, he hoped, would contribute "to the creation of a consciously Jewish art public that knows and loves its artists" and provide an explanation for Jews' failure to create art throughout their long period of exile.[5] None of the artists, including Liebermann, with whom Buber discussed the book project, objected to being included, although it would stamp them as "Jewish artists" and ostensibly make them part of an emerging national canon.

Buber's Zionist project—to inspire a Jewish renaissance through art—coincided with the growing interest in various European cities to collect and preserve Jewish artifacts under the auspices of a Jewish museum.[6] These fledgling museums had no apparent connection with the Zionist agenda and were originally less interested in painting and sculpture than in the decorative arts, believing that these objects must be safeguarded before they fell into oblivion. But Buber's lead was pursued by others. Two other exhibitions that gave pride of place to "Jewish artists" were held in 1906 and 1907, respectively, the former in London and the

FIG. 44. Leopold Pilichowski (1864–1934). *Portrait of Israel Zangwill*, c. 1900. Oil on preprimed canvas; 30 × 39⅞ in. (76 × 101.3 cm). The Jewish Museum, New York, JM 50-51.

latter in Berlin. Both presented the works of art as carriers of social and cultural messages.

The London venue was a surprising one. The exhibition, initiated by Canon Barnett, who had done extensive work among Eastern European Jewish immigrants in London's West End, took place in the Whitechapel Art Gallery. Similar to the pathbreaking Anglo-Jewish exhibition of 1887, Whitechapel included a wide variety of objects relating to Jews and Jewish life. However, it added a new category: "Modern art" was included with the hope that Jewish artists from England and the Continent would have a unique opportunity to show their work. The exhibition included a large number of English Jewish artists (members of the Solomon family were highly visible), many of whose names and works have long been forgotten. They were seen alongside a wide selection from Jozef Israëls (considered "the Nestor of Dutch Art," "the most distinguished and famous of all Jewish painters living today," and "the Jewish Rembrandt of today")[7] and paintings by Liebermann, the Pissarros, Leopold Pilichowski (fig. 44), Moses Maimon, and Edouard Moyse, among others. This display

was believed to help dispel the notion "that Jews, as a race[,] have no genius for the graphic and plastic arts."[8] This trope, commonly voiced in the exhibition of Jewish works of art, was deeply embedded in the commentary to the exhibition, which was provided by Jewish figures. Marion Spielmann, an influential member of the advisory committee, echoed these sentiments ("and the graphic arts, like the others, will before long be recognised as equal witness of the emotional and intellectual genius of the House of Israel"), while astutely noting that "the majority, identifying themselves entirely with their adopted country after the manner of the Jewish people, alike in feeling and in subject, show no trace of distinctive thought or differentiation of artistic sentiment." This lack of distinction, he assumed, would pave the way toward "continual assimilation."[9] Spielmann eschewed the Buberian approach, seeing these artists as raising the honor of the Jewish faith/race but gravitating toward increasingly greater integration into their particular national fold. Others, including Canon Barnett, fostered more grandiose visions for the exhibition, expecting it to

promote relations between Eastern and Western Jews, and ultimately between Jews and gentiles, by overturning gentile misconceptions about Jews. They continued in this manner the nineteenth-century belief that art could contribute to the improvement of society. Yet not all were convinced that the quality of the art displayed disproved the common claim that Jews lacked the ability for graphics. One Jewish commentator, Reverend Morris Jacobs, affirmed the received wisdom, calling the "motley gathering of portraits, etc." "rich in promise" and crediting this sorry state to the Second Commandment.[10] What success the exhibition had in eroding the myths and preconceptions it intended to dissipate and in promoting goodwill among peoples is impossible to gauge, but the exhibition did attract large audiences (over 150,000 persons were reported to have visited it) of Jews and gentiles.[11]

Unlike the London exhibition, the Berlin *Ausstellung jüdischer Künstler* (Exhibition of Jewish Artists), held at the Galerie für alte und neue Kunst (Gallery for Old and New Art), made European painting and sculpture its central focus. Also unlike the London

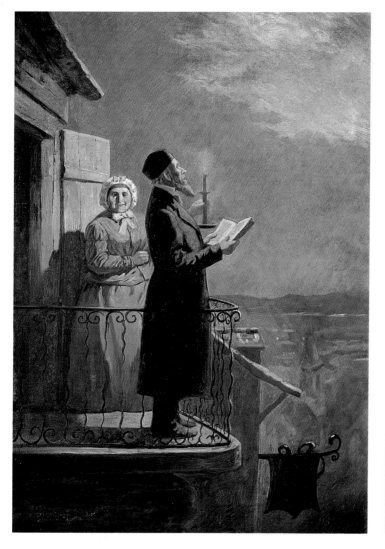

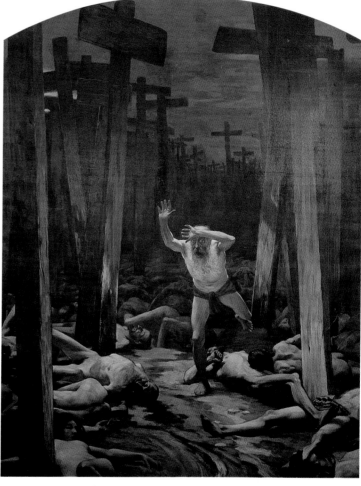

FIG. 45. Alphonse Lévy (French, 1843–1918). *Evening Prayer*, 1883. Oil on canvas; 24 × 17 in. (61 × 43 cm). Musée du Judaïsme, Paris.

FIG. 46. Samuel Hirszenberg (Polish, 1865–1908). *The Wandering Jew*, 1899. Oil on canvas; 135 × 115⅜ in. (343 × 293 cm). The Israel Museum, Jerusalem.

exhibition, the spearhead of the Berlin exhibition was a Jewish nationalist, Alfred Nossig, who promoted Buber's agenda.[12] In bringing together forty sculptures and more than 150 paintings by several dozen artists of Jewish origin (many of whom were not shown in London), the organizers had a far-reaching goal. Nossig, a sculptor, poet, and intellectual from Galicia who moved to Berlin in 1900, was ideologically aligned with the nascent Zionist movement, though often in conflict with its leading figures (fig. 43). He assumed that the exhibition could transmit a cultural message

and urged people to observe the exhibited works and confront the nature of "racial uniqueness of the Jewish race in art." In his introduction to the exhibition catalogue, he touched on a wide variety of issues that connected art to politics, culture, and identity. Less concerned with the issue of whether Jews had talents in the graphic and plastic arts than the English Jewish committee, Nossig worked from a nationalist premise: Was there a common denominator to works of art by Jews? How did they evoke the nature of the Jewish predicament, its historical trials and

tribulations, its rootlessness? How did they show the essence of the Jewish spirit? Nossig and the organizing committee were motivated by the upsurge in artistic creation in the previous generations and sensed that the emergence of Jewish artists on the European scene warranted public attention.

Ausstellung jüdischer Künstler brought together artists from the nineteenth century (for example, Moritz Oppenheim, Maurycy Gottlieb, Camille Pissarro [d. 1903]) with many living ones, whose style and concerns differed dramatically from those of their

predecessors. Some were represented by single works while others, like Ury and Israëls, were given considerable attention and space.[13] The *Ausstellung* was designed to evoke the essence of Jewish creativity, a perplexing conundrum, since the exhibition was extremely diverse, both thematically and geographically. It placed artists whose themes were ostensibly of a universal nature, like Pissarro and Israëls, together with those who concentrated almost solely on Jewish themes, like Isidor Kaufmann. The interplay between artists from Eastern Europe (Gottlieb, Maurycy Minkowski, Samuel Hirszenberg) and Western Europe (Jacques Hast, Alphonse Lévy, Benno Becker), between portraits of Jewish figures (Spinoza) and non-Jewish ones (Jules Guesde), and between pastoral scenes and depictions of Jewish ritual and tragedy revealed a vibrant artistic world that touched on many areas of human experience (for an example of Lévy's work, see fig. 45). Yet this assembly of works was generally at odds with the artistic atmosphere in the burgeoning metropolis of Berlin, where modernism was making its mark. The exhibition was even shunned by Liebermann, a major figure in Berlin modernism and the founder of the Berlin Secession art movement, either for personal or ideological reasons.[14] Nevertheless, it aroused interest and "Jewish pride" in certain Jewish circles, whose members took pleasure in its celebration of Jewish creativity.[15] Berlin Jewry in general, though, showed minimal interest in the exhibition. One can assume that assimilating Jews were uncomfortable with those works celebrating Jewish rituals and customs or depicting the harsh conditions of Jews in Eastern Europe at the turn of the century, what the English organizers had depicted as "Judenschmerz." Other Jews in Berlin may also have found the category "Jewish artists" unappealing to their patriotic sensibilities.

Far away from the artistic capitals of the world, another venue for "Jewish artists" emerged: Jerusalem. There, in the center of the new city, Boris Schatz founded the Bezalel

Art Institute in 1906 as a museum with an accompanying school for arts and crafts. Schatz, like Buber and Nossig, was driven by a nationalist agenda. He wanted his museum to "prove to the world that there is such a thing as Jewish art and that it may lay an example for Jewish artists, and prompt them to create in the Jewish spirit."[16] Schatz actively solicited paintings, sculptures, and self-portraits by prominent Jewish artists (for example, Liebermann and Israëls), establishing a "Jewish pantheon" as a source of hope and direction while fulminating against all aspects of modernist art. Special attention within the small quarters of the museum was granted to works evoking the Jewish spirit, as exemplified by Samuel Hirszenberg's haunting painting *The Wandering Jew* (1899; fig. 46). Hirszenberg's painting, which shows a Jew emerging from the rubble of a history of persecution wrought by Christian society, became a Zionist icon and remained centrally hung in Bezalel for almost a generation. Yet Schatz struggled to achieve his goal: to turn Bezalel into a haven for exhibiting Jewish artists. Modernism was to be preferred.

These vignettes from Basel, London, Berlin, and Jerusalem provide us with several glimpses into the intricate relationships that obtain among politics, culture, and identity in exhibiting nineteenth-century Jewish artists in the twentieth century. It was during that first decade of the new century that the category of "Jewish artists" was first constructed, generated both by the nationalist upsurge and by individuals who associated Jewish creativity in the visual arts with the promotion of Jewish integration. By "Jewish artists," these exhibitions meant artists of Jewish extraction, disregarding the themes or issues pursued in their work. The present exhibition, which brings together twenty-one artists of Jewish origin from Western and Eastern Europe (only ten of whom appeared in the 1907 venue), is apparently the first sequel to these initial shows and follows a similar working definition of "Jewish artist."[17] It thus urges reflection on the reception of these artists amid the

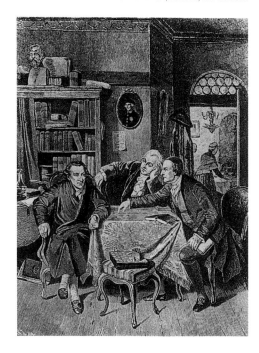

FIG. 47. Louis Katzenstein (German, 1822–1907). *Lessing and Lavater at the Home of Moses Mendelssohn*, c. 1860. Oil on canvas. Whereabouts unknown.

dramatic events of the twentieth century and on the role politics, culture, and identity play in exhibiting works of art. In turning to their reception, we are interested to see how these artists weathered the storm of modern trends in art, how they were identified during the course of the twentieth century, and whether they remained pigeonholed as "Jewish artists." What happened to the initial attempts to create a Jewish canon, to promote "Jewish artists" and Jewish artistic creativity? How were these artists remembered and how were they incorporated into their national canons? What meanings did Jews and non-Jews attach to their work at various points in time? Politics, culture, and identity were to figure prominently in the way these artists were received. This essay will look at some of these issues in relation to several of the artists who appear both in this and in the 1907 exhibition.

Moritz Oppenheim, sometimes designated "the first Jewish painter,"[18] was a German Jewish artist concerned with the fate and future of the Jewish people. His work and posthumously published recollections show

how his Jewish identity was a major preoccupation, though by no means the only one. As such, he set a standard by which other artists of Jewish origin were later measured. Thanks to the vigorous marketing of and nostalgic yearning for his *Scenes from Traditional Jewish Family Life*, Oppenheim became a household name for German Jewry in the latter part of the nineteenth century.[19] But this series was not the only cause of his stature among German Jews. Some of Oppenheim's significant works touched on the internal fabric of Jewish integration into German society and were commonly reproduced—the heralded *Return of the Jewish Volunteer from the Wars of Liberation to His Family Still Living in Accordance with Old Customs* (1833–34; pl. 1); the icon of German Jewish pride, *Lavater and Lessing Visiting Moses Mendelssohn* (1856; pl. 9; see also fig. 47); the portraits of celebrated German Jews (Heine [see fig. 11] and Börne [1840; pl. 3], for example). Yet it would seem that Oppenheim's image as "the first Jewish painter" grew with time and took on more symbolic meaning during the twentieth century. Oppenheim was not mentioned in Buber's programmatic speech of 1901; his presence in the Berlin exhibition of 1907 was also undistinguished, with only one of his works, *The Village Vendor*, included; during the interwar years, Oppenheim's works appeared in some German Jewish museums, though never given exceptional exposure.[20] All this would change following World War II. Before turning to that development, however, a brief review of his acceptance within the German art world is in order.

As a "German artist" Oppenheim was neither highly ranked nor extremely well known among the German Biedermeier painters of his day. His oeuvre—a phase of Nazarenism, a host of portraits, illustrations of classical books, thematic paintings, and works that touched on the life and visions of Jews in Germany—fit well with the changing currents of art in nineteenth-century Germany. In honor of the one-hundredth

anniversary of Oppenheim's birth, the Kunstverein (art association) of Frankfurt, where the artist settled in 1825 and became a respected resident, held an extensive exhibition. A fine cross section of his paintings was shown: Works of all his major periods were represented among the 142 assembled. Portraits of Jews and gentiles figured prominently. Indeed, his portraits were seen as his premier achievement, two of which were included in the prestigious *Exhibition of the Century* at the National Gallery in Berlin, organized by its director, Hugo von Tschudi, in 1906; others appeared in a 1912 exhibition in Frankfurt focusing on nineteenth-century portraiture. What is significant, however, is the fact that Oppenheim was not passed over on the eve of Nazism when the Frankfurt museum staged a hundredth-anniversary celebration of Frankfurt art (1832–1932), consciously asserting that he continued to maintain a legitimate place in the history of the city's art. He was minor but present, as he was in a Düsseldorf exhibition in 1933.[21] These museological decisions need to be emphasized all the more as they stood in contrast to the developing Nazi policy of *Gleichschaltung*, which strove to eliminate all dissenting views and opinions and to create a uniform, one-dimensional society. Oppenheim did not fall into total oblivion, as has been claimed, until the Nazi period.

Oppenheim, the "Frankfurt portraitist," would gradually be lifted from the ravages of the ideological cleansing and horrors of Nazism. His resurrection would begin with cameo appearances in the major post-Holocaust exhibitions in Frankfurt and Cologne in the 1960s, followed by more extensive and direct attention in New York exhibitions in 1977 and 1981.[22] The Israel Museum in Jerusalem granted Oppenheim a major retrospective (eighty works were shown) in 1983, curated by Elisheva Cohen, herself a former Frankfurt Jew and chief curator of the museum's Bezalel wing. The crowning moment came in December 1999, when the re-created Jewish Museum, Frankfurt am

Main, opened a comprehensive retrospective under the patronage of German chancellor Gerhard Schröder.[23] Of the artists exhibited here, Oppenheim was not the first to receive such extensive and official recognition, but he was the first in Germany. In fact, he was recognized long before major German artists of the nineteenth century received similar treatment and attention.

How can we explain the resurgence of interest in and representation of Oppenheim following the war? Elisheva Cohen's measured and judicious words in the 1983 exhibition catalogue provide a clue. She made no effort to turn Oppenheim into a legendary figure or to make a place for him in the national Jewish pantheon, nor did she assert his artistic persona beyond his apparent contribution. She claimed that in the history of nineteenth-century German art, "Moritz Oppenheim may not have been one of its outstanding figures," but, she added, "he deserves to be remembered. . . . [He] stood between the ages of repression and emancipation. . . . In his own way Moritz Oppenheim stands as a true and worthy representative of a significant period in German-Jewish history."[24] In short, Oppenheim became a symbol of German Jewry and German-Jewish symbiosis prior to the catastrophe. Oppenheim's paintings appealed to diverse constituencies in the post-Holocaust era: to those who desired to assert the role of Jews in German society before the onslaught of Nazism, to those who wanted to enlighten Germans about the Jewish past, and to those who wished to present Judaism in its purest mode. No other Jewish artist from the nineteenth century could fulfill this cultural desideratum. Oppenheim's themes and preoccupations fit the role perfectly, in much the same way as scholars of history and thought have turned Moses Mendelssohn's life and writings into a symbol of German-Jewish rapprochement. Oppenheim offered a congenial representation of Jewish life with its customs and rituals that was also open to Christians and respectful of German traditions. The platitudes Louis Edward Levy

had showered on Oppenheim's traditional family life series in 1895 reflected the values the post-Holocaust generation sought in Oppenheim's work: "poetry and earnestness, piety and tenderness, sobriety and conscientiousness . . . the human and the pathos of that old-time Jewish life."[25] Oppenheim's work exuded a sense of serenity, lacking the harsh portrayals of Jewish life—and troubling encounters with the non-Jewish world—that we witness in works of a Minkowski or a Hirszenberg, for example. Constructing a world according to Oppenheim's paintings enabled a generation after the Holocaust, Jews and non-Jews (first and foremost Germans) alike, to situate "the first Jewish painter" in his rightful place in his hometown of Hanau, in his chosen city of Frankfurt, and in Jewish centers—New York and Jerusalem. Significantly, the title of the major retrospective in Hanau/Frankfurt was *Moritz Daniel Oppenheim: Jewish Identity in Nineteenth-Century Art*. The word "German" was not included.

Isidor Kaufmann of Austria has often been seen, incorrectly, as an epigone of Oppenheim. One exhibition (Yeshiva University Museum, New York, 1977) focused on their common treatment of Jewish themes, helping to create the twin image and solidifying their identification as "Jewish artists." Kaufmann's breadth of creativity was more limited than Oppenheim's, and his subjects revolved around Jewish figures and life in a more concentrated manner than those of his predecessor. Kaufmann had a clear social agenda: to glorify and exalt Judaism through art. He "strove to reveal its beauties and its nobility and tried to make the traditions and institutions that speak of such great religious devotion and reverence accessible for Gentiles as well."[26] Kaufmann's aims, similar to Oppenheim's, isolated him in the highly nationalistic atmosphere of interwar Austria. In his case, too, it took the post-Holocaust generation, the emergence of a vibrant Jewish museum in Vienna, and a powerful drive to reimplant Jewish culture

into Austrian consciousness to make a claim on Kaufmann—to assert his relevance to fin-de-siècle Austrian art.

Kaufmann would not be seen as a mere Oppenheim imitator: He was to be situated as a Viennese artist, even though his claim to fame lay in his portrayals of Jewish life. His Jewish genre scenes were placed within the artistic context of the Munich school of genre painting, which included such figures as Carl Spitzweg, Eduard Grützner, and Franz von Defregger.[27] G. Tobias Natter's bilingual catalogue, with its unique title *Rabbiner-Bocher-Talmudschüler. Bilder des Wiener Malers. Isidor Kaufmann, 1853–1921* (Rabbis, Students, Talmud Scholars. Paintings of the Viennese Artist Isidor Kaufmann, 1853–1921), said everything. Kaufmann was both the artist of the traditional Jewish world and a Viennese painter. The exhibition in the Vienna Jewish Museum was part of its concerted effort and Natter's, as its guest curator, to reinstate an aspect of the agenda of the first exhibitions of the twentieth century. They wanted to demonstrate Jewish creativity in the visual arts, but above all to affirm Jewish contributions to Austrian culture and to illuminate the shared traditions with non-Jewish Viennese artists (for example, Friedrich Georg Waldmüller). A concerted effort was made to assemble Kaufmann's finest paintings from near and far, both to promote his achievement and to enable as thorough a viewing of his oeuvre as possible.

Kaufmann was one of several artists the museum and Natter have highlighted in the last decade. Another, Broncia Koller-Pinell, also appears in this show (fig. 48). Unlike Kaufmann, she and Tina Blau (also exhibited here and at the Vienna Jewish Museum) were not shown at any of the early Jewish exhibitions, possibly because their Jewish roots were unknown to the organizers (both converted to Christianity in the late nineteenth century). Both—Blau more than Koller-Pinell—were relatively well known at the beginning of the century in Austria, and both fell into a certain obscurity. The impetus

FIG. 48. Broncia Koller-Pinell (Austrian, 1863–1934). *My Mother*, 1907. Oil on canvas; 35¾ × 30½ in. (91 × 77.5 cm). Österreichische Galerie Belvedere, Vienna.

to show their works in the Vienna Jewish Museum emerged from the desire to make their Jewish roots known to Viennese society. They had no clear thematic connection to any obvious Jewish project (though one of Tina Blau's paintings, *Jewish Street in Amsterdam* [1875–76; pl. 57], relates ostensibly to Jews) nor was any hidden reference to Judaism detected. Their Jewish extraction would now be part of their Austrian personae. Exhibiting artists of Jewish origin in Vienna in the late twentieth century became an integral part of the attempt to refashion the image of Jews and Judaism in the eyes of Austrian society and to guarantee their place in the history of turn-of-the-century Austrian art.

Did this phenomenon repeat itself elsewhere? The French case, represented here by two artists—Camille Pissarro and Jacques-Emile-Edouard Brandon—presents a somewhat different development. Pissarro (d. 1903) was given much exposure at the London show in 1906, and four of his paintings hung in Berlin. Brandon remained a rather unknown entity. Brandon's art on Jewish themes was hardly even noticed by *Ost und West* and *Mult és Jövö*, two journals that

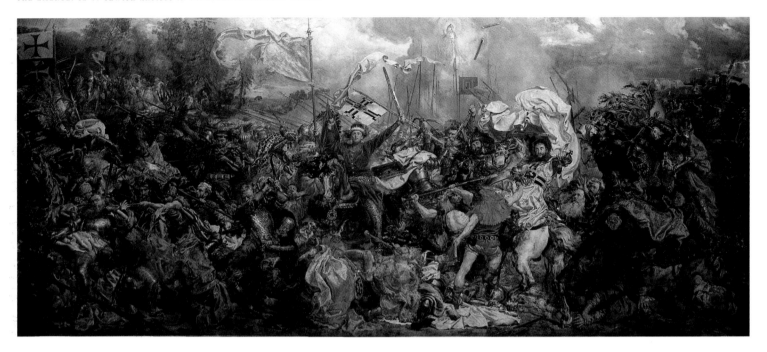

FIG. 49. Jan Matejko (Polish, 1838–1893). *The Battle at Grunwald*, 1878.
Oil on canvas; 167¾ × 388⅝ in. (426 × 987 cm).
Muzeum Narodowe w Warszawie, Warsaw.

popularized Jewish art in the early twentieth century. He was overshadowed by other Jewish genre artists and did not position himself amid French art of the nineteenth century. Neither he nor Edouard Moyse, another genre artist, had sufficient creativity to withstand the dramatic changes that transpired in the world of art in the last quarter of the century. For these reasons, and because there was no French Jewish museum to speak of until the mid-1990s, both Moyse and Brandon were rarely seen outside the purview of Jewish museums in other countries.

Pissarro, of course, presents the more intricate problem of definition. Heralded as a "Jewish artist" by the exhibitions in the early twentieth century and later viewed as such within the parameters of Jewish museums that have given special attention to his work in the last generation, Pissarro's "Jewishness" as an Impressionist artist has rarely been mentioned.[28] Audiences outside the purview of Jewish museums have been oblivious to his Caribbean Jewish extraction and totally unconcerned with the possible questions

generated by his birth. For the wider public he remained a French artist of Caribbean birth who figured prominently in the Impressionist movement, and within this context his work has received extensive attention. It would appear that while Oppenheim became the "Jewish artist" to represent German Jewry and Kaufmann the bridge between Viennese art and Jewish tradition, no French artist of Jewish extraction could carry the burden of both worlds.

Other nineteenth-century artists in this exhibition from other countries have symbolized the struggle of identity and belonging for the twentieth century. Jozef Israëls and Maurycy Gottlieb are two of them. Born in Groningen (Holland) in 1824, Israëls became a noted Dutch painter in his lifetime and an important figure in the Hague school, often compared to Rembrandt. His works were exhibited extensively (less so in Holland than in Scotland and England), and some gradually found their way into Dutch museums. After receiving an important bequest of his works from a major Israëls collector, Jean Charles

Joseph Drucker, the Rijksmuseum exhibited eleven paintings and seven watercolors in 1911. Israëls's star declined in certain art circles beginning in the 1880s, but it rose dramatically among Jews in Holland and abroad.

No other artist of Jewish origin was so coveted by Jews in the early twentieth century as Israëls. In the Hebrew press, his "Hebrew soul" was considered the overriding spirit in all his paintings. Buber's speech in 1901 raised the ante further. Israëls—"the great master"—was the epitome of the "Jewish artist," claimed Buber, as his work evoked the sense of history and prefigured the future "redemption." Buber's poetic language magnificently expressed the yearning of some Jews for an artistic voice to illuminate their quest for a new world enriched by historical consciousness:

And if the Jewish figures that he creates sit or stand ever so peacefully, there is mystery in their lines and tragedy in the rigidity of their poses. Eons speak out of

these silent, motionless individuals and a yearning that is trampled by fate. Yes, it is the gigantic, dark-as-death hand of fate that hovers above them like a gray, heavy cloud, invisible to our eyes, yet aware of the master's sweetest dreams, the first hint of redemption stirs, a redemption that will be victorious. . . .We are the first generation that understands and appreciates him.[29]

Yet Israëls was far from elated by such embraces. He flatly rejected the notion of a "Jewish artist," asking, "In what manner is there a particular Jewish way of painting and a non-Jewish one? Is there a Jewish sea and a non-Jewish sea?"[30] Notwithstanding his declarations, Israëls was at the center of attention in all the early exhibitions of Jewish art, his works cherished and reproduced.[31] Artists of Jewish extraction regarded him as their inspiration and lauded his ability to penetrate to the essence of the Jewish experience, as did Jewish writers, who assessed his work in various contexts.[32] Jews and Dutch, old and young, simple and distinguished, mourned his passing in 1911.

As the recent (1999) Israëls retrospective has shown, the artist remained a part of Dutch culture following his death. Exhibitions were held in his honor in different locations in the 1920s and again in 1961, and he figured prominently in a major exhibition of the Hague school in 1983 in the Hague, Paris, and London. In all these shows and in subsequent ones in other venues, emphasis was duly placed on the core of his oeuvre—fishing-village scenes, depictions of peasant life, portraits, and genre scenes.[33]

As was true for Oppenheim and Kaufmann, the retrospective gave pride of place to both aspects of the artist's world, declaring in no uncertain terms that the Jewish elements in Israëls's life and work need to be integrated into the mainstream of his oeuvre.[34] In sponsoring two separate venues for the retrospective (Groningen Museum and Amsterdam Jewish Historical Museum) and

according each a separate title and themes (*Jozef Israëls: Master of Sentiment*; *Jozef Israëls: Son of the Ancient People*), the museums accepted Israëls's dual self-identification as a Dutchman and a Jew. Research on Israëls's Jewish oeuvre inevitably contributed to this situation, but politics and cultural developments were no less significant. The changing atmosphere in the last quarter of the twentieth century and the growing acceptance of a multicultural environment were certainly factors. Dutch society, which had prided itself on its tradition of tolerance and civility, emerged from World War II "a shattered country" and "racked by the guilt" of its treatment of the Jews during the war.[35] It found itself open to a reassessment of the place of Jews in its culture, a task in which the Amsterdam Jewish Historical Museum would play a crucial role. Established in 1932, it became an increasingly important voice and presence in treating the evolution and complexity of Jewish life in Holland, rightfully earning it the honor of housing a segment of the Israëls retrospective. One can only conjecture that this would have been to the artist's satisfaction.

Just as the public grew to accept the diverse worlds that governed Israëls's life, Maurycy Gottlieb was gradually appropriated into the national canon of modern Polish art. Ezra Mendelsohn offers a fascinating interpretation of the showing of Gottlieb's *Christ Preaching at Capernaum* (1878–79; pl. 18).[36] It hangs in a special gallery in the National Museum in Warsaw dedicated mostly to the preeminent Polish history painter of the nineteeenth century, Jan Matejko, Gottlieb's mentor and devoted master. *Christ Preaching at Capernaum* hangs, consciously or unconsciously, opposite Matejko's towering work *The Battle at Grunwald* (Bitwa pod Grunwaldem), completed in 1878 (fig. 49). Matejko's painting, as Mendelsohn shows, deals with the 1410 victory of Polish forces over the Order of the Teutonic Knights, a dramatic moment in the national history of the Poles, who in the 1870s lived under

Habsburg/German/Russian rule and were bereft of national sovereignty. Considering that during that same period Germany had reached unification under Bismarck while the Poles had been defeated in their revolt in 1863, Matejko's painting was a clarion call to maintain the Polish nationalist spirit. In Mendelsohn's words, "The gallery in which it is exhibited remains a place of pilgrimage, where visitors are inspired by its vision of Polish bravery and take to heart, no doubt, the need for eternal vigilance against Poland's rapacious neighbours."[37] It is here, in this sacred space of Polish nationalism, amid other works by Matejko and contemporary Polish artists, that Gottlieb's *Christ Preaching at Capernaum* is displayed. Mendelsohn asks how Gottlieb's painting speaks to Matejko's, and his answer is intriguing. Because *Christ Preaching at Capernaum* represents, in his view, "the hope for a society based on universalism and love, in which Jews and Poles, both connected to the figure of Christ, will live in peace and harmony,"[38] it adds an additional element— universalism—to the nationalist call of Matejko's work. Though it is unclear when exactly the painting was hung in this fashion, one can claim that by so positioning his work, Gottlieb, a beloved student of Matejko's, is being drafted into the realm of "Polish artists."

Gottlieb was never forgotten by the Poles. They continued to evoke his memory after his death in 1879. But Gottlieb was also appropriated by the Jews. They, too, wanted to claim him for their own, to assert that he belonged to them. Again it was Buber in 1901 who sensitively addressed the artist's "melancholy and struggle," who saw in Gottlieb's work a precursor to the "new Judaism" (that is, Zionism), "a herald who . . . is not blessed to behold the promised land himself."[39] As Mendelsohn has shown, not all Jews accepted Gottlieb as a Zionist symbol. Some, like the integrationists, claimed that his art originated from and confirmed their worldview: the integration of Jews into Polish society. But the struggle over the legacy of this artist and his apparent identity did not end

there. Even individual works were interpreted according to ideological perspectives. For example, the well-known Polish Zionist leader Yehoshua Thon, while drafting Gottlieb into the nationalist arena at a major exhibition of Gottlieb's work in Kraków in 1932, dismissed *Christ Preaching at Capernaum* for failing to convey the artist's national instinct.[40] This was at a time, however, that antisemitism was rising in Polish society and closing in on the aspirations of those who trusted in some alliance with the Poles. The trying war years and the difficult aftermath sealed that for years to come.

Following World War II, interest in Gottlieb quickly revived. Small exhibitions in honor of the hundredth anniversary of his birth took place at The Jewish Museum in New York and at the Bezalel Museum in Jerusalem in 1956. Individual works began to appear in various group exhibitions in Poland and abroad in the 1950s. The Tel Aviv Museum of Art, the recipient of his *Jews Praying in the Synagogue on Yom Kippur* (1878; pl. 15), granted it a distinct place in a museum noted for its celebration of the "secular" world. Gottlieb's intricate and moving depiction of different generations of men and women in prayer and contemplation in a synagogue that seems all-embracing has been able to remain a constant presence in the Tel Aviv museum.

Rapprochement came in Gottlieb's case as well. *Christ Preaching at Capernaum*, the symbol of universalism, and the *Jews Praying in the Synagogue on Yom Kippur*, the icon of attachment to the Jewish past and representation of the destroyed Jewish world, joined together in a major Gottlieb retrospective in 1991 at the Tel Aviv Museum of Art. Present at the opening were the leaders of post-communist Poland and modern Israel.[41] It was a meeting of paintings, of politics, and a vision of a new world meant to overcome the difficult memories of the war and its troubled antecedents.[42] The title of the retrospective—*In the Flower of Youth: Maurycy Gottlieb 1856–1879*—prepared by the

Tel Aviv Museum of Art in cooperation with many Polish individuals and institutions, highlighted the tragically short life of this Galician Jewish artist. The title avoided the complex issue of identification. Gottlieb was to be linked exclusively neither to the Poles nor to the Jews; his integrated nature and vision of integration were to hover over his work. Symbiosis achieved.

Almost one hundred years have passed since the vigorous efforts were made to showcase "Jewish artists." These artists had different levels of engagement with Jewish culture and civilization, but their work was seldom grounded within that thematic realm alone. Eventually, as these case studies have shown, other factors determined their reception and representation, inevitably complicating the definition of a "Jewish artist." Yet it would appear that political and cultural currents have not dismissed the implications of identity in shaping the image of these artists. National canons are in flux just as national narratives are being questioned. Multiculturalism has opened the canon and widened the definitions of identity. Moreover, genuine efforts by individuals and Jewish museums to understand the role of Jews in European countries before the Holocaust have asserted a place for a Jewish identity in these artists' worlds and made this part of their agenda. None of the artists in this exhibition can be seen today as purely "Jewish artists," but neither can their Jewish roots be hidden from the eye of the beholder.

NOTES

My thanks to Professor Ezra Mendelsohn for his helpful comments on this essay.

1. Martin Buber, "Address on Jewish Art," in *The First Buber: Youthful Zionist Writings of Martin Buber*, ed. and trans. Gilya G. Schmidt (Syracuse N.Y.: Syracuse University Press, 1999), 48. Schmidt has provided a complete collection and excellent translations of Buber's early writings on Jewish art.

2. Ibid., 55.

3. Avner Holtzman, *Aesthetics and National Revival: Hebrew Literature against the Visual Arts* (Tel Aviv: Zmora-Bitan and Haifa University Press, 1999), 78–83 (Hebrew).

4. Apparently, a photograph of Maurycy Gottlieb's painting *Jews Praying in the Synagogue on Yom Kippur* was shown at the congress. See Ezra Mendelsohn, "Art and Jewish History: Maurycy Gottlieb's *Christ Preaching at Capernaum*," *Zion* 62 (1997): 190 n. 87 (Hebrew). For Buber's comments on Gottlieb, see *The First Buber*, 56.

5. Martin Buber, *Jüdische Künstler* (Berlin: Jüdischer Verlag, 1903), [12]. I have followed Schmidt's translation in *The First Buber*, 105. Buber himself composed only one essay for the volume, an extensive one on Ury, in which he attempted to show how Ury's work earned him the appellation "Jewish artist" (*The First Buber*, 71). See also *The First Buber*, 64–87.

6. Richard I. Cohen, *Jewish Icons: Art and Society in Modern Europe* (Berkeley and Los Angeles: University of California Press, 1998), 186–218; Barbara Kirshenblatt-Gimblett, *Destination Culture: Tourism, Museums, and Heritage* (Berkeley and Los Angeles: University of California Press, 1998), 79–111.

7. These designations are culled from reports on the exhibition in the *Jewish Chronicle* of 1906 and from the exhibition catalogue, *Whitechapel Art Gallery: Exhibition of Jewish Art and Antiquities* ([London, 1906]).

8. *Jewish Chronicle*, 9 November 1906.

9. M. [Marion] H. Spielmann, "Jewish Art," in *Whitechapel Art Gallery*, 85.

10. Jacobs's remarks appear in the *Jewish Chronicle*, 21 December 1906. For a more extensive discussion of the relationship between the Second Commandment and Jewish artistic creativity, see Kalman P. Bland, *The Artless*

Jew: Medieval and Modern Affirmations and Denials of the Visual (Princeton, N.J.: Princeton University Press, 2000).

11. For a recent discussion of this exhibition, see Julia Weiner, "A Brush-Up for Anglo-Jewry," *Manna* 58 (winter 1998): 28–30.

12. *Ausstellung jüdischer Künstler*, exh. cat. (Berlin: Galerie für alte und neue Kunst, 1907).

13. Israëls helped the organizers find his works for the exhibition but did not actively participate in mounting it, due either to his advanced years or his reservations about its definition of Jewish art. See the important essay by Edward van Voolen, "Israëls: Son of the Ancient People," in *Jozef Israëls 1824–1911*, ed. Dieuwertje Dekkers, exh. cat. (Groningen: Groninger Museum; Amsterdam: Jewish Historical Museum; Zwolle: Waanders Publishers; Groningen: Institute of Art and Architectural History [RuG], 1999), 58.

14. It is not clear why Liebermann was not represented at this show. His personal relations with Nossig were certainly strained (see Shmuel Almog, "Alfred Nossig: A Reappraisal," *Studies in Zionism* 7 [1983]: 12), yet Liebermann may also have been hesitant to appear in this context. He had recently been at the center of a serious controversy over the Secessionist movement that had strong antisemitic overtones. See Peter Paret, *The Berlin Secession: Modernism and Its Enemies in Imperial Germany* (Cambridge, Mass.: Harvard University Press, 1980), 170–82.

15. See the comments by Berthold Feiwel and others in Holtzman, *Aesthetics and National Revival*, 82.

16. Boris Schatz to Harry Friedenwald, 15 September 1930, Central Zionist Archives, Jerusalem, L42/6; quoted in Cohen, *Jewish Icons*, 215. See also Gideon Ofrat, *One Hundred Years of Art in Israel*, trans. Peretz Kidron (Boulder, Colo.: Westview Press, 1998), 21–33.

17. The following artists also appeared in 1907: Oppenheim, Gottlieb, Israëls, Minkowski, Pissarro, Simeon Solomon, Solomon J. Solomon, Hirszenberg, Ury, and Kaufmann. Previous exhibitions have concentrated exclusively on Jewish artists from America or from England. In these shows, some artists expressed discontentment with the classification "Jewish artist." No previous exhibition has attempted to offer an introduction to European Jewish artists.

18. *Moritz Oppenheim: The First Jewish Painter*, exh. cat. (Jerusalem: The Israel Museum, 1983).

19. Ismar Schorsch, "Art as Social History: Oppenheim and the German Jewish Vision of Emancipation," in ibid., 31–61; reprinted in Schorsch, *From Text to Context: The Turn to History in Modern Judaism* (Hanover, N.H.: Brandeis University Press and University Press of New England, 1994), 93–117.

20. See also the minimal treatment of Oppenheim in Franz Landsberger, *Einführung in die jüdische Kunst* (Berlin: Philo Verlag, 1935), 56.

21. *Jubiläums-Ausstellung des Vereins zur Verbreitung religiöser Bilder* (Düsseldorf, 1933); *Hundert Jahre Frankfurter Kunst 1832–1932* (Frankfurt a. M., 1932).

22. *Families and Feasts: Paintings by Moritz Daniel Oppenheim and Isidor Kaufmann*, exh. cat. (New York: Yeshiva University Museum, 1977); Norman L. Kleeblatt, *The Paintings of Moritz Oppenheim: Jewish Life in Nineteenth-Century Germany*, exh. cat. (New York: The Jewish Museum, 1981).

23. Georg Heuberger and Anton Merk, eds., *Moritz Daniel Oppenheim. Die Entdeckung des jüdischen Selbsbewusstseins in der Kunst*, exh. cat. (Frankfurt: Jüdisches Museum der Stadt Frankfurt am Main, 1999).

24. *The First Jewish Painter*, 28.

25. *The Jewish Year Illustrated by Pictures of Old-Time Jewish Family Life Customs and Observances from the Paintings by Moritz Oppenheim* (Philadelphia: The Levytype Co., 1895), n.p.

26. Kaufmann's words from 1917; quoted in Cohen, *Jewish Icons*, 154.

27. G. Tobias Natter, *Rabbiner-Bocher-Talmudschüler. Bilder des Wiener Malers. Isidor Kaufmann, 1853–1921*, exh. cat. (Vienna: Jüdisches Museum der Stadt Wien, 1995), 13–23.

28. Recently, Nicholas Mirzoeff has argued for the Jewish component of his art, claiming that Pissarro "made the passage of a Caribbean Jew across modern Paris the very subject of his work." See Mirzoeff, "Pissarro's Passage: The Sensation of Caribbean Jewishness in Diaspora," in *Diaspora and Visual Culture: Representing Africans and Jews*, ed. Nicholas Mirzoeff (London and New York: Routledge, 2000), 73.

29. *The Early Buber*, 56.

30. Quoted by Nahum Sokolov in Holtzmann, *Aesthetics and National Revival*, 77.

31. See *Jozef Israëls 1824–1911*, passim; in the 1907 exhibition catalogue, no other artist was given as much exposure. Four of his paintings were reproduced, none of which had any apparent Jewish association.

32. Van Voolen, "Israëls: Son of the Ancient People," passim.

33. For a complete list of such exhibitions, see *Jozef Israëls 1824–1911*, 381–82.

34. Ibid.; Cohen, *Jewish Icons*, 238, 245.

35. Quotations from J. A. Kossmann-Putto and E. H. Kossmann, *The Low Countries and History of the Northern and Southern Netherlands* (Lauwe: Stichting Ons Erfdeel vzw, 1994), 55.

36. Ezra Mendelsohn, "Art and Jewish-Polish Relations: Matejko and Gottlieb at the National Museum in Warsaw," in *Jewish Studies at the Central European University*, ed. András Kovács (Budapest: Jewish Studies Program, Central European University, 2000), 171–80. The following discussion is based on this essay.

37. Ibid., 173.

38. Ibid., 180; see also Mendelsohn, "Art and Jewish History," passim.

39. *The Early Buber*, 56. Gottlieb was to be included in a second volume of *Jüdische Künstler* that was never published. It was also to include Hirszenberg, Pissarro, and several other artists of Jewish origin.

40. Mendelsohn, "Art and Jewish History," 190.

41. Nehama Guralnik, *In the Flower of Youth: Maurycy Gottlieb 1856–1879*, exh. cat. (Tel Aviv: Tel Aviv Museum of Art and Dvir Publishers, 1991). See also Larry Silver, "Jewish Identity in Art and History: Maurycy Gottlieb as Early Jewish Artist," in *Jewish Identity in Modern Art History*, ed. Catherine M. Soussloff (Berkeley and Los Angeles: University of California Press, 1999), 87–113.

42. Guralnik, *In the Flower of Youth*, 11–14.

Timeline

	1780s	1790s
France	Metz essay contest on the subject "Are There Means of Making the Jews Happier and More Useful in France?" (1785). Beginning of French Revolution (1789). Jews send *cahiers de doléances*, document of grievances, to National Assembly (1789).	Emancipation of French Jews (1790, 1791).
England	Daniel Mendoza becomes leading boxer of period (late 1780s–90s).	Problems of Jewish poor highlighted in London magistrate's study of police (1795).
Germany	Wilhelm Christian Dohm publishes the essay "Concerning the Amelioration of the Civil Status of the Jews" (1781). Naftali Herz Wessely urges Jews to acquire secular education in his pamphlet *Divrei Shalom v'Emet* (Words of Peace and Truth). Moses Mendelssohn publishes *Jerusalem* (1783). Prussia abolishes the *Leibzoll* (body tax) on Jews (1787).	Destruction of the Frankfurt ghetto by French troops (1796).
Italy	Decree in duchy of Parma and Piacenza allows Jews to own real estate (1783).	French army brings Jews temporary emancipation (1796–98).
Habsburg Austria (Galicia)	In 1789, an edict was extended to the Jews of Galicia. *Judenpatent* grants Jews in Galicia right to own land but also imposes new taxes and mandates secular education (1789).	Popular, rabbinic-led resistance to government-sponsored modern Jewish schools begins.
Poland	Jews do not enjoy political or economic municipal rights.	Pale of Settlement created as only legal place for Jews to live in Russian Empire (1791). Jews fail to get support of government to protect Jews in free towns (1792). Russia receives most of remainder of Poland in partitions of 1793 and 1795.
Netherlands	Patriot Revolt (1787). Authorities strengthen hand of the *parnassim*, Jewish communal leaders, because of their support against the patriots (1787).	The Batavian (Dutch) Republic emancipates the Jews, with support of Dutch *maskilim* (promoters of Jewish Enlightenment) (1796). Jonas Daniel Meyer admitted as barrister to the Court of Holland (1796).

1800s 1810s 1820s

1800s	1810s	1820s
Jewish population numbers about 46,000 (1808). Napoleonic Assembly of Notables and Sanhedrin in Paris (1806–7). Jewish community reorganized; "Infamous Decree" restricting Jewish business activities passed (1808).	The "Infamous Decree" lapses (1818).	Expansion of modern Jewish schools.
Jewish population numbers about 15,000, concentrated in London.	Minute books of three major Ashkenazi synagogues abandon Hebrew and Yiddish for English. Sir Walter Scott's novel *Ivanhoe* introduces positive Jewish characters: Sir Isaac of York and Rebecca (1819).	First efforts to introduce aesthetic reforms in synagogues.
Jewish population numbers under 400,000. Under French rule, Jews in Westphalia receive equal rights (1808). Organ installed in first Reform synagogue (1807).	Partial emancipation in Prussia (1812). About 800 Jewish volunteers fight in "Wars of Liberation" against Napoleon (1813). Reform Temple opens in Hamburg and creates dissension (1818). Congress of Vienna permits abolition of emancipation laws in German states (1815). Hep! Hep! anti-Jewish riots erupt (1819). Association for Culture and the Scientific Study of the Jews founded (1819).	Felix Mendelssohn, converted grandson of Moses Mendelssohn, performs a piano recital for Goethe (1821). Heinrich Heine publishes his first verse collection (1822).
Jewish population numbers about 30,000. French influence strong and equality of Jews recognized. Modern Jewish gymnasium (high school) established in Reggio (1802).	Jews restored to ghettos in Piedmont (1815).	Samuel David Luzzatto, a leader of the Italian Haskalah (Jewish Enlightenment movement), translates prayer book into Italian (1821). Collegio Rabbinico, Italy's first rabbinical seminary, established in Padua (1829).
Jews number about 250,000. 104 modern Jewish schools, opened by governmental order, are closed because of fear of harmful influence of "anti-religious" teachers (1806).	*Maskilim* reestablish modern Jewish school in Galicia (1813). Belz Hasidic dynasty founded (1815) and Hasidism thrives. Jews barred from positions in state, municipal, and judicial offices as well as from teaching positions (edicts of 1804, 1811, and 1821).	Haskalah critics of Hasidism circulate satiric attacks on the movement.
Jews number about 400,000.	Post–Congress of Vienna Jewry treated as a separate estate until Russian Revolution of 1917. (Creation of Congress Poland in 1815 following the Congress of Vienna; further references to Poland will be to Congress Poland.) 1815 Constitution prohibits Jews from exercising limited political and civic rights granted in 1804.	Small assimilationist movement among wealthy Jews begins. Czar Nicholas I orders Jewish youth inducted into the army in draconian measure (1827).
Jewish population numbers about 46,000. Jews complain that their legal rights not always enforced (1806).	Establishment of Holland's first modern Jewish school in Groningen (1815).	

	1830s	1840s
France	École Rabbinique, France's first rabbinical seminary, established at Metz (1830). Rothschilds heavily involved in finance during July monarchy (1830–48). Judaism joins other religions in France in receiving state subsidies (1831). Achille Fould elected as deputy to Parliament (1834). Rachel (Felix), actress, first appears at the Comédie Française (1838).	Adolphe Franck, philosopher and Jewish communal leader, elected to the French Academy of Moral and Political Sciences (1844) and becomes professor at the Collège de France (1849–86). Adolphe Crémieux becomes minister of justice (1848). Antisemitic riots through many towns and villages in Alsace during the Revolution of 1848.
England	Jews achieve right to vote, though had voted earlier (1835). Board of Deputies of British Jews recognized by government as representing Jews (1835). Moses Montefiore knighted (1837).	Moses Montefiore (together with Adolphe Crémieux of France) involved in international diplomacy in the Damascus Affair (1840). Disputes over seating of Lionel de Rothschild, elected to Parliament (1847).
Germany	Daniel Moritz Oppenheim paints *The Return of the Jewish Volunteer from the Wars of Liberation to His Family Still Living in Accordance with Old Customs* (1833–34). Samson Raphael Hirsch, founder of modern Orthodoxy, publishes *Nineteen Letters on Judaism* (1836).	Three Reform rabbinical assemblies held (1844–46). Frankfurt constitution endorses full rights for German Jews, but the revolution fails (1848).
Italy	Jews active in revolutionary outbreaks against authorities in central and northern Italy (1831).	King Carlo Alberto signs new constitution and emancipates the Jews of Piedmont (1848). Daniele Manin, a Jew by matrilineal decent, leads the Risorgimento movement (1848).
Habsburg Austria (Galicia)	Modern Jewish schools established in Kraków (1830–35).	Rabbi and *maskil* S. J. Rapoport flees Galicia because of strife with Hasidim (1840). Freedom of religious conscience included in post-revolution constitution (1848). Galician bureaucracy enforces old restrictive regulations against Jews (beginning in 1848).
Poland	Jews participate in uprising of 1831.	The *kahal* (organized Jewish community) abolished (1844). Czar Nicholas I establishes network of reformed Jewish schools (1844).
Netherlands	Carl Asser, one of the first Jews to practice law in Holland, dies after a career of almost thirty years (1836).	Samuel Sarphati active in Amsterdam as a physician and social reformer.

1850s

Jewish population numbers about 75,000.
The Péreire brothers establish the Crédit Mobilier, a major joint stock investment company (1853–54).

Jewish population numbers about 35,000.
Sir David Salomons becomes Lord Mayor of London (1855).
De facto emancipation of Jews of England with the seating of Lionel de Rothschild in Parliament (1858).

Jewish population numbers over 400,000 in the German states.
Jewish Theological Seminary, first rabbinical seminary in Germany, founded (1854).
Mathematician Moritz Stern becomes first Jewish full professor in a German university (1859).

Jewish population numbers about 40,000.
Kidnapping of Jewish child, Edgardo Mortara, by the Roman Catholic Church (1858).

Jewish population numbers about 400,000.
Further restrictive governmental decrees.

Jewish population numbers about 600,000.
Prejudice against Jews joining craft guilds continues.
First Hebrew novel, Abraham Mapu's *Ahavat Tsiyyon*, published (1853).
First two Jews elected as deputy elders to merchant guild of Warsaw, but only to discuss issues regarding Jews (1856).

Jewish population numbers about 60,000.
Law obligates public education and ends separate Jewish education. Jews flock to government-sponsored public schools (1857).

1860s

Alliance Israélite Universelle, an international defense and educational agency, founded (1860).
Camille Pissarro gains reputation as leading Impressionist painter (1865).
Gustave Bédarridès becomes *avocat général* of the Cour de Cassation (supreme court of appeals) (1867).

Benjamin Disraeli, a baptized Jew, chosen as prime minister of Great Britain (1868).

Baden is first German state to fully emancipate its Jews (1862).
Gerson Bleichroeder becomes Bismarck's private banker.
Moritz Elstätter becomes Baden's minister of finance, only Jew to hold ministerial position in Germany before World War I (1868).

With the establishment of Kingdom of Italy, all Jews except for those in Rome have equal rights (1861).
Emilio and Giuseppe Treves, Jewish brothers, establish Italy's largest publishing house (1864).

Polish deputies in Galician Diet oppose civic rights for Jews (1861).
Emancipation of Jews (1867).
Small number of Jewish males studying in high schools and universities.

Jews allowed to enter name in municipal registers of citizens in Congress Poland (1861).
Special Jewish taxes abolished (1862).
Jews participate in the Polish uprising against Russia (1863).
Modern literature in Yiddish begins to appear.

Michael Godefroi becomes minister of justice (1860).

1870s

Jews of Algeria are granted French citizenship through the Crémieux Law (1870).
Six Jews in the national legislature (1871).

Eight Jews in Parliament (1871).
Jews have access to Oxford and Cambridge fellowships (1871).

New German constitution gives Jews full rights (1871).
Leopold Ullstein, a major newspaper publisher, establishes a large book-publishing house (1877).
Beginning of political antisemitic movement in Germany.

Abolition of ghetto of Rome and final emancipation of Rome's Jews (1870).
Eleven Jews in Italian Parliament (1871).

Hasidic rabbis advocate political participation by their followers.

Mendele Moykher-Seforim writes *The Nag*, popular Yiddish allegory about persecution of the Jews in Russia (1873).

Aletta Jacobs becomes first female physician in the Netherlands (1879).

	1880s	1890s	1900s
France	Edouard Drumont publishes his antisemitic *La France juive* (Jewish France) (1886) Émile Durkheim appointed to first chair in social science in Europe at the University of Bordeaux (1887).	Alfred Dreyfus, member of the army's general staff, is arrested for treason (1894). Émile Zola publishes *J'accuse*, a passionate pro-Dreyfus demand for justice (1898).	Jewish population numbers about 86,000. Dreyfus pardoned (1899) and exonerated (1906). France's first Reform synagogue, the Union Libérale Israélite of Paris, secures legal recognition (1907).
England	Nathaniel de Rothschild elevated to the peerage (1885).	Creation of the Jewish Historical Society of England, a product of the interest in the past generated by the 1887 exhibition.	Jewish population numbers about 180,000. Israel Zangwill's *Children of the Ghetto*, about immigrant life in London's East End, is published (1902). Claude Montefiore establishes the Jewish Reform Union (1902). Aliens Act restricts immigration, directly affecting Jews (1905). Herbert Samuel becomes a cabinet minister (1909).
Germany	Publication of Oppenheim's series by Heinrich Keller.	Sixteen antisemites elected to the Reichstag (1893). Central Union of German Citizens of Jewish Faith founded (1893).	Jewish population numbers about 600,000. Eduard Bernstein elected to Parliament as Social Democrat representative (1902). Martin Buber publishes *Tales of Rabbi Nachman of Bratslav* (1906).
Italy	Completion of the Florence Moorish synagogue (1882)	Luigi Luzzatti becomes minister of finance.	Jewish population numbers fewer than 40,000. Giuseppe Ottolenghi becomes first Jewish minister of war in Europe (1904). Luigi Luzzatti becomes prime minister (1909).
Habsburg Austria (Galicia)	Jews migrate to Vienna and emigrate to the United States (continuing to World War I).	Publication of Theodor Herzl's *The Jewish State* (1896). Freud's *Interpretation of Dreams* published (1899).	Jewish population numbers about 800,000. Jews attracted to groups advocating Jewish national autonomy in Europe. Jewish socialists establish Jewish Social-Democratic Party (1905).
Poland	Pogroms in Russia (1881–82) and Warsaw (1881) shake Polish Jewry. Mass emigration until World War I. Hovevei Zion (Lovers of Zion) committees functioning from 1883.	Restrictive "May Laws" of 1882 extended to Poland (1891).	Jewish population numbers about 1,315,000. Series of pogroms in Russia in the unstable period before and after the failed revolution of 1905 remind Polish Jews of their vulnerability. 85,000 Jewish children still attend traditional heder.
Netherlands	I. A. Levy founds the Liberal Union (1885).	Abraham Wertheim, a prominent banker, elected to the Senate as a Liberal (1897). Henri Polak helps establish the Social Democratic Labor Party (1898). Herman Heijermans writes play *Ghetto*, which deals with problem of the proletariat (1899).	Jewish population numbers about 100,000.

Artist Biographies

The countries cited here refer to the nations with which the artists are primarily associated, and are not necessarily their birthplaces.

Tina Blau (Austrian, 1845–1916)

Born in Vienna to parents who had come from Bohemia and Moravia, Tina Blau was originally named Regina Leopoldine and registered in the Jewish community. Her artistic inclination was felt at an early age and encouraged by her father. From youth she had a passion for nature and for depicting landscapes, and she caught the attention of August Schaeffer, the artist and gallery director, who took her under his wing when she was fifteen years old. Through Schaeffer, she also met the landscape artist Julius E. Marék. By the age of twenty-two she exhibited *At the Brook* (*Am Bach*) at the Österreichischen Kunstverein (Austrian Art Society). She subsequently began exhibiting in various venues in Vienna, selling her first painting in 1869.

Blau's early success and continued fascination with nature led her to seek out other artistic and natural worlds. Blau became a perennial traveler. Munich was her first destination, where she came into contact with French realist art (especially Courbet) and students of the Barbizon school. Blau worked in Bavaria with the history painter Wilhelm Lindenschmidt at the Kunstschule für Mädchen. Her artistic connections and influences widened during these years. She became close to the artist Emil Jakob Schindler, with whom she often traveled to Szolnok (southeast of Budapest) and other places, and who shared her interest in the effects of sunlight on the portrayal of landscape. Rembrandt and Frans Hals began to engage her after she visited Holland in the mid-1870s. Blau later became enthralled with the Prater, a park in the center of Vienna, painting it over and over.

In 1883 she converted to Protestantism under the influence of her future husband, the artist Heinrich Lang. It would seem that her Jewish roots were no longer an important aspect of her identity, although she undoubtedly encountered many elements of Jewish life in her travels and work. Other than

Jewish Street in Amsterdam (1875–76; pl. 57), no evidence of an engagement with things Jewish is apparent.

Blau's career became international in the 1880s. In 1890 the Munich Art Society mounted her first single-artist show. Sixty paintings were exhibited, many of them landscapes. Several years after the death of her husband in 1891, Blau returned to Vienna, where she worked in a studio at the Prater, taught art to women, and held several solo exhibitions that were attended by Kaiser Franz-Joseph. Though relatively well known in her time (she was exhibited in the Austrian Association of Women Artists 1901 Secession exhibition *The Art of the Woman* along with Berthe Morisot, Rosa Bonheur, and Käthe Kollwitz), her work fell into obscurity until recently.

Richard I. Cohen

SELECTED BIBLIOGRAPHY

Natter, G. Tobias. *Plein Air. Die Landschaftsmalerin Tina Blau 1845–1916*. Exh. cat. Vienna: Jüdisches Museum der Stadt Wien, 1996. See older literature there.

———, and Claus Jesina. *Tina Blau (1845–1916)*. Salzburg: Verlag Galerie Welz, 1999.

Tina Blau, c. 1873. Photograph by Franz Hanfstaengl.

Jacques-Émile-Edouard Brandon (French, 1831–1897)

Jacques-Émile-Edouard Brandon was born into a wealthy Bordeaux family of Spanish-Portuguese Jewish descent. In 1849 he began his artistic education at the École des Beaux-Arts in Paris, eventually becoming a pupil of Camille Corot. At the Ville d'Avray, Brandon worked with Corot and may have completed at least one of his landscapes in addition to drawing his portrait. The two painters corresponded and sent each other sketches during the time Brandon was in Italy (1856–63) and met frequently when Brandon returned to Paris. While in Italy, Brandon became acquainted with Edgar Degas and Gustave Moreau, eventually becoming a friend of Degas and an important collector of his work. Likewise, Degas had works by Brandon in his collection.

Brandon's initial successes were with Christian subjects, which were in demand during the period of prosperity of Napoleon III, and he is known for his series of works depicting the life of Saint Brigitte. A painting of Saint Brigitte exhibited at the Paris Salon in 1861 earned him the commission to decorate an oratory in her honor in Rome. But Brandon began to delve into Jewish themes in the 1860s, fascinated by the life of Jews in their classrooms and synagogues. *The Sermon of Dayan Cardozo* was exhibited at the Salon in Paris in 1866 and awarded a medal. This work would be followed by others relating to the Sabbath and the synagogue. *Rabbi with Children* (1869), a sensitive portrayal of a rabbi with three students, experiments with issues of shade and light. Similar works with a rabbi and children in the synagogue were to follow. Brandon participated in the first Impressionist exhibition of 1874 with his *Scene in a Synagogue* as well as with a drawing and several watercolors. Although later influenced by Impressionism, the majority of Brandon's work is academic in nature, and he did not participate in subsequent Impressionist

exhibitions. Though his interest in contemporary Jewish life became increasingly dominant, his work was not shown at the Exhibition of Jewish Artists in 1907, attesting to his rather minimal visibility at the time. Recently his paintings have surfaced at public auctions.

One of his last paintings, *Silent Prayer, Synagogue of Amsterdam, "The Amidah" ("La Guamida")* (pl. 11), executed in 1897, gives prominence to the Portuguese Synagogue of Amsterdam, inaugurated in 1675. Brandon's family history created a special link between him and this impressive synagogue, which had attracted the interest of many artists since the seventeenth century.

Richard I. Cohen and Karen Levitov

SELECTED BIBLIOGRAPHY

Goldman-Ida, Batsheva. "A Synagogue Interior by Edouard Brandon." *Tel Aviv Museum of Art Annual Review* 6 (1996–97): 62–72.

Kleeblatt, Norman L., and Vivian B. Mann. *Treasures of The Jewish Museum.* New York: Universe Books, 1986. 162–63 (entry by Kleeblatt).

Nochlin, Linda. *The Politics of Vision: Essays in Nineteenth-Century Art and Society.* New York: Harper and Row, 1989. See esp. 149.

Vittorio Matteo Corcos (Italian, 1859–1933)

Vittorio Matteo Corcos was born in Livorno to a family of modest means. Following the Risorgimento, the unification of Italy, Jews, such as the Corcos family, readily integrated into Italian society. This atmosphere facilitated Corcos's artistic education. In 1875 he began study with Enrico Pollastrini at the Accademia di Belle Arti in Florence; he later studied with Domenico Morelli in Naples. Morelli was an influential forerunner of the Macchiaioli, a group of artists inspired by French Romantic painting and the Barbizon school. They were interested in light, color, and the "effects" of nature, often captured *all'aperto* (outdoors). In the new atmosphere of liberation and unification, artists sought to convey the essence of Italian identity in scenes of everyday life rather than the historical or biblical subjects of academic painting, utilizing the new technique of *macchia* (meaning "stain" or "patch") to achieve a more spontaneous effect. Although he painted in a conservative style to please certain patrons, Corcos utilized the patchwork effect of the Macchiaioli in much of his portraiture and in his plein-air landscapes.

Corcos went to Paris in 1880, where he studied with Léon Bonnat and painted under contract with the dealer Goupil. While in France, Corcos exhibited several works at the Paris Salon and achieved recognition and success, especially for his female portraits and society scenes. He also illustrated French and English magazines, book covers, and posters.

In 1886 Corcos returned to Florence for military service. That same year he married Emma Ciabatti and converted to Catholicism. Corcos nevertheless maintained close connections to a circle of Jewish artists in Livorno and Florence, painting their portraits as well as those of other leading figures of society. He traveled to France, England, Germany, and Portugal for portrait commissions, primarily of celebrities of art, literature, finance, society, and royalty, such as

Vittorio Corcos

Emperor William II of Germany, Queen Amelia of Portugal, and Queen Marguerite of Italy.

During the 1920s, Corcos was a member of the Gruppo Labronico, a cultural organization in Livorno, and continued to receive prestigious portrait commissions, including that of Mussolini in 1928.

Karen Levitov and Francesca Morelli

SELECTED BIBLIOGRAPHY

Braun, Emily. "From the Risorgimento to the Resistance: One Hundred Years of Jewish Artists in Italy." In *Gardens and Ghettos: The Art of Jewish Life in Italy*, ed. Vivian B. Mann, exh. cat. Berkeley and Los Angeles: University of California Press, 1989. 137–89.

Morelli, Francesca. "Vittorio Matteo Corcos." In *Gardens and Ghettos: The Art of Jewish Life in Italy*, ed. Vivian B. Mann, exh. cat. Berkeley and Los Angeles: University of California Press; 1989. 332.

Vito d'Ancona (Italian, 1825–1884)

Vito d'Ancona was born in Pesaro to a large, wealthy family of Sephardic descent. He was one of the originators of the Macchiaioli, the artistic movement dedicated to Italian subjects painted with dramatic tonal contrasts and broad brushstrokes (*macchia*, or "patch"). D'Ancona studied art at the Accademia di Belle Arti in Florence. There he met Serafino De Tivoli, who became a close friend and fellow supporter of the Risorgimento. The eleven Macchiaioli artists who gathered at the Caffè Michelangiolo in Florence, a number of whom were Jewish, supported a unified Italy. Their paintings reflected their interest in Italian nationalism through subjects of everyday life, often painted *all'aperto* (outdoors) in a loose, nonacademic style.

D'Ancona traveled in Italy in 1856, studying paintings in museums in Bologna, Mantua, Modena, and Venice. In 1861 he won the gold medal at the National Exposition in Florence for his *Dante e Beatrice* (1859), but he refused the award, believing that the jury was incompetent. From 1867 to 1874 he lived in Paris, where he encountered French avant-garde artists and was exposed to Japanese prints, newly introduced to Paris after the Exposition Universelle of 1867. D'Ancona expressed particular admiration for the works of the realist painter Gustave Courbet, who, like the Macchiaioli, emphasized subjects from modern life and the flattened perspective and simplified forms of Japanese prints.

D'Ancona returned to Florence in 1875 when his health began to deteriorate. Here he painted his uncle's estate in *View of Volognano* (1878; pl. 45), using the *macchia* techniques of broad patches of color and deep shadows. D'Ancona's images of his uncle's estate showed not only the Tuscan landscape much admired by the Macchiaioli but also reflected the recent end to restrictions forbidding Jews to own property.

Karen Levitov and Francesca Morelli

SELECTED BIBLIOGRAPHY

Boime, Albert. *The Art of the Macchia and the Risorgimento: Representing Culture and Nationalism in Nineteenth-Century Italy*. Chicago: University of Chicago Press, 1993. See esp. 201–3.

Broude, Norma. *The Macchiaioli: Italian Painters of the Nineteenth Century*. New Haven, Conn.: Yale University Press, 1987.

Mann, Vivian B., ed. *Gardens and Ghettos: The Art of Jewish Life in Italy*. Exh. cat. Berkeley and Los Angeles: University of California Press, 1989. See esp. 329 for biography by Francesca Morelli.

Vito d'Ancona

Jacob Meyer de Haan

(Dutch, 1852–1895)

Jacob Meyer de Haan, who was represented in many seminal works by Gauguin, underwent a process of acculturation common to many Jews in Western Europe in the nineteenth century. His father, Isaac Aron, a very successful matzo and bread manufacturer in Amsterdam, was an observant Jew associated with the Ashkenazic Orthodox community. His son challenged that world in life and work from an early age. De Haan received a traditional Jewish education. Three works from his Amsterdam period—*The Talmudic Dispute* (1878), *Is the Chicken Kosher?* (c. 1880; see fig. 5), and *Uriel d'Acosta* (1878–80)—are in the spirit of Jewish genre paintings, but they lack their characteristic intimacy and warmth. Like other artists of Jewish origin in the nineteenth century—for example, Maurycy Gottlieb—de Haan portrayed d'Acosta, the rebellious figure of the seventeenth century, to symbolize a perennial confrontation between traditional ways and a secular identity. The other two works caricature issues central to traditional Jewish society. Yet his accomplished *Portrait of a Young Jewish Girl* (c. 1886; pl. 58) reveals nothing of his ambivalence with Jewish themes.

In 1888 de Haan left this life—and this painting style—behind and moved together with his student Joseph Jacob Isaacson to Paris, where he was introduced to members of the French avant-garde by Theo van Gogh. After de Haan met Gauguin in 1889, the two artists moved to Le Pouldu, Brittany, where de Haan remained for more than a year and a half while working closely with the French artist. The period was to leave a significant impression on the work of both de Haan and Gauguin. In the case of de Haan, it was characterized by his swift assumption of Gauguin's synthetist style and the incorporation of various Gauguin motifs and arrangements. De Haan also pursued Gauguin's interest in Breton nature, life, and figures, creating some of his most celebrated

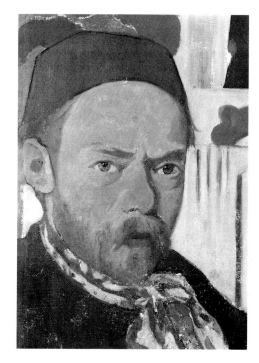

Jacob Meyer de Haan. *Self-Portrait* (detail), 1889–91. See pl. 60.

canvases (such as his paintings of farmhouses at Le Pouldu of 1889–90). Gauguin's portraits of de Haan exaggerated the younger artist's features and depicted him as somewhat demonic. De Haan planned to join Gauguin on his trip to Tahiti, but failing health and increasing financial complications, caused by conflict with his previously supportive family, intervened. Instead, de Haan returned to Paris in 1890, where he died several years later of tuberculosis, remembered more for his appearance in Gauguin's art than for his own creative work.

Richard I. Cohen

SELECTED BIBLIOGRAPHY

Jaworska, Wladyslawa. *Gauguin and the Pont-Aven School*. Trans. Patrick Evans. Greenwich, Conn.: New York Graphic Society, 1972.

———. "Jacob Meyer de Haan, 1852–1895." *Nederlands Kunsthistorisch Jaarboek* 18 (1967): 210–12, 223.

Zafran, Eric, ed. *Gauguin's Nirvana: Painters at Le Pouldu, 1889–1890*. Exh. cat. New Haven, Conn.: Wadsworth Atheneum Museum of Art, Hartford, and Yale University Press, 2001.

Maurycy Gottlieb

(Galician, 1856–1879)

Drohobycz in eastern Galicia was in the midst of an economic boom when Maurycy Gottlieb was born in 1856. Gottlieb's father was part of the rising bourgeoisie in a city where Jews made up about half of the multinational and multireligious population. Drohobycz bustled with diverse political and cultural orientations. One of eleven children, Gottlieb sensed this crucible from an early age, both in grade school, run by the monastery of Saint Basil, and in a Polish gymnasium that he later attended. As one of the few Jews in both institutions, Gottlieb felt himself an outsider, but he was taken under the wings of his art teacher, who encouraged him to pursue his studies in Lvov. There, in 1869, Gottlieb studied at the Michal Godlewski School for Art. His artistic education expanded in the early 1870s when he attended the Vienna Art Academy. During his stay in Vienna, he encountered the works of one of the leading Polish painters of his day, Jan Matejko, who then headed the Kraków Academy of Art. Gottlieb was enamored with his work and followed him to Kraków.

While under Matejko's guidance, Gottlieb's Polish identity was brought to the fore. Gottlieb's stay in Kraków was short-lived, however, and with the recommendation of Matejko he moved to Munich to study with Karl von Piloty, the history painter. In Munich, Gottlieb's Jewish roots surfaced. In 1876 he executed *Self-Portrait as Ahasuer* (see fig. 16), *Shylock and Jessica*, *A Jewish Wedding*, and other works while also falling under the spell of Rembrandt, whose paintings he saw in the Pinakothek.

During the last three years of his life, Gottlieb produced several works that showed the increasing influence of Rembrandt. Three of the most notable are *Jews Praying in the Synagogue on Yom Kippur* (1878; pl. 15), a work in which the artist raised many issues in connection to his Jewish identity; *Christ before His Judges* (1877–79; see fig. 29), where he

returned to a historical theme and portrayed Christ as a Jew in controversy with Roman authorities; and *Christ Preaching at Capernaum* (1878–79; pl. 18), in which the artist expressed his universalistic vision and hope for brotherhood between Jews and Poles. The last two paintings were never finished, because Gottlieb became terminally ill. He is buried in the Kraków Jewish cemetery.

Richard I. Cohen

SELECTED BIBLIOGRAPHY

Amishai-Maisels, Ziva. "The Jewish Jesus." *Journal of Jewish Art* 9 (1982): 84–104.

Guralnik, Nehama. *In the Flower of Youth: Maurycy Gottlieb, 1856–1879*. Exh. cat. Tel Aviv: Tel Aviv Museum of Art and Dvir Publishers, 1991.

Mendelsohn, Ezra. "Art and Jewish History: Maurycy Gottlieb's *Christ Preaching at Capernaum*." *Zion* 62, no. 2 (1997): 173–91 (Hebrew).

———. "Art and Jewish-Polish Relations: Matejko and Gottlieb at the National Museum in Warsaw." In *Jewish Studies at the Central European University*, ed. András Kovács. Budapest: Jewish Studies Program, Central European University, 2000. 171–80.

Silver, Larry. "Jewish Identity in Art and History: Maurycy Gottlieb as Early Jewish Artist." In *Jewish Identity in Modern Art History*, ed. Catherine M. Soussloff. Berkeley and Los Angeles: University of California Press, 1999. 87–113.

Maurycy Gottlieb

Solomon Alexander Hart

(British, 1806–1881)

Born to a Plymouth silversmith, Solomon Alexander Hart and his family moved to London in 1820, where he was apprenticed to the engraver Charles Warren. He later studied at the Royal Academy for three years (1823–26), showing a special proclivity for miniature portraiture. Notwithstanding, and possibly as a result of, the political debates on Jewish emancipation in England, Hart exhibited at the academy in 1830 his *Interior of a Jewish Synagogue at the Time of the Reading of the Law*. The painting, now in the Tate Gallery, uses a realistic style to depict the interior of a former Polish synagogue in London. Several years later he became an associate member of the Royal Academy; in 1840 he became a full member, the first Jew to be so elected.

Hart, as he later observed in his memoir, *Reminiscences*, was concerned that he not be seen as "the painter of merely religious ceremonies." During his visit to Italy in 1840–41, he produced a series of drawings of church and synagogue interiors, possibly inspired by the English artist David Roberts, which later served him in a variety of paintings. His entry to the Royal Academy in 1850, *The Feast of the Rejoicing of the Law at the Synagogue in Leghorn, Italy* (1850; pl. 10), captured the ornate interior of the Leghorn (Livorno) synagogue, while other works (*Interior of a Church in Florence* and *Interior, Saint Marks*) continued his attention to detail and architectural motifs. Hart also painted many canvases depicting English historical and literary scenes, revealing his interest in both English culture and his Jewish heritage. Subjects from Shakespeare and Walter Scott's novels and historical paintings such as *The Conference of Menassah ben Israel and Oliver Cromwell* gave expression to his pride in his native country. Though biblical paintings were uncommon for Hart, in 1878 he exhibited *The Temple of the Jews at Shilo: Hannah Presenting the Infant Samuel to the High Priest*

Solomon Alexander Hart

Eli at the Royal Academy to considerable acclaim. The painting portrays the high priest and his costume with the Temple menorah and the hills of the holy land in the background.

Richard I. Cohen and Dara Keese

SELECTED BIBLIOGRAPHY

Cohen, Richard I. *Jewish Icons: Art and Society in Modern Europe*. Berkeley and Los Angeles: University of California Press, 1998. 158–59.

Hart, Solomon Alexander. *Reminiscences of Solomon Hart*. Ed. Alexander Brodie. London: Wyman and Sons, 1882.

Important Judaica: Books, Manuscripts, Silver, Gold, Ceramics, Works of Art and Paintings. Sotheby's auction catalogue, New York, 1999. 96–97.

Kleeblatt, Norman L., and Vivian B. Mann. *Treasures of The Jewish Museum*. New York: Universe Books, 1986. 150–51 (entry by Kleeblatt).

Parkinson, Ronald. *Catalogue of British Oil Paintings 1820–1860*. London: Victoria and Albert Museum, 1990.

Samuel Hirszenberg

(Polish, 1865–1908)

Few Jewish artists at the turn of the twentieth century evoked such Jewish nationalist aspirations as Samuel Hirszenberg. The son of a weaver from Lodz, Hirszenberg was destined to follow in his father's footsteps to support their large family, but he preferred to study art. He pursued his training first in Warsaw and then in Kraków, where he came under the tutelage of the leading Polish painter of the day, Jan Matejko. In 1885 he went to study in Munich. Although his work previously had been infused with Jewish themes (for example, *Talmud Lesson*, a depiction of Spinoza sitting together with Uriel d'Acosta), his return to Lodz in 1891 intensified this focus. There he found a city teeming with thousands of Jewish refugees from czarist Russia. Witnessing the displacement of a people strengthened Hirszenberg's emerging Zionism, and he began to concentrate on the historical and contemporary plight of the Jews.

Hirszenberg's *Wandering Jew* (1899; see fig. 46) confronted the predicament of displacement head-on. Exhibited first in Lodz and then in Warsaw, the painting was sent to the international exhibition in Paris in 1900. *Wandering Jew* brought together the tradition of Polish realism in art with a stark portrayal of the Jews' endless struggle with Christianity. The painting was followed by other dramatic works (for example, *The Jewish Cemetery*, 1892; pl. 29) that were popularized in some Jewish circles. But it was Hirszenberg's *Exile* (1904; see fig. 32), whose present whereabouts are unknown, that became a Zionist icon and catapulted the artist into the forefront of the discussion on Jewish nationalist art. Based on Daumier's *The Fugitives*, the painting depicted Jews of all ages and social positions trekking through the snow to an undetermined destination. Reproductions of the painting hung in many Jewish homes at the beginning of the twentieth century. Another Hirszenberg work, *The Black Banner* (1905; pl. 27), continued the theme of mass

movement by placing Jews in a funeral procession, the intensity of the moment accentuated by the foreboding sky and the startled looks on the mourners' faces.

In 1907 Hirszenberg immigrated to Palestine to assume a teaching position at the newly founded Bezalel Academy of Arts and Design in Jerusalem. His works from the eleven months he lived in Jerusalem shifted away from evocative subjects to focus on sites and personalities in the city, often with more colorful backgrounds. He died in September 1908. Upon his death, Hebrew writers deeply mourned his passing, having seen him as "the pioneer of the Hebrew artistic revival."

Richard I. Cohen

SELECTED BIBLIOGRAPHY

Amishai-Maisels, Ziva. *Depiction and Interpretation: The Influence of the Holocaust on the Visual Arts.* Oxford and New York: Pergamon Press, 1993.

Cohen, Richard I. *Jewish Icons: Art and Society in Modern Europe.* Berkeley and Los Angeles: University of California Press, 1998. See esp. 223–36.

Holtzman, Avner. *Aesthetics and National Revival: Hebrew Literature against the Visual Arts.* Tel Aviv: Zmora-Bitan Publishers and Haifa University Press, 1999 (Hebrew).

Kleeblatt, Norman L., and Vivian B. Mann. *Treasures of The Jewish Museum.* New York: Universe Books, 1986. 166–67.

Lewbin, Hyman. *Rebirth of Jewish Art: The Unfolding of Jewish Art in the Nineteenth Century.* New York: Shengold Publishing, 1974. 71–75.

Ofrat, Gideon. *In Praise of Galut.* Jerusalem: Carta, 2000 (Hebrew).

———. *On the Ground: Early Eretz-Israel Art.* Vol. 1. Jerusalem: Omanut Israel, 1993 (Hebrew). See esp. 213–26.

Samuel Hirszenberg, 1908

Jozef Israëls

Jozef Israëls (Dutch, 1824–1911)

The renowned Dutch painter Jozef Israëls was born in Groningen into an observant and middle-class family, one of eleven children. Though expected to become a rabbi, Israëls began taking drawing and painting lessons at an early age. When he was eighteen, he moved to Amsterdam to continue his studies with Jan Adam Kruseman. A year later he was accepted at Amsterdam's Koninklijke Akademie. After exposing himself to new styles in art in Paris, he returned to Amsterdam in 1847, where he resumed his studies at the Akademie under the tutelage of Kruseman and the historical artist Jan Willem Pieneman. Several of his paintings had already been exhibited in Amsterdam and Groningen, and by 1851 he was appointed to the Akademie and had executed several historical paintings. However, Israëls was already turning to the genre scenes (especially those of fishermen) that were to become his trademark. By the late 1850s his use of light was already eliciting comparisons with Rembrandt.

Israëls's stature grew in the 1860s. Following *The Shipwrecked Mariner* (1861), depicting a procession with a dead fisherman, which was exhibited at important venues to significant acclaim, Israëls painted several works evoking the sad fate of the fisherwoman. Human suffering, death, and sober scenes commonly treated by realist artists predominated in his work, as in *The Last Breath* (1872; pl. 47), *The Fisherman's Return*, and *From Darkness to Light* (1871). In 1871 Israëls moved with his family to The Hague, a city thriving with artistic vibrancy. The artist settled comfortably into this environment, and his oils, watercolors, and etchings became internationally well known. By the 1880s Israëls was already considered one of Holland's leading artists, his work widely discussed and exhibited. In 1881 he made the acquaintance of the German artist Max Liebermann, with whom he would remain in close contact until his death.

Throughout his life Israëls turned on occasion to Jewish themes and personalities. From his earlier portraits in the 1840s of Eleazar Herschel and Rabbi Benjamin Schnap to his portraits of Professor Goudsmit (1866), Isaac Tobias Philips (c. 1870), and the Hijmans (c. 1872), Israëls turned later in life to depict Jewish subjects (*A Son of the Ancient Race* [c. 1889; pl. 48], *A Jewish Wedding* [1903; pl. 49]) and biblical themes (*Self-Portrait [with Saul and David in the Background]* [1908; pl. 46]). These works were produced while the artist continued his lifelong preoccupation with domestic scenes and figures in the fields and the water, often poignantly presented. He died in 1911 and, after a state funeral, was buried in the Jewish cemetery of Scheveningen.

Richard I. Cohen

SELECTED BIBLIOGRAPHY

Berkowitz, Michael. "Art in Zionist Popular Culture and Jewish National Self-Consciousness, 1897–1914." *Studies in Contemporary Jewry: An Annual*, no. 6 ("Art and Its Uses: The Visual Image and Modern Jewish Society") (1990): 9–41.

Dekkers, Dieuwertje, ed. *Jozef Israëls, 1824–1911*. Exh. cat. Groningen: Groninger Museum; Amsterdam: Jewish Historical Museum; Zwolle: Waanders Publishers; Groningen: Institute of Art and Architectural History (RuG), 1999.

Eisler, Max. *Jozef Israëls*. London: The Studio, 1924.

Gans, Mozes Heiman. *Memorbook: History of Dutch Jewry from the Renaissance to 1940*. Trans. Arnold J. Pomerans. Baarn: Bosch and Keuning, 1977. See esp. 404–13.

Jozef Israëls: Son of the Ancient People. Museum brochure, Amsterdam Jewish Historical Museum, 1999.

Jozef Israëls—On Life and Death. Museum brochure, The Tel Aviv Museum of Art.

Kleeblatt, Norman L., and Vivian B. Mann. *Treasures of The Jewish Museum*. New York: Universe Books, 1986. 160–61.

Isidor Kaufmann
(Austrian, 1853–1921)

Born in Arad (now in Rumania), then a frontier fortress in the Austro-Hungarian Empire, Isidor Kaufmann began his artistic career with a drawing of Moses in 1874. He studied briefly at the Budapest State School of Drawing but then moved to Vienna, where he was to live for the remainder of his life. After a checkered initiation at the Viennese Academy of Visual Arts, Kaufmann eventually gained the support and encouragement of his mentor, Josef Trenkwald, a distinguished historical painter. Kaufmann did not follow in Trenkwald's footsteps, however. By 1883–84 he had turned to genre painting and engaged the interest of the art dealer Friedrich Schwarz, who cultivated promising artists. Kaufmann depicted everyday life, incorporating Jewish and non-Jewish themes and characters. Chess players, milliners, beggars, and rabbis appear in sympathetic portrayals.

Beginning in 1894, Jewish genre scenes formed the basis of Kaufmann's work. He was inspired by his visits to areas of the empire where traditional Jewish life continued to be vibrant. His sketches from these trips provided the source for his paintings on mahogany of traditional Jewish life—synagogues, rabbis, Hasidim, Talmud study, Jews in prayer, and the like. He wanted to document the life of traditional Judaism, to highlight its unique values, and to bridge it with the world of acculturated Vienna. This passion encouraged the artist, in 1899, to set up a "Sabbath Room" in the Jewish Museum of Vienna. The room, which contained artifacts and furniture, would inspire similar rooms in other Jewish museums. Yet Kaufmann did not relinquish his interest in painting portraits of bourgeois Viennese society. His technique emphasized the brightness of color and the subdued nature of the subjects.

Kaufmann's work was exhibited in various exhibitions of the Wiener Künstlerhaus; at various international exhibitions in Paris, Berlin, and Munich; and at the first major

exhibition of Jewish artists in 1907 in Berlin. Very popular among Viennese Jews, Kaufmann did not have to rely solely on their support, as his works were purchased by Jews and non-Jews alike, including the Austrian state minister for culture and education and the reigning prince of Liechtenstein. Interest in his work grew considerably after his death, especially following World War II.

Richard I. Cohen

SELECTED BIBLIOGRAPHY

Cohen, Richard I. *Jewish Icons: Art and Society in Modern Europe.* Berkeley and Los Angeles: University of California Press, 1998. 171–75.

Families and Feasts: Paintings by Oppenheim and Kaufmann. Exh. cat. New York: Yeshiva University Museum, 1977. See text by Alfred Werner, "Oppenheim and Kaufmann: Fine Genre Painters."

Kutna, G. "Isidor Kaufmann." *Ost und West* 3 (1903): 589–603.

Natter, G. Tobias, ed. *Rabbiner-Bocher-Talmudschüler. Bilder des Wiener Malers Isidor Kaufmann, 1853–1921.* Exh. cat. Vienna: Jüdisches Museum der Stadt Wien, 1995. In German and English.

Isidor Kaufmann, c. 1906

Broncia Koller-Pinell, aka Bronislawa Pineles

(Austrian, 1863–1934)

Bronislawa Pineles was born in Sanok on the San, Galicia, in 1863. She received her first lesson in painting from the sculptor Josef Raab at the age of eighteen. As women were not expected to pursue the arts as a career, she claimed to be taking the lessons only for her own pleasure. She would continue her lessons as a private student of the painter Alois Delug. From 1885 on she studied with Ludwig Herterich in Munich. She first exhibited at the International Arts Exposition in Vienna in 1888.

Pineles met the medical doctor and physicist Dr. Hugo Koller, her junior by five years, among the circle of friends of Hugo Wolf, the "Brucknerians"; they married in 1896. From that point on, she started signing her works "Broncia Koller-Pinell." After 1908 she mostly signed "Broncia Koller." In order to avoid disagreements with her Catholic in-laws regarding the religious education of their children, the couple moved first to Hallein, then to Nuremberg. During that time, Koller-Pinell was creating Impressionist-style works.

After returning to Vienna in 1902, Koller-Pinell quickly became part of the city's vibrant artistic life, thanks both to her ambition and to the large fortune of her husband. She was a regular client of the architect Josef Hoffman, who remodeled her Vienna apartment twice and also remodeled her country home in Oberwaltersdorf. However, the central figure in her life was Gustav Klimt. Her inclusion in the Viennese exposition of 1908 made their relationship even closer. The piece she exhibited there, the nude *Sitting* (*Marietta*) (1907; pl. 72), is still considered her most famous work.

Koller-Pinell slowly gained access to the circle of young Expressionists. After Klimt's death, she championed Egon Schiele as his only worthy successor. After 1918, Koller-Pinell added still lifes to her repertoire of portraits and landscapes. The influence of the new

Broncia Koller-Pinell, c. 1900

realism, in which form and color have been toned down, is apparent in this work. Koller-Pinell died in 1934 in Vienna.

G. Tobias Natter

SELECTED BIBLIOGRAPHY

Baumgartner, Sieglinde. "Broncia Koller-Pinell. 1863–1934. Eine österreichische Malerin zwischen Dilletantismus und professionell Monographie und Werkverzeichnis." Unpublished diss., Fakultät der Universität Salzburg, 1989.

Broncia Koller-Pinell. Eine Malerin im Glanz der wiener Jahrhundertwende. Exh. cat. Vienna: Selbstverlag, 1993.

Jahrhundert der Frauen. Vom Impressionismus zur Gegenwart. Österreich 1870 bis heute. Exh. cat. Salzburg: Residenz Verlag, 1999.

Die Malerin Broncia Koller. Exh. cat. Vienna: Selbstverlag, 1980.

Max Liebermann
(German, 1847–1935)

Born into a wealthy Jewish family in Berlin, where his father and uncle ran a prosperous cotton manufacturing business, Max Liebermann studied at the Weimar Academy (against the wishes of his father). His bourgeois heritage might have attuned him to themes of bourgeois leisure and prosperity emerging from Impressionist painters in France, but he also shared contemporary French taste for humbler subjects, notably peasants and rural landscapes. An early and abiding preoccupation with such scenes and figures can be seen in his paintings of the early 1870s, where ramshackle corners of houses or open farm fields are often occupied by figures performing simple chores or crafts. A good example of this interest is *Flax Spinners in Laren* (1887), a version of his massive work in dark colors, which depicts the collective labor of rural young women and children in their distinctive folk costumes and linen caps. In addition to their general emulation of popular peasant pictures of France, such as those of Millet, these images derive from Liebermann's firsthand experience of contemporary Dutch art and rural settings (he was a regular visitor to Holland beginning in 1871) as well as seventeenth-century Dutch painting traditions.

Liebermann was engaged with his Jewish identity from this early period. His *Synagogue in Amsterdam* (1876) was followed by his much-discussed image of biblical history, *The Twelve-Year-Old Jesus in the Temple* (1879; see fig. 4), in which the adolescent Jesus discusses theology with a group of rabbis. The work evoked antisemitic criticism, leading Liebermann to avoid religious subjects in the future but not Jewish themes or personalities. He did a series of paintings of the busy Amsterdam Judengasse (Jewish Street) at the beginning of the twentieth century (pl. 52).

Sought after by important Berlin cultural figures, Liebermann was commissioned to paint a wide range of Jewish personalities (for example, the philosopher Hermann Cohen, 1913), part of the liberal and prosperous Berlin milieu. Liebermann was in close contact with several artists of Jewish origin, Jozef Israëls in particular, and in the late 1920s actively supported the creation of a Berlin Jewish museum.

The founder and first president (after 1899) of the breakaway, internationalist Berlin Secession, Liebermann was chided for his cosmopolitanism and un-German character. Though his Jewish identity and international modernism remained visible and controversial, he rose to the top of the Berlin artistic community, becoming the president of the Prussian Academy of Arts (1920) and the recipient of an honorary doctorate from the University of Berlin (1912). Two major retrospectives were held at the Prussian Academy to commemorate his seventieth and eightieth birthdays (1917, 1927). No previous artist of Jewish origin had enjoyed such a notable career.

Liebermann was buried in the Jewish cemetery on Schönhauser Allee, Berlin, in 1935.

Larry Silver

SELECTED BIBLIOGRAPHY

Achenbach, Sigrid, and Matthias Eberle. *Max Liebermann in seiner Zeit*. Exh. cat. Berlin: Nationalgalerie, 1979.

Eberle, Matthias. *Max Liebermann, 1847–1935: Werkverzeichnis der Gemalde und Ölstudien*. Munich: Hirmer, 1995.

Makele, Maria. *The Munich Secession*. Princeton, N.J.: Princeton University Press, 1990.

Max Liebermann: Der Realist und die Phantasie. Exh. cat. Hamburg: Hamburger Kunsthalle, 1997.

Natter, G. Tobias, and Julias Schoeps, eds. *Max Liebermann und die französischen Impressionisten*. Exh. cat. Cologne: Dumont in association with the Jewish Museum, Vienna, 1997.

Paret, Peter. *The Berlin Secession: Modernism and Its Enemies in Imperial Germany*. Cambridge, Mass.: Harvard University Press, 1980.

———. "The Enemy Within." Leo Baeck Memorial Lecture. New York: Leo Baeck Institute, 1984.

Pauli, Gustav. "Liebermann: Eine Auswahl aus den Lebenswerk des Meisters." In *101 Abbildungen*. Stuttgart and Berlin: Deutsche Verlags-Anstalt, 1921.

Roogoff, Irit. "Max Liebermann and the Painting of the Public Sphere." In *Art and Its Uses: The Visual Image and Modern Jewish Society*. Studies in Contemporary Jewry, vol. 6. Ed. Ezra Mendelsohn. New York: Oxford University Press, 1990. 91–110.

Schütz, Chana C. "Max Liebermann as a 'Jewish' Painter: The Artist's Reception in His Time." In *Berlin Metropolis: Jews and the New Culture, 1890–1918*. Ed. Emily D. Bilski. Exh. cat. New York: The Jewish Museum; Berkeley and Los Angeles: University of California Press, 1999. 146–63.

Werner, Alfred. "The Forgotten Art of Max Liebermann." *Art Journal* 22, no. 3 (spring 1964): 214–21.

Wesenberg, Angelika, ed. *Max Liebermann— Jarhundertwende*. Berlin: Alte Nationalgalerie, 1997.

Max Liebermann, c. 1895

Maurycy Minkowski
(Polish, 1881–1930)

Maurycy Minkowski was born into an educated middle-class family in Warsaw. At the age of five he suffered an accident that left him deaf and unable to speak for the rest of his life. At the Kraków Academy of Fine Arts, where he studied from 1900 to 1904 under the tutelage of Jan Stanislawski, Leon Wyczólkowski, the Polish Impressionist artist, and Józef Mehoffer, the designer of stained glass, Minkowski painted primarily landscapes and portraits. Following the failed Russian revolution of 1905, pogroms in Bialystok and Siedlce broke out. Minkowski witnessed these firsthand, and his impressions marked a turning point in his artistic career. He began to depict the victims—their displacement, poverty, and persecution. These paintings are distinguished by their realist style with somber hues and flattened space that heighten the emotional poignancy of the subject. Few artists presented so dramatically the plight of Eastern European Jews.

Alongside his concentration on the difficulties of everyday life—soup kitchens, bread lines, refugees—Jewish women and their religious traditions fascinated the artist. *After the Pogrom* (1905; pl. 30), *The Arranged Marriage* (1910s), and *Tisha B'Av* (1920s) exemplify the pride of place he granted women in his work. Minkowski was well established in Warsaw's cultural circles and thrived on the support of Jewish patrons. During the 1920s he gradually turned to watercolors, brightened his palette, and returned to his interest in landscape painting with an Impressionist bent. Portraiture also became part of his repertoire. Though his work did not follow the regnant artistic styles, Minkowski nevertheless had success. He had several solo exhibitions in Europe that encouraged him to embark on a major trip to Argentina in 1930, designed as the first leg of a North American tour. His opening exhibition in Buenos Aires, under the auspices of the Polish ambassador, attracted interest. Two

Maurycy Minkowski

months later, the artist was killed in a car accident. Many of his paintings were auctioned off in the 1940s, and some have resurfaced in recent years. A major collection of works remains in Buenos Aires, some of which were damaged in a terrorist bombing in 1994.

Richard I. Cohen and Dara Keese

SELECTED BIBLIOGRAPHY

Baker, Zachary M. "Maurycy Minkowski (1881–1930): The Threefold Death of a Polish Jewish Artist." Unpublished manuscript.
———. "Salvaging the Threatened Legacy of a Neglected Artist: The Maurycy Minkowski Collection in Buenos Aires." *The Council of American Jewish Museums Newsletter* 7 (June 1998): 10–14.
Cohen, Richard I. *Jewish Icons: Art and Society in Modern Europe.* Berkeley and Los Angeles: University of California Press, 1998. See esp. 245–51.
Kleeblatt, Norman L. "Maurycy Minkowski." In *Bilder sind nicht verboten.* Ed. Jürgen Harten, Marianne Heinz, and Ulrich Krempel. Exh. cat. Düsseldorf: Städtische Kunsthalle Düsseldorf und Kunstverein für die Rheinlande und Westfalen, 1982. 254–55.
Schorsch, Ismar. "Art as Theology." Leaflet of the Jewish Theological Seminary, New York, n.d.

Edouard Moyse
(French, 1827–1908)

Edouard Moyse was the youngest of six children born to Abraham Moyse and Rose Bernard, French Jews from Nancy. In his youth the family moved to Paris, and Moyse pursued his artistic education at the École des Beaux-Arts, where he studied under Martin Drolling. Moyse was first interested in portrait painting; later he showed a particular penchant for portraits of rabbis. He first exhibited at the Paris Salon in 1850 and was awarded a Médaille de Deuxième Classe in 1882. Together with Edouard Brandon (and later Alphonse Lévy), Moyse was one of the first painters of Jewish life in France during the time when the orientalist painters were picturing Jewish communities and "types" in North Africa. His elevation of Jewish themes in nineteenth-century French art was quite rare at the time.

Moyse, like most Parisian Jews, was from the eastern Alsace region, where a traditional way of life took precedence over the modernizing tendencies of the metropolitan areas. Artists from this region of France produced nostalgic renderings of subjects such

Edouard Moyse. *Self-Portrait* (detail), 1869. See pl. 14.

as Hebrew Bible stories and depictions of everyday life. Moyse's biblical scenes gained him recognition both by the Paris Salon and by aristocratic Parisian Jews who were pleased to see their ancestors depicted as noble and sophisticated. The technical excellence of *The Covenant of Abraham* (c. 1860; pl. 13), for example, dignifies the subject of circumcision, which may have seemed distasteful to gentiles.

Karen Levitov

SELECTED BIBLIOGRAPHY

Cohen, Richard I. *Jewish Icons: Art and Society in Modern Europe*. Berkeley and Los Angeles: University of California Press, 1998.

Moritz Daniel Oppenheim

(German, 1800–1882)

Born in January 1800 in Hanau's Judengasse to a successful merchant's family, Moritz Daniel Oppenheim received a traditional Jewish education and attended a drawing academy in his hometown. In 1817 he began his formal training at the art academy in Munich, where he remained for two years. During this period he also painted in Hanau, Frankfurt, and Paris. In 1821 he went to Rome, where he was to spend almost four years studying with the leading German artists of the Nazarene school, who were engaged in reviving New Testament themes. These artists—Johann Friedrich Overbeck, Julius Schnorr von Carolsfeld, Joseph Anton Koch, and Bertel Thorvaldsen—had a definite influence on Oppenheim's work during this period. However, during his various trips to Italian cities, Oppenheim showed an independent bent and grew attached to realistic painting, especially portraits of Italian common people.

In 1825 Oppenheim returned to Germany, where he settled in Frankfurt and became the first Jew to become a member of the Frankfurt Museum Society. During his first years in Frankfurt, his work included religious paintings as well as portraits of individuals (members of the Rothschild family and the writers Heinrich Heine and Ludwig Börne, to name but a few) and groups. But the high point was his encounter with the German writer Johann von Goethe, who served as an inspiration to Oppenheim. Goethe was instrumental in the coveted distinction granted Oppenheim by Grand Duke Karl August of Saxony-Weimar-Eisenach in 1827, the title of professor.

In turning in the early 1830s to the issue of Jewish acculturation in German society, Oppenheim created *The Return of the Jewish Volunteer from the Wars of Liberation to His Family Still Living in Accordance with Old Customs* (1833–34; pl. 1), a work that brought together different artistic genres and contemporary themes. Yet he never confined himself to one area of interest. In the decades to come he would continue to paint religious themes, portraits, and genre and historical paintings. From 1865 until his death, he was deeply engaged in creating *Scenes from Traditional Jewish Family Life*, which emerged as a popular cultural artifact in the life of German Jewry. Its idyllic portrayal of Jewish life before the onslaught of modernity and secularization appealed to different audiences and was widely disseminated, overshadowing Oppenheim's extensive oeuvre, which had spanned more than six decades.

Oppenheim's memoir (*Erinnerungen*), published posthumously in 1924, provides many insights into the artist's deliberations and intimate feelings.

Richard I. Cohen

SELECTED BIBLIOGRAPHY

Cohen, Elisheva, ed. *Moritz Oppenheim: The First Jewish Painter*. Exh. cat. Jerusalem: The Israel Museum, 1983.

Cohen, Richard I. *Jewish Icons: Art and Society in Modern Europe*. Berkeley and Los Angeles: University of California Press, 1998. See esp. 160–71.

Heuberger, Georg, and Anton Merk, eds. *Moritz*

Moritz Daniel Oppenheim. *Self-Portrait in the Studio* (detail), 1877. The Israel Museum, Jerusalem.

Daniel Oppenheim: Jewish Identity in Nineteenth-Century Art. Exh. cat. Frankfurt: Jüdisches Museum der Stadt Frankfurt am Main, 1999. In German and English.

Kleeblatt, Norman L. "Illustrating Jewish Lifestyles on Opposite Banks of the Rhine: Alphonse Lévy's Alsatian Peasants and Moritz Daniel Oppenheim's Frankfurt Burghers." *Jewish Art* 16–17 (1990–91): 53–63.

Oppenheim, Moritz. *Erinnerungen*. Ed. Alfred Oppenheim. Frankfurt: Frankfurter Verlags-Anstalt A.-G., 1924; Heidelberg: Manutius, 1999.

Ismar Schorsch. *From Text to Context. The Turn to History in Modern Judaism*. Hanover, N.H.: Brandeis University Press and University Press of New England, 1994. 93–117.

Camille Pissarro
(French, 1830–1903)

Born on the Caribbean island of Saint Thomas, the painter Camille Pissarro was in fact named Jacob Pizarro, but, like the rest of his family, he adopted a French name in daily life. His Sephardic Jewishness was very different from mainland Orthodoxy, exemplified by his parents' own marriage in defiance of traditional law. After drawing and sketching in the Caribbean, especially in association with Danish artist Fritz Melbye, he moved to France in 1855, where he studied at first with the Danish Jewish artist David Jacobsen. He soon became associated with the artistic avant-garde, developing a close relationship to Paul Cézanne, perhaps because both men were rebelling against their businessmen fathers. He was a founding member of the Impressionist group in 1874 and showed with them until the group's demise in 1886.

As Pissarro did not depict scenes of Jewish life, he has rarely been thought of as a Jewish artist. However, acculturated French Jews were not calling for religious art but rather, as Isidore Cahen remarked in his review of the Salon of 1874: "We are only expressing a preference for subjects of a general order and universal interest." Pissarro's fascination with the depiction of visual "sensation" met that bill and allowed him a wide range: "Impressionism should only be a theory of pure observation, without losing either fantasy, liberty or grandeur." Yet even this formal approach ran into the increasingly racialized culture of his day. In 1883 the critic Joris-Karl Huysmans accused the Impressionists of being color-blind, a malady that was then held to affect Jews disproportionately. Pissarro protested this characterization of "our diseased eyes" but soon adopted the Neo-Impressionist style of *pointillisme*, perhaps seeking refuge from such charges in an apparently scientific depiction of color. By 1888, the "dot" seemed to him unable "to follow sensation with enough inevitability," and Pissarro abandoned

Camille Pissarro, c. 1895

it in favor of a style that he called "passage." The new style brought with it new subject matter, as Pissarro turned to the representation of the modern city, precisely the environment that was supposed to render Jews color-blind.

The 1890s culminated in the Dreyfus Affair, which polarized French public opinion around the "Jewish question." Pissarro, who was for Dreyfus, wrote to Bernard Lazare, author of a well-known pamphlet on the subject, that he was proud to see a fellow Jew make the argument that "race is a fiction." On his death in 1903, Jewish publications throughout the world mourned his passing.

Nicholas Mirzoeff

SELECTED BIBLIOGRAPHY

Herzberg, Janine Bailly, ed. *Correspondance de Camille Pissarro.* 5 vols. Paris: Éditions de Valhermeil, 1980–91.

Lloyd, Christopher. *Camille Pissarro.* New York: Rizzoli, 1981.

Mirzoeff, Nicholas. "Pissarro's Passage: The Sensation of Caribbean Jewishness in Diaspora." In *Diaspora and Visual Culture: Representing Africans and Jews.* Ed. Nicholas Mirzoeff. London and New York: Routledge, 2000. 57–75.

Pissarro, Joachim. *Camille Pissarro.* New York: Harry N. Abrams, 1993.

Abraham Solomon
(British, 1824–1862)

Abraham Solomon was the fourth of eight children born into an Ashkenazic family that settled in England in the late eighteenth century. The family business of importing straw hats from Italy flourished, allowing the Solomons to send three of their children—Abraham, Rebecca, and Simeon—to art school. Their successful business also brought the Solomon family into contact with the high society of their aristocratic clientele. These associations proved fruitful for the painting career of Abraham Solomon.

Solomon began his artistic training at the art preparatory school of Henry Sass and continued after age thirteen at the schools of the Royal Academy of Art in London. He exhibited regularly at the Royal Academy beginning in 1846, mostly showing paintings in the style fashionable at the time—literary and genre scenes with subjects clothed in eighteenth-century costume. His early works depicted Jewish subjects as well. He was especially noted for his innovative use of two connected paintings to tell a story. Solomon's first critical success came in 1854 with *First Class—The Meeting and at First Meeting Loved* (pl. 36), in which for the first time he placed his subjects in a modern setting and contemporary clothing. Along with fame, this painting brought scandal: its depiction of a flirtatious meeting between a young man and young woman in a train car while the woman's guardian sleeps was considered improper by Solomon's Victorian audience. In response to the outcry the painting elicited, Solomon agreed to repaint it, producing a more acceptable version in which the elderly guardian is awake and conversing with the young man, while the young woman sits at a respectable distance. As a companion piece to the revised version of the painting, Solomon produced *Second Class—The Parting, "Thus part we rich in sorrow, parting poor"* (1855; pl. 35). Here a poor widow bids her young son farewell as they travel by train to the seaport

where he will join his ship. This picture met with praise for its sense of character and well-told story. This pair of paintings exemplifies Solomon's penchant for subjects of social consciousness. Critics of his time compared him to William Hogarth, the moral satirist par excellence. Another pair of Solomon's moralistic paintings is *Waiting for the Verdict* (1857; see fig. 10) and its companion *"Not Guilty" (The Acquittal)* (1859). *Waiting for the Verdict*, the biggest success of Solomon's career, earned him recommendation to the Royal Academy, but he was elected an associate member only on the day of his death in 1862.

Karen Levitov and Richard I. Cohen

SELECTED BIBLIOGRAPHY

Casteras, Susan P. "Abraham Solomon's *First Class—The Meeting* and *Second Class—The Parting*." Unpublished gallery talk, 2 February 1988.

Jewish Artists of Great Britain, 1845–1945. Exh. cat. London: Belgrave Gallery Ltd., 1978. See esp. 8–9.

Solomon: A Family of Painters. London: Geffrye Museum and Birmingham Museum & Art Gallery, 1985.

Werner, Alfred. "Jewish Artists of the Age of Emancipation." In *Jewish Art: An Illustrated History.* Ed. Cecil Roth. New York: McGraw-Hill, 1961. 564–66.

Abraham Solomon

Rebecca Solomon

(British, 1832–1886)

The seventh child of the Solomon family, Rebecca gained artistic inspiration from her mother, Kate, an accomplished amateur watercolorist, and her elder brother Abraham, already a successful painter by the time of Rebecca's adolescence. Beginning in 1846, Rebecca trained at the Spitalfields School of Design, established a few years prior to her attendance. The more prestigious Royal Academy schools, where her brothers trained, did not accept women as students until 1860. However, Rebecca did exhibit regularly at the Royal Academy beginning in 1858.

Rebecca Solomon was highly regarded as an artist in her day. She painted primarily fashionable scenes from seventeenth- and eighteenth-century dramas and contemporary moral themes. The latter work (for example, *The Plea* [1865]) brought her into the circle of Pre-Raphaelite artists. A review in the *Art Journal* of May 1860 praised her painting *Peg Woffington's Visit to Triplet* (1860) as "a picture of great power, and in execution so firm and masculine that it would scarcely be pronounced the work of a lady." In Solomon's time, it was typical for critics to be amazed that a woman was capable of artistic proficiency. Rebecca exhibited widely and received prestigious private commissions, but her work did not sell to public collections. To supplement her income, Rebecca worked in the studios of other more prominent artists—including John Phillip and John Everett Millais—assisting in painting backgrounds or copying works for reproduction as prints. She also provided illustrations to magazines such as *London Society* and *The Churchman's Family Magazine*.

Dependent on her family for financial support as an unmarried woman, Rebecca lived with her elder brother Abraham until his death in 1862, then with her younger brother, Simeon. Like Simeon, Rebecca became infamous for her eccentric lifestyle, and gossip rumored her to be an excessive drinker. After

Simeon's arrest for indecency in 1873, Rebecca's career plummeted. She exhibited only once more, in 1874, before her death in 1886 in a street tram accident.

Karen Levitov and Richard I. Cohen

SELECTED BIBLIOGRAPHY

Cherry, Deborah. *Painting Women: Victorian Women Artists.* New York: Routledge, 1993.

Marsh, Jan, and Pamela Gerrish Nunn. *Pre-Raphaelite Women Artists.* New York: Thames and Hudson, 1999.

Nead, Lynda. *Myths of Sexuality: Representations of Women in Victorian Britain.* Oxford and New York: Blackwell, 1988.

Nunn, Pamela Gerrish. "Rebecca Solomon: Painting and Drama." *Theatrephile* 2, no. 8 (1985): 3–4.

———. "Rebecca Solomon's *A Young Teacher*." *Burlington Magazine* 130 (1988): 769–70.

Solomon: A Family of Painters. Exh. cat. London: Geffrye Museum and Birmingham Museum & Art Gallery, 1985.

Weiner, Julia. "Jewish Women Artists in Britain 1700–1940." In *Rubies and Rebels: Jewish Female Identity in Contemporary British Art.* Ed. Monica Bohm-Duchen and Vera Grodzinski. Exh. cat. London: Barbican Art Gallery and Lund Humphries Publishing, 1996. 29–39.

Simeon Solomon

(British, 1840–1905)

The youngest of the Solomon children, Simeon achieved both the greatest success and the greatest infamy of his artistic family. Having lost his father in early childhood, Simeon regarded his elder brother Abraham as a father figure and artistic mentor. Sixteen years older than Simeon, Abraham had achieved financial and artistic success by the time Simeon began his training in London at F. S. Carey's Academy at age twelve and the Royal Academy schools in 1856. Simeon's early paintings centered on Old Testament subjects, probably an influence of the religious beliefs of his sister Rebecca. Rebecca, also a successful painter, had close contacts with the British

Simeon Solomon (entry overleaf). Photograph by David Wilke Wynfield. Albumen print; 8¼ × 6 in. (20.5 × 15.1 cm). Royal Academy of Arts, London.

Pre-Raphaelites. Simeon's biblical themes (the influence of the Song of Songs on his work was profound) soon caught the attention of the older Pre-Raphaelite artists Dante Gabriel Rossetti and William Holman Hunt.

By his early twenties, Simeon had become well known for his Jewish religious subjects, such as *Carrying the Scrolls of the Law* (1867; pl. 41), of which he produced several versions. During the 1860s he depicted ten Jewish religious ceremonies, first published by contemporary London magazines, which reflected the artist's struggle with his traditional upbringing. Solomon also showed his work regularly at the Royal Academy. Encouraged by his friends the painter Edward Burne-Jones and the poet Algernon Swinburne, Simeon expanded his subjects to include religious mysticism and classical pagan themes. The inspiration came from the idealized figures of Italian Renaissance painting and sculpture, which Simeon studied during several trips to Italy from 1866 to 1870. The idealized male beauty and androgynous

figures he painted were acclaimed by the Aesthetic movement, but Simeon's family and the general public were dismayed.

In 1871 Simeon published a prose poem entitled "A Vision of Love Revealed in Sleep," in which he adopted the model of ancient Greeks for love between men. The poem was violently attacked by a contemporary critic, and Simeon's open homosexuality began to cause embarrassment to his family. On 11 February 1873 he was arrested and convicted for indecency. Although he continued to paint, he was unable to sell his work, and he took refuge in alcoholism and spent many years in a poorhouse. *Head* (*Saint Peter or "Help Lord or I Perish"*) (pl. 38), painted in 1892, shows the turmoil of social condemnation, alcohol, and poverty, yet it retains the intense spirituality that characterized Solomon's work. His checkered career notwithstanding, over fifty of his works were shown at the Whitechapel Exhibition of Arts and Antiquities in 1906. He was buried by his family in Willesden Jewish Cemetery.

Karen Levitov and Richard I. Cohen

SELECTED BIBLIOGRAPHY

Cohen, Richard I. *Jewish Icons: Art and Society in Modern Europe.* Berkeley and Los Angeles: University of California Press, 1998. See esp. 160–63.

Falk, Bernard. *Five Years Dead: A Postscript to "He Laughed in Fleet Street."* London: The Book Club, 1937.

Kolsteren, Steven. "Simeon Solomon and the Song of Songs." *Journal of Jewish Art* 11 (1985): 47–59.

Morgan, Thais E. "Perverse Male Bodies: Simeon Solomon and Algernon Charles Swinburne." In *Outlooks: Lesbian and Gay Sexualities and Visual Cultures.* Ed. Peter Horne and Reina Lewis. London and New York: Routledge, 1996.

Reynolds, Simon. *The Vision of Simeon Solomon.* Stroud, England: Catalpa Press, 1984.

Seymour, Gayle Marie. "The Life and Work of Simeon Solomon (1840–1905)." Ph.D. diss., University of California, Santa Barbara, 1986.

Solomon: A Family of Painters. Exh. cat. London: Geffrye Museum and Birmingham Museum & Art Gallery, 1985.

Solomon J. Solomon
(British, 1860–1927)

Solomon J. Solomon is perhaps as well known for his role in implementing the use of strategic camouflage during World War I as for his portraits of London's illustrious high society. Solomon studied at the Royal Academy schools in London and trained under Alexandre Cabanel at the École des Beaux-Arts in Paris and at the Akademie in Munich. He first exhibited at London's Royal Academy in 1881, establishing a reputation with his portraits and biblical and mythological scenes in historical style with backgrounds inspired by his visit to the Middle East. He was elected a member of the Royal Academy in 1894 and a Royal Academician in 1906, the second Jew ever to receive that honor, and was the first Jewish president of the Royal Society of British Artists in 1918.

Solomon's *Samson and Delilah* (1887) established his reputation for painting Jewish subjects, which he continued in subsequent themes from the Hebrew Bible, portraits of his Jewish friends, and genre scenes such as *High Tea in the Sukkah* (1906; pl. 25). Solomon's commitment to Jewish affairs continued through his founding of the Maccabeans professional society and the Ben Uri Art Society. Solomon was known not only for his Jewish subjects but also for his portraits of London's elite, including Queen Victoria and a host of famous society people. His portraits recall the grand manner of English portraiture with the addition of Impressionist devices, as can be seen in his *Miss Grace Stettauer* (1901; see fig. 7).

Solomon enrolled in World War I in the Artist Volunteers of the British military. He was eventually made lieutenant colonel and sent to France to help implement the use of strategic camouflage. After returning to England in 1916, he set up a school for camouflage and authored a book on his findings. Significant excerpts from his unpublished war diary are reprinted in Olga Somech Phillips's biography of the artist.

Solomon also wrote *The Practice of Oil Painting and of Drawing as Associated with It* (1910).

Karen Levitov

SELECTED BIBLIOGRAPHY

Bensusan, S. L. [Samuel Levy]. *Solomon J. Solomon*. Berlin: Jüdischer Verlag, 1903.

Phillips, Olga Somech. *Solomon J. Solomon: A Memoir of Peace and War*. London: Herbert Joseph, 1933.

Solomon, Solomon J. *The Practice of Oil Painting and of Drawing as Associated with It*. Philadelphia: J. B. Lippincott Company; London: Seeley & Co., Ltd., 1910.

———. *Strategic Camouflage*. London: J. Murray, 1920.

Solomon J. Solomon RA. Exh. cat. London: Ben Uri Art Gallery, 1990.

Solomon J. Solomon, 1904

Lesser Ury (German, 1861–1931)

After Lesser Ury's father died, when the boy was eleven years old, his mother moved the family from Poznan to Berlin. In 1879 Ury embarked on his artistic studies in Düsseldorf under Hermann Wislicenus, a student of Eduard Bendemann. There he painted stylistically academic genre scenes. After traveling to Munich, Antwerp, Brussels, and Paris, where he developed a passion for city life, Ury found a home in the Belgian village of Volluvet and became fascinated by the daily life of the peasantry. Ury's stay in Belgium marked a shift in his work from genre scenes to rural landscapes characterized by subtle and expressive color contrasts.

In 1887 Ury settled in Berlin, where he would live out his days. He transferred his evocative use of color from landscapes to Berlin cityscapes and street scenes, being one of the first artists to give expression to the life of city dwellers. Ury's paintings of Berlin (*At the Friedrichstrasse Station, Berlin Street Scene—Leipziger Platz*), done in the spirit of the Parisian Impressionists Manet and Monet, captured the vibrancy and movement of the city streets, the effects of electric light, and the spectacle of pedestrians seeing and being seen. A precursor to German Expressionism, Ury incorporated Symbolist color and night scenes to convey the alienation of the individual in the modern metropolis.

Although best known for his cityscapes, Ury painted many works with Jewish themes. While attending the Brussels Academy in the 1880s, he had begun work on several major paintings (*Jerusalem* and *Jeremiah*) that addressed the issues of exile and suffering. These paintings and several others (including *Moses on Mount Nebo*) were included in the 1907 exhibition of Jewish artists in Berlin, where Ury and Jozef Israëls were the most extensively exhibited artists. Ury's monumental paintings (for example, *Rebecca, David and Jonathan, Moses*) were part of his design to mold a Jewish iconography, illuminating his appreciation of the

Lesser Ury

predicament of Jewish life. He maintained an interest in the Bible throughout his lifetime, constantly depicting classic scenes (for example, *Jacob Blessing Benjamin*) with distinct attention to their emotional content. Many of his more important paintings on Jewish themes have not survived.

Dara Keese and Richard I. Cohen

SELECTED BIBLIOGRAPHY

Bilski, Emily D. "Images of Identity and Urban Life: Jewish Artists in Turn-of-the-Century Berlin." In *Berlin Metropolis: Jews and the New Culture, 1890–1918*. Ed. Emily D. Bilski. Exh. cat. New York: The Jewish Museum; Berkeley and Los Angeles: University of California Press, 1999. 102–45. See older literature there.

Goldman-Ida, Batsheva. "*Moses* (Approaching Mt. Sinai) by Lesser Ury." *Tel Aviv Museum of Art Annual Review* 5 (1995): 32–37.

Schlögl, Herbert A. *Lesser Ury: Zauber des Lichts*. Exh. cat. Berlin: Käthe-Kollwitz Museum and Gebr. Mann Verlag, 1995.

Exhibition Checklist

Tina Blau (Austrian, 1845–1916)
In der Krieau, 1882
Oil on canvas
42 × 33½ in. (107 × 85 cm)
Vienna City Museum, Vienna

Tina Blau (Austrian, 1845–1916)
Jewish Street in Amsterdam, 1875–76
Oil on wood
14 × 10 in. (35 × 25 cm)
Collection Vera Eisenberger KG, Vienna

Jacques-Émile-Edouard Brandon
(French, 1831–1897)
Silent Prayer, Synagogue of Amsterdam, "The Amidah" ("La Guamida"), 1897
Oil on panel
34½ × 68½ in. (87.7 × 174 cm)
The Jewish Museum, New York; Gift of
Brigadier General Morris C. Troper in memory
of his wife Ethel G. Troper and his son Murray
H. Troper, JM 78-61

Jacques-Émile-Edouard Brandon
(French, 1831–1897)
Heder, 1870
Oil on panel
13¾ × 18⅛ in. (35 × 46 cm)
The Israel Museum, Jerusalem

Vittorio Corcos (Italian, 1859–1933)
Portrait of Emilio Treves, 1907
Oil on canvas
53½ × 31½ in. (136 × 80 cm)
Studio Paul Nicholls, Milan

Vittorio Corcos (Italian, 1859–1933)
Portrait of Yorik, 1889
Oil on canvas
78⅜ × 54⅜ in. (119 × 138 cm)
Museo Civico Giovanni Fattori, Livorno, Italy

Vito d'Ancona (Italian, 1825–1884)
View of Volognano, 1878
Oil on canvas
15 × 10¼ in. (38 × 26 cm)
Istituto Matteucci, Viareggio, Italy

Vito d'Ancona (Italian, 1825–1884)
Self-Portrait, c. 1860
Oil on canvas
16⅛ × 13 in. (41 × 33 cm)
The Israel Museum, Jerusalem; Gift of Prof.
Paolo d'Ancona, Milan

Vito d'Ancona (Italian, 1825–1884)
Nude, 1873
Oil on canvas
10⅜ × 16⅛ in. (26.5 × 41 cm)
Civica Galleria d'Arte Moderna, Milan

Jacob Meyer de Haan (Dutch, 1852–1895)
Self-Portrait, 1889–91
Oil on canvas
12¾ × 9⅜ in. (32 × 25 cm)
Collection Mr. and Mrs. Arthur G. Altschul,
New York

Jacob Meyer de Haan (Dutch, 1852–1895)
Breton Women Scutching Flax (Labor), 1889
Oil on plaster transferred to canvas
52½ × 79¼ in. (133.4 × 201.3 cm)
Private collection; Courtesy of Nancy Whyte
Fine Arts

Jacob Meyer de Haan (Dutch, 1852–1895)
Portrait of a Young Jewish Girl, c. 1886
Oil on canvas
53 × 39⅝ in. (135 × 100.5 cm)
Joods Historisch Museum, Amsterdam

Jacob Meyer de Haan (Dutch, 1852–1895)
Kerzellec Farm, Le Pouldu, 1889
Oil on canvas
28⅞ × 36⅜ in. (73.5 × 93 cm)
Kröller-Müller Museum, Otterlo, Holland

Maurycy Gottlieb (Galician, 1856–1879)
Portrait of a Young Jewish Woman, 1879
Oil on canvas
24½ × 20 in. (62.2 × 51 cm)
Muzeum Narodowe w Warszawie, Warsaw

Maurycy Gottlieb (Galician, 1856–1879)
Christ Preaching at Capernaum, 1878–79
Oil on canvas
106⅞ × 82¼ in. (271.5 × 209 cm)
Muzeum Narodowe w Warszawie, Warsaw

Maurycy Gottlieb (Galician, 1856–1879)
Self-Portrait, 1878
Oil on canvas
31⁷⁄₁₆ × 25⁵⁄₁₆ in. (79.8 × 63.9 cm)
Weizmann Institute of Science, Rehovot, Israel;
Gift of the Michael and Dora Zagaysky
Foundation

Maurycy Gottlieb (Galician, 1856–1879)
Jews Praying in the Synagogue on Yom Kippur,
1878
Oil on canvas
96½ × 75½ in. (245 × 192 cm)
Tel Aviv Museum of Art, Tel Aviv; Gift of
Sidney Lamon, New York

Solomon Alexander Hart (British, 1806–1881)
*The Feast of the Rejoicing of the Law at the
Synagogue in Leghorn, Italy*, 1850
Oil on canvas
55⅝ × 68¾ in. (141.3 × 174.6 cm)
The Jewish Museum, New York; Gift of Mr. and
Mrs. Oscar Gruss, JM 28-55

Samuel Hirszenberg (Polish, 1865–1908)
The Black Banner, 1905
Oil on canvas
30 × 81 in. (76.2 × 205.7 cm)
The Jewish Museum, New York; Gift of the
Estate of Rose Mintz, JM 63-67

Samuel Hirszenberg (Polish, 1865–1908)
The Sabbath Rest, 1894
Oil on canvas
59½ × 78 in. (151 × 198 cm)
The Ben Uri Gallery, The London Jewish
Museum of Art

Samuel Hirszenberg (Polish, 1865–1908)
The Jewish Cemetery, 1892
Oil on canvas
78 × 117 in. (200 × 297 cm)
Musée d'art et d'histoire du Judaïsme, Paris;
Gift of Mr. and Mrs. Lenemann and
Mr. C. P. Kelman

Jozef Israëls (Dutch, 1824–1911)
The Last Breath, 1872
Oil on canvas
44 × 69½ in. (112 × 176.5 cm)
Philadelphia Museum of Art, Philadelphia;
Given by Ellen Harrison McMichael in memory
of C. Emory McMichael

Jozef Israëls (Dutch, 1824–1911)
A Jewish Wedding, 1903
Oil on canvas
54 × 58¼ in. (137 × 148 cm)
Rijksmuseum, Amsterdam

Jozef Israëls (Dutch, 1824–1911)
*Self-Portrait (with Saul and David in the
Background)*, 1908
Oil on canvas
38⅛ × 27½ in. (97 × 70 cm)
Stedelijk Museum, Amsterdam

Jozef Israëls (Dutch, 1824–1911)
A Son of the Ancient Race, c. 1889
Oil on canvas
43½ × 33¼ in. (110.5 × 85.7 cm)
The Jewish Museum, New York; Museum
purchase through The Eva and Morris Feld
Purchase Fund, 1985-123

Isidor Kaufmann (Austrian, 1853–1921)
Two Views of a Farm, n.d.
Oil on canvas
upper panel: 3½ × 11¾ in. (9 × 30 cm); lower
panel: 5 × 11¾ in. (12.5 × 30 cm)
The Israel Museum, Jerusalem; Gift of Mr.
Michael M. Zagaysky

Isidor Kaufmann (Austrian, 1853–1921)
Portrait of Isidor Gewitsch, c. 1900
Oil on panel
18 × 14⅝ in. (45.9 × 37.1 cm)
The Jewish Museum, New York; Gift of Mr. and
Mrs. M. R. Schweitzer, JM 5-63

Isidor Kaufmann (Austrian, 1853–1921)
Hearken Israel, 1910–15
Oil on canvas
30⅜ × 39 in. (77 × 99 cm)
Private collection, Maryland

Isidor Kaufmann (Austrian, 1853–1921)
There's No Fool Like an Old Fool, c. 1887–88
Oil on wood
11⅜ × 14½ in. (29 × 37 cm)
Collection Vera Eisenberger KG, Vienna

Isidor Kaufmann (Austrian, 1853–1921)
Blessing the Sabbath Candles, c. 1900–1910
Oil on wood
18⅞ × 23⅜ in. (48 × 60 cm)
Private collection, New York

Broncia Koller-Pinell (Austrian, 1863–1934)
Sylvia Koller with Birdcage, 1907–08
Oil on canvas
39⅜ × 39⅜ in. (100 × 100 cm)
Collection Vera Eisenberger KG, Vienna

Broncia Koller-Pinell (Austrian, 1863–1934)
Sitting (Marietta), 1907
Oil on canvas
42⅜ × 58½ in. (107.5 × 148.5 cm)
Collection Vera Eisenberger KG, Vienna

Max Liebermann (German, 1847–1935)
Stevensstift in Leiden, 1890
Oil on canvas
31 × 40 in. (78.5 × 101.5 cm)
Kunsthandel Wolfgang Werner, Bremen/Berlin

Max Liebermann (German, 1847–1935)
Self-Portrait with Straw Hat (Panama Hat), 1911
Oil on wood
31¾ × 25½ in. (80.8 × 64.8 cm)
Akademie der Künste, Berlin; Acquired with the
support of BHF-Bank Aktiengesellschaft Berlin
and the society of friends of the Akademie der
Künste, Berlin

Max Liebermann (German, 1847–1935)
Jewish Street in Amsterdam, 1908
Oil on wood
29 × 24¾ in. (74 × 63 cm)
Städtische Galerie im Städelschen Kunstinstitut,
Frankfurt

Max Liebermann (German, 1847–1935)
Bathing Boys, 1900
Oil on canvas
44½ × 59¾ in. (113 × 152 cm)
Stiftung Stadtmuseum Berlin

Maurycy Minkowski (Polish, 1881–1930)
After the Pogrom, 1905
Oil on canvas
58¼ × 44¾ in. (148 × 113 cm)
Tel Aviv Museum of Art, Tel Aviv; Gift of
Zagaysky, Warsaw, c. 1936–37

Maurycy Minkowski (Polish, 1881–1930)
He Cast a Look and Went Mad, 1910
Oil on canvas
29 × 41⅝ in. (73.6 × 105.8 cm)
The Jewish Museum, New York; Gift of Mrs.
Rose Mintz, JM 14-75

Edouard Moyse (French, 1827–1908)
The Covenant of Abraham, c. 1860
Oil on canvas
22¾ × 33¾ in. (58 × 86 cm)
Collection Reuven and Naomi Dessler,
Cleveland, Ohio

Edouard Moyse (French, 1827–1908)
Self-Portrait, 1869
Oil on canvas
27¾ × 22¾ in. (70.5 × 58 cm)
Musée d'art et d'histoire du Judaïsme, Paris;
Gift of Mrs. Weill

Moritz Daniel Oppenheim
(German, 1800–1882)
*The Return of the Jewish Volunteer from the
Wars of Liberation to His Family Still Living in
Accordance with Old Customs*, 1833–34
Oil on canvas
34 × 36 in. (86.4 × 91.4 cm)
The Jewish Museum, New York; Gift of Richard
and Beatrice Levy, 1984-61

Moritz Daniel Oppenheim
(German, 1800–1882)
Self-Portrait, 1822
Oil on canvas
17⅜ × 14⅜ in. (44 × 36.5 cm)
The Israel Museum, Jerusalem; Gift of Dr.
Arthur Kauffmann, London, through the British
Friends of the Art Museums of Israel

Moritz Daniel Oppenheim
(German, 1800–1882)
Ludwig Börne, 1840
Oil on canvas
46⅞ × 35½ in. (119 × 90 cm)
The Israel Museum, Jerusalem; Received
through IRSO

Moritz Daniel Oppenheim
(German, 1800–1882)
Sabbath Rest, 1866
Oil on canvas
20½ × 23 in. (48.9 × 58.4 cm)
The Jewish Museum, New York; Gift of the
Oscar and Regina Gruss Charitable and
Educational Foundation, 1999-86

Moritz Daniel Oppenheim
(German, 1800–1882)
Wedding, 1861
Oil on canvas
11¼ × 14¾ in. (28.5 × 37.5 cm)
The Israel Museum, Jerusalem

Moritz Daniel Oppenheim
(German, 1800–1882)
Yahrzeit Minyan, 1875
Oil on canvas
20½ × 26⅜ in. (52 × 67 cm)
Private collection, New York

Moritz Daniel Oppenheim
(German, 1800–1882)
Lionel Nathan de Rothschild as Bridegroom, 1836
Oil on canvas
47 × 40⅛ in. (119.5 × 102 cm)
The Israel Museum, Jerusalem; Received
through IRSO

Moritz Daniel Oppenheim
(German, 1800–1882)
Charlotte von Rothschild as Bride, 1836
Oil on canvas
46⅞ × 40½ in. (119 × 103 cm)
The Israel Museum, Jerusalem; Received
through IRSO

Moritz Daniel Oppenheim
(German, 1800–1882)
*Lavater and Lessing Visiting Moses
Mendelssohn*, 1856
Oil on canvas
27½ × 23½ in. (70 × 60 cm)
Judah L. Magnes Museum, Berkeley, California;
Gift of Vernon Stroud, Eva Linker, Gerda
Mathan, Ilse Feiger and Irwin Straus in memory
of Frederick and Edith Straus

Camille Pissarro (French, 1830–1903)
Jallais Hill, Pontoise, 1867
Oil on canvas
34¼ × 45¼ in. (87 × 114.9 cm)
Metropolitan Museum of Art, New York;
Bequest of William Church Osborn, 1951

Camille Pissarro (French, 1830–1903)
*Avenue de l'Opéra, Place du Théâtre Français:
Misty Weather*, 1898
Oil on canvas
29⅛ × 36 in. (74 × 91.5cm)
Collection Mr. and Mrs. Herbert Klapper,
New York

Camille Pissarro (French, 1830–1903)
Elderly Woman Mending Old Clothes, 1902
Oil on canvas
21¼ × 25½ in. (54 × 65 cm)
Collection Sara and Moshe Mayer, Tel Aviv

Camille Pissarro (French, 1830–1903)
Self-Portrait, 1903
Oil on canvas
16⅛ × 13 in. (41 × 33 cm)
The Tate Gallery, London; Presented by Lucien
Pissarro, the artist's son, 1931

Abraham Solomon (British, 1824–1862)
*First Class—The Meeting and at First Meeting
Loved*, 1854
Oil on canvas
27¼ × 38⅛ in. (69.2 × 96.8 cm)
National Gallery of Canada, Ottawa; Purchased
1964

Abraham Solomon (British, 1824–1862)
*Second Class—The Parting "Thus part we rich in
sorrow, parting poor,"* 1855
Oil on canvas
27 × 38 in. (68.5 × 96.5 cm)
The National Railway Museum, York, UK

Abraham Solomon (British, 1824–1862)
Young Woman Drawing a Portrait, 1851
Oil on canvas
11½ × 13½ in. (29.2 × 34.3 cm)
The Forbes Magazine Collection, New York

Rebecca Solomon (British, 1832–1886)
The Love Letter, 1861
Oil on canvas
21¼ × 16½ in. (54 × 41.9 cm)
The Forbes Magazine Collection, New York

Rebecca Solomon (British, 1832–1886)
The Governess, 1851
Oil on canvas
26 × 34 in. (66 × 86.3 cm)
Edmund J. and Suzanne McCormick Collection,
New Haven, Connecticut

Rebecca Solomon (British, 1832–1886)
The Arrest of the Deserter, 1861
Oil on canvas
43⅜ × 33½ in. (110 × 85 cm)
The Israel Museum, Jerusalem; Gift of
Mrs. Stella Permewan, Liverpool
Through the British Friends of the Art
Museums of Israel

Simeon Solomon (British, 1840–1905)
Moses in His Mother's Arms, 1860
Oil on canvas
23½ × 19 in. (59.7 × 48.3 cm)
Delaware Art Museum, Wilmington; Bequest of
Robert Louis Isaacson, 1999

Simeon Solomon (British, 1840–1905)
Two Acolytes Censing, 1863
Watercolor on paper
15¾ × 13¾ in. (40.2 × 35 cm)
The Ashmolean Museum, Oxford; Visitors of the
Ashmolean Museum

Simeon Solomon (British, 1840–1905)
*The Drought: "Judah mourneth, and the gates
thereof languish ..." (Jeremiah 14:2–3)*, 1866/72
Watercolor, bodycolor and chalks on paper
15⅜ × 8 in. (39 × 20.3 cm)
The Jewish Museum, New York; Museum
Purchase with funds provided by the Fine Arts
Acquisitions Committee, 1999-68

Simeon Solomon (British, 1840–1905)
Carrying the Scrolls of the Law, 1867
Watercolor and gouache, varnished
14 × 10 in. (35.7 × 25.5 cm)
The Whitworth Art Gallery, The University of
Manchester

Simeon Solomon (British, 1840–1905)
Head (Saint Peter or "Help Lord or I Perish"),
1892
Oil on canvas
23⅜ × 17¾ in. (60 × 45 cm)
Tel Aviv Museum of Art, Tel Aviv; Gift of the
Ben Uri Society, London, early 1930s

Solomon J. Solomon (British, 1860–1927)
Self-Portrait, c. 1896
Oil on canvas
39 × 29½ in. (99 × 74.9 cm)
Private collection, London

Solomon J. Solomon (British, 1860–1927)
Lilian Friedländer, 1905
Oil on canvas
51¼ × 39⅜ in. (130 × 100 cm)
Collection Carmel Friedländer Agranat,
Jerusalem

Solomon J. Solomon (British, 1860–1927)
High Tea in the Sukkah, 1906
Ink, graphite, and gouache on paper
15½ × 11½ in. (39.4 × 29.2 cm)
The Jewish Museum, New York; Gift of
Edward J. Sovatkin, JM 91-55

Lesser Ury (German, 1861–1931)
Unter den Linden after the Rain, 1888
Oil on canvas
19 × 14½ in. (48.3 × 37 cm)
Collection Friede Springer, Berlin

Lesser Ury (German, 1861–1931)
Reclining Nude, 1889
Oil on canvas
37 × 69¼ in. (96.3 × 177.5 cm)
Berlinische Galerie, Landesmuseum für
moderne Kunst, Photographie und Architektur,
Berlin

Lesser Ury (German, 1861–1931)
Rebecca at the Well, c. 1908
Oil on canvas
26¾ × 19⅞ in. (68 × 50.5 cm)
Stiftung Jüdisches Museum, Berlin

Lesser Ury (German, 1861–1931)
Girl in a Roman Café, 1911
Oil on canvas
18⅛ × 22½ in. (46 × 57 cm)
Nationalgalerie, Staatliche Museen, Berlin

Lesser Ury (German, 1861–1931)
Lesser Ury Smoking in the Studio, 1912
Oil on canvas
28 × 39½ in. (71 × 100.5 cm)
Private collection, Freiburg, Germany

Selected Bibliography

Alderman, Geoffrey. *Modern British Jewry*. Oxford: Clarendon Press, 1998.

Amishai-Maisels, Ziva. "The Jewish Jesus." *Journal of Jewish Art* 9 (1982): 84–104.

Bendt, Vera. *Judaica Katalog*. Berlin: Berlin Museum, 1989.

Berkowitz, Michael. *Zionist Culture and West European Jewry before the First World War*. Chapel Hill: University of North Carolina Press, 1996.

Bilski, Emily D., ed. *Berlin Metropolis: Jews and the New Culture, 1890–1918*. Exh. cat. New York: The Jewish Museum; Berkeley and Los Angeles: University of California Press, 1999.

Birnbaum, Pierre. *Jewish Destinies: Citizenship, State, and Community in Modern France*. New York: Hill and Wang, 2000.

———, and Ira Katznelson, eds. *Paths of Emancipation: Jews, States, and Citizenship*. Princeton, N.J.: Princeton University Press, 1995.

Bohm-Duchen, Monica, and Vera Grodzinski, eds. *Rubies and Rebels: Jewish Female Identity in Contemporary British Art*. Exh. cat. London: Barbican Art Gallery and Lund Humphries Publishing, 1996.

Boime, Albert. *The Art of the Macchia and the Risorgimento: Representing Culture and Nationalism in Nineteenth-Century Italy*. Chicago: University of Chicago Press, 1993.

Broude, Norma. *The Macchiaioli: Italian Painters of the Nineteenth Century*. New Haven, Conn.: Yale University Press, 1987.

Brugger, Ingrid, ed. *Jahrhundert der Frauen: Vom Impressionismus zur Gegenwart Österreich 1870 bis heute*. Exh. cat. Vienna: Kunstforum Wien und Residez Verlag, 1999.

Buber, Martin, ed. *Jüdischer Künstler*. Berlin: Jüdischer Verlag, 1903.

Cahn, Walter. "Moritz Oppenheim: Jewish Painting and Jewish History." *Orim* 1 (1985): 77–85.

Canepa, Andrew M. "Emancipation and Jewish Response in Mid-Nineteenth-Century Italy." *European History Quarterly* 16 (1986): 403–39.

Cherry, Deborah. *Painting Women: Victorian Women Artists*. New York: Routledge, 1993.

Cohen, Elisheva, ed. *Moritz Oppenheim: The First Jewish Painter*. Exh. cat. Jerusalem: The Israel Museum, 1983.

Cohen, Richard I. *Jewish Icons: Art and Society in Modern Europe*. Berkeley and Los Angeles: University of California Press, 1998.

Frankel, Jonathan, and Steven Zipperstein, eds. *Assimilation and Community: The Jews in Nineteenth-Century Europe*. Cambridge and New York: Cambridge University Press, 1992.

Gans, Mozes Heiman. *Memorbook: History of Dutch Jewry from the Renaissance to 1940*. Trans. Arnold J. Pomerans. Baarn: Bosch and Keuning, 1977.

Gay, Peter. *Pleasure Wars*. New York and London: W. W. Norton, 1998.

Gay, Ruth. *The Jews of Germany: A Historical Portrait*. New Haven, Conn.: Yale University Press, 1992.

Gidal, Nachum T. *Jews in Germany from Roman Times to the Weimar Republic*. Cologne: Könemann, 1988.

Graetz, Michael. *The Jews in Nineteenth-Century France: From the French Revolution to the Alliance Israélite Universelle*. Trans. Jane Marie Todd. Stanford, Calif.: Stanford University Press, 1996.

Guralnik, Nehama. *In the Flower of Youth: Maurycy Gottlieb, 1856–1879*. Exh. cat. Tel Aviv: Tel Aviv Museum of Art and Dvir Publishers, 1991.

Harris, Ann Sutherland, and Linda Nochlin. *Women Artists, 1550–1950*. Exh. cat. Los Angeles: Los Angeles County Museum of Art; New York: Alfred A. Knopf, 1976.

Hart, Solomon Alexander. *Reminiscences of Solomon Hart*. Ed. Alexander Brodie. London: Wyman and Sons, 1882.

Heuberger, Georg, and Anton Merk, eds. *Moritz Daniel Oppenheim: Jewish Identity in Nineteenth-Century Art*. Exh. cat. Frankfurt: Jüdisches Museum der Stadt Frankfurt am Main, 1999. In German and English.

Hyman, Paula E. *The Jews of Modern France*. Berkeley and Los Angeles: University of California Press, 1998.

Katz, Jacob. *Out of the Ghetto: The Social Background of Jewish Emancipation, 1770–1870*.

Cambridge, Mass.: Harvard University Press, 1973.

———, ed. *Toward Modernity: The European Jewish Model*. New Brunswick, N.J.: Transactions Press, 1987.

Kleeblatt, Norman L., and Vivian B. Mann. *Treasures of The Jewish Museum*. New York: Universe Books, 1986.

Kohlbauer-Fritz, Gabirele. *Zwischen Ost und West Galizische Juden und Wien*. Vienna: Jüdisches Museum der Stadt Wien, 2000.

Lewbin, Hyman. *Rebirth of Jewish Art: The Unfolding of Jewish Art in the Nineteenth Century*. New York: Shengold Publishing, 1974.

Lowenstein, Steven M. *The Mechanics of Change: Essays in the Social History of German Jewry*. Atlanta: Scholars Press, 1992.

Mann, Vivian B., ed. *Gardens and Ghettos: The Art of Jewish Life in Italy*. Exh. cat. Berkeley and Los Angeles: University of California Press, 1989.

Mann, Vivian B., with Emily D. Bilski. *The Jewish Museum, New York*. New York: Scala Books, 1993.

Marsh, Jan, and Pamela Gerrish Nunn. *Pre-Raphaelite Women Artists*. New York: Thames and Hudson, 1999.

McCagg, William O., Jr. *A History of Habsburg Jews, 1670–1918*. Bloomington and Indianapolis: Indiana University Press, 1989.

Mendelsohn, Ezra, ed. *Art and Its Uses: The Visual Image and Modern Jewish Society*. Studies in Contemporary Jewry, vol. 6. New York: Oxford University Press, 1990.

Meyer, Michael A., ed. *German-Jewish History in Modern Times*. 4 vols. New York: Columbia University Press, 1997.

Morawinska, Agnieszka. *Nineteenth-Century Polish Paintings*. New York: National Academy of Design, 1988.

Mosse, George L. "Jewish Emancipation: Between *Bildung* and Respectability." In *The Jewish Response to German Culture: From the Enlightenment to the Second World War*. Ed. Jehuda Reinharz and Walter Schatzberg. Hanover, N.H.: University Press of New England, 1985. 1–10.

Natter, G. Tobias, ed. In *Rabbiner-Bocher-Talmudschüler. Bilder des Wiener Malers Isidor Kaufmann, 1853–1921*. Exh. cat. Vienna: Jüdisches Museum der Stadt Wien, 1995. 341–59.

Nochlin, Linda. *The Politics of Vision: Essays in Nineteenth-Century Art and Society*. New York: Harper and Row, 1989.

Oppenheim, Moritz. *Errinerungen*. Ed. Alfred Oppenheim. Frankfurt: Frankfurter Verlags-Anstalt A.-G., 1924; Heidelberg: Manutius, 1999.

Ost und West: Illustrierte Monatsschrift für das gesamte Judentum. Vols. 1–20. Berlin: Verlag Ost und West, 1900–1920.

Paret, Peter. *Art as History: Episodes in the Culture and Politics of Nineteenth-Century Germany*. Princeton, N.J.: Princeton University Press, 1988.

———. *The Berlin Secession: Modernism and Its Enemies in Imperial Germany*. Cambridge, Mass.: Harvard University Press, 1980.

Piatkowska, Renata, and Magdalena Sieramska. *The Museum of the Historical Jewish Institute*. Warsaw: Wydawnictwa Artystyczne i Filmowe, 1995.

Rathbone, Gilliam, ed. *The Ben Uri Story from Art Society to Museum and the Influence of Anglo-Jewish Artists on the Modern British Movement*. Exh. cat. London: The London Jewish Museum of Art, 2001.

Reynolds, Simon. *The Vision of Simeon Solomon*. Stroud, England: Catalpa Press, 1984.

Rosenblum, Robert, Maryanne Stevens, and Ann Dumas. *1900: Art at The Crossroads*. Exh. cat. London: Royal Academy of Arts, 2000.

Roth, Cecil. *A History of the Jews in England*. Philadelphia: Jewish Publication Society, 1979.

———, ed. *Jewish Art: An Illustrated History*. New York: McGraw-Hill, 1961.

Rozenblit, Marsha L. *The Jews of Vienna, 1867–1914: Assimilation and Identity*. Albany: State University of New York Press, 1983.

Rubens, Alfred. *A History of Jewish Costumes*. New York: Crown Publishers, 1967.

Salbstein, Michael C. N. *The Emancipation of the Jews in Britain*. London: Associated University Presses, 1982.

Schorsch, Ismar. *From Text to Context: The Turn to History in Modern Judaism*. Hanover, N.H.: Brandeis University Press and University Press of New England, 1994.

Schwab, W. M., and Julia Weiner. *Jewish Artists: The Ben Uri Collection*. London: Ben Uri Art Society and Lund Humphries Publishing, 1994.

Schwarz, Karl. *Jewish Artists of the Nineteenth and Twentieth Centuries*. New York: Philosophical Library, 1949.

Seymour, Gayle Marie. "The Life and Work of Simeon Solomon (1840–1905)." Ph.D. diss., University of California, Santa Barbara, 1986.

Soussloff, Catherine M., ed. *Jewish Identity in Modern Art History*. Berkeley and Los Angeles: University of California Press, 1999.

Weinryb, Bernard D. *The Jews of Poland.* Philadelphia: Jewish Publication Society, 1973.

Weisberg, Gabriel P. *Beyond Impressionism: The Naturalist Impulse.* New York: Harry N. Abrams, 1992.

Werner, Alfred. "Jewish Artists of the Age of Emancipation." In *Jewish Art: An Illustrated History.* Ed. Cecil Roth. New York: McGraw Hill, 1961. 539–74.

————. "Oppenheim and Kaufmann: Fine Genre Painters." *Families and Feasts: Paintings by Oppenheim and Kaufmann.* Exh. cat. New York: Yeshiva University Museum, 1977. 5–15.

Wistrich, Robert S. *The Jews of Vienna in the Age of Franz Joseph.* Oxford: Littman Library, Oxford University Press, 1989.

Photography Credits

Pl. 26 © Collection Carmel Friedländer Agranat, Jerusalem (photograph by Avraham Hay)

Pl. 60 © Collection Mr. and Mrs. Arthur G. Altschul, New York

Fig. 14 © Anger-Museum, Erfurt, Germany

Fig. 34 © 2001 Artists Rights Society (ARS), New York/ADAGP, Paris

Fig. 33 © 2001 Artists Rights Society (ARS), New York, Giraudon/Art Resource, New York

Pls. 50, 51, 52, 53 © 2001 Artists Rights Society (ARS), New York/VG Bild-Kunst, Bonn (photographs by Hans-Joachim Bartsch, Ursula Edelmann, and Roman März)

Pl. 42, fig. 19 © The Ashmolean Museum, Oxford

Fig. 40 © Bayerische Staatsgemaldesamm-lungen, Neue Pinakothek, Munich

Pl. 28 © The Ben Uri Gallery, The London Jewish Museum of Art

Fig. 11 courtesy of The Bridgeman Art Library International, Ltd., London

Pl. 43 © Civica Galleria d'Arte Moderna, Milan

Pl. 39 © Delaware Art Museum, Wilmington

Pl. 13 © Collection Reuven and Naomi Dessler, Cleveland, Ohio

Pls. 22, 57, 71, 72 © Collection Vera Eisenberger KG, Vienna

Pls. 33, 37 © The Forbes Magazine Collection, New York

Fig. 24 courtesy of W. Ernest Freud, by arrangement with Mark Paterson and Associates, London

Illus. p. 178 courtesy of Fundación IWO, Buenos Aires (photograph by S. Londynski, Paris)

Figs. 20, 38 courtesy of Giraudon/Art Resource, New York

Fig. 4 © Hamburger Kunsthalle, Hamburg (photograph by Elke Walford)

Fig. 41 © Hôtel de Ville, Le Quesnoy, France

Pls. 2, 3, 5, 7, 8, 12, 23, 32, 44, figs. 25, 28, 29, 32, 44, 46, illus. p. 179 (bottom) © The Israel Museum, Jerusalem (photographs by

Avshalom Avital, Avi Ganor, David Harris, and Richard Hori)

Pl. 45 © Istituto Matteucci, Viareggio, Italy

Pls. 1, 4, 10, 11, 20, 25, 27, 31, 40, 48, illus. p. 11, figs. 3, 15, 27, 44 © The Jewish Museum, New York (photographs by Richard Goodbody, Richard Hori, John Parnell, Nicholas Sapieha, Malcolm Varon, and Elke Walford)

Fig. 42 Courtesy of the Jewish National and University Library, Department of Manuscripts and Archives

Pl. 58, fig. 5 © Joods Historisch Museum, Amsterdam

Pl. 9 © Judah L. Magnes Museum, Berkeley, California

Pl. 61 © Kröller-Müller Museum, Otterlo, Holland

Fig. 23 courtesy of Leo Baeck Institute, Jerusalem

Fig. 12 courtesy of Erich Lessing/Art Resource, New York

Pl. 63 © Collection Sara and Moshe Mayer, Tel Aviv

Pl. 62 © Metropolitan Museum of Art, New York

Illus. p. 171 (left and right) courtesy of Ministero per I Beni e le Attività Culturali, Instituto Centrale per il Catalogo e la Documentazione, Rome

Pl. 29 © Musée d'art et d'histoire du Judaïsme, Paris (photograph by Jacques L'Hoir)

Fig. 36 © Musée de l'Assistance Publique-Hôpitaux de Paris, Paris

Figs. 1, 37 © Musée des Beaux-Arts, Brest, France

Illus. p. 180 courtesy of Musée Pissarro, Pontoise (photograph by Cundal Downes and Co.)

Pl. 55 © Museo Civico Giovanni Fattori, Livorno (photograph by Nicholas Sapieha)

Fig. 31 reproduced with permission © 2000 Museum of Fine Arts, Boston

Pls. 17, 18 © Muzeum Narodowe w Warszawie, Warsaw (photographs by Teresa Żółtowska)

Fig. 49 © Muzeum Narodowe w Warszawie, Warsaw

Pl. 59 courtesy of Nancy Whyte Fine Arts, New York

Pl. 69 © Nationalgalerie, Staatliche Museen, Berlin (photograph by Jörg P. Anders)

Fig. 18 © Board of Trustees, National Gallery of Art, Washington

Pl. 36 © National Gallery of Canada, Ottawa

Fig. 16 © National Museum, Kraków

Illus. p. 175 (right), p. 181 courtesy of National Portrait Gallery, London (photograph by Elliot and Fry, and Cundall Downes and Co.)

Fig. 21 courtesy of Nimatallah/Art Resource, New York

Fig. 6 NYC © 2001 (photograph by Malcolm Varon)

Fig. 39 © The Oskar Reinhart Foundation, Winterthur, Switzerland

Figs. 13, 48 © Österreichische Galerie Belvedere, Vienna

Fig. 43 taken from *Ost und West*, 1901

Pl. 47, fig. 30 © Philadelphia Museum of Art, Philadelphia

Pls. 6, 19, 21, 24, 68, fig. 9 courtesy of private collections

Pl. 14 courtesy of Réunion des Musées Nationaux (photograph by Gilles Berizzi)

Figs. 22, 45 courtesy of Réunion des Musées Nationaux/Art Resource, New York (photographs by Gilles Berizzi)

Fig. 17 courtesy of Réunion des Musées Nationaux/Art Resource, New York (photograph by Bulloz)

Fig. 35 courtesy of Réunion des Musées Nationaux/Art Resource, New York (photograph by Jean Schormans)

Pl. 49 © Rijksmuseum, Amsterdam

Fig. 8 courtesy of Rothschild Archive Trust

Illus. p. 182 © Royal Academy of Arts, London

Pl. 35 © Science and Society Picture Library, Science Museum, London

Fig. 26 © Seitz-Gray, Frankfurt

Fig. 7 © Sotheby's, London

Pl. 66 © Collection Friede Springer, Berlin

Illus. p. 177 courtesy of Staatliche Museen zu Berlin, Kunstbibliothek, Lipperheidesche Kostumbibliothek, Berlin (photograph by Nicola Perscheid)

Pl. 46 © Stedelijk Museum, Amsterdam

Pl. 65 courtesy of Stern Art Dealers, London

Pl. 70 © Stiftung Jüdisches Museum, Berlin (photograph by Jens Ziehe)

Pl. 54 © Studio Paul Nicholls, Milan

Pl. 64, fig. 10 © The Tate Gallery, London

Pls. 15, 30, 38 © Tel Aviv Museum of Art, Tel Aviv (photographs by Avraham Hay)

Illus. p. 175 (left) courtesy of Tel Aviv Museum of Art, Tel Aviv

Pl. 67 © VG Bild-Kunst, Bonn

Fig. 2 © Victoria and Albert Museum, London

Pl. 56 © Vienna City Museum, Vienna

Pl. 16 © Weizmann Institute of Science, Rehovot, Israel (photograph by Avraham Hay)

Pl. 41 © The Whitworth Art Gallery, The University of Manchester

Pl. 34 © Yale Center for British Art, New Haven, Connecticut (photograph by Richard Caspole)

Index

no